# Photographic Processing

# Photographic Processing

PROCEEDINGS OF THE SYMPOSIUM ON PHOTOGRAPHIC
PROCESSING HELD AT THE UNIVERSITY OF SUSSEX, FALMER,
SUSSEX, SEPTEMBER, 1971

*Edited by*

# R. J. COX

*Fellow of the Royal Photographic Society, London, England*

1973

Published for The Scientific and Technical Group
of the Royal Photographic Society by

ACADEMIC PRESS: LONDON AND NEW YORK

ACADEMIC PRESS INC. (LONDON) LTD.
24/28 Oval Road
London, NW1

*U.S. Edition published by*
ACADEMIC PRESS INC.
111 Fifth Avenue,
New York, New York 10003

Set in 11/12pt. Monotype Baskerville, printed by letterpress,
and bound in Great Britain at The Pitman Press, Bath

# Contributors

M. AELTERMAN, *Research and Development Laboratories, Agfa-Gevaert N.V., Mortsel, Belgium.*

W. F. BERG, *Institute of Photography (ETH-Z), 8006 Zürich, Switzerland.*

K. G. CLARK, *Micro-Image Technology Ltd., High Wycombe, England.*

J. H. COOTE, *Ilford Limited, Ilford, Essex, England.*

S. COUPRIÉ, *Centre de Recherches, Kodak-Pathé S.A., 30 Rue des Vignerons-94, Vincennes, France.*

H. F. FRIESIER, *Institute of Photographic Science, Technical University, Munich, West Germany.*

G. GEHIN, *Centre de Recherches, Kodak-Pathé S.A., 30 Rue des Vignerons-94, Vincennes, France.*

G. GREEN, *Research Laboratory, Kodak Limited, Wealdstone, Harrow, Middlesex, England.*

W. GROSS, *Institute of Photography (ETH-Z), 8006 Zürich, Switzerland.*

M. GROSSA, *Dupont (Deutschland) GmbH, Photo Products Department, 6078 Neu-Isenberg, West Germany.*

E. GÜNTHER, *Research Laboratories, Agfa-Gevaert A.G., Leverkusen, West Germany.*

R. W. HENN, *Research Laboratories, Eastman Kodak Company, Rochester, N.Y. 14650, U.S.A.*

H. K. HOWELL, *Itek Optical Systems Division, 10, Maguire Road, Lexington, Mass., U.S.A.*

T. H. JAMES, *Research Laboratories, Eastman Kodak Company, Rochester, N.Y. 14650, U.S.A.*

J. KARRIER, *Institute of Photography (ETH-Z), 8006 Zürich, Switzerland.*

S. KITROSSER, *Itek Optical Systems Division, 10 Maguire Road, Lexington, Mass., U.S.A.*

G. I. P. LEVENSON, *Research Laboratory, Kodak Limited, Wealdstone, Harrow, Middlesex, England.*

L. LUGOSY, *Dupont (Deutschland) GmbH, Photo Products Department, 6078 Neu-Isenberg, West Germany.*

R. MATEJEC, *Research Laboratories, Agfa-Gevaert A.G., Leverkusen, West Germany.*

Max Meier, *CIBA-GEIGY Photochemie A.G., 1701 Fribourg, Switzerland.*

H. D. Meissner, *Research Laboratories, Agfa-Gevaert A.G., Leverkusen, West Germany.*

A. Meyer, *CIBA-GEIGY Photochemie A.G., 1701 Fribourg, Switzerland.*

W. E. Mueller, *E. I. du Pont de Nemours & Co. Inc., Photoproducts Department, Experimental Station, Wilmington, Delaware 19898, U.S.A.*

I. A. Olivares, *Research Laboratories, Eastman Kodak Company, Rochester, N.Y. 14650, U.S.A.*

W. Pistor, *Dupont (Deutschland) GmbH, Photo Products Department, 6078 Neu-Isenberg, West Germany.*

R. B. Pontius, *Research Laboratories, Eastman Kodak Company, Rochester, N.Y. 14650, U.S.A.*

M. G. Rumens, *Research Laboratory, Kodak Limited, Wealstone, Harrow, Middlesex, England.*

M. Schellenberg, *CIBA-GEIGY Photochemie A.G., 1701 Fribourg, Switzerland.*

M. Schlesinger, *Institute of Photographic Science, Technical University, Munich, West Germany.*

C. J. Sharp, *Research Laboratory, Kodak Limited, Wealstone, Harrow, Middlesex, England.*

G. Vanreusel, *Research and Development Laboratories, Agfa-Gevaert N.V., Mortsel, Belgium.*

G. F. van Veelen, *Research and Development Laboratories, Agfa-Gevaert N.V., Mortsel, Belgium.*

J. F. Willems, *Photochemical Research Department Agfa-Gevaert N.V., Mortsel, Belgium.*

R. G. Willis, *Research Laboratories, Eastman Kodak Company, Rochester, N.Y. 14650, U.S.A.*

# Preface

The papers which comprise the text of this volume all relate to the processing of silver halide materials although the original notice to prospective authors invited papers on the processing of any system.

It seems that non-silver processes, which are all rather specialized even though they are used in great volume in their proven applications, are not seen to have a significant processing stage by those who design them. They all do require some treatment after the exposure to produce a usable image and for the most part this treatment involves a fluid, be it a powder, a dispersion in organic solvent, or a gas; only the purely thermographic processes require no fluid unless for the sake of argument we invoke a caloric flux! However, the received concept is of a non-processed material.

Processing, then, can be seen as a special characteristic of silver halide systems and it has been this way for a century and a half since the system of Fox Talbot with its wet processing first competed with and then prevailed over the direct-positive process of Daguerre which, although it involved treatment with mercury vapour, would be seen in the present context as a dry process not involving a processing step.

The silver–halide–polymer system has survived, though constantly changing and diversifying, because of its inherent subtlety and complexity and because the prime mover of the system, $Ag^+ + e \rightleftharpoons Ag$, can be employed in a host of pre- and post-exposure processes to achieve an astonishing range of effects, some being quite contradictory. It can be used to form dye images and it can be used to destroy them, as this volume shows. It can be used to form a silver image and to prevent its formation. It can be used to harden gelatin and it can be used to disintegrate it. This list can be extended.

The important point is that the system has had sufficient complexity to be adaptable in each decade to meet the new demands of the day and the present indications are that it will continue to do so while often relinquishing certain applications to non-silver processes. The question naturally arises at the present time as to whether purely electronic systems will render silver halide systems obsolete, particularly in that they involve no processing and offer almost instantaneous access. As the

miniaturization of electronic circuitry progresses, a point will eventually be reached where circuit elements will be decreased to molecular dimensions and when we get there we will be back in the realm of silver halide crystals. Invented now, the sophisticated silver halide grain would be hailed as an advance in sub-microminiaturization, allowing sub-microcircuits to be *grown* by the billion cheaply enough for expendable use in hard copy. Moreover, it should be borne in mind that microcircuits are currently produced by photographic methods as the paper by K. G. Clark explains.

A conference on photographic processing, therefore, can be expected to reflect the range of current endeavour in bringing out of the cornucopia the items currently in demand. The meeting on which this volume is based was no exception. The fact that some of the topics were being debated a century ago indicates only that the context and the language have changed. The context changes because for a process to receive considerable notice three factors are simultaneously required; feasibility, availability, and saleability; the language changes because we have to describe and interpret the mechanisms with the tools provided by the academic disciplines of physics and chemistry. As these improve or extend so does our understanding *Plus ça change*! . . .

Of great interest today are processes for colour photography which is now past the half-way point in replacing silver-image materials where there is competition. In some fields, e.g. motion picture, the replacement by colour is already virtually complete. There is intense, current activity on in-camera processes. Therefore, a good deal of the material of the conference is relevant to the improvement of colour processes by making them more rapid in access, more stable in their colours, as well as environmentally more acceptable by recovery of scarce resources and by using less toxic materials for items that will pass into effluent. Under the heading of contradictions, we see in a paper by Lugosy how autocoupling, a process that can lead to undesirable organic stains in a colour development, might be harnessed and used as the imaging system in a monochrome process.

A glance over the history of fundamental research on the silver halide process shows, because of factors already mentioned, how understanding advances in a spiral manner. Theories are superseded only to be returned to after much advance, though at a different level. Once there was an induction period in development, a generation later it was ascribed to delayed visibility, then we had it again as a phenomenon that accounted for superadditivity; now, as early chemical and physical development draw together in the pre-filamentary stage, the induction period concept loses favour to a simple autocatalysis.

Movement round this spiral of accepted insight is not a smooth progression. It can be delayed for years by dominant personalities like Hurter and Driffield who, established by major contributions, lay down dogma with which lesser men hasten to accord and from which strong men hesitate to diverge. Sometimes the turn is hastened, or disturbed, by a radically new observation. The electron microscope gave us the certainty that the image developed from silver halide had a filamentary structure and this has been one of the fundamental facts of post-war studies on development, distinguishing the "chemical" from the "physical" form. The studies of Berry and Pontius with their co-workers in the last three years appeared to have revealed the mechanism of the formation of filaments; development started by forming a spherical mass of silver and this became a filament only when the assymetric delivery of silver ions from silver halide became too fast for the reduced atoms to diffuse to maintain the spherical shape.

This matter was nicely settled when W. E. Mueller presented a paper, included here, which claimed that filaments can be formed by the reduction, *in situ*, of pre-filaments of a non-metallic silver complex. This paper was the subject of an intense discussion at the Conference, a special, off-shoot session being held to allow extra time. Can this finding be confirmed by others? will it prove just a red-herring? or will it take us round the spiral from the currently accepted electrode theory of development to a new version of the Ostwald-Abegg supersaturation theory? By the time the Royal Photographic Society holds its next meeting on processing, we may know the answer.

G. I. P. LEVENSON

*Harrow*
*October*, 1972

# The Science Committee of the Royal Photographic Society

| | |
|---|---|
| *Chairman* | MR. J. W. JANUS |
| *Vice-Chairman* | MR. G. W. SMITH |
| *Hon. Treasurer* | MR. R. J. COX |
| *Hon. Secretary* | MR. C. J. V. ROBERTS |
| *Representatives* | MR. K. R. WARR |
| *of Council* | MR. J. G. C. STEELE |
| *Committee* | MR. G. ALLBRIGHT |
| | MR. R. COLMAN |
| | MR. D. J. DEARNLEY |
| | MISS M. J. G. GUNST |
| | MR. D. H. O. JOHN |
| | MR. A. M. KRAGH |
| | MR. P. NUTTALL-SMITH |
| | MR. J. G. C. STEELE |
| *Convenor of the Conference* | DR. G. I. P. LEVENSON |

The Science Committee of the Royal Photographic Society consists of the Committee of the Scientific and Technical Group of the Society together with two representatives of Council. Its function is to plan, at the highest level, events concerned with scientific and technical photography.

The Scientific and Technical Group of the Royal Photographic Society seeks to encourage and stimulate interest in scientific and technical aspects of photography. An important activity of the Group is the publication of *Photographic Abstracts*, a journal which contains abstracts of papers and patents in the field of photographic science and technology.

Further details of the future programme of the Scientific and Technical Group of the Royal Photographic Society, and forms of application for membership can be obtained from:

> The Hon. Secretary,
> Scientific and Technical Group,
> Royal Photographic Society,
> 14 South Audley Street,
> London, W1Y 5DP

# Contents

# The Induction of Development

# The Initiation of Development

## T. H. JAMES

*Research Laboratories, Eastman Kodak Company, Rochester, N.Y., U.S.A.*

ABSTRACT. Various experimental procedures used to obtain information on the mechanism of initiation of development are reviewed. These include microscopic examination, use of long wave radiation to follow the growth of optical density in unfixed grains, mathematical analysis of rate of development curves, initiation of development in an experimental developer followed by intensification in a standard developer, and examination of the dependence of the rate at various stages of development and conditions of exposure on the composition, temperature, and oxidation-reduction potential of the developer. The use of low temperature exposures to produce latent image centres of near threshold size and to obtain a controlled growth of latent image centres is discussed. Although not conclusive, the available evidence suggests that, if a change in basic mechanism occurs during the course of development in a low solvent type developer, it occurs much earlier than the start of filamentary growth of the developing silver.

## INTRODUCTION

The process of development is often divided, at least conceptually, into an initiation and a continuation stage. The idea that the initial stage in the reduction of a grain is a relatively long "induction period" during which no apparent change occurs, and that this is followed by a very rapid microscopically visible growth of silver, stems from early observations made with the optical microscope. In the late 1920's, Tuttle and Trivelli[1] made motion picture micrographs that suggested the "popcorn" description of development. To quote their description of development by Metol, "Development in most cases starts from centres on the grain. During development, the grain is in constant vibration as a whole. This movement, which is of the order of 0.00001 in, is plainly visible on the screen . . . the grain throws out thread-like protuberances which are also in rapid movement. The appearance of these streamers has given rise to the idea that some grains explode upon development." This idea is more fanciful than factual.

3

## MECHANISMS

The early theory of development, the supersaturation mechanism suggested by Ostwald and modified by Abegg and Schaum, provided for more than one rate determining step, since it postulated that the silver halide first passes into solution, where the silver ions are very rapidly reduced in the homogeneous phase, and growth of the developed image proceeds by deposition of silver onto the latent image centres. The theory does not provide, however, for a difference in mechanism between the early and later stages. Present day theory, on the other hand, provides distinct possibilities for a change in mechanism, or a shift in the importance of competing mechanisms as development proceeds. It has been suggested that development is initiated by a solution physical development process and continued by an essentially solid state reduction process, or vice versa; that the initiation of development involves a catalytic reduction of silver ions in contact with the developer at the silver—silver halide interface, and subsequent reduction occurs by an electrolytic mechanism; and that a type of latensification by the developer involving transport of electrons through the conduction band of the silver halide is important in the initial stage of development, but another process becomes dominant once the development centres have grown to sufficient size. It has also been suggested that no essential change in mechanism occurs and that the differences in rate are simply due to the increasing size and number of the development centres as development progresses.

## EXPERIMENTAL TECHNIQUES

In the absence of an on the spot molecule observer, such as provided by a Maxwell demon, the problem of obtaining and interpreting data on the progress of reaction during the period in which no apparent change is occurring in the grain is not an easy one. Once the developer reaches the grain, we are not justified in assuming that the lack of apparent change means that none is occurring. Latent image centres are not normally detected by even the electron microscope, and must grow substantially before such detection is achieved in the current state of the art. It seems safe to assume that significant changes have occurred before the development centres are detected.

It is always easier to speculate than to design definitive experiments. Definitive experiments are still to be found, but several general procedures have been followed in the study of the initiation of development. Each has its pitfalls for the unwary.

The use of macroscopic model systems, such as large crystals grown from molten silver bromide and the various experimental models used to study the kinetics of electro-chemical reduction of silver halide, are not

applicable. The latter use macroelectrodes, and the amount of photolytic silver required to initiate development in the former appears to be much larger than that corresponding to normal latent image centres in emulsion grains.

## MICROSCOPIC STUDIES

In addition to the early microscopic studies by Tuttle and Trivelli already mentioned, kinetic studies of development of emulsion grains several microns or more in diameter deposited as individual grains or grain monolayers on the microscope slide or cover glass have been made by Meidinger,[2] Frieser,[3] Rabinovich[4] and Berg and Ueda.[5] Fujisawa et al.[6] used cinephotomicrography to study silver bromide and iodobromide crystals of 50–100 $\mu$ size grown from ammoniacal solution. Recently, a Diploma Dissertation by Hans Eger[7] reported extensive work which he had carried out in Professor Frieser's laboratory, using an infrared television microscope technique to study the course of development in grain monolayer coatings. The grains were several microns in average size and were prepared by the classical Smith–Trivelli procedure.

The microscopic studies show that, at least for the large grains studied, development of the individual grain can progress in several ways, depending on the composition of the developer and to some extent on exposure conditions. Eger distinguishes "moss development", which starts at many points on the grain surface; "accretion development", which spreads throughout the grain from one or a few initiation points; "point development", in which a few initiation centres become visible but subsequently grow only very slowly; "sprouting development", in which the silver seems to grow out of the grain like sprouts from a seed; "explosion development", in which the outward growth is quite violent; and "infectious development", in which protuberances from one developing grain start development in another. Similar classifications have been suggested by Rabinovich. Moss development occurred in heavily exposed grains developed in a slow acting, high sulphite content developer with a short induction period. Accretion and sprouting development occurred when there was a small number of active nuclei and the developer showed a marked induction period. Explosion development occurred in weakly exposed grains developed by a high activity, high pH developer of low sulphite content. Point development occurred in slowly acting developers with a high solvent action on silver bromide, particularly p-phenylenediamine developers of pH 9·5–11, and low pH, high sulphite Glycin developers. Solvent action was clearly visible.

The microscopic studies show that solvent action on the silver halide can play at least two roles in the early stage of development. It can

accelerate the initiation stage for at least some latent image centres. If the developer activity is too low or the solvent action too high, however, development centres can become separated from the silver halide, and then can grow only by physical development. These indications of the microscopic studies are supported by studies on conventional coated emulsions.

There are definite drawbacks to the microscopic technique. It requires large grains which are often not typical of grains in practically used emulsions. The grains on the microscope slide are not in their normal emulsion environment, and the relative rates of initiation and continuation of development differ from those in coated emulsions. The continuation stage of development can proceed much more rapidly if the restraining gelatin layer is disrupted. Collection of sufficient data to be meaningful statistically in rate studies is a laborious process. Moreover, before a development centre can be detected by the optical microscope it must already have grown to about $0 \cdot 3$ $\mu$ so that no information can be obtained in this way as to the details of the very early stages of growth.

## ELECTRON MICROSCOPY

The electron microscope can be used to detect development at an earlier stage, but lacks the ability of the optical microscope to monitor the continuous progress of development in a single grain. Initiation and continuation can be followed statistically, however.[8] Electron micrographic studies have shown that in the early stage of development by low solvent developers the silver centres grow as roughly rounded particles. At some stage, the particles begin to grow predominantly in one dimension, and filamentary growth becomes dominant. It has been proposed that this change in the form of the developed silver coincides with the transition from the induction period to the continuation stage. However, the silver particles often reach a diameter of 15–20 nm before they start to grow as filaments and, in moderately fine grain emulsions, this can correspond to a reduction of at least several per cent of the available silver ions of the grain. There is no evidence for a real change in mechanism of development at this stage, only of a change in the details of the growth of the silver particles.

## OTHER TECHNIQUES

Other methods of obtaining information on the early stages of development depend on the use of actual photographic emulsions, either in liquid or in coated form. A major problem is the choice of criteria for the initiation of development and the conditions of study. Obviously, we want as sensitive a method as possible consistent with accuracy and

reasonable facility of application to detect that reduction of the silver halide has indeed started.

Watkins used the time of visual appearance of the image as his criterion for determining the time required to obtain a desired degree of development. This method has obvious limitations for scientific work.

One objective method, which can be used with either liquid or coated emulsions to detect development at an early stage and follow continuously the formation of silver, is to monitor the silver with infrared or long wave visible radiation that does not affect the course of development. This method was used by Fortmiller and the author[9] to follow the course of development in liquid and coated emulsions. More recently, Gorokhovskii and his co-workers[10] have used radiation of $\lambda 670$–725 to follow the course of development in ordinary coated emulsions. They made optical density measurement on strips of film which had been developed for different times, then immersed in a stop bath and washed, but not fixed. In highly exposed emulsions, where the amount of latent image silver exceeded considerably that for normal exposures, they were able to follow the course of development beginning immediately from the latent image. After a period in which the measured densities showed a random fluctuation around a horizontal line corresponding to the latent image, density increased and quickly reached a region of linear growth with time. The time at which the density curve broke away from the latent image region was taken as the induction or initiation period. This period, for both a hydroquinone and a p-phenylenediamine developer, showed only a small dependence on exposure over an exposure range of two orders of magnitude. No estimate of the size of the latent image centres was attempted. In the region of normal exposures, the density-time curves showed a considerably larger dependence on exposure. Silver analyses also were made in subsequent experiments, using Feigl's microanalytical colorimetric method. These measurements also indicated an initial linear growth of silver with time for a dilute hydroquinone developer in the very early stages, followed by a region of auto-accelerating growth in which the ratio of optical density to silver (covering power) decreased rapidly as the particle size increased.

Broun and Chibisov[11] followed the rate of change of optical density by comparing the intensities of light transmitted through undeveloped and developing layers of thinly coated emulsion. Samples removed from the developer at various times were washed and desensitized with pinakryptol yellow before the optical measurements and the undeveloped control sample was treated similarly. With D-76 and with a metol-hydroquinone developer containing added thiosulphate, a decrease in density occurred initially, followed by the increase corresponding to

formation of silver. Broun and Chibisov interpret this to mean that some solution of silver halide precedes development, and that "chemical development follows the physical development mechanism under conditions of normal development." They saw no evidence that solution preceded development for a sulphite-free Glycin developer, however.

It is also possible to follow the progress of development in some developers by monitoring changes in the composition of the developer, such as an increase in an oxidized form of the developer,[12] a change in the redox potential, or the release of hydrogen ions in the reaction of organic developers.[13]

## DEVELOPMENT RATES

Conventional density-time of development curves have often been used to obtain rates of development in early and later stages. One method of obtaining a measure of the initiation period from such curves is to assume a mathematical relation for the rate beyond the initiation period and extrapolate this relation to zero density of developed silver. This method is useful under some conditions. A sound theoretical basis for this procedure has not been established, however, and it can lead to unreliable and sometimes absurd values, as I have shown in a recent publication.[14] Another method of obtaining a measure of rate in the early stage is to take the reciprocal of the time required to form a very small, but accurately measurable amount of reaction product. As a means of increasing the accuracy of determination of the time required to produce a fixed, small amount of developed silver, an arrested development technique followed by amplification with a standard developer has been used. In this method,[15] strips of coated film can be immersed in the developer under study for various times, each so short that either no image or only a faint image is visible, and the strips then are transferred, after an intermediate short stop and wash treatment, to the standard developer to amplify the development initiated by the test developer. In a modification of this procedure, Karrer and Berg[16] initiated development in samples of liquid emulsion, which were then quenched, coated on glass plates, and treated in a redox buffer which would destroy latent image but not larger particles formed by partial development. Development was then completed in a standard surface developer. Within $0.3$ s, the shortest time tested, development by a dilute hydroquinone-ascorbic acid developer of pH $12.15$ had proceeded to a point where the centres were no longer destroyed by the latent image bleach.

One difficulty, often overlooked, in evaluating data from conventional rate curves is to determine what the data mean in terms of the development of individual grains. For example, if the time required to reduce 1%

of the total developable silver halide is chosen as a measure of the rate of initiation of development, it could represent the time required to reduce (1) 1% of each developable grain, (2) 1% of the total number of developable grains, or (3) a mixture of some totally developed, some partially developed, and some undeveloped grains. It is possible to find examples of each of these three.[14] With some emulsions and developers, exposure conditions can be found such that all or nearly all of the grains develop in parallel fashion, and other exposure conditions such that at any stage of gross development, the silver deposit is made up largely of fully developed grains and the increase in density with time of development represents an increase in the number of fully developed grains. The first condition was achieved in some of my experiments with motion picture positive emulsions of fairly uniform grain size, given a moderate to low intensity exposure at room temperature at a level corresponding to well on the shoulder of the characteristic curve. Kinetic curves for the growth of density and mass of silver under these conditions can be reasonably interpreted as representing the progress of development in the individual grain. The second condition was achieved by making the exposure at the same total energy level, but with the emulsion at 77°K. The kinetic curves for gross development in this case represented the time distribution of the initiation periods of the individual grains.

The low temperature exposure of this type of emulsion provides the formation of threshold or near threshold latent image centres in all or the great majority of grains in the emulsion coating. This is indicated by the kinetic behaviour of development of these latent images, and is further supported by Hamilton's analysis[17] based on his latent image models. A comparison of the temperature dependence of development of the low temperature and room temperature latent images by several developing agents showed that the overall activation energies for the low temperature images were in general several kilocalories per mole larger than for the room temperature images. Activation energies close to those for the low temperature latent images were obtained with room temperature exposures for the toe region of the characteristic curve, but the activation energies had dropped to within 1 kilocalorie of shoulder value for exposures corresponding to the lower part of the straight line portion of the curve, where the average number of quanta absorbed per grain was only about 30.

A modification of the low temperature exposure technique apparently can be used to build up latent image centres by successive stages. This technique, originally used by Webb[18] in a study of the mechanism of latent image formation, is to apply the exposure in two or more equal fractions at liquid nitrogen temperature, with warm-up periods in

between. The first installment is made at 77°K, then the emulsion is warmed to room temperature and then cooled down to liquid nitrogen temperature before the second exposure installment is made. This procedure is repeated until the complete exposure has been applied. The initial exposure forms latent image centres of near threshold size in some or all of the emulsion grains. Each subsequent installment allows these latent image centres to become a little larger. Although the precise amount of silver added to each centre by each installment exposure is unknown, experiments with several emulsions have shown that the low temperature latent image acquires development characteristics of a room temperature image only if the low temperature exposure is applied in several installments. The proper choice of emulsion is important, however.

## CONTINUITY OF MECHANISM

Conventional plots of density or silver versus time of development for conditions under which the majority of the grains are developing in parallel fashion show no evidence of a point of discontinuity or sudden change in the development rate. Although first order plots of the type illustrated by Willis, Ford and Pontius[19,20] suggest a discontinuity, measurements of silver formed in the early stages before the data start to conform to the first order relation show no actual discontinuity.[14] In general, analysis of the curve shape gives no evidence for a change in mechanism as development progresses.

Evidence for a change in mechanism also has been sought in activation energy data and in the relation between the redox potential of the developer and the rates of development in the early and later stages of development. For the high level exposures with grains developing in parallel fashion, little change in activation energy, not more than 1–2 kcal mol$^{-1}$ at best, has been observed[14] for most developers as development progresses from the initial to the continuation stage, and the usual change, when one occurs, is a decrease in activation energy. Ascorbic acid is an exception. Here, the observed increase in activation energy[20,21] may signal a real change in mechanism. Redox potential measurements on a large number of derivatives of p-phenylenediamine show about the same dependence of rate on potential in the initiation and continuation stages of development. In general, with the possible exception of ascorbic acid, these data give no evidence of a change in mechanism as development progresses in a low solvent developer.

For exposures made at liquid nitrogen temperature, or for exposures at room temperature corresponding to the toe region of the characteristic curve, activation energies several kilocalories per mole higher than those

for the high level, room temperature exposures were obtained. Moreover, qualitative differences in the rate-potential relation for liquid nitrogen temperature and room temperature exposures were observed when the potential of a single developer, in this case the ferrous-EDTA developer, was changed by varying the pH. The rate of development of image formed at the low temperature increased as the potential became more negative, whereas the rate of development for high level exposures made at room temperature was nearly independent of potential or even decreased slightly.

In general, there is no clear evidence for a change of mechanism as development in a low solvent developer progresses from the early to the later stages for exposures corresponding to the shoulder region of the characteristic curve. The presumption is that no significant change in mechanism occurs. On the other hand, the evidence suggests that real differences may exist in the mechanisms in the initiation and continuation stages of development for latent image centres of threshold or near threshold size. This may be true also for larger latent image specks when solvent action on the silver halide is relatively high.

The author has not discussed charge effects because he does not consider that changes in rate brought about by charge effects represent a change in mechanism. These are kinetic effects representing a change in the effective concentration of the developing agent at the reaction site. Charge effects can have an important influence on the relative rates of initiation and continuation of development, however. I have reviewed charge effects and charge barrier theory in some detail in a recent publication.[14]

Our knowledge of the details of the initiation of development is still rather meagre. The evidence does suggest, however, that if a change in basic mechanism occurs, the transition from the initial mechanism probably has largely taken place by the time the development centres have become as large as at least some of the latent image centres formed by a shoulder-level exposure made at room temperature, and well before the transition from non-filamentary to filamentary silver. This may not be true for all emulsions, but seems to be for the relatively simple motion picture type of emulsion that I have used in most of my kinetic studies.

Several proposals have been made of mechanisms that might apply to the very early stages of development of the very small centres.[14]

1. Development might start by the interface catalysis mechanism and, as the growing silver nucleus became large enough to show the properties of silver crystals, shift to the electrode mechanism as the dominant one.[22] If a threshold type latent image centre consists of only four to five silver atoms, the area it presents to the developer will be less than that occupied

by a typical developer molecule, i.e. 50–60 Å$^2$ for hydroquinone, Metol, or Phenidone. Developer molecules or ions making contact with such small silver specks would overlay both latent image silver and adjoining silver halide. After the silver centres had grown to a few hundred silver atoms, the area of the silver would exceed that of the developer molecule, and as the silver speck continued to grow, the probability of the developer molecule contacting only silver surface would exceed that of contacting silver–silver halide interface. If development could take place equally well by electron transfer to a silver centre and by the formation and decomposition of an activated complex between silver ion, silver, and developing agent, the latter would be the dominant process initially and the former would become dominant as development progressed.

2. The developer may interact with the silver halide, independently of the latent image centres or subcentres, to form isolated silver atoms, possibly at kink sites, or to transfer electrons to surface states.[23] This type of process could occur over a much larger surface area than that confined to the vicinity of the latent image centres. The atoms or electron-occupied surface states ($Ag^+$—$\varepsilon$—$Ag^+$) could then thermally dissociate to inject electrons into the conduction band of the silver halide. Latent image centres or subcentres could then grow in the same way as if the electrons were made available by further light exposure. The facts that developers can latensify internal latent image and can form silver centres in the interior of macrocrystals show that the developer can cause growth of silver centres without actually contacting the centres.

3. Deformation of the conduction band in the vicinity of latent image centres might favour transfer of electrons from the developer to those centres through the conduction band.[23] Either this mechanism or that suggested in the preceding paragraph could be the dominant mechanism in the early stages, and another mechanism become dominant as the silver centres grew, e.g. mechanism (1) (two stages).

4. Solvent action could make subsurface centres accessible to the developer and possibly enhance the accessibility of surface centres. The presence of a mild silver halide solvent accelerates the process of internal image latensification. Excessive solvent action could result in isolation of the development centres from the silver halide as development progresses, however, and cause a transition from development occurring essentially in the solid state to solution physical development.

Finally, the presence in the developing solution of oxidized developer or strong inhibitors can significantly affect the probability of development of a grain, particularly for very small latent image centres. It has been observed,[24] for example, that at moderate levels of exposure, the addition of quinone to a sulphite-free hydroquinone developer can both

accelerate the development of some grains and destroy the developability of others. This action may be important in lith type development.[25,26] The key factor here may be the relative probabilities that a molecule of oxidizing agent reach the small development centre and oxidize it to an inactive centre before a molecule of developing agent causes the addition of one or more silver atoms to the centre. Willis *et al.*[27] have recently shown that development inhibitors such as 1-phenyl-5-mercaptotetrazole can promote bleaching of some latent image centres by developers containing substituted p-phenylenediamines while allowing other latent image centres to develop.

## References

1. Tuttle, C. and Trivelli, A. P. H., *Photogr. J.*, **68,** 465 (1928).
2. Meidinger, W., *Physik. Z.*, **36,** 312 (1935); **38,** 565 (1937); *Z. Naturforsch.*, **6a,** 375 (1951).
3. Frieser, H., *Z. Wiss. Photogr.*, **39,** 67 (1940).
4. Rabinovich, A. J., Bogoyavlenski, A. N. and Zuev, Y. S., *Acta Physicochimica USSR*, **16,** 307 (1942).
5. Berg, W. F. and Ueda, H., *J. Photogr. Sci.*, **11,** 365 (1963).
6. Fujisawa, S., Mizuki, E. and Kubotera, K., *Wiss. Photogr.* (Ergebnisse der Intern. Konf. fur Wissenschaftliche Photographie, Köln, 1956), Eichler, Frieser H. and Helwich, O. eds., Verlag. Helwich, Dr. O. Darmstadt, 1958, p. 392.
7. Eger, H., "Ultrarot-mikrokinematographische und radiochemische Untersuchung der photographischen Entwicklung," 1969.
8. Pontius, R. B., Willis, R. G. and Newmiller, R. J., presented at the Intern. Congr. Photogr. Sci., Moscow, Aug. 4, 1970.
9. Fortmiller, L. J. and James, T. H., *PSA Journal (Photographic Science and Technique)*, **17B,** 102 (1951); **18B,** 76 (1952); **19B,** 109 (1953); *Science and Applications of Photography*: (Proc. R.P.S. Centenary Conf., London, 1953) p. 161.
10. Gorokhovskii, Yu. N., Polovtseva, G. L. and Shamsheva, A. L., *Uspekhi Nauchn. Fotogr.*, **13,** 30 41 (1968). see also K. A. Avgustinovich, G. G. Bagaeva, Yu. N. Gorokovskii, and A. V. Pirus, *Zh. Nauchn. Prikl. Fotogr Kinematogr.* **11,** 39 (1966).
11. Broun, Zh. L. and Chibisov, K. V., *Zh. Nauchn. Prikl. Fotogr. Kinematogr.*, **8,** 59 (1963).
12. Roberts, H. C., Image 70, Preprints of Paper Summaries (23rd Annual Conference Photogr. Sci. Eng., SPSE, New York, May 18–22, 1970) p. 43.
13. Ford, F. E., *Photogr. Sci. Eng.*, **13,** 171 (1969).
14. James, T. H., *Photogr. Sci. Eng.*, **14,** 371 (1970).
15. James, T. H., *J. Franklin Inst.*, **234,** 371 (1942).
16. Karrer, J. and Berg, W. F., *Image* 70, Preprints of Paper Summaries, (23rd Annual Conference. Photogr. Sci. Eng. SPSE, New York, May 18–22, 1970) p. 84.
17. Hamilton, J. F., *Photogr. Sci. Eng.*, **14,** 122 (1970).
18. Webb, J. H. and Evans, C. H., *J. Opt. Soc. Am.*, **28,** 249 (1938).
19. Willis, R. G., Ford, F. E. and Pontius, R. B., *Photogr. Sci. Eng.*, **14,** 141 (1970).
20. Willis, R. G. and Pontius, R. B., *Photogr. Sci. Eng.*, **14,** 384 (1970).
21. James, T. H., *J. Am. Chem. Soc.*, **66,** 91 (1944).
22. James, T. H., *J. Phys. Chem.*, **66,** 2416 (1962).

23. Jaenicke, W., *Photogr. Sci. Eng.*, **6,** 185 (1962).
24. James, T. H., *J. Phys. Chem.*, **44,** 42 (1940).
25. James, T. H., *Photogr. Sci. Eng.*, **12,** 67 (1968).
26. Suga, T., *Nippon Shashin Gakkai Kaishi*, **32,** 87, 138 (1969).
27. Willis, R. G., Turk, D. and Pontius, R. B., *Image* 71, Preprints of Paper Summaries, (24th Annual Conference Photogr. Sci. Eng., SPSE, Chicago, Ill., April 20–23, 1971), p. 43.

# Induction of Development as Determined by a Chemical Criterion

## J. KARRER and W. F. BERG

*Department of Photography, Swiss Federal Institute of Technology (ETH-Z)*

ABSTRACT. Using a monodisperse liquid emulsion, uniform exposure, locus- and orientation independent development and controlled bleaching treatment in order to detect the onset of development, the induction of chemical photographic development was studied. An induction period, as defined in this work, could not be detected for times as short as 1/1000 that required for complete development.

## INTRODUCTION

With conventional photographic materials, development kinetics normally display an induction period: for a certain length of time there is no visible change. Microscopic observations often reveal corresponding behaviour on individual grains which appear unchanged for a certain length of time followed by rapid massive reduction.

It is often thought that the apparent delay in the onset of development denotes a process in some way distinct from massive reduction, e.g. it has been stated to be characterized by a higher activation energy.

Investigations of coated layers are complicated by side events which are not of fundamental—though of vast technological—interest: swelling of the gelatin; diffusion of developer into the layer; change of composition of the solution, since the components do not diffuse in at the same rate, etc.

The present investigations utilize a model situation designed to achieve two aims: to overcome the complications just stated, and to attain higher sensitivity of detection of the onset of development. For this it is essential to attain uniformity throughout. Emulsion consisting of monodisperse grains is used in the liquid state; it is exposed so as to obtain nearly identical latent-image centres; developer and stop bath solutions are stirred in rapidly. Any change in the latent-image (development) centres is detected by a slow-acting bleach treatment whereby uniformity is again assured, and bleaching kinetics becomes an important characteristic.

To anticipate: no induction period could be detected on our system with this approach for times as short as 1/1000 that required for total development, and naturally in view of these findings, the onset of development did not depend on temperature. It appears that here development is a uniform process as judged by our chemical criterion.

## PROCEDURE

For the discussion of the onset of development we use the quotient $n_{PD}/n_D$, in which

$n_{PD}(t_D)$ = the number of grains which have started the reaction, i.e. which are part-developed after a time $t_D$;

$n_D$ = the total number of grains which are "developable", i.e. carry a latent-image centre.

It is simple to find $n_D$. For the determination of $n_{PD}$ we have utilized the following operating scheme:

1. Liquid emulsion placed in a flow system.
2. Exposure.
3. First development (short) for a time $t_D$, at various temperatures.
4. Stop.
5. Preparation of coated samples: addition of gelatin and hardener, coating, drying, washing, drying again.
6. Bleach (followed by washing and drying): to remove any unchanged latent-image.
7. Total development: to determine $n_{PD}$ from measurements of density or of silver.

Steps 1 to 4 were carried out on a modified apparatus which was first described by Audran[1] and others and varied by Keller[2] (Fig. 1).

Liquid monodisperse emulsion of cubic silver bromide grains ($0.44 \mu$ edge length) was fed continuously on to a horizontal endless perforated band (of width 35 mm), which moved with variable speed in a loop.

For exposure the band with the emulsion traversed a glass plate of 12 cm length. Below the glass was fitted a 1000 W halogen-lamp from Osram. During exposure the emulsion was thoroughly stirred. The stirring system consisted of a plexiglass plate with seven ribs, parallel to the direction of flow and dipping into the emulsion, fitted to the vibrating part of a loud-speaker movement without membrane. The unit vibrated with a frequency of 400 Hz. With this method we obtained a narrow size-frequency distribution of the latent-image centres.

For the experiments we used in the main two different exposures: a very strong one, well on the shoulder of the characteristic curve for a plate coated with the same emulsion (arrow, Fig. 2), corresponding to

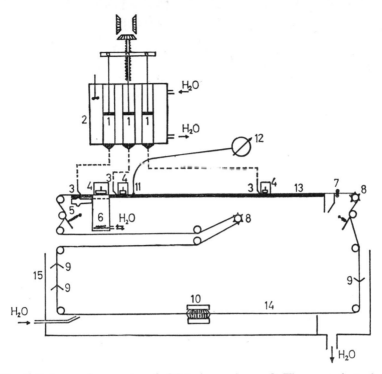

Fig. 1. Scheme of apparatus: 1. Metering syringes; 2. Thermostatic tank; 3. Jets; 4. Stirrers; 5. Blower; 6. Watercooled lamp house with halogen lamp; 7. Squeegee rollers and collecting funnel; 8. Sprocket wheels; 9. Rubber squeegee; 10. Brushes; 11. NTC resistor; 12. Recorder; 13. Reaction trough; 14. Band for transport; 15. Washing trough.

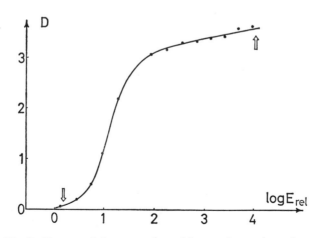

Fig. 2. Characteristic curve of emulsion used coated on plates. The arrows mark the exposures applied.

0·35 s and 1·7 × 10⁵ lx, and a very weak one in the foot of the curve, of 0·35 s and 10·5 lx. The uniform exposure conditions ensured that even here, 40% of the grains were developable.

Following exposure the developer solution was added and stirred in with a mixing system similar to that described above. For the first development the following grain-surface developer was used:

| | |
|---|---|
| Ascorbic acid | 24 g |
| Hydroquinone | 45 g |
| Sodium hydroxide | 60 g |
| Water to make | 1000 ml |

For use this developer was diluted 1 + 10 (together with the emulsion 1 + 20). The time of development could be varied from 0·3–8 s. Figure

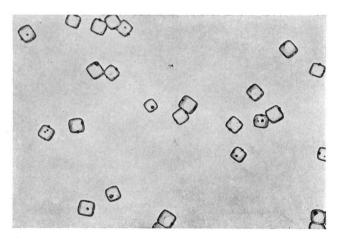

Fig. 3. Electron micrograph of part-developed grains. Exposure: 0.35 s
1·7 × 10⁵ lx; development time: 0·8 s.

3, an electron micrograph showing partially developed grains (development time 0·8 s), gives an idea of the uniformity reached by the procedure used.

Development was stopped with dilute acetic acid. More gelatin and hardener were added and samples were coated on plates and dried. By washing the plates in running water the remaining developer and stopping chemicals were removed and the plates dried again.

On these plates, presumably, were grains with unchanged latent image centres, part-developed grains and grains without development centres. To be able to determine the number of part-developed grains it was necessary to destroy any remaining unchanged latent-image centres.

This was done by a very gentle bleaching treatment such that part-developed grains would remain developable. The bleaching bath had the following composition:

| | |
|---|---|
| FeII | 0·11 m |
| FeIII | 0·09 m |
| $Br^-$ | $10^{-3}$ m |

An amount of citrate ions was added depending on the redox potential desired. The iron redox potential was adjusted to a value 20 to 30 mV more positive than the silver equilibrium potential of the system. So as to provide for all samples identical bleaching conditions we used a vessel with a volume of 10 litres in which 54 samples could be bleached simultaneously. On the bottom of the vessel was a magnetic stirrer, and pure nitrogen continuously bubbled through the solution. The protection against aerial oxygen was such that the redox potential drifted only by about 10 mV during 20 h.

The bleaching treatment was stopped by washing the samples in running water; they were then dried.

To find the number of part-developed grains, i.e. those which were still developable after the bleaching treatment, we developed these grains to completion. Because the emulsion was monodisperse, the number of developed grains was proportional to silver content and under certain conditions even to density.

It should be noted that any density values cited below are those obtained with the second development (after the first one normally no density change was detectable).

**RESULTS**

All density values or amounts of silver are normalized through that obtained without bleaching treatment to compensate for variations in coating thickness. In Fig. 4 the effect of bleaching treatment is shown on latent image resulting from both a strong (□) and a weak exposure (○). The figure shows normalized density as a function of bleaching time $t_R$. Latent image produced by a weak exposure is destroyed relatively quickly; it is completely bleached in about 5 h. Latent image built up by a strong exposure first shows a flat maximum and starts to decrease after about 6 h.

In Fig. 5 the bleaching of latent image and that of part-developed grains after strong exposure is compared. Normalized amount of silver is shown as a function of bleaching time. The figure demonstrates that the part-developed grains remain unbleached even after 20 h. In this case it

is thus possible to distinguish clearly between latent-image and part-developed grains.

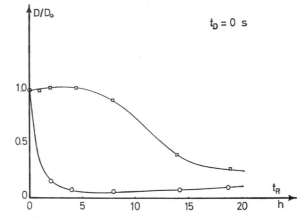

Fig. 4. Normalized density as a function of time of bleaching for latent image;
$\square$ 0·35 s, 1·7 × 10⁵ lx; o 0·35 s, 10·5 lx.

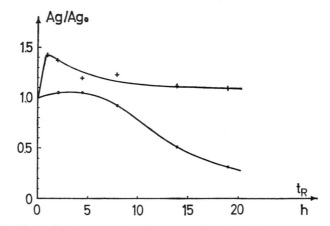

Fig. 5. Normalized amount of silver as a function of time of bleaching;
• latent image; + part-developed samples.

In the system used here the number of part-developed grains is proportional to the amount of silver. Since $n_D$, the total number of developable grains, is constant, we can use the function

$$\mathrm{Ag} = f(t_D)$$

instead of the function

$$n_{PD}/n_D = f(t_D).$$

Figure 6 shows normalized silver content as a function of time of first development, at two temperatures, 21 and 60°C. The surprising result was a constant silver content for all times of development, independent of

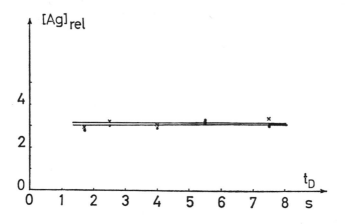

Fig. 6. Relative amount of silver as a function of time of first development ($t_R = 18$ h). Exposure: 1·1 s, 1·7 $\times$ 10$^5$ lx. Line ... 21°C; line × × × 60°C.

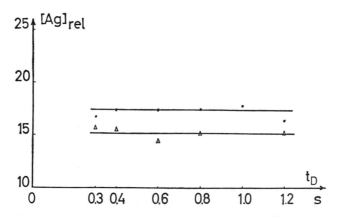

Fig. 7. Relative amount of silver as a function of time of first development ($t_R = 18$ h). Exposure: 0·35 s, 1·7 $\times$ 10$^5$ lx. Line ... 20°C; line △ △ △ 70°C.

temperature. That means that all developable grains have started reduction during the first 1·5 s.

The experiment was repeated with shorter development times. The results are given in Fig. 7 and show that here, too, all developable grains have started to develop already after 0·3 s, that is 1/1000 of the time

2

needed for complete development in the liquid emulsion under our conditions.*

Since the times of first development could not be shortened any further, the experiments were repeated with very weak exposure, i.e. smaller latent-image centres. In Fig. 8 the bleaching of latent image and of

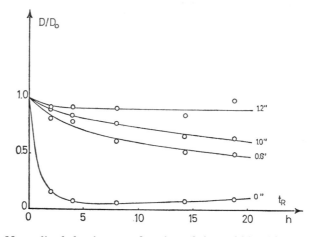

Fig. 8. Normalized density as a function of time of bleaching treatment. Parameter is the time of first development. Exposure: 0·35 s, 10·5 lx.

partially developed centres of weakly exposed grains is compared. Parameter is the time of development.

As also seen in Fig. 4, after about 5 h the latent image is completely bleached whereas the part-developed samples show only a small loss in density.

Discrimination between latent image and part-developed grains in this case is not so clear as before. This is the reason why for presentation of results in Fig. 9, a more complicated approach was chosen which brings in bleaching kinetics as a new variable: normalized densities are shown as a function of first development time at different bleaching times between 0 and 4 h. The value of density for the latent image is always below that for part-developed samples and practically zero for a bleaching time of 4 h.

To make the results more clear we will discuss a model. Figure 10 shows the expected normalized density as a function of bleaching time and first development time. In model (a) we assume that an induction

---

* The curve for the higher temperature of 70°C also being a horizontal line, lies below that for 20°C. We regard this as an artifact, perhaps due to latent-image fading.

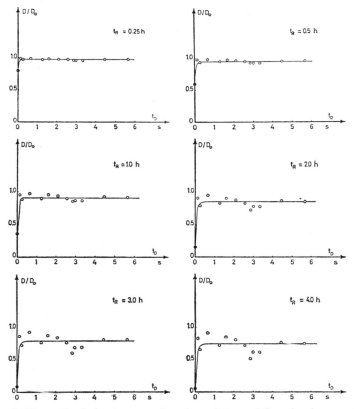

Fig. 9. Normalized density as a function of time of first development at various times of bleaching $t_R$. Exposure: 0·35 s, 10·5 lx.

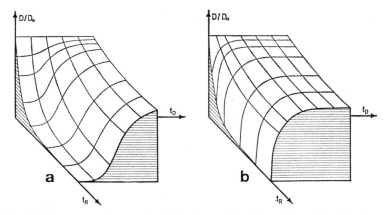

Fig. 10. The expected normalized density as a function of time of first development and the time of bleaching. Assumption: Model (a). An induction period exists. Model (b). It does not exist.

period exists in the sense of a delayed onset of development. In that case the curves

$$D/D_0 = f(t_R, t_D = 0) \qquad \text{and} \qquad D/D_0 = f(t_R, \Delta t_D)$$

in which $\Delta t_D$ means the delayed onset of development, must be identical, i.e. the gradient

$$\left( \frac{\partial (D/D_0)}{\partial t_D} \right)_{t_R} = 0 \qquad \text{for} \qquad t_D = 0$$

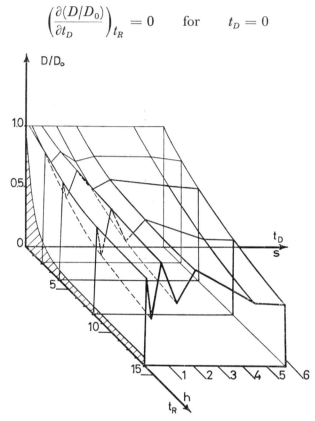

Fig. 11. Experimental results in the model diagram: Neighbouring points are connected by straight lines.

In model (b) we assume that the development reaction starts at all centres at once. That means that all latent-image centres are enlarged at the time $\Delta t_D$. There will be a clear difference in bleaching between such part-developed centres and unchanged latent-image centres. In this case the gradient

$$\left( \frac{\partial (D/D_0)}{\partial t_D} \right)_{t_R} > 0 \qquad \text{for} \qquad t_D = 0$$

In Fig. 11 the experimental results are shown in the same manner as in the model diagrams. Normalized density is plotted as a function of both bleaching time and time of first development. Neighbouring points are connected by straight lines. A section of Fig. 11 is shown in Fig. 12 $(0 \leqslant t_R \leqslant 4 \text{ h})$, in which best-fitting curves are drawn through the points. The gradient is evidently greater than zero; hence under our conditions, development is concluded to have started at all grains at once as soon as they have made contact with developer.

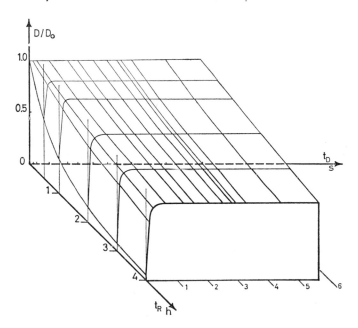

Fig. 12. Section of Fig. 11 in which the best fitting curves are drawn through the points.

## CONCLUSION

In the liquid emulsion system investigated development started at once at all grains carrying a latent-image centre in a hydroquinone-ascorbic acid solution at pH 12·1, so that the hydroquinone molecules are essentially doubly-charged. No delay in the onset of the reaction could be found. An induction period in this sense did not exist or was at least shorter than 0·3 s, which is in the order of 1/1000 of the time needed for complete development in the liquid emulsion; this finding applies for both large and small latent-image centres. In accordance with this, onset of development did not depend on temperature. When an induction

period is seen in development kinetics of coated layers we would now have to assume this to be the result of secondary effects.

How far this statement may be generalized will have to be examined in future work.

## ACKNOWLEDGEMENT

We wish to thank the Polaroid Corporation (Cambridge, Mass., USA) for their financial support of this work.

### References

1. Audran, R., Jouy, A. D., Reutenauer, G. and Kaufmann, R., *Sci. Ind. Photogr.*, **35**, 33 (1964).
2. Keller, H., Das Fading des latenten Bildes und die Sensibilisierung durch Gelatine bei Silberbromid-Hydrosolen. *Diss. ETH Nr.* 3974 (1967).

# Studies of the Earliest Stage of Photographic Development by Measurement of Extinction

H. FRIESER and M. SCHLESINGER

*Institute of Photographic Science, Technical University, Munich*

ABSTRACT. A study at the earliest stage of development by extinction measurements sensitive down to $10^{-6}$. By this means it is possible to observe the change in extinction due to exposure as well as that due to development.

## INTRODUCTION

One of the most interesting problems in photographic development is the interpretation of the process which occurs on the development speck at the very beginning of development on silverbromide grains.[1] The experimental investigations of this phase are very difficult due to the extremely small change of the grain and, therefore, especially ingenious techniques must be used in order to obtain useful information. (See for instance.[2]) In our investigations the extinction change caused by development was measured.

The conventional kinetic methods, by which important data on the later stage of development are obtained, fail for this investigation because they are performed at a stage of development at which visible densities are generated. In order to measure the kinetics at the beginning stage of development by extinction measurements, extinction changes in the order of the latent images must be detectable. That means for this purpose, extinction changes down to $10^{-6}$ must be recorded. Experimental devices which can be used are described by several authors.[3-6]

Unfortunately it is not possible to calculate from the extinction change the amount of silver formed by exposure or development. However, it is possible to calibrate this method by chemical analysis of silver, but this can only be performed at a relatively high silver concentration. Extremely sensitive analytical methods are known for the determination of silver.

27

The application of these methods is limited by the fact that for the chemical analysis a fixation process is necessary and because of the very high excess of silver halide and gelatin a part of the dissolved silver ions is permanently retained. Frieser and Eschrich[7] have shown, that under their experimental conditions an extinction change of $\Delta \log_{10} E = 10^{-3}$ corresponds to a silver concentration of $10^{-8}$ g Ag cm$^{-2}$ respectively at $5 \cdot 6 \times 10^{13}$ silver atoms cm$^{-2}$. Similar results were obtained also by other authors.[4] An extrapolation from these values to lower ones is uncertain, since the extinction depends also on the size of the silver particles in the layer. Therefore it is not possible to calculate exactly the silver concentration from the values of the measured extinction. In spite of these difficulties, important information can be gained by these measurements about the action of development as can be seen in the following.

## EXPERIMENTAL

The experimental setup was conceived and built by G. Stückler in the Institute of Photographic Science of the Technical University, Munich.[6] It will be described in a later paper.

The principle is as follows (Fig. 1): A star with 8 rays is exposed on the sample with actinic light. The resulting latent image is scanned with a rotating star of similar form using inactinic light (infra-red, $\lambda \approx 780$–880 nm). A signal is obtained of a frequency of 8 Hz superposed by electronic noise. To suppress the latter the output is amplified by a selective amplifier (bandwidth 12 Hz) and multiplied with a referenz signal (8 Hz), using a Hall-Multiplicator. After damping by a RC-term, the effective bandwidth is 0·015 Hz. Signals caused by irregularities of the sample can be suppressed by a compensating signal which is variable in amplitude and phase. Measurements of extinction changes of $10^{-6}$ are possible due to the narrow bandwidth and the relatively high time constant of the device ($\tau = 17$ s). Therefore the output $U_{out}$ must be corrected for $\tau = 0$.

$$U_{corr} = U_{out} + \frac{dU_{out}}{dt} \tau. \qquad (1)$$

The extinction is defined by:

$$E = \frac{\Delta T}{T} = \Delta \ln T \qquad \Delta T \ll T \qquad (2)$$

$$T = \text{transparency}$$

For the experiments Perutz-Dia-Repro-Normal and Kodak High Resolution plates were used. The composition of the developer was as

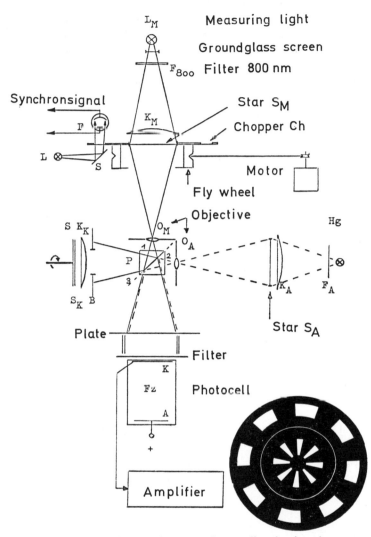

Fig. 1. Experimental set up for measuring small extinction changes.

follows: hydroquinone 0·5 g, sodium sulphite anhydrous 3 g, sodium carbonate 10 g, KBr 2 g per litre.

At all experiments the photographic layer was located in the developer during the exposure. This was necessary because by the addition of the developer to the exposed layer during the experiment the extinction would be changed. In a series of experiments the development was made in a cuvette. In order to have a better reproducibility it was advantageous

to bathe the photographic plate for 3 min in the developer and put it on a glass plate. After careful cleaning of the surfaces, this combination was used in the experimental device. A depletion of the developer must not be taken into consideration, since only the beginning of development is investigated. After compensation of the noise signal, the layer is exposed and the extinction is measured.

## RESULTS

First results of our investigations will be shown, obtained with plate Perutz-Dia-Repro-Normal. Figure 2 shows a reproduction of the recorder

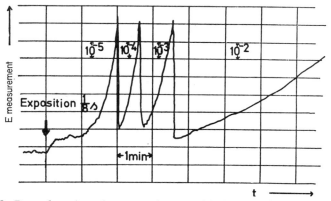

Fig. 2. Recorder plot of an experiment with Perutz-Dia-Repro-Normal plate. Exposure time 1/15 s. Output ($E_{measured}$) vs. time.

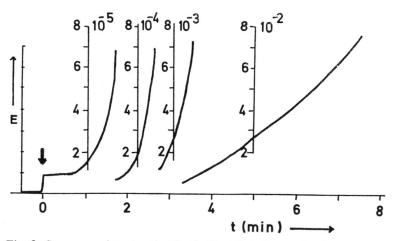

Fig. 3. Same experiment as in Fig. 2. Damping due to the time constant ($\tau = 17$ s) corrected. Extinction vs. time of exposure.

plot. The output is plotted versus the development time. The measurements were performed in different sensitivity ranges, given in the figure. The recorder plot oscillates before exposure about the mean value. The deviations are essentially caused by electronic noise. The moment of exposure of the photographic plate is marked in the recorder plot by an arrow. After exposure the extinction first increases by forming the latent image. The increase corresponds to the time-constant of the RC-term ($\tau = 17$ s) and reaches a final value. One minute after exposure a second increase is observed, which is caused by the action of the developer. The extinction first increases slowly, later on more rapidly. The recorder plot must be corrected respectively to equation (1). Figure 3 gives the corrected values of the extinction. In this diagram the extinction changes

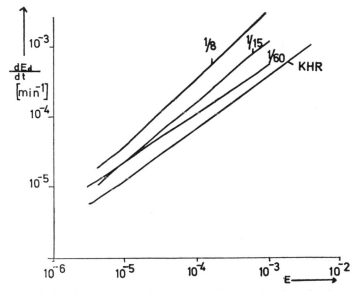

Fig. 4. Relation between rate of reaction and extinction due development ($E_d$). Perutz-Dia-Repro-Normal plate with different exposure times. KHR-Kodak High Resolution plate.

at once at the moment of exposure ($t = 0$) to extinction values corresponding to the latent image. During development the extinction grows superproportional and the rate of reaction increases with the proceeding reaction, which can be clearly seen in Fig. 4. The rate of reaction $dE/dt$ is plotted versus extinction in logarithmic scale. One obtains in Fig. 4 straight lines over 3 decades with a gradient $p$. Therefore:

$$dE/dt = k \times E_p \qquad k = \text{constant} \qquad (3)$$

For Perutz-Dia-Repro-Normal and using an exposure time greater than 1/8 s, $p$ is nearly one. In this case by integration the logarithm of extinction (log E) becomes proportional to the time of development $t$. That means: The logarithm of extinction grows linear with development time.

Figure 5 shows that this is valid mainly at short developing times and especially for long exposure (1/15 s). At a developing time longer than 5 min the curves bend off. Whether this is caused by a new mechanism of the reaction or by a change of the covering power on account of the increase of the silver particles, can not be decided.

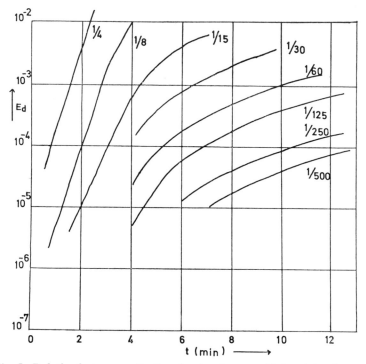

Fig. 5. Relation between extinction due development ($E_d$) and development time. Perutz-Dia-Repro-Normal plate. Different times of exposure.

The experiments have shown, that it is possible to measure extinction changes caused by development smaller than those caused by the formation of the latent image. The very beginning of the development is an autocatalytic reaction. It seems that development starts immediately after exposure, which agrees with the results of Karrer and Berg.[2] Extrapolating the curves of Fig. 5 to zero time, values for the extinction were obtained, which are about 5% of the extinction of the latent image.

The experimental values which we have obtained up to now are not sufficient to make far-reaching theoretical conclusions. We intend to continue our investigations using homodisperse emulsions and different kinds of developer. In addition the relation between extinction and silver concentration will be considered.

### References

1. James, T. H., *Photogr. Sci. Eng.*, **14,** 371 (1970).
2. Karrer, J. and Berg, W. F., *J. Photogr. Sci.*, **19,** 143 (1971).
3. van Kreveld, A. and Jurriens, H. J., *Physica*, **4,** 297 (1937).
4. Nail, N. R., Moser, F. and Urbach, F., *J. Opt. Soc. Am.*, **46,** 218 (1956).
5. Frieser, H. and Brand, P., *Z. Wiss. Photogr.*, **59,** 87 (1965).
6. Stückler, G., Aufbau einer Apparatur zur Messung geringster Extinktionsänderungen für die Bestimmung des latenten photographischen Bildes. Diplomarbeit Inst. f. wiss. Photographie der Techn. Universität München.
7. Frieser, H. and Eschrich, D., *Ber. Bunsenges*, **70,** 694 (1966).

# General Mechanisms

# A General Mechanism of Photographic Development

## R. G. WILLIS and R. B. PONTIUS

*Research Laboratories, Eastman Kodak Co., Rochester, New York, U.S.A.*

ABSTRACT. The kinetics of development by hydroquinones, ascorbic acid, an aminoreductone, $p$-aminophenols, $p$-phenylenediamines including color developers, and combinations of these are reviewed and explained by a general mechanism of development. In this mechanism it is proposed that all development by Michaelis type developers occurs by a combination of *direct* and an *indirect* electrode process. In the direct process it is visualized that electrons are transferred directly from the reduced form of the developer to the growing silver speck or filament without adsorption, and the rate of development is first order in the developer concentration. In the indirect process it is visualized that electrons pass from the reduced developer to the silver surface through an adsorbed layer of oxidized developer, and the rate depends on the developer concentration to the one-half power.

# Conservation

# The Desilvering of Bleach-Fix Solutions by Electrolysis

## C. J. SHARPE

*Research Laboratory, Kodak Limited, Wealdstone, Harrow, Middlesex*

ABSTRACT. Electrode potential measurements indicated that silver deposition is the main reaction occurring at the cathode during the electrolysis of used bleach-fix solutions. The very low plating efficiency of the recovery of silver by electrolysis appears to be caused mainly by the dissolution of the silver on the cathode by the bleach-fix solution. Some improvement in plating efficiency was obtained by placing the electrodes in separate cells.

## INTRODUCTION

In the processing of colour materials it is necessary to remove the silver image without affecting the dye image. This operation has generally been achieved at a convenient stage by converting the silver image into silver bromide with a bromided bleach such as an aqueous solution of potassium ferricyanide and potassium bromide. The silver bromide is then removed by dissolving in a normal fixing solution.

The processing procedure can be simplified and shortened by using a combined bleach-fix solution. However, the single solution cannot be prepared simply by mixing together one of the usual bleaching solutions and thiosulphate, because the bleach oxidizes the thiosulphate. A more stable solution can be produced by using a ferric EDTA complex salt mixed with thiosulphate and sulphite. Such a solution oxidizes the silver image to a soluble complex thiosulphate and also dissolves the undeveloped silver halide.

The bleaching operation can be represented as follows:

$$\text{Fe EDTA}^- + \text{Ag} + 2\text{S}_2\text{O}_3^{2-} \rightarrow \text{Fe EDTA}^{2-} + \text{Ag}(\text{S}_2\text{O}_3)_2^{3-}$$

A combined bleach-fix solution based on the ferric EDTA complex was introduced a number of years ago[1] for the processing of colour paper. Since that time, the bleach-fix solution has been used in a number of colour processes.

Apart from the need to use separate bleach and fix solutions with the usual ferricyanide or dichromate bleaches, these substances have the

41

disadvantage of being pollutants. For example, ferricyanide solutions slowly produce small quantities of cyanide which are injurious to plant and animal life. Moreover, it is possible that because of the increasing awareness of the dangers of pollution the discarding of relatively large volumes of such chemicals to waste may be banned in some areas in the future. The ferric-EDTA bleach is less harmful, and efforts to reduce pollution will no doubt encourage the further use of the iron bleach-fix solution.

When a bromiding bleach is followed by fixation, all the silver accumulates in the fixing bath and a number of methods are available for recovering it. On the other hand, a difficulty arises in the recovery of silver from the single bleach-fix solution since the solution has been designed to dissolve the silver image, and therefore tends to dissolve any silver produced by the recovery process. Therefore, when the usual electrolytic cells are used with the bleach-fix solutions the yields are poor in comparison with what can be recovered from ordinary fixers. For this reason a study has been made of the problems involved in the electro-deposition of silver from a bleach-fix solution to evaluate the likelihood of making the method more practical.

Silver can be recovered smoothly from ferric-EDTA bleach-fix solutions by means of a process based on steel wool. This method is specially appropriate in that the iron content of the solution is replenished by the dissolution of the steel wool. However, it is not proposed to discuss the method further in the present paper.

## EXPERIMENTAL
### Cathode Potentials

To obtain more information on the reactions occurring at the cathode during electrolysis of the used bleach-fix solutions, the current flowing through a small cell was determined at various cathode potentials. The cathode consisted of a 1 in wide strip of stainless steel which was immersed in 150 ml of solution to a depth of 2 in, and a 0·5 in diameter carbon rod served as an anode. A stirrer was fitted between the electrodes. The EMF for the cell was supplied by a stabilized D.C. voltage unit, and a saturated calonel electrode was used as reference electrode for determining the cathode potentials.

For this investigation, the applied voltage was slowly increased and the current and cathode potentials were measured. Bleach-fix solutions containing 1 and 3 g of silver per litre (added as silver bromide) were used with and without stirring. For comparison, the solution without silver was also examined. The bleach-fix solutions used was of a ferric-EDTA-thiosulphate formulation.

The results are shown in **Fig. 1**.

It can be seen that as the cathode potential was reduced to about $-0.1$ V with the silver-containing samples, current began to flow and it increased rapidly to a plateau. Only a very small current was produced with the non-silver solution. On decreasing the potential further to below $-0.4$ V, the current produced with the silver-containing solutions

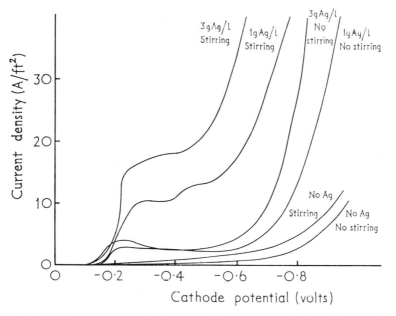

Fig. 1. Relation between cathode potential and current density with 1 g and 3 g per litre silver with and without stirring. Temperature of solutions 25°C.

again started to increase rapidly. However, a potential of about $-0.8$ V was required with the non-silver solution before any significant current flowed. Much lower currents were produced with the unstirred silver-containing solutions than with the corresponding stirred solutions.

From a comparison of the curves it would appear that the discharge of silver is the only reaction occurring at the cathode in the range $-0.1$ to $-0.4$ V approximately. At the considerably lower potentials at which the current becomes appreciable in the absence of silver, various reactions may take place at the cathode such as the formation of hydrogen, hydrogen sulphide and ferrous EDTA ion. Similar reactions would occur with the silver-containing solution if the cathode potential was reduced considerably below that required to deposit the silver.

Since the deposition of silver is the sole reaction occurring at the

cathode at potentials of around $-0.1$ to $-0.4$ V (corresponding to a maximum current density of about 18 A ft$^{-2}$ with the 3 g silver per litre solution), the inefficiency of the plating operation could not be due to a large part of the current being used to promote some other reaction. The inefficiency must therefore be caused by the dissolving of part of the deposited silver by the ferric EDTA complex.

The reactions occurring at the cathode when electrolysing a used bleach-fix solution under conditions where only silver is deposited, may be represented as follows:

$$Ag\ (S_2O_3)_2{}^{-3} \rightleftharpoons Ag^+ + 2\ S_2O_3{}^{2-}$$

$$Ag^+ + e^- \rightarrow Ag$$

$$Ag + Fe\ EDTA^- + 2\ S_2O_3{}^{2-} \rightarrow Ag\ (S_2O_3)_2{}^{3-} + Fe\ EDTA^{2-}$$

## Experiments with Silver Recovery Cells

### ELECTROLYSIS AT LOW CURRENT DENSITIES

Low current densities ranging from $0.1$ to $0.2$ A ft$^{-2}$ are used in many electrolytic units installed in this country for recovering silver from used fixing baths. In the present experiment, the effect of using low current density conditions was tried with the bleach-fixed solution containing 3 g silver per litre added as silver bromide. The cathode consisted of a 2 in wide strip of stainless steel which was immersed to a depth of 3 in in the solution (6 in$^2$ of cathode area). The rear of the strip was insulated. The anode was a $0.5$ in diameter carbon rod.

A current of $8.3$ mA ($0.2$ A ft$^{-2}$) was applied for 10 h but no silver was deposited on the cathode. Assuming the equivalent of 4 g silver deposited for each ampere-hour, a total of $0.33$ g of silver should theoretically have been produced.

### ELECTROLYSIS AT HIGH CURRENT DENSITIES

(1) *No agitation*

It would appear that the rate of dissolution in the previous experiment was as fast as the rate of deposition of the silver. The present experiment was carried out with the current raised to $0.1$ A ($2.4$ A ft$^{-2}$) in order to increase the plating rate. The same electrolytic unit was used as before, and after 2 h the cathode was covered with a black deposit which consisted of silver and silver sulphide. Analysis of the solution indicated that $0.08$ g silver had been removed from solution, i.e. the current efficiency was about 10 %. The evidence of sulphiding, showed that a bleach-fix solution was similar to an ordinary fixer in that agitation is necessary to avoid sulphiding if more than a low current density is to be used.

(2) *Agitation of the solution during electrolysis*

The electrolytic unit was the same as in the previous experiments but this time the solution was agitated by a stirrer between the electrodes and the electrolysis was carried out with a current of 0·1 A for 5 h.

A pale cream-coloured deposit was produced on the cathode and weighed 0·08 g. The current efficiency was only 4%.

(3) *Recovery rates at various current densities*

The earlier experiments showed that silver can be recovered from a bleach-fix solution by using a relatively high current density (2·4 A ft$^{-2}$) although sulphiding must be prevented by agitating the solution. A series of experiments were then carried out to find the amount of silver plated out at various current densities.

The cathode consisted of a 1 in wide stainless steel strip which was immersed to a depth of 2 in in the solution, i.e. 2 in$^2$ surface area. The back of the strip was insulated. A 0·5 in diameter carbon rod served as anode. The electrodes were placed in a 150 ml beaker containing 70 ml bleach-fix solution having a silver concentration of 2·8 g per litre (added as silver bromide). A small stirrer was placed between the electrodes.

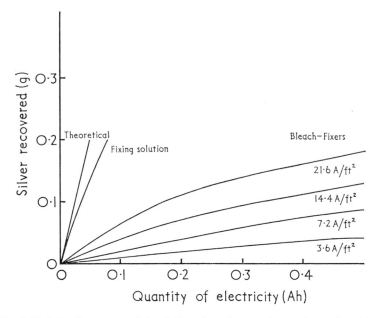

Fig. 2. Relation between weight of silver plated out and quantity of electricity passed through the cell at various current densities.

A number of runs were carried out at various current densities and for various times, and after each experiment the amount of silver plated out was obtained by determining the silver concentration of the solution. For comparison, a normal fixing solution containing the same concentrations of thiosulphate and silver as in the bleach-fix solutions was electrolysed using a current density of $7 \cdot 2$ A ft$^{-2}$.

The results are shown in Fig. 2. The curve relating the theoretical amount of silver recovered for different quantities of current is also shown.

No silver was plated out on the cathode when the current density was $1 \cdot 8$ A ft$^{-2}$ but a small quantity was produced when the current density was raised to $3 \cdot 6$ A ft$^{-2}$. Increasing amounts of silver were produced as the current density was raised further. However, even at the highest current density that was used, the current efficiency was very low.

The silver deposits obtained on the cathode for most of the current density runs were pale cream. However, the deposits obtained after passing $0 \cdot 2$ A for 2 h at a current density of $21 \cdot 6$ A ft$^{-2}$ were brown, which pointed to the presence of a small amount of silver sulphide.

### (4) *Dissolution rate of the silver in the bleach-fix solution*

The low current efficiency of the deposition of silver appears to be due mainly to the dissolution of the silver deposit on the cathode by the bleach-fix solution. In order to compare the dissolution and plating rates, the apparatus described in the previous section was used. The cathode was first plated with silver by electrolysing the bleach-fix solution containing 3 g silver per litre for a total of 5 h at 150 mA current ($10 \cdot 8$ A ft$^{-2}$) with the normal rate of stirring. At intervals the cathode was removed from the solution and washed, dried and weighed in order to determine the amount of silver remaining. After the completion of the plating operation the electrolysis was stopped but the stirring was continued and the cathode again weighed at intervals to determine the dissolution rate. The results are shown in Fig. 3. A curve relating the theoretical amount of silver which should be recovered with time with a current of 150 mA is also shown. The very high dissolution rate of the silver deposit obviously accounts largely for the inefficiency of the recovery.

### (5) *Effect of varying the stirring rate*

A comparison was made of the rate of plating on the cathode when low and high stirring rates were used. The two stirring rates were obtained by varying the voltage on the stirrer motor. The same equipment was used as before, and at the start $0 \cdot 1$ A was passed through the solution

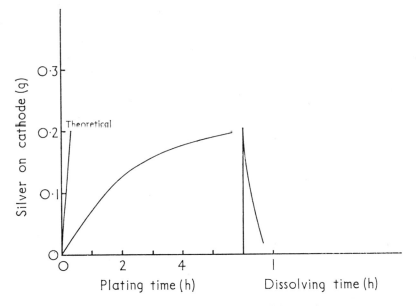

Fig. 3. Comparison between the plating and dissolution rates.

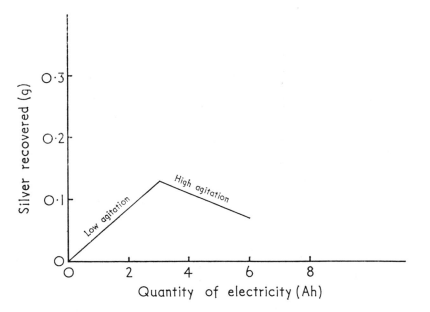

Fig. 4. Relation between silver deposited and current at low and high
agitation rates.

for 3 h at low agitation after which the weight of deposit was determined. The electrolysis was continued for a further 3 h with high agitation, after which the weight of deposit was again determined.

The results of this experiment which are given in Fig. 4 show that increasing the agitation favoured the rate of dissolution and silver was lost from the cathode.

(6) *Effect of electrolysis on the composition of the bleach-fix solution*

For an electrolytic process to be economically viable the desilvered bleach-fix solution would need to be re-used after suitable addition of chemicals to take care of exhaustion as well as of changes occurring during electrolysis. A test was therefore carried out to find the effect of electrolysis on the composition of the solution. The usual equipment with 2 in$^2$ of cathode area and 70 ml of bleach-fix solution containing 3 g silver per litre was used and the electrolysis was carried out for 5 h with stirring at 0·1 A current. For comparison a 70 ml sample of the bleach-fix solution was also stirred for 5 h without electrolysis.

The two solutions were then analysed and it was found that there were no significant changes in the thiosulphate and EDTA concentrations and the pH value. However, while stirring without electrolysis resulted in a loss of 8% in the bisulphite concentration, with electrolysis the loss was about 30%.

(7) *Effect of pH on the current efficiency*

In the earlier experiments, the solution was prepared by dissolving the required amount of silver bromide in the working strength bleach-fix solution, but the pH was left at its initial value of 6·7. This procedure might be valid for those processes where a wash occurs between development and bleaching. However, in a process without a washing stage between development and bleaching, developer will accumulate in the bleach-fix solution, by carry-over. This results in higher pH values in the bleach-fix solution.

A comparison was therefore made of the quantities of silver produced by electrolysing bleach-fix solutions at pH values of 6·7 and 7·8 respectively. Both solutions, which contained 3 g silver per litre, were electrolysed for 2½ h at 0·1 A. The usual electrolytic unit was used and the amount of silver produced in each case was as follows:

| pH of bleach-fix | Weight of deposit | Current efficiency |
|:---:|:---:|:---:|
| 6·7 | 0·07 g | 7% |
| 7·8 | 0·15 g | 15% |

The results show the increased recovery rate at the higher pH value, but even under these conditions, the current efficiency was still low.

(8) *Separation of the electrodes*

The low plating current efficiency is caused at least partly by the dissolution of the silver on the cathode by the ferric EDTA complex, and increased efficiency would be expected if most, if not all, of the iron EDTA complex reduced by this reaction could be maintained in the reduced form. To achieve this, the reduced complex could be prevented

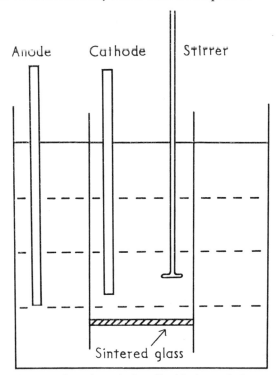

Fig. 5. Diagram of an electrolytic cell with sintered glass partition.

from mixing with that re-oxidized at the anode by keeping the electrodes in compartments separated by a suitable membrane. The effect was tried of separating the two electrode compartments by mean of a sintered glass disc of porosity 4. The arrangement adopted is shown in Fig. 5. The solutions contained silver equivalent to 3 g per litre.

The electrolysis was carried out for different times using 0·1 A current (7·2 A ft$^{-2}$) and the weights of the silver plated out were determined by analysing the solutions. After 3 h, the solution in the cathode compartment was noticeably less red than at the start, and after 5 h it was yellow, indicating that nearly all the ferric complex had been reduced.

The results of the silver plating tests are shown in Fig. 6.

For comparison, a curve is included showing the results obtained when the electrodes were in the same solution. A much higher plating rate was obtained with the separate electrode compartments and this is no doubt caused by the lower ferric EDTA concentration near to the cathode during most of the electrolysis.

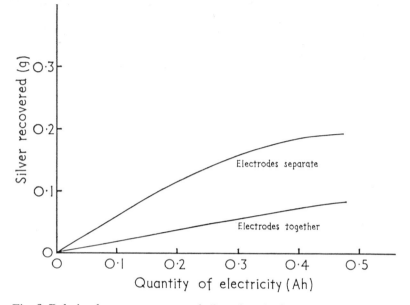

Fig. 6. Relation between current and silver deposited on the cathode when (a) the electrodes are in the same solution and (b) are in separate compartments.

(9) *Larger scale tests*

Some commercially available silver recovery units are fitted with a rotating cathode, and in the present test the effect was tried of using a rotating cylindrical cathode with the bleach-fix solution. The cathode consisted of a sheet of stainless steel measuring 10 in by 7·2 in which was formed into a cylinder round the long axis to give a surface area of 0·5 ft². It was designed so that it could be attached to a motor rotating at 150 rev/min. The anode consisted of two carbon strips measuring 4 in wide and having a length approximately equal to the depth of the liquid. The anodes were fitted on opposite sides of the cathode as shown in Fig. 7. A rather less smooth source of d.c. current was used than in the earlier experiments.

The electrode assembly was installed in a vessel holding 30 litres of bleach-fix solution, the cathode being completely submerged. The

solution contained 3 g silver per litre and the electrolysis was carried out for 5 h with 10 A (current density 20 A ft$^{-2}$). The amount of silver recovered after this time was 17·5 g, which is equivalent to an efficiency of 8·8%.

A second test was carried out in which the current was increased to 15 A (current density 30 A ft$^{-2}$). Again the electrolysis was carried out

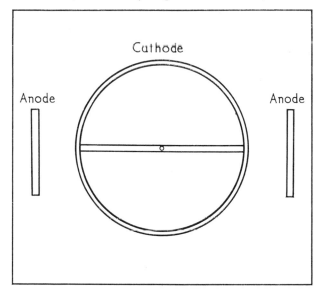

Fig. 7. Diagram (top view) of an electrolytic cell consisting of a rotating cylindrical cathode and stationary carbon anodes.

for 5 h and the amount of silver produced was 34·5 g which gives an efficiency of 11·5%. The deposit on the cathode was light cream in colour.

## DISCUSSION

Relatively high current densities are required when electrolysing bleach-fix solutions, otherwise the rate of dissolution of the silver is greater than the potential plating rate and no silver is recovered. The amount of silver which is produced depends on the current density and also on the rate of stirring since this affects the dissolution rate. However, low agitation conditions are not advisable since they lead to the formation of silver sulphide on the cathode and in the solution at low silver concentrations.

The majority of commercially available silver recovery units for photofinishers do not operate at current densities around 10 to 20 A ft$^{-2}$

and such values appear to be desirable for use with the bleach-fix solutions. Some modifications would therefore be needed to such units in order to increase the current density before any silver could be produced. Even then, the efficiency of plating would be very low, and large electrode surfaces would be needed with high currents to make the amount of silver plated out worthwhile.

During most of this work the concentrations of ferrous and ferric EDTA complexes were not determined. It was assumed that while some of the ferric complex would be converted to ferrous by dissolving part of the silver deposit, and perhaps to a small degree by cathodic reduction, the ferrous complex so produced would be re-oxidized to ferric again by anodic oxidation and by contact with air. However, in a 5 h run at 15 A with a commercially available electrolytic unit the ferrous complex was found to increase from 7 to 24% of the total iron concentration. There was also a fall in the sulphite concentration which showed that the anodic process also involved the oxidation of sulphite.

To maintain the lowest ferric concentration during electrolysis in order to reduce the dissolution rate of the silver, there would seem to be some advantage if the equipment were designed so as to exclude air.

Another way of maintaining the EDTA complex in the ferrous state after reduction at the cathode is to place the electrodes in separate compartments while excluding air from the cathode compartment, and this may point the way for future work. However, such an arrangement would complicate the design of the electrolytic unit and increase its cost. There appears to be little danger of sulphiding when the bleach-fix solution is electrolysed with a high current density so long as the agitation is effective, but there may be a greater tendency for the sulphide to be formed under conditions which produce higher concentrations of the ferrous complex.

For a silver recovery process to be commercially acceptable it should be possible to reuse the bleach-fix solution after removing the silver and making up to strength those chemicals which are reduced in concentration by "carry-over" or during electrolysis. No significant change in the thiosulphate or EDTA concentrations occurs during electrolysis but the sulphite is reduced considerably in concentration and this would need to be taken into account in designing a suitable replenisher. Any ferrous complex which is formed could be oxidized to the ferric state by aeration. Suitable additions of ferric EDTA and thiosulphate would be necessary to offset loss in concentration through dilution by carry-over.

## Reference

1. M. Heilmann, Mitt. Forsch Lab. Agfa Leverkusen-München, 1, 256–261 (1955).

# Fixer Composition and Washing Rates

## A. GREEN and G. I. P. LEVENSON

*Research Laboratory, Kodak Limited, Wealdstone, Harrow, Middlesex*

ABSTRACT. Sodium and ammonium thiosulphate fixers were compared in respect of the rate of washing following fixation. No significant difference in washing rates was observed after fixing in thiosulphate-bisulphite solutions in acid conditions. In neutral solution the ammonium salt showed an advantage when fixing was carried to the stage of clearing. When acetic acid was present in the fixer with or without alum, the ammonium thiosulphate allowed easier washing.

## INTRODUCTION

There is considerable interest at the present time in speeding up photographic processing as well as in economizing in the materials used, especially in reducing the consumption of water.

The use of ammonium thiosulphate in place of the sodium salt has allowed faster fixation. Alnutt who contributed the first extensive paper on ammonium-thiosulphate fixers[1] found no noteworthy difference between the rates of washing of films and papers after fixing in F5 and in an ammonium thiosulphate solution ATF-5 of generally similar character though of 43% greater molarity in thiosulphate.

Crabtree *et al.*[2] reported at the same time that there was no difference in the rates of washing after fixation in F23 and F24 and the ammonium thiosulphate analogues of these, but that washing after use of the ammonium analogue of F5 was 30% faster.

More recently a brochure issued by a chemical manufacturer[3] has claimed a one-third reduction in washing time to follow from using ammonium thiosulphate.

We have been studying rates of washing for some time using a specially designed apparatus which was described briefly in an earlier paper.[4] This apparatus, which is described more fully here, enabled us to follow rapid washing processes by measuring conductivity changes in the emulsion layer. It was also convenient for washing layers in a standardized manner for selected times before carrying out tests for residues by conventional

3

analysis or by spot testing for residual thiosulphate in the manner of Mattey and Henn.[5]

Using this technique we have compared washing rates after using sodium and ammonium fixers. Having in mind the need for the results to be relevant to the conditions found in compact processing equipment, the conditions chosen were such that the fixer would become appreciably loaded with silver in the act of fixation.

## EXPERIMENTAL

When a film is fixed in a non-hardening fixer, and then washed in a flow of tap water, the washing is complete in less than one minute. With conventional techniques, therefore, it is very difficult to make analyses during the early stages of washing. The apparatus which we have developed is intended primarily to follow conductivity changes in the emulsion, but it also allows us to wash consistently for short times.

The apparatus is shown in Fig. 1, and diagrammatically in Fig. 2. It consists of a printed-circuit board A, on which are a pair of electrodes, B and C. The electrodes had small holes bored through them so that film could be held against them by vacuum, and when a piece of film, emulsion outwards, was in position it formed one wall of the washing cell. The printed-circuit board was fixed to a Perspex block, D, which was mounted on a laboratory stand. The cell had a removable front element, E, which could be clamped over the film where it was sealed by means of two strips of circular-section rubber, F. When the cell was assembled, the slot so formed through which the wash water passed measured 30 mm wide $\times$ 1 mm $\times$ 50 mm long. Water (or other processing solutions) at controlled temperature could be run through the cell from a reservoir. The rate of flow through the cell was determined by the cell itself, and was 205 ml min$^{-1}$; excess water was by-passed by means of the overflow pipe G. In practice the wash water was run through the cell through a solenoid valve which was controlled by a timer. Before use the cell could be adjusted to the correct temperature by running the wash water through it for a short while. Most of the outside of the cell was covered in thin metal foil which acted as an electrical screen when grounded.

Measurements of conductivity changes were made by following the voltage drop of a high frequency signal passing through the cell via the pair of electrodes. The equivalent circuit is shown in Fig. 3. The voltage measured by the recorder was a function of the conductivity.[4] The apparatus is more sensitive at low conductivities, and this is, of course, quite suitable for following the course of film washing. In practice the conductivity reading always includes a constant contribution from the conductivity of the wash water in the cell.

The apparatus was also used to determine the start and stop of the water flow, as it could detect the presence of wash water in the cell, and short wash times could be used with consistent results.

Although processing prior to washing could be carried out in the cell this was not done in our experiment as we wanted to approach the real

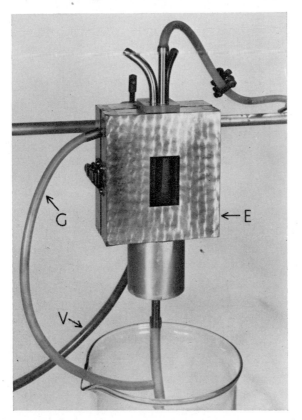

Fig. 1. The washing cell. Key: E, removable front element of cell. G, overflow pipe. V, vacuum line.

conditions by processing in a limited volume of fresh fixer which became partially exhausted. The film size used was $35 \times 120$ mm and the fixing was carried out in a rotating drum 31 mm in diameter and 100 mm long which contained 10 ml of fixer per piece of film. Both fixing and washing were carried out at $20°C$ throughout these experiments. After fixing for the required time the film sample was removed from the tube, shaken and the back of the film wiped dry before placing it in the washing cell. Washing was carried out using Colne Valley tap water and was continued

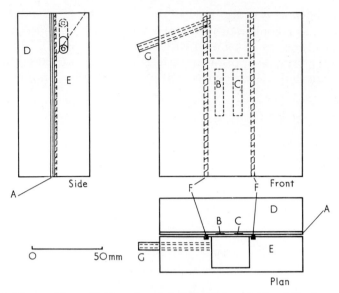

Fig. 2. The washing cell. Key: A, printed circuit board, B and C, electrodes. D, rear element of cell. E, removable front element of cell. F, circular section rubber. G, overflow pipe.

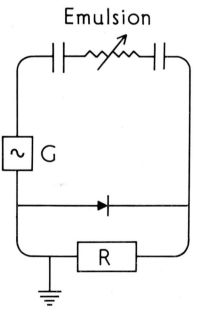

Fig. 3. The diagrammatic circuit of the apparatus used. G is a 15 MHz signal generator and R a recorder.

while the conductivity curve was obtained, or until the required time after which analysis for residual thiosulphate was made.

Preliminary experiments to compare plain gel coatings with emulsion coatings indicated that emulsion coatings would have to be used. As will be seen, the ease with which silver complexes, formed *in situ*, will wash out of the emulsion depends upon several factors of the fixation process—the time of fixing, the thiosulphate cation, the pH and the presence of secondary factors, e.g. sulphite, acetate and aluminium ion.

The fixing of a silver-halide emulsion within the ordinary acceptable times does not reach the state of equilibrium that obtains when a plain gel layer is immersed in a silver-bearing fixing solution. In modern photographic practice, rapid access is important and fixing times are kept to the minimum that will yield satisfactory results.

A coating of a non-screen X-ray emulsion on one side of a single-sided film, was used because of the high ratio of silver halide to gelatin in emulsions of this sort. The data reported here were obtained when the emulsion was 12 months old, though experiments in the same context had been made while the emulsion was fresh, and when a difference appeared this is noted below. Three basic fixer formulae were compared. These are given as C, D and E in Table 1. Formula C was composed entirely of

**Table 1**

**Composition of experimental fixers: g litre$^{-1}$**

|  | C | D | E |
|---|---|---|---|
| $Na_2S_2O_3 \cdot 5H_2O$ | 248 | — | — |
| $(NH_4)_2S_2O_3$ | — | 148 | 148 |
| Sodium metabisulphite | 25 | 25 | — |
| Amonium metabisulphite | — | — | 24.04 |
| pH adjusted to 4·5 and 7·0 with | NaOH | NaOH | $NH_4OH$ |

sodium salts. Formula D contains ammonium thiosulphate but has sodium metabisulphite, in the manner of typical commercial fixers. Formula E has all ammonium ion and was prepared from a molar solution of ammonium thiosulphate by adding ammonium hydroxide and sulphur dioxide in the correct proportions to give the required level of ammonium bisulphite.

## RESULTS

Samples of film were fixed in solutions C, D and E at their various pH levels until just clear, and for 4 min, after which washing was carried out

as before. Results for residual thiosulphate after 40 s washing are shown in Table 2.

The conductivity curves for these experiments were regular and need not be shown here. However when some of these experiments were

**Table 2**

**Residues\* after 40 s washing as mg $Na_2S_2O_3 . 5H_2O$ m$^{-2}$**

| Fixer | C | | D | | E | |
|---|---|---|---|---|---|---|
| Fixing time | Clear | 4 min | Clear | 4 min | Clear | 4 min |
| pH 4·5 | 266 | 119 | 383 | 109 | 254 | 92 |
| pH 7·0 | 700 | 85 | 413 | 60 | 198 | 60 |

\*Note: To avoid compounding errors by successive approximations, the residues are given as they were observed, as the average for two runs without rounding off. Only large differences in excess of $\pm$ 15% should be taken as significant. The residue values for the just-cleared films should be regarded with more reserve because they depend on the individual operator's judgement as to the moment when the emulsion is just cleared.

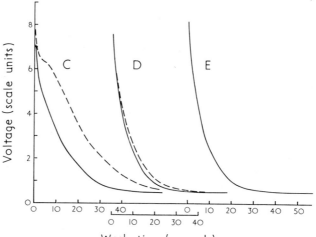

Fig. 4. The change of recorded voltage from the conductivity apparatus with washing time for films processed in Fixers C, D, and E with 15 ml acetic acid litre$^{-1}$ and pH adjusted to 4·5. – – – – – – (fixed to clear); ———— (fixed for 4 min.).

repeated with fixers C, D and E with the inclusion of 15 and 45 ml acetic acid litre$^{-1}$ the pH then being adjusted to 4·5, the conductivity curves

showed interesting differences which are seen in Figs. 4 and 5. The thio-sulphate residues, after 40 s washing, are given in Table 3.

### Table 3

### Residues after 40 s washing as mg $Na_2S_2O_3$ . $5H_2O$ m$^{-2}$

| Fixer | C | | D | | E | |
|---|---|---|---|---|---|---|
| Fixing time | Clear | 1 min | Clear | 4 min | Clear | 4 min |
| ᴗ Acetic acid | 266 | 119 | 383 | 109 | 254 | 92 |
| 15 ml litre$^{-1}$ | >1700 | 327 | 308 | 128 | 232 | 104 |
| 45 ml litre$^{-1}$ | >1700 | 320 | 324 | 167 | 303 | 167 |

Finally some experiments were carried out with hardening fixers containing acetate ion. In these, a four-minute fix was given in fixers C, D and E with 15 g potash alum litre$^{-1}$ added. Figure 6 shows the conductivity curves and Table 4 shows the thiosulphate residues after 80 s washing:

### Table 4

### Residues after 80 s washing as mg $Na_2S_2O_3$ . $5H_2O$ m$^{-2}$

| Fixer (4 min) + 15 g/litre$^{-1}$ alum | C | D | E |
|---|---|---|---|
| Acetic acid conc. | | | |
| O (pH to 4·3)* | 880 | 810 | 880 |
| 15 ml litre$^{-1}$ (pH to 4·5) | 815 | 510 | 580 |
| 45 ml litre$^{-1}$ (pH to 4·5) | 720 | 334 | 356 |

* This solution slowly decomposes to give a white precipitate, the more rapidly at pH 4·5.

## DISCUSSION

The above results show that in the case of hypo-bisulphite solutions, ammonium thiosulphate offered no advantage over sodium thiosulphate in respect of the rate of washing a bromo-iodide emulsion after proper fixation. However, in a given total fixing time, e.g. the 4 min used above, the ammonium fixer has a just significant advantage in that it clears the emulsion more rapidly and the after-clearing stage of fixation is longer. No advantage at all was seen in the preliminary experiments in which plain gelatin film was soaked in silver-bearing fixer.

When the fixation was taken only to the point of clearing, the results

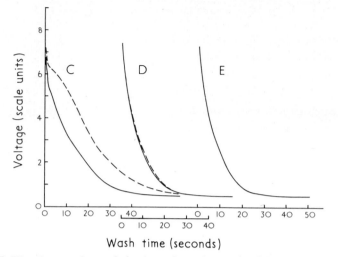

Fig. 5. The change of recorded voltage from the conductivity apparatus with washing time for films processed in Fixers C, D and E with 45 ml acetic acid litre$^{-1}$ added and pH adjusted to 4·5. – – – – – – (fixed to clear); ——————— (fixed for 4 min.).

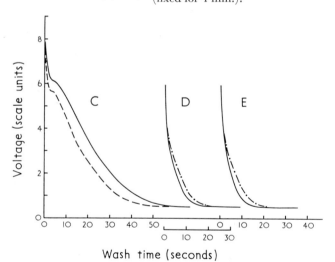

Fig. 6. The change of recorded voltage from the conductivity apparatus with washing time for films processed in Fixers C, D and E for 4 min at pH 4·5.

—·—·—·— (fixer + 15 g potash alum litre$^{-1}$ and 45 ml acetic acid litre$^{-1}$)
– – – – – – (fixer + 15 g potash alum litre$^{-1}$ and 15 ml acetic acid litre$^{-1}$)
——————— (fixer + 15 g potash alum litre$^{-1}$).

(Note: For fixer C the curves for fixer + 15 g potash alum litre$^{-1}$ with 15 ml acetic acid litre$^{-1}$ and 45 ml acetic acid litre$^{-1}$ are indistinguishable. For fixers D and E the curves for + 15 g potash alum litre$^{-1}$ with and without 15 ml acetic acid litre$^{-1}$ are indistinguishable.)

with a fresh emulsion were the same at pH 4·5 and 7·0 in that little advantage was to be gained by using the ammonium thiosulphate. However, with an emulsion aged for 12 months the result for the just-cleared film at pH 7·0 did show a marked drop in residue, as shown in Table 2, when the ammonium salt was used.

When acetate ion was added to the fixer to improve the buffering on the acid side, the position changed markedly in favour of the ammonium thiosulphate, though acetate retarded washing in all instances. Comparison of the conductivity curves for the sodium and ammonium fixers with acetate in Figs. 4 and 5 reveal marked inflections in the sodium thiosulphate curves for the just-cleared condition that are not present, or are not so noticeable in the ammonium counterpart. It seems that the phase of rapid washing changes to one in which a slowly diffusable, or a slowly dissociable complex has to be eliminated before the conductivity can resume its normal pattern of decline.

Although the available evidence does not warrant a definite hypothesis, it is fair to say that these results suggest the transitory incorporation of acetate in a silver-halo-thiosulphate complex of the type described by Brumpton and Hirsch.[6]

Although the addition of acetic acid to a hypo-bisulphite fixer tended to increase the residue level found after a brief wash, acetic tended to reduce the high levels of residue found when alum was present in the fixer. In this instance the ammonium fixer allowed faster washing than the sodium fixer.

These findings reconcile the observations in the literature cited. If Alnutt found roughly equal washing rates after using an F5-type fixer it could well result from his having used a molar concentration of the ammonium thiosulphate greater than was equivalent to the sodium hypo. This could have gone some way towards equalizing the apparent rate of washing.

### References

1. D. B. Alnutt, *J. Soc. Mot. Pict. Eng.*, **41**, 300 (1943).
2. J. I. Crabtree, G. T. Eaton and L. E. Muehler, *J. Soc. Mot. Pict. Eng.*, **41**, 9 (1943).
3. Hoechst AG 1965.
4. A. Green and G. I. P. Levenson, *J. Photogr. Sci.*, **18**, 1, (1970).
5. D. A. Mattey and R. W. Henn, *Photogr. Sci. Eng.*, **10**, 202 (1966).
6. E. R. Brumpton and H. Hirsch, *J. Photogr. Sci.*, **13**, 301 (1965).

# Washing Monobathed Film

A. GREEN and M. G. RUMENS

*Research Laboratory, Kodak Limited, Wealdstone, Harrow, Middlesex*

ABSTRACT. Monobath processed films take 40 s washing, in tap water at 12°C, to reach the level of sodium thiosulphate required for archival permanence. It is found, however, that a 60 s wash at this low temperature is necessary to avoid staining due to residual hydroquinone.

## INTRODUCTION

It is well known as a generality that films wash faster after an alkaline than after an acid fix. Therefore it is to be expected that, after monobath processing, the required wash time will be short, and in fact this is found to be true. The present work was carried out to determine the washing requirements for a film processed in a typical monobath.

One of the disadvantages of monobath processing is that the solution is unstable once used and is prone to oxidation by the atmosphere. In modern monobath processes, therefore, it is useful to use the minimum quantity of processing solution and to use it once only, after which it is discarded. Some processes which we have been concerned with involve processing the film in its own cassette in the case of 35 mm film and in a suitable water and light-tight packet in the case of non-screen X-ray film. Both types of process use the minimum convenient volume of monobath solution so the solution is often near to exhaustion at the end of the process and contains the residues of both development and fixation in large amounts.

Conventional processing, of course, involves acid fixation after development, with sometimes a rinse or acid stop bath in between. Because of this it is unlikely that any large amount of the developer components would be present in the emulsion by the end of fixation, and any small amounts present would be unlikely to give rise to a visible stain, as the pH of the emulsion would be fairly low at the end of washing. In the case of monobath processing, however, not only are the developer components present in the bath immediately prior to the final wash, but the emulsion is likely to be alkaline after washing, and so in this case it is very

63

important to be sure that the developing agents have been removed in order that no visible stain develops during keeping.

For the present work, therefore, we have been concerned not only with residual thiosulphate and silver, but also with the residual developing agents.

## EXPERIMENTAL AND RESULTS

The experiments involved processing 12-cm² sheets of double-sided non-screen X-ray film, packed in heat sealed opaque PVC packets, in a PQ monobath solution containing 20 g litre$^{-1}$ hydroquinone and

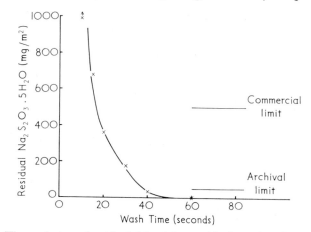

Fig. 1. The variation of residual thiosulphate with time of washing in tap water at 12°C.

200 g litre$^{-1}$ sodium thiosulphate at pH 11·8. This was introduced into the packet in a quantity sufficient to give 0·5 ml of solution for each square centimetre of double-sided film.

After the introduction of the monobath at 24°C into the packet it was agitated by hand under water, also at 24°C, for 4 min. After the agitation period the packs were opened and the films were washed in untempered cold tap water running through a 530 ml wash tank at a rate of 23 ml s$^{-1}$. The water temperature was within 12 ± 0·5°C for the duration of these experiments. After the required wash time the films were removed from the tank and squeegeed. The films were then dried, after which they were analysed for residual thiosulphate by the method described by Mattey and Henn.[1]

Figure 1 shows the results of these experiments. The residual thiosulphate level for "archival" permanence is reached in 38·5 s while that for "commercial" permanence takes only 17·0 s. Analyses for residual silver

were made and these showed that there was no detectable silver in the film after 30 s washing.

From these results one would assume that a wash time of 40 s in cold running tap water could be recommended, but in fact it was found that films washed for 40 s showed a noticeable yellow stain almost immediately. This stain did not appear to increase with time and could be removed at any later time by rinsing in an acid solution (e.g. 2% acetic acid) and washing normally.

The level of stain was determined on a further set of films processed and washed as before, and the results are shown in Fig. 2. The density of the stain was measured to blue light.

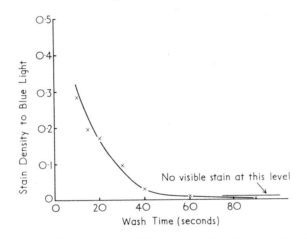

Fig. 2. The variation of density of developer stain with time of washing in tap water at 12°C.

Although the levels are numerically low, the yellow stain is very noticeable at low levels and its appearance is undesirable. There was no noticeable stain after 60 s washing and no stain developed after six weeks keeping in daylight or incubating at 50°C. There was no appreciable change in densities at shorter wash times except that the samples kept in daylight showed signs of fading. At the shorter wash times (less than 20 s) it was difficult to get a reliable reading of the stain level because of the presence of large amounts of sodium thiosulphate. It appeared that the yellow stain was reduced by the presence of thiosulphate, although this could not be confirmed.

It seemed likely that the stain was due to residual hydroquinone, and when the monobath was made up without hydroquinone and the experiments repeated there was no stain. In order to establish the presence of

hydroquinone and the quantity responsible for the stain a further series of experiments were carried out and analysis for hydroquinone attempted.

### Estimation of residual hydroquinone in processed film in the presence of residual thiosulphate

Standard methods for measuring small quantities of hydroquinone in film involve extraction with an acid solution followed by measurement of the U.V. absorbance at 290 nm. This technique was used for our measurements.

### Calibration for hydroquinone

A solution of 0·5 g litre$^{-1}$ hydroquinone was prepared by dissolving the solid in dilute hydrochloric acid (1 ml conc. HCl litre$^{-1}$). This was diluted with more of the acid solution to suitable concentrations for U.V. absorbance measurements. The absorbance was measured against an acid blank on the Unicam SP 800 and the U.V. Spec. at 290 nm. The results obtained with the two instruments agreed very well. (See Fig. 3.)

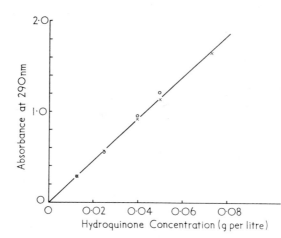

Fig. 3. The change in absorbance at 290 nm with hydroquinone concentration. x — x, UV spec; o — o UNICAM SP 800.

### Estimation of hydroquinone

The film used for this determination was a plain gel coating of the same thickness as a typical non-screen X-ray emulsion. The processed, washed and squeegeed film of standard size was put into a tube containing 10 ml dilute hydrochloric acid (1 ml conc. HCl litre$^{-1}$), the tube was stoppered and rolled on a ball mill for 15 min to obtain standard

agitation. The acid solution was then poured off and the U.V. absorption curve was obtained against an acid blank on the Unicam SP 800.

The procedure was carried out for films processed in monobath with and without hydroquinone, at the correct pH, to determine the effect of the other constituents of the monobath on the absorbance at 290 nm.

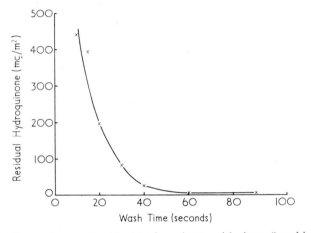

Fig. 4. The variation of residual hydroquinone with time of washing in tap water at 12°C.

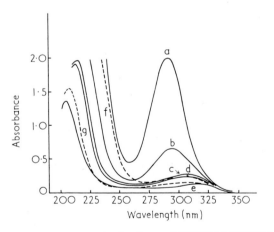

Fig. 5. The absorbance curves obtained on a UNICAM SP 800 for the acid extracts from films processed in monobath solution and then washed in tap water at 12°C for: (a) 10 s, (b) 20 s, (c) 40 s, (d) 80 s, (e) one h, (f) and (g) are the curves for film processed in monobath without hydroquinone and then washed in tap water at 12°C for 10 s and one h respectively. One piece of film was used for (a) and (b) and two pieces for all the others.

When monobath without hydroquinone was used there was an absorbance of less than 0·05 at 290 nm between one film sample washed for 10 s and one washed for an hour (Fig. 5) therefore, the hydroquinone determination would hardly be affected by the absorbance of the other constituents of the monobath.

The results shown in Fig. 4 were obtained by using the same technique with a non-screen X-ray film processed in the manner described in the text.

## DISCUSSION

Our experiments show that although under normal terms a wash time of 40 or even 20 s under these conditions could be safely recommended, in this case where the process is alkaline only very small quantities of residual hydroquinone could be tolerated and so a wash time of at least 60 s in untempered cold tap water, which is commonly at 12°C (54°F), would be called for.

It has been noted that the bulk of the hydroquinone stain appears almost immediately after contact of the wet film with the atmosphere after washing, and so, as a general rule, for this type of monobath processing the shortest required washing time is that at which the stain does not appear soon afterwards.

### Reference

1. D. A. Mattey and R. W. Henn, *Photogr. Sci. Eng.*, **10**, 202 (1966).

Superadditivity in Development

# Superadditive Black and White Developing Agents

## J. F. WILLEMS

*Photochemical Research Department, Agfa-Gevaert, N.V. Mortsel, Belgium*

ABSTRACT. The relationship between chemical structure and superadditive effectiveness in photographic development was systematically investigated for different classes of substances. The existence of a stable radical is a pre-requisite for a strong superadditivity. The formation of a stable semi-quinone demands a chemical structure which allows a high resonance stabilization. In phenidone, the resonance stabilization (as well as the superadditive effect) disappears for example through displacement of the phenyl ring by alkyl subsitution or by the introduction of strongly electrophilic groups. Negative charge or non-coplanar structures also reduce the stability of the semiquinone and the superadditivity. Beyond that, a definite redox potential difference is necessary for superadditive effectiveness on photographic development. The results equally well support the regeneration theory and the charge barrier model as the cause of superadditivity.

## 1. INTRODUCTION

A tutorial account of the work that has been done on the phenomenon of superadditivity was recently given by Levenson.[1]

This paper deals with superadditive development and more specifically with the ideal chemical structure of the auxiliary developing agent. The "auxiliary developing agent" is the reducing agent which is used in the smallest concentration (e.g. Phenidone or Metol). The main developing agents are negatively charged ones of the hydroquinone type.

In 1942 Kendall, in his B.P. 542,502, claimed 1-phenyl-3-pyrazolidinone as a better superadditive developing agent than metol. Under the name of "Phenidone" this compound quickly gained widespread acceptance. Chemical modifications in or on the pyrazolidinone ring made it quite clear that specific chemical structural requirements are necessary in order to obtain a good superadditive action.

Indeed, the superadditive effect was very much reduced or disappeared:

71

(a) when the phenyl group was replaced by a carbonamide group (using semi-carbazide instead of phenyl hydrazine as a reagent for the $\alpha$, $\beta$-unsaturated esters);

(b) when the phenyl group in the 1-position was replaced by a hydrogen atom or by an alkyl group;

(c) when one changes from a five membered pyrazolidinone to a six membered pyridazinone ring.

This made it obvious that prior to starting a programme for synthesizing useful new compounds, a better insight into the mechanism of superadditive action of the auxiliary developing agents was required. At that time two theories for the mechanism of superadditive development were current, the charge-barrier and the regeneration theory. In this survey neither the merits of these two theories nor a possible combination of them will be discussed.

However, attention must be given to the important fact, that during the oxidation of Phenidone, a stable radical—a semiquinone—is formed.

This radical is immediately discharged (reduced) on adding hydroquinone, which points to a regenerative process (Scheme 1).

That the formation of a stable radical by oxidation of the auxiliary developing agents is a prerequisite for high superadditivity with hydroquinone seemed to be corroborated by the results obtained with the pyrazolidinone compounds.

The formation of a stable semiquinone requires a chemical structure with high resonance-stabilization possibilities.

Phenidone possesses such a structure but the unsubstituted as well as the alkyl substituted derivatives lack resonance stabilization.

Stable semiquinone formation is also strongly inhibited when the molecule is not coplanar as in the case of the puckered 1-phenyl-pyridazinone. Finally, introducing a strong electron attracting substituent at the nitrogen atom in the 1-position (the 1-carbonamido-pyrazolidinone) causes electron loss to occur only with great difficulty so that no semiquinone formation is observed.

Our research programme therefore aimed at synthesizing and studying chemical compounds which, by the loss of an electron, can form a stable semiquinone, which in its turn, activates development by negatively charged developing agents.

Before discussing the results of these experiments some consideration is given to:

(a) the development inhibition, encountered by negatively charged developing agents; and

(b) the means to minimize this inhibition.

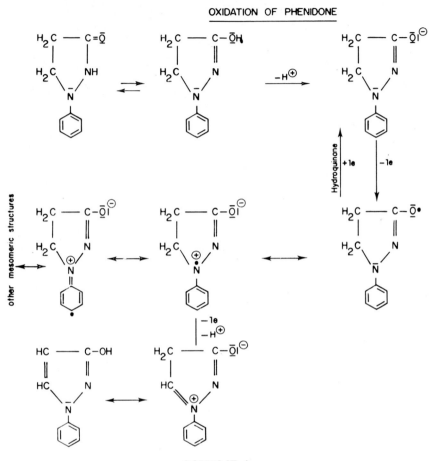

SCHEME 1

## 2. DEVELOPING PROPERTIES OF NEGATIVELY CHARGED DEVELOPING AGENTS

Negatively charged developing agents (ascorbic acid, hydroquinone) possessing a sufficiently negative redox potential to start the reduction of exposed silver halides, are hindered in their absorption on the silver halide grains through Coulomb's repulsion by the negative potential barrier.

For a silver bromide sol of pAg 6,6, with a $\zeta$-potential of $-42$ mV, only a fraction of the negatively charged particles have enough kinetic energy to penetrate this barrier.

When we put this fraction equal to unity for an uncharged developing agent, only 0·17 molecules of a mono-negatively charged developing agent, 0·03 molecules of a developing agent having a double negative charge and 0·0052 molecules of a developing agent having three negative charges can absorb onto the silver halide.

This rough calculation also shows why uncharged developing agents develop without induction period (Fig. 1).

If the developing agent possesses a single negative charge there is a small induction period. The length of this induction period increases progressively as we go to two and to three negative charges.

Another illustration of this phenomenon are the development characteristics of the dialkylaminophenols with a sulfonamide substitution (Scheme 2). Development in a bath with a pH situated between the pK of the hydroxyl group and the pK of the sulphonamide group (mono-anion) occurs with a very small induction period. Development however in a bath with a pH higher than both those pK values has an important induction period.

## 2.1. Influence of cationic substances on hydroquinone development

It is also observed that the induction period increases when the bromide concentration of the developer is increased, and this increase is related to the charge of the developing agent. The more negatively the developer is charged the longer the induction period becomes (Fig. 2).

On the other hand the induction period is shortened by adding suitable catonic substances to the developer, and this shortening becomes more and more pronounced the more negatively charged the developing agent is (Fig. 3).

The activation of the hydroquinone development by cationic compounds is strongly dependent on their chemical structure. This activation parallels both the ability to desorb a previously adsorbed dye p-(3-methyl-5-oxo-4- [2-(1,3,3-trimethyl-2-indolinydene) ethylidene] -2-pyrazolin-1-yl) -benzene-sulphonic acid from a silver bromide sol, and the capacity to reduce the surface tension. The extent of these three phenomena is determined by the use of onium salts with a chemical configuration enhancing the mutual association forces either through Van der Waals forces or through $\pi$-electron attraction.[2] The tetraalkyl-ammonium cation (Cpd. 1) without association forces does not activate the hydroquinone development, neither does it eluate the dye nor does it have any influence on the surface tension.

A slight activation is observed with the ethyl pyridinium cation (Cpd 2). The dodecylpyridinium cation (Cpd 3) through Van der Waals forces and the methylquinolinium cation (Cpd 4) through $\pi$-electron

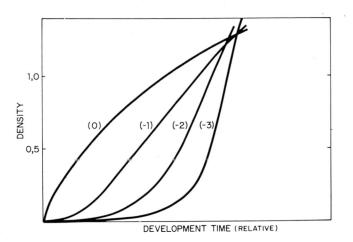

Fig. 1. Relation between charge of developing agent and induction period.

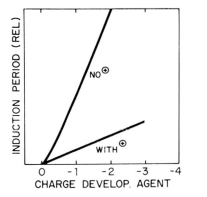

Fig. 2. Influence of bromide on induction period.

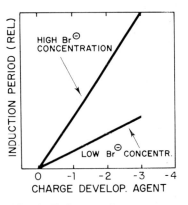

Fig. 3. Influence of quaternary salts on induction period.

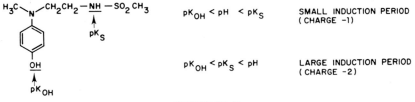

SCHEME 2

attraction are strong activators for the hydroquinone development. Moreover they easily desorb the dye and show tensioactive properties. The relative strength of the activation corresponds to the magnitude of both the elution and the tensioactivity (Fig. 4).

However, when the cationic property is neutralized through betaine formation by introducing negatively charged groups, both the activation and the elution capacity are strongly reduced.

This is illustrated by comparing on the one hand the good activation, elution- and tensioactive properties of the p-carbethoxy-benzylpyridinium cation (Cpd 1) and on the other hand the strongly reduced activation and elution capability of the p-carboxybenzylpyridinium cation (Cpd 2), although this compound exerts the same tensioactivity (Fig. 5).

## 2.2. Modified hydroquinones

All these properties point to the great importance of the adsorption capability of the negatively charged developing agents onto the silver halide. This important factor in superadditivity is illustrated by some results obtained with modified hydroquinone derivatives.

2.2.1. It is to be expected that by introducing a cationic substituent in a hydroquinone molecule the Coulomb-repulsion encountered by the latter will be reduced to a great extent. Consequently the development must be faster. This is clearly shown by the experimental results plotted in Fig. 6. Although the introduction of an electron attracting quaternary ammonium group causes an unfavourable positive shift of the redox potential ($+39$ mV for the mono- (Cpd 1) and $+129$ mV for the disubstituted derivative (Cpd 2)), the marked increase of the adsorption tendency makes those compounds actively develop a silver halide emulsion. They even desorb a previously adsorbed dye from silver bromide sol, contrarily to hydroquinone itself.[3]

This corresponds with the adsorption values on silver bromide, collected in the last column of Fig. 6.

If, however, the positive charge of the quaternary ammonium group is neutralized by the introduction of a negatively charged sulphonic acid group resulting in a betaine (Cpd 3), the development activity drops again. This compound is no longer adsorbed on the silver halide and consequently the dye is not desorbed from the silver bromide sol.

2.2.2. Another interesting phenomenon is observed when studying the developing properties of the homologues class of the alkyl substituted hydroquinones (Fig. 7).[4] Considering the development activity (expressed as the time needed to reach a $D = 0.5$) a function of the length of the substituting alkyl group, it is observed that the activity increases

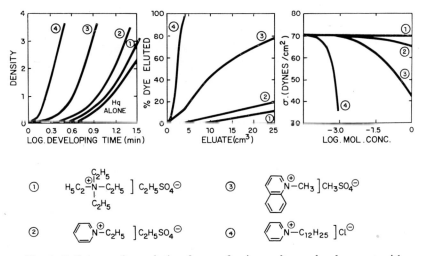

Fig. 4. Influence of association forces of onium salts on development with hydroquinone, on elution of adsorbed dye and on surface tension.

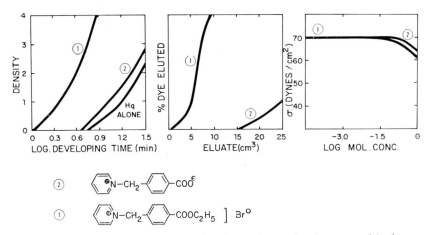

Fig. 5. Influence of the basicity of onium salts on development of hydro-quinone, on elution of adsorbed dye and on surface tension.

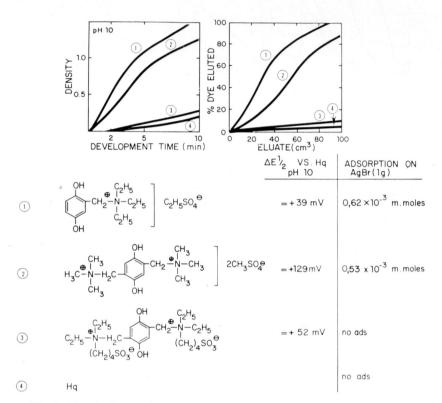

Fig. 6. Developing-, adsorption-, and redox properties of hydroquinones substituted with a quaternary group.

surprisingly when an alkyl group is introduced into the benzene ring. Increase of the chain length results in a further but more moderate increase in activity. With the addition of Phenidone practically all mutual differences in activity disappear.

Almost no superadditivity is noticed with the combination of hexyl-hydroquinone and Phenidone.

The same picture is obtained in the homologues series of the alkylhydroquinone-sulphonic acids (Fig. 8). The activity of the octylhydroquinone sulphonic acid is about the same as that of the octyl-hydroquinone sulphonic acid—Phenidone mixture.

At first sight one is tempted to ascribe the increase of the developing activity of the alkylhydroquinones with increasing number of carbon atoms in the alkyl group, to a more favourable redox potential.

From the values of the half-wave potentials of the alkylhydroquinones and alkylhydroquinones-sulphonic acids it can be seen (Fig. 9) that the introduction of alkyl groups into the hydroquinone molecule causes a shift of the potential towards more negative values. This shift is in agreement with the direction of the influence of the assumed inductive and hyperconjugative effects. However, this shift is not linear with increasing number of carbon atoms of the alkyl group, since the inductive electron releasing effect of a supplementary methylene group decreases with the lengthening distance.

However the developing activity continues to rise with increasing chain length.

It seems therefore that it is not so much the redox potential that causes the differences in developing activity, but the growing tendency of these compounds to be adsorbed onto the silver or the silver halide.

As a matter of fact, when the length of the carbon chain of the alkyl residue in a hydroquinone molecule increases, the latter becomes more hydrophobic and the tendency to leave the solution in order to be adsorbed onto a surface, increases. To illustrate this phenomenon, adsorption values of hydroquinone, methylhydroquinone and butyl hydroquinone on silver are plotted in Fig. 10.

These values correspond quite well with the observed development activity.

### 2.3. Developing properties of dialkylhydroxylamines

To complete this picture some results with other developing agents, the hydroxylamines, are illustrated.

Hydroxylamines belong to the class of the amino hydroxy developing compounds, i.e. to the monoanions, and are to be compared to the amino-phenols. It is known that the aminophenols (e.g. Metol) not only develop

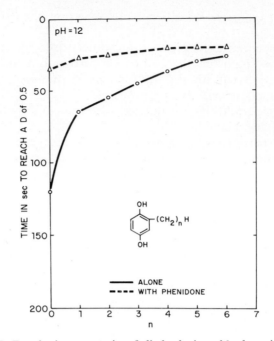

Fig. 7. Developing properties of alkyl substituted hydroquinones.

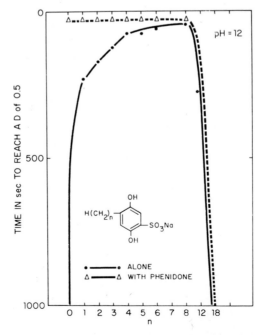

Fig. 8. Developing properties of alkyl substituted hydroquinones-sulphonic acids.

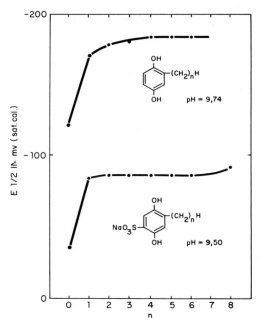

Fig. 9. Redox behaviour of alkyl hydroquinones and alkyl hydroquinone-sulphonic acids.

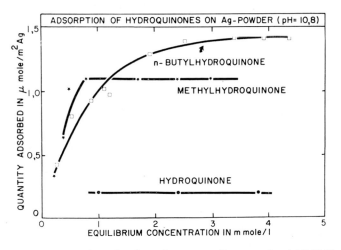

Fig. 10. Adsorption of hydroquinones on silver powder (pH 10·8).

with a small induction period, but also that they are not activated by quaternary salts and by Phenidone.

Hydroxylamines and the alkyl hydroxylamines, e.g. diethylhydroxylamine (Cpd 1) however are very hydrophilic compounds and although they have only one negative charge they are not adsorbed and are very poor developing agents (Fig. 11).

Analogously to hydroquinone, introduction of either cationic substituents (Cpds 2 and 3) or a hydrophobic alkyl residue (Cpd 4), causes the developing capability to increase markedly. Introducing an anionic group (Cpd 5) however, again has the opposite effect.[5]

## 3. STRUCTURAL REQUIREMENTS FOR OPTIMAL SUPERADDITIVE ACTION OF THE AUXILIARY DEVELOPING AGENT

In drafting the characteristics of a suitable structure for an auxiliary developing agent, we have to take into account the following requisites:

(a)  Good adsorption of the auxiliary developing agent which has to start the development without induction period.

(b)  High stability of the corresponding semiquinone to make possible:
the regeneration of the reduced form from this semiquinone by the main developing agent,
the adsorption or co-adsorption of the main developing agent which is the source of the available electrons.

Translating these into physico-chemical terms, the pre-requisites for optimal superadditive development are:

(a)  High stabilitity constant of the semiquinone

$$K = \frac{(S)^2}{(R)(Q)} \text{ or } \log K = \frac{E_2 - E_1}{2}$$

(b)  A redox potential more negative than the redox potential of the $Ag/Ag^+$ system (Ag-halide) to make the reduction possible, but not more negative than the redox potential of the main developing agent, to make the regeneration possible.

$$(-) \qquad\qquad\qquad\qquad\qquad (+)$$
$$E_{\text{main dev.}} > E_{\text{aux.}} > E_{Ag/Ag^+}$$

(c)  The semiquinone is not an anionic and preferably a cationic species.

In the following sections these rules are checked with different classes of chemical compounds.

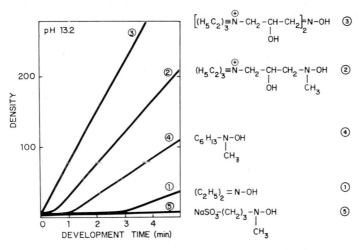

Fig. 11.  Developing properties of dialkylhydroxylamines.

## 3.1. The p-phenylenediamines

It is known from the studies of Michaelis that the univalent oxidation products of the p-phenylenediamines, the so-called Würsters salts, are free radicals stabilized by resonance (Scheme 3). The stability of these positively charged semiquinone radicals depends on their chemical structure.

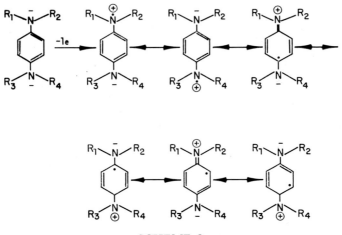

SCHEME 3

Their stability is markedly enhanced by replacing successively the four hydrogen atoms on the two nitrogen atoms by four alkyl groups (Fig. 12).[6]

The superadditivity increases as the stability of the semiquinones increases. The unsubstituted p-phenylenediamine, which does not form a stable semiquinone, does not act superadditively with hydroquinone but the tetraethyl p-phenylene-diamine, forming the very stable Würsters blue, is the most active superadditive developing agent.

In the experimental conditions hydroquinone, used alone, gives no density.

Further it is known that cyclization of the two ethyl groups on the nitrogen atom to a pyrrolidine ring notably favours a more planar configuration of the semiquinone and hence its stability, but also a more negative redox potential. This results in a marked increase of the super-additivity (compare (Cpd 1) to (Cpd 2) for the mono ringclosure and (Cpd 3) to (Cpd 5) for the di-ringclosure). (Fig. 13.)

The same effect but to a higher degree is observed with a ringclosure of a N-alkyl group on the carbon atom in the ortho position of the benzene ring, resulting in the strongly superadditively acting amino tetrahydroquinolines (compare (Cpd 1) to (Cpd 4) and (Cpd 3) to (Cpd 6)).

The opposite effect is however observed with structural changes, which destroy the coplanarity of the molecule.

This is illustrated with the N-tetraalkyl toluidines (Cpd 7). The presence of a methyl group on the benzene nucleus indicates that the dialkylamino group is out of plane. The resonance hybrid of the semi-quinone requires that the three substituents on the nitrogen atom in-cluding the benzene ring, lie in one plane. If this configuration is not possible because of steric conditions, the formation of the semiquinone is inhibited, and as is shown in Fig. 13, no superadditivity with Cpd 7 is observed. The same phenomenon occurs with ring closure of both the alkyl groups to a non planar six-membered piperidine ring. (Compare (Cpd 1) and (Cpd 2) to (Cpd 8)).

Two years after the publication of these results, Newmiller et al.[8] established a linear relationship between the semiquinone formation constant and the redox potential $E_1$ of the first oxidation step, calculated by Tong and Glesmann[9] and the superadditivity of N,N-dialkyl-p-phenylenediamines with hydroquinone and ascorbic acid (Fig. 14).

By introducing electron releasing substituents (X) in the N,N-diethyl-p-phenylenediamine molecule (I) the redox potential is made more negative and the superadditivity effect increased (Table I).

An exception is the hydroxy-substituted derivative, where only a

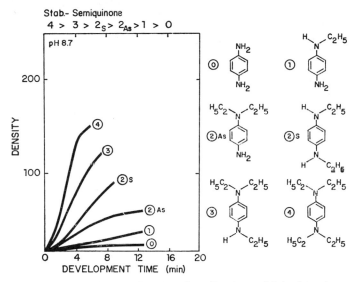

Fig. 12. Superadditivity of p-phenylenediamines with hydroquinone.

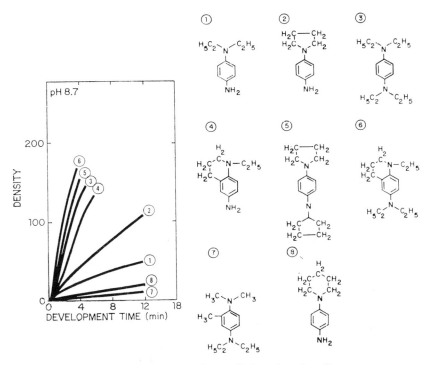

Fig. 13. Influence of ringclosure of tetraalkyl p-phenylenediames on super-
additive development with hydroquinone.

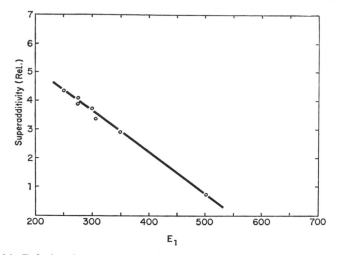

Fig. 14. Relation between superadditivity with ascorbic acid and $E_1$ of dialkyl p-phenylenediamine (Newmiller *et al.*).[8]

TABLE 1

| | X | $\Delta E 1/2$ versus I (X = H) | Induction period (Dev. time to reach d = 0.2) | Rate super— additivity (Dev. time for d=0.2 → 0.5) |
|---|---|---|---|---|
| | — | — | 150 | 48 |
| | H | — | 105 | 38 |
| | $OC_2H_5$ | − 69 | 56 | 20 |
| | $NH_2$ | − 164 | 22 | 7 |
| | $NHCH_3$ | − 205 | 17 | 6 |
| | $O^{\ominus}$ | −284 | 51 | 48 |

shortening of the induction period but no rate superadditivity is observed. This would point to the fact that the semiquinone formed is no longer reduced by the hydroquinone. Indeed, the blue coloured semiquinone of the hydroxy derivative is not discoloured by an alkaline solution of hydroquinone, unlike the other semiquinones of this series.[6]

Before concluding this section on the p-phenylenediamines, it is worth while to mention another important item in this argument, namely the influence of the charge of the semiquinone on superadditivity.

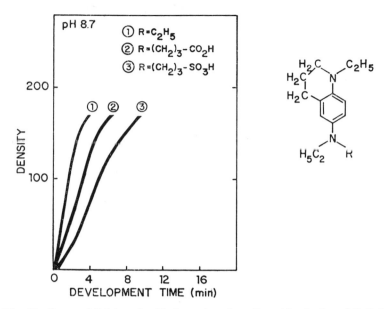

Fig. 15. Superadditivity of sulfonic and carboxylic acid substituted 6-dial-
kylaminotetrahydroquinolines with hydroquinone.

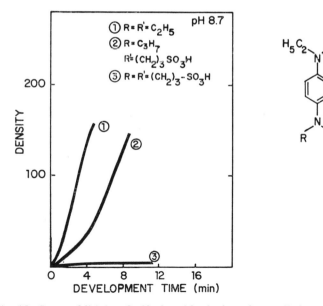

Fig. 16. Superadditivity of sulfonic acid substituted tetraalkylparaphenylene
diamines with hydroquinone.

Introducing a carboxylic (Cpd 2) or a sulphonic group (Cpd 3) in the N-alkyl-chain of the strongly superadditivity acting 6-dialkylamino-tetrahydroquinolines results in the decrease of the superadditive effect[7] (Fig. 15).

The same effect is observed with the tetraalkyl-p-phenylenediamines (Fig. 16). Introducing one (Cpd 2) or two (Cpd 3) sulphonic acid groups in the strongly superadditively acting tetraethyl para-phenylenediamine results in a decrease, respectively in a disappearance of the superadditive effect. In the case of the sulpho-disubstituted derivative (Cpd 3), both the reduced form and the semiquinone are anionic and with such compounds, even when their redox-potentials are favourable and their semiquinones are stable, no superadditivity effects are observed.

The monosulpho or monocarboxylic acid group substituted derivatives from a semiquinone with a betaine structure (II) and a substantial superadditivity remains.

( II )

Summarizing we can conclude that the experimental results obtained in the para-phenylenediamine class have proved the preconceived chemical structural requirements for good superadditivity.

### 3.2. The aminophenols

From the results obtained with the para-phenylenediamines, it might be deduced that p-methylaminophenol, Metol, the oldest known and still very widely used superadditive developer with hydroquinone, has not been in fact a very opportune choice.

Indeed, it is to be expected that the stability of the semiquinones of aminophenole increases in the order: primary (Cpd 1) < secondary

(Cpd 2) and metol) < tertiary-amino group (Cpd 3). Accordingly the superadditivity effect increases (Fig. 17).[10] Ring closure of the two alkyl groups to a planar pyrazolidine ring (Cpd 4) favours the resonance stabilization of the corresponding semiquinone resulting in an enhanced superadditivity. Ring closure however to a puckered six membered piperidine ring (Cpd 5) has the opposite effect.

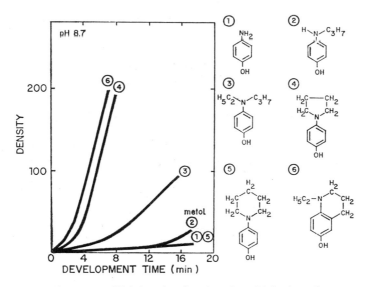

Fig. 17. Superadditivity of aminophenoles with hydroquinone.

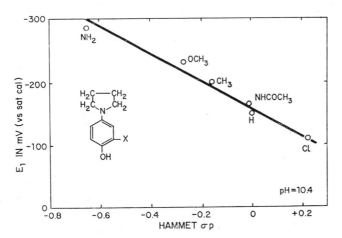

Fig. 18. Relation between $\sigma p$ and $E_1$ of 4-hydroxy-N-phenylpyrrolidines.

Ring closure of the N-propyl substituent (Cpd 2) on the ortho carbon of the benzene ring, (forming 6-hydroxy tetrahydroquinoline derivatives (Cpd 6)), also results in a more planar configuration, a higher semi-quinone formation constant, a more favourable redox potential and consequently in a much intensified superadditive effect. These results are in complete accordance with the results obtained with the p-phenylenediamines.

The redox properties of 4-hydroxy-N-phenylpyrrolidine can be strongly influenced by the introduction of electron releasing or electron attracting substituents. As can be seen from Fig. 18, the redox potential of the first oxidation step shows a very good correlation with the Hammett para-sigma constants, which take into account both the inductive and the mesomeric effects of the substituents.[11]

The same effect was observed by Ficken et al.[12] in the pyrazolidinone series.

In Fig. 19 it is demonstrated that there is a linear relationship between the observed superadditivity and the redox potential of the first electron loss, the more negative this potential the higher the superadditivity.

However, an exception must be made for the amino substituted derivative. In spite of a very negative redox potential only a very slight superadditivity is observed. Beside the fact that the semiquinone formation constant is a hundred times lower than that of the other derivatives it is also observed that the semiquinone is no longer regenerated by hydroquinone, which is normal in view of the very negative value of the redox potential.

A linear relationship is also observed between the redox potential and the superadditivity with the 6-hydroxy-tetrahydroquinoline derivatives (Fig. 20).

In this series also an exception is observed. The 4-sulphobutyl derivative, although possessing a favourable redox potential and a high semiquinone formation constant, lacks any superadditivity with hydroquinone because of its anionic character.

The influence of anionic substituents in the p-amino-phenol series is once again illustrated in Fig. 21 (compare (Cpd 1) to (Cpd 2) and (Cpd 3) to (Cpd 4)).[7]

### 3.3. Heterocyclic azines

Heterocyclic azines possess an electronic configuration, which makes that their semiquinones, formed by the loss of one electron, are extremely stable due to the high resonance stabilization (Scheme 4).

Since the azines display a variety of redox potentials (E) by variation of the heterocyclic nuclei, they also constitute an excellent means to

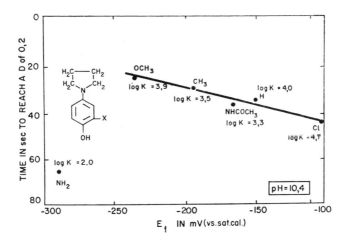

Fig. 19. Relation between superadditivity with hydroquinone and $E_1$ (and log K) of 4-hydroxy-N-phenylpyrrolidines.

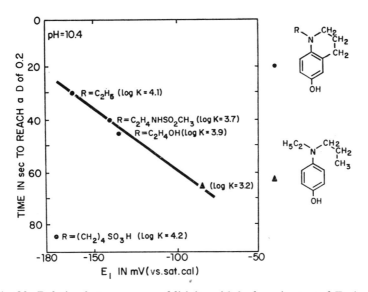

Fig. 20. Relation between superadditivity with hydroquinone and $E_1$ (and log K) of 6-hydroxy-tetrahydroquionines.

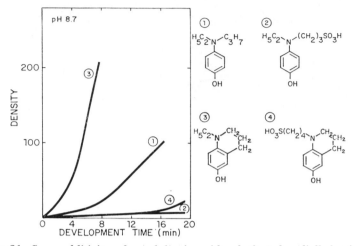

Fig. 21. Superadditivity of a sulphonic acid substituted p-dialkylamino-phenol and a sulphonic acid substituted 6-hydroxy-tetrahydroquinoline with hydroquinone.

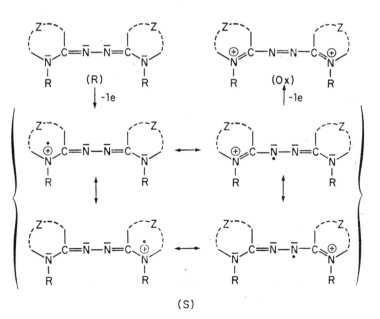

(S)

SCHEME 4

verify the rules just formulated for the ideal chemical structure of the auxiliary developing agents.[13]

As indicated in Fig. 22, heterocyclic azines form very stable semi-quinones, in contrast to the aliphatic azines (Cpd 7), where no semi-quinone formation is observed because of the lack of stabilization possibility by resonance. Nevertheless only the pyridonazines (Cpd 3, 4, 5) exhibit a superadditive effect with hydroquinone. This is explained by the fact that the redox potentials both of the benzthiazolone azine (Cpd 1) and of the quinolone azine (Cpd 2) are too positive. They are not reducing agents for the silver halide. The pyridonazines however are very suitable reducing agents forming stable semiquinones and they may be considered as a class of the best superadditive developing agents for hydroquinone or ascorbic acid. Both the superadditive activity and the redox potential increase with increasing length of the N-alkyl chain in accordance with the increasing inductive electron releasing effect of longer alkyl groups.

Once again the anionic sulphopropyl derivative (Cpd 6), in spite of its suitable redox potential and high semiquinone formation constant, is inactive towards superadditive development.

### 3.4. Photoreducible dyes

Reviewing the results discussed so far we may conclude that a linear relationship between the redox potential for the loss of the first electron and the superadditive development rate with negatively charged developing agents is clearly established. The more negative the redox potential the higher the superadditivity. The regeneration of the semi-quinone of the auxiliary developing agent by the negatively charged main developing agent requires however that its electro-chemical potential be no more negative than that of the main developing agent itself.

Two examples, one in the p-phenylenediamine and one in the p-hydroxyphenylpyrrolidine-series where this requirement was not met with have already been mentioned.

To illustrate this phenomenon more clearly some results obtained with photoreducible dyes of the thiazine, the oxazine and the phenazine type are discussed.[14] In the redox equilibria of these compounds semi-quinones are involved (Scheme 5). Moreover these dyes possess widely varying redox potentials depending on their chemical structure, so that they are very well suited to study superadditivity in function of the redox potential. Ascorbic acid, which, used alone has no developing properties in the chosen circumstances, is employed as the main developing agent.

From Fig. 23 in which the superadditivity is plotted against the redox

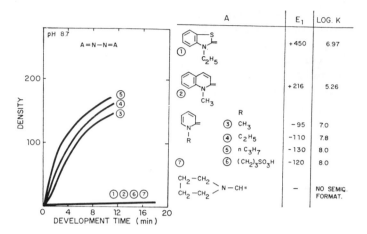

Fig. 22. Superadditivity of heterocyclic azines with hydroquinone.

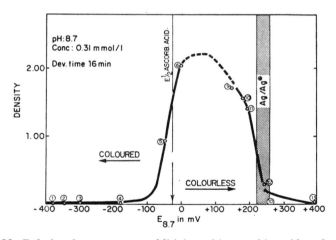

Fig. 23. Relation between superadditivity with ascorbic acid and redox
potential of redox indicators and auxiliary developing agents.

potential we can see that the redox indicators neutral red (Cpd 1),
safranine T (Cpd 2), phenosafranine (Cpd 3), and nile blue (Cpd 4)
show no superadditive effect with ascorbic acid and are not discoloured
in the developing solution. With methylene blue (Cpd 5) a slight dis-
coloration is observed which is attended by a weak superadditive action.
A complete discoloration and a large superadditive effect is observed
with thionine (Cpd 6).

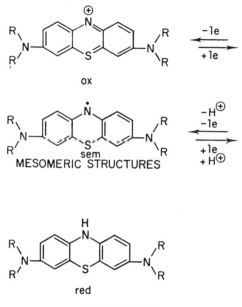

ox

MESOMERIC STRUCTURES

red

SCHEME 5

These results are in accordance with the fact that redox indicators, added to ascorbic acid containing developers, are only reduced to the leucodyes, if their redox potential is more positive than that of ascorbic acid. These leuco dyes are strong reducing agents, which in the adsorbed state on the silver halide grain start the development. The semiquinone so formed is immediately reduced again by the negatively charged ascorbic acid, which now no longer suffers an electrostatic repulsion (Scheme 6).

redox indicator (dye)              ascorbic acid
(= oxidizing agent)        ——————————————→        leuco dye (= reducing agent)

when $E_{ascorbic\ acid}$ is more negative than $E_{redox\ indicator}$

leuco dye  $\xrightarrow{Ag^+}$  semiquinone of dye + Ag

semiquinone of dye + ascorbic acid  ⟶  leuco dye + oxidized ascorbic acid

SCHEME 6

When the redox potential of the superadditive developing compound becomes more and more positive, the superadditivity drops again in accordance with the dependence of superadditivity on the redox potential, an effect already illustrated with pyrazolidones, p-phenylenediamines, p-aminophenols and azines. The results obtained with these compounds in the same conditions are also plotted in Fig. 23. In agreement with the redox properties the superadditivity drops in the sequence, pyridonazine (Cpd 9), 6-hydroxytetrahydroquinoline (Cpd 10), Phenidone (Cpd 11), p-dialkylaminophenol (Cpd 12) and quinolineazine

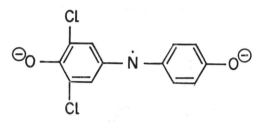

Sem. of Tillman 's reagent ($E_{8.7}=\pm100\,mV$)

( III )

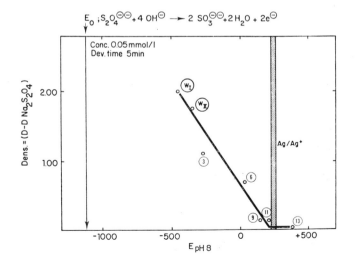

Fig. 24. Relation between superadditivity with sodium dithionite and redox potential of redox indicators, auxiliary developing agents and Weitz-radicals.

(Cpd 13). As already mentioned the latter compound no longer shows superadditivity because its redox potential is more positive than the redox potential of the $Ag/Ag^+$ system in the experimental conditions. No reduction and hence no formation of a semiquinone occurs.

The redox indicator, 2,6-dichloroindophenol (Tillmans reagent)(III) which has a suitable redox potential ($E_{8.7} = \pm 100$ mV) and which readily discolours in the ascorbic acid developing bath, shows no superadditive action. The semiquinone formed is however of an anionic nature and such semiquinones cause no superadditivity with negatively charged developing agents.

### 3.5. Superadditivity of auxiliary developing agents, forming stable semiquinones with sodium dithionite

In order to generalize these quantitative data on the relationship between redox potential and superadditivity, the results obtained with a negatively charged reductor sodium dithionite with a very negative redox potential ($E_0 = -1120$ mV) are plotted in Fig. 24.[14] The redox indicator phenosafranine (Cpd 3) which is not discoloured by and shows no superadditive action with ascorbic acid, is discoloured in the sodium dithionite developing bath and exhibits a larger superadditive action than thionine (Cpd 6) in accordance with its more negative redox potential.

We can further generalize the superadditivity phenomenon by showing the results obtained with redox systems of which the redox potential ($E_2$) of the transition sem $\rightleftharpoons$ ox is situated in the suitable redox region (Scheme 7).

This is the case with the Weitz radicals that are formed by reduction of dialkyldipyridylium salts. These semiquinones are involed in a reversible redox system and are extremely stable due to the large delocalization possibility of the old electron (Scheme 8).

The redox potential ($E_2$) for the transition ox $\rightleftharpoons$ sem for Cpd W I is $-446$ mV and for Cpd W II is $-349$ mV.

Solutions of Cpd WI and Cpd WII are respectively coloured a very intense blue and green by sodium dithionite, which points to the formation of the radicals. These radicals are very strong reducing agents and are reoxidized by oxidizing agents (e.g. silver halides) to the dipyridylium salts (Scheme 9).

Due to this reversible redox reaction, the high stability of the semiquinones and the suitable redox potential a high superadditivity with dithionite is expected, and this is proved by the results of the experiments plotted in Fig. 24, where the quantitative relationship between the redox potential and the superadditivity is also maintained.

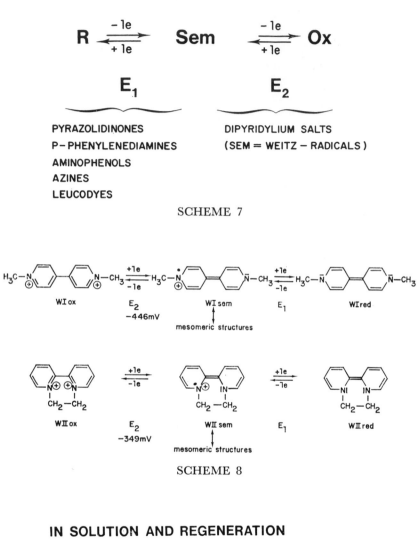

SCHEME 7

SCHEME 8

## IN SOLUTION AND REGENERATION

$$\tfrac{1}{2}\ S_2O_4^{\ominus\ominus} + Ox^{\oplus\oplus} + 2\ OH^{\ominus} \longrightarrow Sem^{\bullet\oplus} + SO_3^{\ominus\ominus} + H_2O$$

## ON AgBr

$$Ag^{\oplus} + Sem^{\bullet\oplus} \longrightarrow Ag + Ox^{\oplus\oplus}$$

SCHEME 9

## References

1. Levenson, G. I. P., *Photogr. Sci. Eng.*, **13,** 299 (1969).
2. Willems, J. F., *Int. Konf. Wiss. Photogr. Cologne*, 400 (1956).
3. Willems, J. F., *Photogr. Sci. Eng.*, **4,** 101 (1960).
4. Willems, J. F. and van Veelen, G. F., *J. Photogr. Sci.*, **14,** 48 (1966).
5. Willems, J. F., Paper presented at the International Conference on Scientific and Applied Photography, Budapest, 1972.
6. Willems, J. F. and van Veelen, G. F., *Photogr. Sci. Eng.*, **6,** 39 (1962).
7. van Veelen, G. F. and Willems, J. F., *Photogr. Sci. Eng.*, **12,** 41 (1969).
8. Newmiller, R. J., Pontius, R. B. and Willis, R. G., *Photogr. Sci. Eng.*, **11,** 244 (1967).
9. Tong, L. K. J. and Glesmann, M. C., *Photogr. Sci. Eng.*, **8,** 319 and 326 (1964).
10. Willems, J. F. and van Veelen, G. F., *Photogr. Sci. Eng.*, **6,** 49 (1962).
11. Willems, J. F. and van Veelen, G. F., *Photogr. Sci. Eng.*, **10,** 306 (1966).
12. Ficken, G. E., Mason, L. F. A. and Ramsay, D. W., *J. Photogr. Sci.*, **13,** 294 (1965).
13. Willems, J. F., van Veelen, G. F. and Vandenberghe, A., *Photogr. Sci. Eng.*, **13,** 312 (1969).
14. Willems, J. F., *Photogr. Sci. Eng.*, **15,** 213 (1971).

# Superadditivity in Colour Development

## G. F. van VEELEN

*R & D Laboratories Agfa-Gevaert N.V., Mortsel, Belgium*

ABSTRACT. A survey of literature on superadditivity in colour development is given and is compared with superadditivity in black-and-white development. Generally superadditivity in colour is explained by the same regeneration mechanism as that in black-and-white. There are however a few fundamental differences that throw some doubt on the correctness of this assumption. The main points are:

1. The oxidation of colour developers by air in the absence of silver halide is increased by Phenidone, the oxidation of hydroquinone on the contrary is not increased by Phenidone;
2. The p-phenylenediamines develop with a short induction period, hydroquinone with a large one;
3. The p-phenylenediamines are far better adsorbed onto silver than hydroquinone;
4. The redox potential of the p-phenylenediamines is much more positive than the potential of phenidone or Metol, the potential of hydroquinone is of the same order as that of Phenidone or Metol and
5. The activation of colour development is coupler-dependent.

These points are discussed in detail.

A direct analytical proof, that Phenidone is indeed regenerated in emulsion during colour development, is difficult to give, because Phenidone is rapidly oxidized by air and not protected by the colour developing agent.

## INTRODUCTION

Black-and-white developers added to a colour developer often increase significantly the amount of silver developed in a fixed time. With regard to silver formulation, the black-and-white developing agent and the colour developing agent form a superadditive mixture.

With the dye formation we have to distinguish between two cases:

1. The dye formation is decreased by the black-and-white developer.
2. The dye formation is increased.

101

G. F. VAN VEELEN

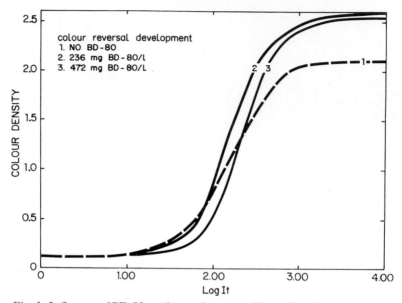

Fig. 1. Influence of BD-80 on the sensitometry of the yellow layer of a colour reversal emulsion

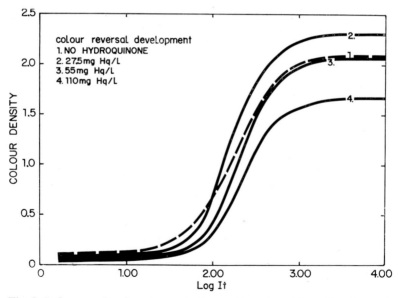

Fig. 2. Influence of hydroquinone on the sensitometry of the yellow layer of a colour reversal emulsion

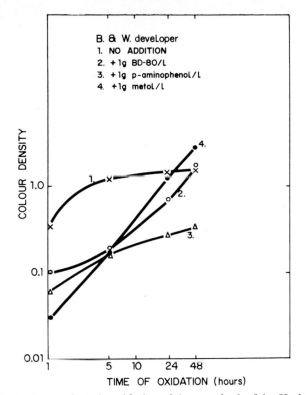

Fig. 3. Protection against air-oxidation of the cyan bath of the Kodachrome
type II by some *p*-aminophenols

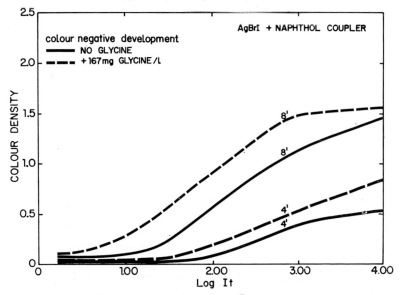

Fig. 4. Effect of Glycine on the sensitometry of a colour negative emulsion
with naphthol coupler at different developing times

An example of the first case is the use of dihydroxybenzenes at moderate or large concentration. The second case can be illustrated by Phenidone or Metol at low concentration.

Often both phenomena of colour activation and deactivation can occur simultaneously: so Metol can activate the development of the toe of the sensitometric curve of a colour negative material, but deactivate the region of maximum density. On the contrary, in a colour reversal material the toe is easier deactivated than the maximum density.

Activation is more pronounced at short development time and can change in deactivation, when development is continued for a long time.

## SURVEY OF LITERATURE
### Influence of black-and-white developing agents on sensitometry

Literature on this subject is not very extensive. Most data are given in patent literature.

An early patent of Schinzel[1] describes the use of p-benzylaminophenol (=BD-80) as gradation improver. Even now this agent is used in the cyan developer of the Kodachrome K12 processing.

BD-80 gives a sensitometric curve with a higher gradation and shorter toe (Fig. 1). With hydroquinone at a lower concentration roughly the same result can be obtained (Fig. 2).

Bogoljoebskij et al.[2] give an extensive survey of patents in the field of balancing developing agents, particularly alkylated hydroquinones.

### Anti-oxidizing effect of black-and-white developing agents

Evans and Hanson[3] described the use of substituted hydroquinones or p-aminophenols in the colour developer or in the emulsion as anti-oxydants. Brandenburger[4] describes the use of Metol and Glycine as anti-oxidizing agents in colour developers.

Figure 3 shows the favourable effect of some p-aminophenols on the oxidation of CD-4 in the cyan developer of the Kodachrome type II emulsion.

### Acceleration of development

The first patent that describes the use of a black-and-white agent as an accelerator of colour development comes from Neumann[5]. He claimed the favourable effect of Metol in a coupler containing developing baths.

Agfa A.G.[6] claimed an increase of sensitivity of colour film containing substantive couplers by the use of p-aminophenol, Metol, pyrocatechol or Glycine in colour developers.

Figures 4 and 5 show the effect of Glycine and Metol on a colour negative development. Metol has a stronger activating effect than Glycine. Hydroquinone has a deactivating effect as is shown by Fig. 6.

Mason[7] discovered the very strong accelerating effect by a low concentration of the 3-pyrazolidones. This is demonstrated in Fig. 7.

As Mason[7] has mentioned, Phenidone does not accelerate colour development in the presence of a soluble pyrazolone coupler. This is however not a general case for pyrazolone couplers, because in most cases substantive pyrazolone couplers do not impede activation, although activation is generally less than with cyan or yellow couplers. Figure 8 shows the activation in the case of a pyrazolone coupler.

A silver chloride emulsion is also activated by Phenidone (Fig. 9).

Substituted p-aminophenols are claimed as development accelerators by Ganguin, Ramsey and Kaye.[8]

In colour reversal development somewhat different results are obtained than in colour negative development. Figures 10, 11 and 12 show the activation by Phenidone and Metol on the three layers of a colour reversal film.

In the toe of the sensitometric curve (Fig. 11) deactivation occurs rather easily as a result of the low concentration of silver halide remaining after the first development. Competition between pure black-and-white development and colour development will appear predominantly in this region. This is clearly the case with hydroquinone and even with Metol at higher concentration.

### Secondary effects

As claimed by Mason[7] the acceleration of development by Phenidone has also several secondary effects. It improves the selectivity of development, gives a more smooth dye grain structure and an improvement of the spectral absorption of the dye.

We have done some experiments with a monolayer of cubic silver bromide grains having an edge length of $1.5\ \mu$. The couplers were a two-equivalent naphthol coupler and a four-equivalent pyrazolone coupler. The dye grain became more diffuse when the Phenidone concentration was increased. The change of dye structure as to the micrograininess is illustrated in Figs. 13 to 17.

The amounts of silver developed in the monolayers and the densities before and after extraction in methyl acetate are given in Table 1. The results show that the amount of silver is considerably increased by the presence of Phenidone. The colour density is also increased at low Phenidone concentration and goes through a maximum. The results obtained before and after extraction of the dyestuff in methylacetate are not very different.

The effect of Phenidone on the macrograininess of a fine-grain silver iodobromide emulsion with pyrazolone coupler is shown in Figs. 18 and 19.

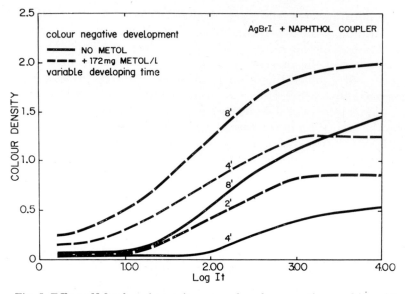

Fig. 5. Effect of Metol on the sensitometry of a colour negative emulsion with naphthol coupler at different developing times

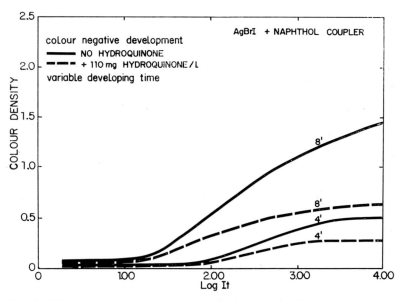

Fig. 6. Effect of hydroquinone on the sensitometry of a colour negative emulsion with naphthol coupler

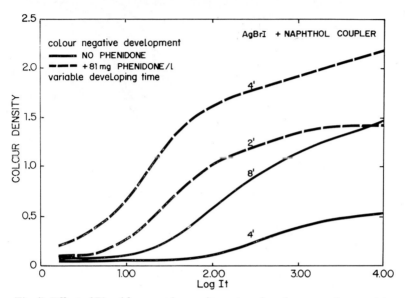

Fig. 7. Effect of Phenidone on the sensitometry of a colour negative emulsion with naphthol coupler

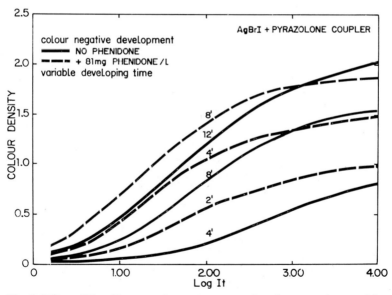

Fig. 8. Effect of Phenidone on the sensitometry of a colour negative emulsion with pyrazolone coupler

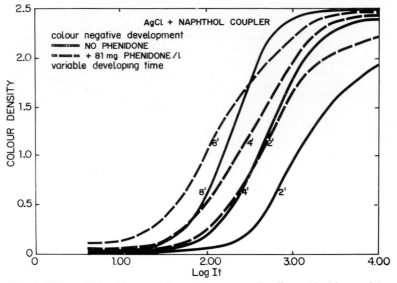

Fig. 9. Effect of Phenidone on the sensitometry of a silver chloride emulsion
with naphthol coupler

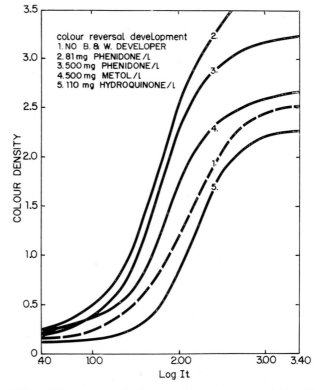

Fig. 10. Effect of Phenidone and Metol on the sensitometry of the yellow layer
of a colour reversal film

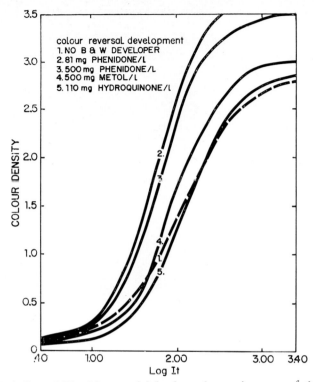

Fig. 11. Effect of Phenidone and Metol on the sensitometry of the cyan layer of a colour reversal film

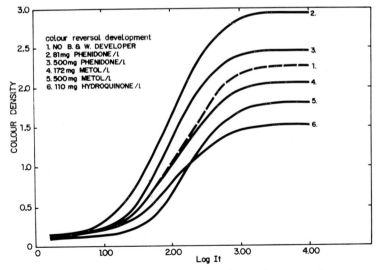

Fig. 12. Effect of Phenidone and Metol on the sensitometry of the magenta layer of a colour reversal film

Fig. 13. The dye sphere of the naphthol coupler after colour development in the absence of Phenidone. No bleaching bath has been used ($\times$ 600).

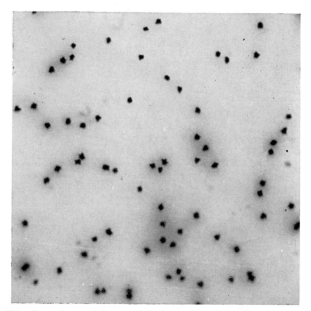

Fig. 14. The dye sphere of the naphthol coupler after colour development in the presence of 81 mg Phenidone per litre. No bleaching bath has been used ($\times$ 600).

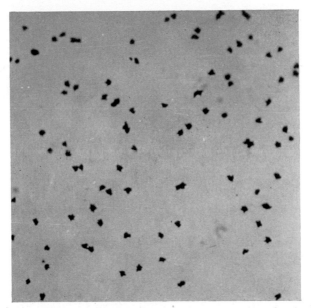

Fig. 15. The dye sphere of the naphthol coupler after colour development in the presence of 405 mg Phenidone per litre. No bleaching bath has been used (× 600).

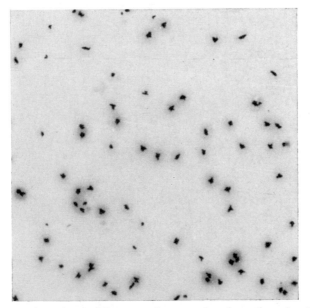

Fig. 16. The dye sphere of the pyrazolone coupler after colour development in the absence of Phenidone. No bleaching bath has been used (× 600).

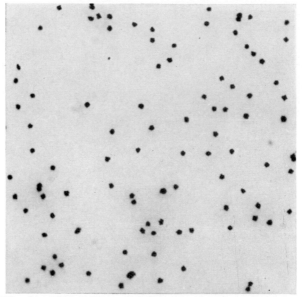

Fig. 17. The dye sphere of the pyrazolone coupler after colour development in the presence of 64 mg Phenidone per litre. No bleaching bath has been used ($\times$ 600).

Fig. 18. Macrograin structure of the pyrazolone dye obtained after colour development in the absence of Phenidone ($\times$ 600). Development time: 3 min. Colour density: 0.81. Silver developed: 94 mg m$^{-2}$.

Fig. 19. Macrograin structure of the pyrazolone dye obtained after colour development in the presence of 64 mg Phenidone per litre ($\times$ 600). Development time: 1 min. Colour density: 0·84. Silver developed: 101 mg m$^{-2}$. Same exposure as for Fig. 18.

G. F. VAN VEELEN

## Table 1

### Acceleration of colour development by Phenidone
(AgBr + pyrazolone coupler)

| mg Phenidone per litre | mg Ag m$^{-2}$ developed | Colour density* in emulsion | Colour density† in methylacetate |
|---|---|---|---|
| 0   | 18 | 0·13 | 0·16 |
| 3·2 | 27 | 0·20 | 0·21 |
| 16  | 32 | 0·23 | 0·24 |
| 32  | 37 | 0·26 | 0·26 |
| 64  | 37 | 0·23 | 0·22 |
| 81  | 38 | 0·19 | 0·19 |
| 405 | 41 | 0·06 | 0·06 |

*Maximum absorption measured on a General Electric Recording Spectrophotometer.

†Obtained after extraction of the dye from 25 cm² film into 25 cm³ solvent.

*Note.* Exposure and development time are identical for all layers.

It is well known, that a homogeneously distributed dye has a higher extinction coefficient and a less broad absorption curve than a heterogeneously distributed one. Thus the more smooth dye grain structure and the better spectral absorption are directly connected.

Figures 20 and 21 show the absorption curves obtained. After extraction in methylacetate the difference between the spectra obtained in the absence and presence of Phenidone has almost disappeared (Fig. 22).

### Activation and deactivation explained by redox reactions

The quinonediimines, the fully oxidized form of the colour developers, are at high pH readily deaminated to the quinonemonoimine.[9] In order to explain the high efficiency of colour formation, Vittum and Weissberger[10] assume that the quinonemonoimine forms a reversible redox equilibrium with the colour developing agent. In the presence of coupler this equilibrium is shifted due to removal of quinonediimine by coupling.

Redox reactions are also considered in order to explain the activation by Metol and Phenidone (Mason[11] and van Veelen[12,13]), and to explain the deactivation by hydroquinone (van Veelen[12]). Oguchi and co-workers[14] discuss the activation by Metol and p-benzalaminophenol on the same base.

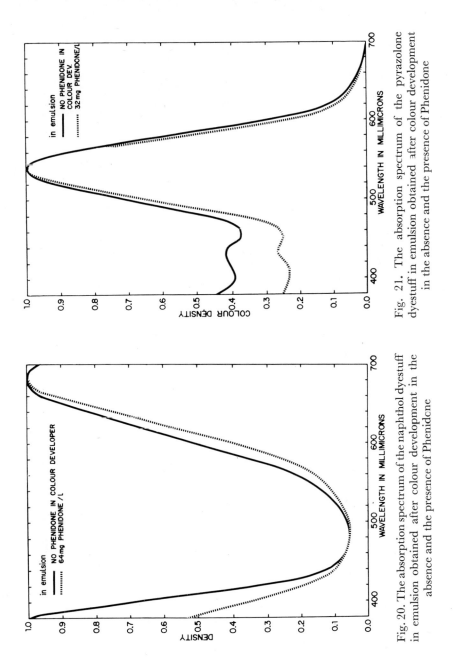

Fig. 20. The absorption spectrum of the naphthol dyestuff in emulsion obtained after colour development in the absence and the presence of Phenidone

Fig. 21. The absorption spectrum of the pyrazolone dyestuff in emulsion obtained after colour development in the absence and the presence of Phenidone

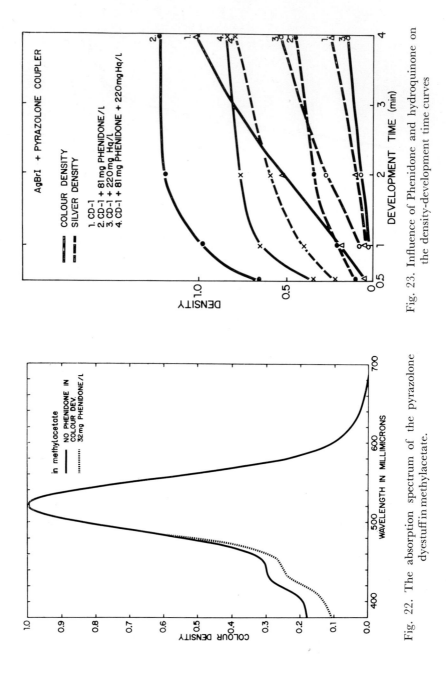

Fig. 23. Influence of Phenidone and hydroquinone on the density-development time curves

Fig. 22. The absorption spectrum of the pyrazolone dyestuff in methylacetate.

## OWN EXPERIMENTS

### Experimental results with black-and-white agents

For these experiments the following developing bath was used:

| | |
|---|---|
| sodium hexametaphosphate | 1 g per litre |
| sodium sulphite | 4 g per litre |
| potassium bromide | 2 g per litre |
| CD-1 | 1 g per litre |
| sodium carbonate | 50 g per litre |
| black-and-white developing agent | variable quantity |
| pH | 10·80 |

CD-1 = N,N-diethyl-p-phenylenediamine. HCl

The concentration of the colour developing agent was but 1 g per litre in order to obtain high superadditivity.

Figure 23 shows once again the activation by Phenidone (curve 2) and deactivation by hydroquinone (curve 3). The mixture of both gives intermediate results (curve 4). The silver densities all lie far above the density of the silver developed by the colour developing agent only.

### Superadditivity

The combined CD-1+Phenidone developer gives a superadditive silver-formation as shown in Fig. 24. The mixture is not only super-additive in density, but also in rate of density increase (see arrows).

In the absence of coupler and at low sulphite concentration silver formation is only slightly superadditive at short development time (Fig. 25). At high sulphite concentration the development is somewhat more superadditive, although considerably less than in the presence of colour coupler (Fig. 26).

An increase of the concentration of Phenidone shortens the induction period of colour formation. A high concentration however leads to silver formation without significant dye formation (Figs. 27 and 28).

The influence of varying quantities of black-and-white developers on development is given in Fig. 29. The shape and height of the curves are dependent on the development time. The shorter the development time the higher the relative activation.

Figure 30 shows the effect of Metol at varying quantities of colour developing agent. The dotted lines correspond to the silver formation. The curve "Metol only" is a calculated one. For the calculation it is assumed, that the ratio silver density to colour density obtained in the presence of Metol equals the ratio obtained in the absence of Metol. It appears that above a concentration of 1 g CD-1 only little silver is developed without colour formation. The same comparison is made for

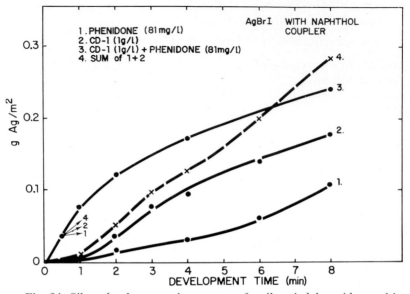

Fig. 24. Silver-development time curves of a silver iodobromide emulsion
containing a naphthol coupler

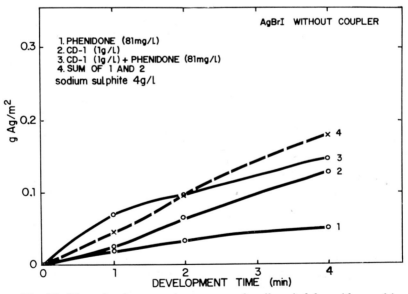

Fig. 25. Silver-development time curves of a silver iodobromide emulsion
without coupler. The developing bath contained 4 g sodium sulphite per
litre.

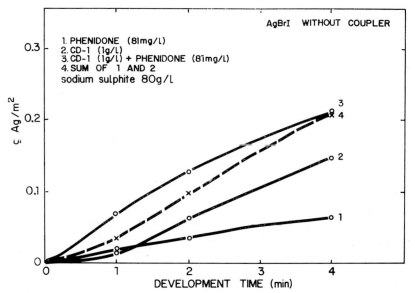

Fig. 26. Silver-development time curves of a silver iodobromide emulsion without coupler. The developing bath contained 80 g sodium sulphite per litre.

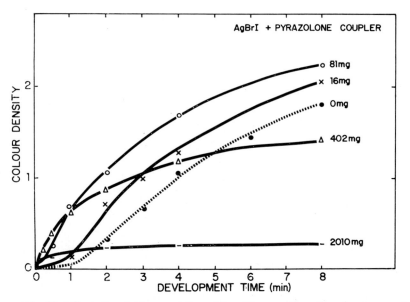

Fig. 27. Effect of variable quantities of Phenidone on the colour development of a silver iodobromide emulsion

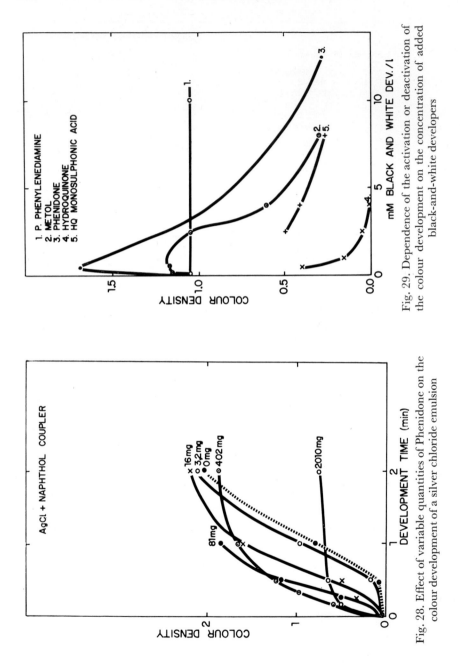

Fig. 29. Dependence of the activation or deactivation of the colour development on the concentration of added black-and-white developers

Fig. 28. Effect of variable quantities of Phenidone on the colour development of a silver chloride emulsion

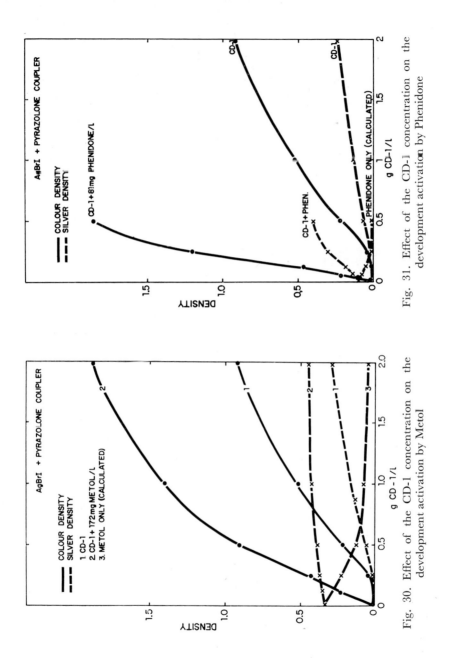

Fig. 31. Effect of the CD-1 concentration on the development activation by Phenidone

Fig. 30. Effect of the CD-1 concentration on the development activation by Metol

Phenidone (Fig. 31). In this case all silver developed is used for colour formation.

## DISCUSSION

A scheme of possible reactions is given in Table 2. PPD, PPD* and QDI are used as symbols for the colour developing agent and its oxidation products, R, S and T as the symbols for the black-and-white developing agent and its oxidation products. PAP and QMI are p-aminophenol and its monoimine.

### Table 2
#### Scheme of possible reactions

| | |
|---|---|
| (1)  PPD + Ag$^+$ → PPD* + Ag⎫ | |
| (2)  PPD* + Ag$^+$ → QDI + Ag⎭ | (p-phenylenediamines) |
| (3)  R + Ag$^+$ → S + Ag | |
| (4)  S + PPD ⇌ R + PPD* | |
| (5)  2PPD* ⇌ PPD + QDI | (Phenidone activation) |
| or (6)  S + PPD* ⇌ R + QDI | |
| (7)  R + 2Ag$^+$ → T + 2Ag | |
| (8)  T + PPD ⇌ R + QDI | (Metol activation) |
| (9)  QDI + coupler → dye | |
| (10)  QDI + OH$^-$ → QMI | |
| (11)  R + QDI ⇌ S + PPD* | |
| (12)  R + PPD* ⇌ S + PPD | |
| (13)  2S ⇌ R + T | (hydroquinone) |
| (14)  T + SO$^2_3{}^-$ → T.SO$_3{}^-$ | |
| (15)  QMI + PPD ⇌ PAP + QDI | |

### Deactivation

Let us consider first the deactivation by hydroquinone. Hydroquinone develops with a large induction period, so that it is normal that the colour developing agent starts development. The quinonediimine formed is reduced by the hydroquinone instead of being used for colour formation (reaction 11). This reaction can only be important, when the semiquinone of hydroquinone is quicker taken away from the equilibrium by sulphonation than the quinonediimine by colour coupling.

Following experimental facts are in agreement with this scheme:

1. In the absence of sodium sulphite hydroquinone does not deactivate.[12]

2. Tetra-chloro hydroquinone is an activating instead of deactivating compound.

3. Recent experiments of Baetzold[15] have shown, that QDI as well as PPD* are rapidly reduced by hydroquinone.

## Activation

Metol and Phenidone are compounds which start development with low induction period (reactions 3 and 7). In the case of Metol its mono-imine T is reduced by the colour developing agent with formation of the quinonediimine and subsequent colour formation (reactions 8 and 9). This redox reaction is completely comparable to that proposed by Vittum and Weissberger[10] for p-aminophenol and its monoimine.

In the case of Phenidone the semiquinone reacts with the colour developing agent with formation of the radical PPD* (reaction 4), which dismutates into PPD + QDI (reaction 5). Metol and Phenidone are the primary developers and are continuously regenerated by the secondary developer, the p-phenylenediamine compound.

As pointed out by Mason,[11] the scheme is quite similar to that of Phenidone/hydroquinone or Metol/hydroquinone systems in black-and-white developers. He was able to give it the necessary conclusive evidence by demonstrating analytically, that Phenidone during colour development in the absence of air is almost quantitatively regenerated.

Oguchi and co-workers[14] found that especially Metol gives very diffuse dye grains. The higher the concentration of the black-and-white agent, the more diffuse the dye clouds. They explain the diffuseness of the colour grains by the same redox mechanism given in Table 2. A high concentration of the black-and-white developing agent retards or prevents the shift of the equilibrium reaction 4 or 8 to the right. In the meantime, the oxidation product of the black-and-white developer can diffuse far away from the silver halide grain, before it is reduced. This explains the diffuseness of the colour grains obtained in the presence of black-and-white developers.

At very high concentration of black-and-white developer diffusion of T or S outside the emulsion layer or secondary reactions as sulphonation, deamination or dismutation can even lead to an irreversible loss of T and S from the equilibrium. In that case silver will have been developed without formation of colour.

As pointed out by Oguchi[14] the diffuseness of the dye grain increases its apparent extinction coefficient. Superadditivity may be partly due to this effect.

We have studied this possibility more in detail in the case of Phenidone. Figure 32 shows the colour density obtained and the amount of developed silver for varying quantities of Phenidone.

With up to 81 mg of Phenidone the colour yield is nearly identical for a same amount of developed silver. This means, that:

1. Little or no silver is developed without colour formation.

2. The molar extinction of the dye does not vary significantly with different concentrations of Phenidone. A somewhat higher extinction of the order of 10 per cent can however not be excluded. These results were taken from the upper part of the sensitometric curve. Higher colour density by hazing may be of more importance in the lower part of the sensitometric curve and could add to a higher negative sensitivity.

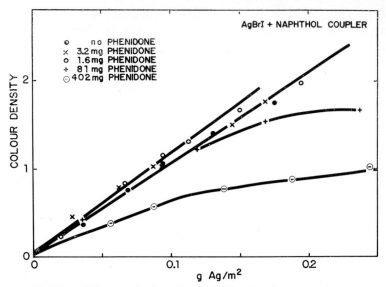

Fig. 32. The efficiency of colour formation in the absence and presence of Phenidone

### Comparison between superadditivity in black-and-white and in colour

If the process of activation of colour development has the same fundamental origin as superadditivity in black-and-white developers, we should expect that developing agents, which give high superadditivity with hydroquinone, are also strong accelerators of colour development.

Tables 3 and 4 show that this is indeed the case. In the last column the ratio of densities obtained with and without black-and-white developer after two minutes of development can be considered as a measure of superadditivity of the p-aminophenols. Ring closure to the tetrahydroquinoline structure leads to more stable semiquinone, consequently to a higher superadditivity with hydroquinone and likewise to a higher acceleration of colour development. Particularly effective are the tetraalkyl-p-phenylene-diamines (Table 4).

### Table 3
### Activation of colour development
(AgBrI + pyrazolone coupler)

| Black and white developing agent (0·5 m M per litre) | Density after 2 min dev.time | Density ratio |
|---|---|---|
| None | 0·26 | — |
| Phenidone | 1·26 | 4·9 |
| 1-(p-aminophenyl)-3-amino-pyrazoline | 0·54 | 2·1 |
| p-AMINOPHENOLS: | | |
| p-aminophenol | 0·50 | 1·9 |
| Metol | 0·56 | 2·2 |
| p-benzylaminophenol | 0·36 | 1·4 |
| p-benzalaminophenol | 0·40 | 1·5 |
| p-dimethylaminophenol | 0·61 | 2·3 |
| p-N,N-ethyl-isopropylamino-phenol | 0·55 | 2·1 |
| 1-ethyl-6-hydroxy-1,2,3,4-tetrahydroquinoline | 1·09 | 4·2 |

### Table 4
### Activation of colour development
(AgBrI + pyrazolone coupler)

| Black and white developing agent (0·5 m M per litre) | Density after 2 min dev.time | Density ratio |
|---|---|---|
| None | 0·26 | — |
| p-PHENYLENEDIAMINES: | | |
| p-phenylenediamine | 0·26 | 1·0 |
| N,N-diethyl-N′-3-carboxy-propyl-N′-ethyl-p-phenyl-enediamine | 1·17 | 4·5 |
| N,N-diethyl-N′-4-sulphobutyl-N′-ethyl-p-phenylene-diamine | 1·39 | 5·4 |
| 1-sulphobutyl-6-diethyl-amino-1,2,3,4-tetrahydro-quinoline | 1·41 | 5·4 |
| AZINES: | | |
| 1-methyl-2-pyridone-azine | 0·93 | 3·6 |
| 1-hydroxyethyl-2-pyridone-azine | 0·97 | 3·7 |

<div align="center">

**Table 5**

**Deactivation or activation of colour development**

(AgBrI + pyrazolone coupler)

</div>

| Black and white developing agent (0·5 m M per litre) | Density after 2 min dev.time | Density ratio |
|---|---|---|
| None | 0·26 | — |
| DIHYDROXYBENZENES: | | |
| hydroquinone | 0·16 | 0·6 |
| pyrogallol | 0·30 | 1·1 |
| pyrocatechine | 0·18 | 0·7 |
| chlorohydroquinone | 0·23 | 0·9 |
| tetrachlorohydroquinone | 0·32 | 1·4 |
| hydroquinone (no sulphite) | 0·26 | 1·0 |

Dihydroxybenzenes (Table 5) as already discussed give deactivation, with the exception of pyrogallol and tetrachlorohydroquinone.

Though regeneration of activating black-and-white developers explains many aspects of superadditivity in colour development, several points throw some doubt on the correctness of the regeneration theory in colour.

The main points are:

1. Many black-and-white developers that are normally activators in a colour coupler-containing developing bath delay the oxidation of the colour developing agent by oxygen.

2. The p-phenylenediamines develop with a short induction period, while hydroquinone develops with a large one.

3. The p-phenylenediamines are adsorbed to silver halide or silver. Hydroquinone is practically not adsorbed. The adsorption of most colour developing agents is stronger than that of Metol and only slightly less than that of Phenidone.[16]

4. The p-phenylenediamines are weaker reducing agents than Phenidone or p-aminophenols (more positive $E_1$ or $E_{\frac{1}{2}}$ value of the p-phenylenediamines) (Tables 6 and 7).

5. The activation is dependent on the coupler used.

Let us consider these objections more in detail. Concerning the oxidation of the colour developer by air (point 1), it must be taken into consideration, that relatively large quantities of the p-aminophenols are required to obtain an anti-oxidizing effect. Activation of colour development on the contrary requires only small quantities. A large quantity of Metol deactivates also.

**Table 6**

**Redox potentials of developing agents in mV
(vs. S.C., Eur. Conv., pH 11)**

| Developing agent | $E_{\frac{1}{2}}$ | $E_1$ | $E_2$ |
|---|---|---|---|
| CD-1[20] | $-26$ | $+47$ | $-99$ |

| Black and white developers: | | | | Degree of super-additivity with CD-1* |
|---|---|---|---|---|
| Phenidone[21] | | $-100$ | | 4·9 |
| Metol[22] | $-190$ | | | 2·2 |
| hydroquinone[23] | $-145$ | | | 0·6 |
| hydroquinonemono-sulphonate[23] | $-86$ | | | |
| p-aminophenol[22] | $-143$ | | | 1·9 |
| p-N,N-ethylisopropyl-amino-phenol[22] | $+9$ | $-85$ | $+105$ | 2·1 |
| 1-ethyl-6-hydroxy-1,2,3,4-tetrahydro-quinoline[22] | $-52$ | $-185$ | $+80$ | 4·2 |
| 1-methyl-2-pyridone-azine[22] | $+112$ | $-95$ | $+320$ | 3·6 |

*On AgBrI + pyrazolone coupler
Data from references 20, 21, 22, 23, 24.

**Table 7**

**Redox potentials of developing agents in mV
(vs. S.C., Eur. Conv. pH 11)**

| Developing agent | $E_{\frac{1}{2}}$ | $E_1$ | $E_2$ | Degree of superadditivity with Phenidone* |
|---|---|---|---|---|
| CD-1 | $-26$ | $+47$ | $-99$ | 3·5 |
| CD-2 | $-55$ | $+32$ | $-142$ | 2·9 |
| CD-3 | $-48$ | $+59$ | $-155$ | 3·0 |
| Droxychrome | $-39$ | $+89$ | $-167$ | 2·4 |

*On AgBrI + naphthol coupler

CD-1—4 min dev. time
CD-2—2 min dev. time
CD-3 and Droxychrome—6 min dev. time
Data from reference 20.

Moreover, Phenidone added to the cyan bath of Kodachrome K12 at a concentration of 1 g per litre or lower accelerates the oxidation of the colour developing agent and the formation of the dyestuff in agreement with its effect on colour development (Fig. 33). An identical

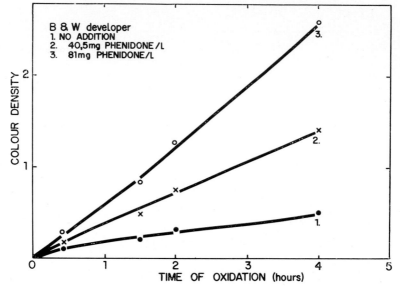

Fig. 33. Effect of Phenidone on the oxidation by air of the cyan bath of Kodachrome type II (BD-80 has been omitted)

acceleration of the oxidation has been observed with the tetraalkyl-p-phenylenediamines. The same effect has also been obtained with many other colour couplers.

Concerning the difference in induction period and adsorption between hydroquinone and the p-phenylenediamines (points 2 and 3), the origin of rate-superadditivity in a black-and-white complex developer must be considered. In such a developer the primary developer is continuously regenerated in adsorbed state by the secondary developer. The fact, that the oxidation product of the primary developer needs not to be desorbed from the silver speck nor the primary developer itself adsorbed for continuation of development, obviously contributes in a significant measure to rate-superadditivity.

Levenson[17] has however shown that Phenidone has no effect on the rate of oxidation of hydroquinone by air. In a colour developer on the contrary Phenidone accelerates the oxidation of the colour developing agent resulting in a more rapid dye formation. These results obtained in the absence of silver halide, makes it doubtful whether

adsorption or desorption phenomena are responsible for activation of colour development.

The fourth objection is important. Considering their half wave potential, the dialkyl-p-phenylenediamines are too weak reducing agents to be able to regenerate Phenidone or the p-aminophenols to a significant extent.

The semiquinones of the dialkyl-p-phenylenediamines are stronger reducing agents than the dialkyl-p-phenylenediamines ($E_2$ more negative than $E_1$) and for this reason the redox reaction (6):

$$S + PPD^* \rightleftharpoons R + QDI$$

is also considered for Phenidone in the scheme of possible reactions.

This reaction can only activate the colour development if reaction (2) or (5) are rate determining. Since PPD* is a stronger reducing agent than PPD and moreover since the dismutation reaction (5) has been proved by Baetzold and Tong[18] to be a rapid reaction, it seems unlikely that reactions (2) or (5) are rate determining. However, now that Willis[19] has shown that the reaction kinetics in the continuation stage can best be explained by assuming that reaction (2) is the rate determining step, the possibility of reaction (6) should be taken into account.

It has to be considered also that the half wave potentials only fix the final equilibrium, but not the kinetics of establishment of this equilibrium. If PPD* is faster removed from the equilibrium reaction (4), for instance by dismutation, than reduced back by Phenidone, equilibrium reaction (4) still can run to the right. It is clear that at increasing concentrations of Phenidone the shift of this equilibrium becomes more and more difficult and leads to hazy colour clouds or even to silver reduction without colour formation.

In the case of Metol the semiquinone is very unstable and for this reason only reaction (8) has been considered. The considerations about Phenidone apply also to Metol with the difference that in this case the equilibrium shifts as a result of the removing of diimine from the equilibrium by direct colour coupling. But a shift of the equilibrium can only be expected when the rate of colour coupling is fast. Finally it depends on the absolute reaction constant of the redox reaction to the right, whether this shift significantly contributes to colour formation.

From this scheme the seemingly contradictory conclusion can be deduced, that a development in the presence of a slow coupler is less accelerated than the one in the presence of a fast coupler. This may explain the dependence of the activation on the coupler used (point 5). At very slow colour coupling rate even deactivation must be expected.

## CONCLUSION

Although superadditivity in black and white and superadditivity in colour have several points in common, there remain striking differences, which throw some doubt on the assumption of a similar regeneration mechanism in both cases.

Another possibility to be considered is the catalytic activation of colour development by the silver reduced by black and white developers, such as Phenidone and Metol.[12] These are stronger reducing agents (more negative $E_1$ or $E_{1/2}$) than the p-phenylenediamines and for this reason, are able to develop smaller latent image specks. When these specks have sufficiently grown colour development sets in. This mechanism could have some importance in colour negative development, but is rather improbable in colour reversal development. Moreover, it cannot explain the diffuseness of the dye grain obtained.

The most direct method to confirm the reaction mechanism is to prove analytically that activating black and white developing agents are indeed regenerated during colour development. These experiments are however difficult to perform, because Phenidone is rapidly oxidized by air in the developing bath and is not protected by the colour developing agents in the absence of colour coupler.

Experiments must be performed under extreme exclusion of air. Till now we have not succeeded in demonstrating unequivocally the regeneration of Phenidone in emulsion and work on this subject is continuated. The analytical results of Mason[11] however suggests the correctness of the regeneration theory.

### References

 1. Schinzel, K., *B.P.* 500, 613 (1936).
 2. Bogoljoebskij, V. A., *Usp. Nauch. Photogr.*, **8,** 61 (1962).
 3. Evans, R. M. and Hanson, W. T., *U.S.P.*, 2,301,387 (1939) and *B.F.*, 952,441 (1944).
 4. Brandenburger, H., *Z. Wiss. Photogr.*, **63,** 113 (1969).
 5. Neumann, H. T., *U.S.P.*, 2, 417, 514 (1940).
 6. Agfa A. G., *B.F.* 1,080,838 (1952).
 7. Mason, L. F. A., *B.P.* 811, 185 (1956).
 8. Ganguin, K. O., Ramsey, D. W. C. and Kaye, A. E., *B.P.* 928, 671 (1960).
 9. Tong, L. K. J., *J. Phys. Chem.*, **58,** 1090 (1954).
10. Vittum, P. W. and Weissberger, A., *Wiss. Photogr. Int. Konf. Köln* 1956, Verlag O. Helwich, Darmstadt (1958) 463.
11. Mason, L. F. A., *J. Photogr. Sci.*, **11,** 136 (1963).
12. van Veelen, G. F., *Wiss. Photogr. Int. Konf. Köln* 1956, Verlag O. Helwich, Darmstadt (1958) 498.
13. van Veelen, G. F., *Med. Vlaamse Chem. Ver.*, **23,** 37 (1961).
14. Oguchi, M., Sato, S., and Horikoshi, A., *Bull. Soc. Sci. Photogr. Japan*, **11,** 16 (1961).
15. Baetzold, R. C., *J. Phys. Chem.*, **74,** 3596 (1970).
16. Shuman, D. C. and James, T. H., *Phot. Sci. Eng.*, **15,** 119 (1971).
17. Levenson, G. I. P. and Rumens, M. G., *J. Photogr. Sci.*, **19,** 135 (1971).
18. Baetzold, R. C. and Tong, L. K. J., *J.A.C.S.*, **93,** 1347 (1971).
19. Willis, R. G. and Pontius, R. B., communication, R.P.S. Symposium on Photographic Processing, Sept. 1971, Brighton.
20. Newmiller, R. J., Pontius, R. B. and Willis, R. G., *Photogr. Sci. Eng.*, **11,** 244 (1967).
21. Horrobin, S., Ramsey, D. W. C. and Mason, L. F. A., *J. Photogr. Sci.*, **11,** 145 (1963).
22. Verbeke, G. and Vanhalst, J., *Photogr. Sci. Eng.*, **10,** 301 (1966).
23. Tong, L. K. J., Bishop, C. A. and Glesmann, M. C., *Photogr. Sci. Eng.*, **8,** 326 (1964).
24. Willems, J. F., van Veelen, G. F. and Vandenberghe, A., *Photogr. Sci. Eng.*, **13,** 312 (1969).

# The Autoxidation of PQ Solutions

G. I. P. LEVENSON and M. G. RUMENS

*Research Laboratory, Kodak Limited, Wealdstone, Harrow, Middlesex*

ABSTRACT. The addition of Phenidone to a hydroquinone developer does not increase the rate of autoxidation of the hydroquinone when the solution is exposed to air or to oxygen. The rate of autoxidation does not appear to be limited by the rate of solution of the gas because it can be varied over a wide range by changing the pH. The Phenidone has no effect at any pH, but when present in high concentration its rate of loss can become appreciable through dismutation of its semiquinone and it can compete with the hydroquinone. When the hydroquinone is present in concentrations above 2 g per litre its rate of autoxidation is insensitive to change in its concentration and is proportional to the area of the gas-solution interface. The evidence suggests that the critical stage of the autoxidation takes place at the gas-solution interface.

## INTRODUCTION

The preparation of a review of the literature on the phenomenon of superadditivity in developers[1] revealed a lack of information on whether such developers are also superadditive towards reaction with oxygen.

The course of the aerial oxidation of the principal superadditive developers, Metol-hydroquinone and Phenidone-hydroquinone, is well established. In his classic, analytical study Tausch[2] showed that on exposing an MQ developer to air or oxygen, or to silver bromide the hydroquinone was preferentially lost. The concentrations of Metol fell appreciably only when the hydroquinone was substantially depleted. Tausch had started out to examine the feasibility of continuously replenishing the MQ developer and, having established the mode of exhaustion, had no motive for examining more closely the reasons why the hydroquinone was preferentially lost.

Later[1] it was proposed that the Metol was protected from depletion by a regenerative interaction between its oxidation product and hydroquinone. The presence of sulphite in the solution favoured the oxidation of the hydroquinone because of the greater ease with which the latter would sulphonate. This view has been confirmed by studies of the stability of the oxidation products of developing agents which agree that the

131

superadditivity shown by an agent such as Metol, with hydroquinone, increases as the stability of the primary oxidation product increases[1].

Phenidone proved to be a near-perfect example of this principle because its semi-quinonoid oxidation product is stable in a sulphite solution, being lost only by dismutation[3] with a half-life measureable in terms of seconds, and consequently it remains at nearly full concentration in the PQ developer until the hydroquinone is quite depleted.[4] A detailed study of the aerial oxidation of the PQ developer was made by van Veelen and Ruysschaert[5] which paralleled the earlier work by Tausch on the MQ developer. Again the emphasis was on establishing the course of the oxidation and on the identification of the oxidation products.

In passing it might be noted that the data of van Veelen and Ruysschaert show that the apparent low rate of loss of Phenidone depends to some extent on its presence in low concentration relative to the concentration of hydroquinone. When the concentration is raised to that at which Metol would normally be used with hydroquinone, the Phenidone shows a rate of loss comparable with that of Metol.

The object of the present work was to check experimentally whether the rate of autoxidation of hydroquinone in an alkaline, sulphite solution is increased superadditively by the addition of Phenidone. The results show that up to the highest rate of oxidation used, the presence of Phenidone had no accelerating effect on the rate of loss of the hydroquinone.

## EXPERIMENTAL

The developing agents used were of photographic grade. The inorganic chemicals were of analytical reagent grade. The basic solution comprised, per litre:

| | |
|---|---|
| Hydroquinone | 4·0 g |
| Sodium sulphite anhydrous | 40·0 g |
| Sodium carbonate anhydrous | 20·0 g |
| pH adjusted as necessary with sodium hydroxide and sulphuric acid. | |

Phenidone was added at 0·1 g per litre for most of the experiments, this being the rate at which optimum superadditivity would be manifested in development. In one run, however, it was used at 1·5 g per litre because van Veelen and Ruysschaert had used concentrations like this.

### 1. Aeration

In the first instance, 100 ml lots of developer exposed to air were shaken vigorously in 500 ml conical flasks at the room temperature of

20–21°C. At the end of the period of shaking, a 25 ml sample was withdrawn and analysed. Fig. 1 shows the results for a series at pH 10·0 with additions of Phenidone at 0·1 and 1·5 g per litre. Analysis for Phenidone was not considered necessary in the case of the lower concentration of Phenidone. A straight deduction was made from the total titre for both

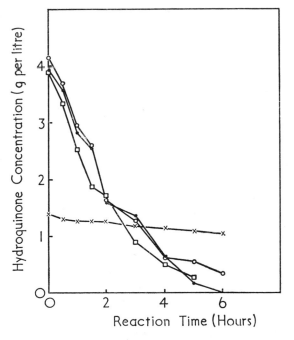

Fig. 1. The course of the loss of hydroquinone from solution at pH 10 on aeration without Phenidone (. — .), with Phenidone at 0·1 g per litre (□ — □) and at 1·5 g per litre (o — o). Phenidone in the PQ solution (x — x).

developing agents, because no measurable loss was to be expected while the hydroquinone remained.

The results show that neither concentration of Phenidone produced a significant change in the rate of loss of hydroquinone. At the higher concentration, Phenidone was lost at an appreciable rate from the outset, as the results of van Veelen and Ruysschaert had shown.

Several further runs were made with air and fully confirmed that, at 0·1 g per litre, Phenidone had no effect on the rate of loss of hydroquinone at pH 10·0. In one run, colloidal silver was precipitated in the developer, by adding silver nitrate, to see if its presence would allow the Phenidone

6

to show an acceleration in oxygen uptake. It had no effect. In some runs air was blown into the flasks to ensure a free supply.

These results need not be reproduced here because it seemed that the rate of loss of hydroquinone in runs of several hours might be limited by secondary factors that would mask any acceleration to be expected from the addition of Phenidone. For this reason recourse was made to pure oxygen to speed up the reaction.

## 2. Oxygenation

When oxygen was used, the oxidations went fast enough to run each sample separately. Twenty five ml of the developer was placed in the pear-shaped, 250 ml separatory funnel to be used for the analysis. The funnel was placed in a water bath at 20°C and oxygen at 4000 cm$^3$ min$^{-1}$ was bubbled through the solution from a glass tube which was drawn to a jet at the immersed end so that it could reach the lowest part in the

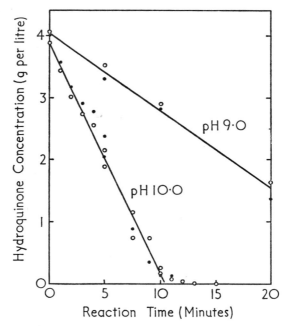

Fig. 2. Loss of hydroquinone from oxygenated solutions at initial pH 9 and 10. Solution with Phenidone (. — .), and without (o — o).

neck above the stop-cock. The oxygen had been passed through water in a vessel packed with marble chips to moisten it because the dry gas would have caused an appreciable evaporation loss in the longer runs. The run was terminated by adding 3·5 ml of 50% sulphuric acid and

simultaneously stopping the flow of oxygen. The hydroquinone was extracted and titrated with ceric sulphate[6].

Fig. 2 shows the course of the loss of hydroquinone from the solution at pH 10. This plot includes data from two separate series of experiments in the first of which the exhaustion was taken about half way and then, to see if the apparently linear fall continued, a second series was done to fill in the latter part. Because the rate of loss of hydroquinone appeared to be constant, suggesting that the rate of oxygenation was a limiting factor, a further series of runs was made at pH 9·0. The rate of loss of hydroquinone was greatly reduced by lowering the pH, but the Phenidone again had no significant effect.

## (1) Effect of pH

To examine the effect of pH more widely, from pH 9 to 11·5, another series of oxidations was carried out. In each case the sample of hydroquinone developer with and without Phenidone was oxidized for five minutes. Fig. 3 shows the loss of hydroquinone in five minutes plotted

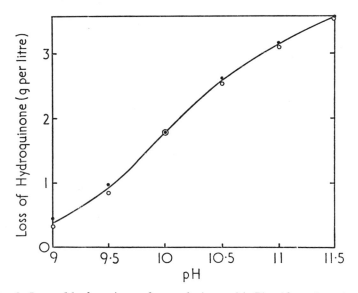

Fig. 3. Loss of hydroquinone from solutions with Phenidone (. — .) and without (o — o) at various pH levels.

against the initial pH. The rate of autoxidation varied throughout the range which showed that the oxygen concentration as such was not a limiting factor at pH 10. The rate was insensitive to the presence of Phenidone.

The data of Fig. 3 suggested that the rate of autoxidation of the hydroquinone was a function of the concentration of an entity, such as hydroquinone ($-1$) ion, derived from an acid dissociation with $pK$ near $10 \cdot 0$. In that experiment the pH had not been controlled after the start and had risen appreciably throughout the run. For example, from $11 \cdot 0$ it had increased to $11 \cdot 7$. Therefore, two further series of oxidations were undertaken on the hydroquinone-only solutions, in the presence of a

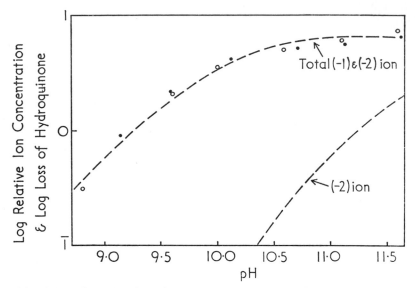

Fig. 4. The loss of hydroquinone in a 5 min oxygenation plotted on log ordinate against pH. The broken curves show the calculated ion concentrations for an entity with $pK$ values of 10 and 12. The data for solutions buffered with carbonate $(. - .)$ have been shifted $0 \cdot 13$ pH units to the right to improve the fit to the curve for the total ion concentration which, below ph $10 \cdot 5$, comprises mainly the $-1$ ion.

glass electrode, and the pH was held within $0 \cdot 05$ pH of the initial value throughout the run, by small additions of sulphuric acid. Because a $pK$ value near 10 was in question the runs were made both (a) with the carbonate-buffered formula given above, and (b) with only sodium hydroxide present as alkali.

The results of these pH-controlled runs are shown in Fig. 4 plotted as log rate against pH. By way of comparison, the log ion concentration of an entity such as hydroquinone with $pK_1 = 10$ and $pK_2 = 12$ are shown as broken curves. The experimental data have been adjusted vertically for absolute rate and those for the carbonate-containing solution have been shifted $0 \cdot 13$ to higher values on the pH scale to bring them as close

as possible to the curve for $pK$ 10. That is, the data for the carbonate-free run correspond to a $pK \simeq 10 \cdot 0$ while those for the carbonate solution correspond to a $pK \simeq 9 \cdot 87$.

## (2) *Interfacial area*

The effect of increasing the area of contact between the oxygen and the solution was examined by increasing the volume of the solution in the oxidation vessel from 25 ml to 50, 75 and 100 ml. The oxidation was for 5 minutes at 20°C in each case. See Table 1.

**Table 1**

**Effect of increasing area of contact between oxygen and the solution**

| (a) Volume of solution (ml) | (b) Drop in HQ concentration (g per litre) | (c) Solution depth (cm) | (d) Loss of HQ per cm depth (g) |
|---|---|---|---|
| 25 | 2·40 | 4·5 | 0·0133 |
| 50 | 1·49 | 5·5 | 0·0135 |
| 75 | 1·15 | 6·0 | 0·0143 |
| 100 | 0·92 | 7·0 | 0·0132 |

Because of the pear shape of the oxidation vessel the depth was not proportional to the volume. When the total loss of hydroquinone was divided by the depth of the solution, i.e. the path length of the bubble stream, the rate of loss per cm of depth, as shown in column (d) was constant to better than $\pm 5\%$.

## (3) *Temperature*

The effect of temperature on the rate of autoxidation was measured over the range 10°–30°C in a five-minute oxygenation of the hydroquinone-sulphite-carbonate solution, which had a pH of 10·0 at 20°C. Fig. 5 shows the loss of hydroquinone in grams per litre. A best straight line has been drawn through the data and the slope of this line has been corrected between 15° and 25°C using a slope factor of 1·16 to take account of the reduction in solubility of oxygen with increase in temperature.

The slope factor was taken as a mean figure from the data for solutions of salts in Seidell's "Solubilities of Inorganic and Metal-organic compounds" (D. Van Nostrand Co. Inc.). The corrected line shows a rate

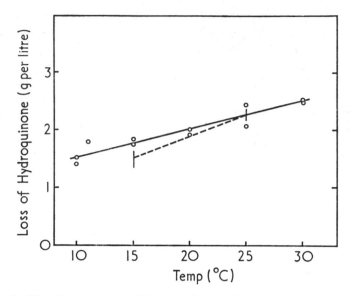

Fig. 5. The change in loss of hydroquinone with temperature in 5 min oxygenations. The slope of the best line between 15° and 25°C has been increased in proportion to the change in solubility of oxygen with temperature to give the broken line.

factor of 1·50 for the 10°C interval and this corresponds to an "activation energy" value of 7·0 kcal. By comparison with a phosphate buffer, the solution showed a shift of pH value from 10·0 at 15°C to 9·95 at 25°C and no correction has been applied for this.

(4) *Atmospheric pressure*

No attempt was made to control the gas pressure of the oxygen beyond the shift from air to oxygen. The barometric pressure was noted for each run but did not vary more than ±7 mmHg from 760 mm and this overall variation of 2% has been ignored in presenting the data.

(5) *Concentration of hydroquinone*

The above experiments showed that the rate of loss of hydroquinone was insensitive to the concentration of that agent at the outset of oxidation and appeared to respond to concentration only at the end of the run. To examine this more closely, a series of oxidation runs were made in which the initial concentration of hydroquinone in the usual sulphite-carbonate solution was set at 4·0, 2·0 and 1·0 g per litre. The pH was set at 10·0 and maintained constant during each oxidation by additions of sulphuric

acid. The results of the three runs, given in Fig. 6, show that the course of the oxidation in the later stages does not depend on the starting point. In other words, the toe portion of the curve is not some consequence of earlier stages of the reaction, nor the secondary result of the accumulation of reaction products etc. The toe reflects the dependence of the rate of autoxidation on the concentration of the hydroquinone.

Fig. 6 also shows the same data plotted on a logarithmic ordinate. The broken curve represents the zero-order response also shown by the straight line running through the original plot. The part of the data corresponding to the toe of the original curve between 10 and 15 min

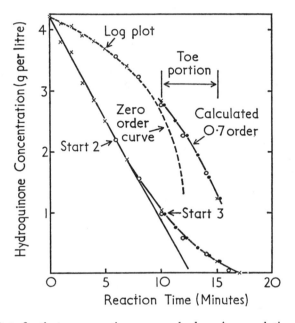

Fig. 6. Data for three oxygenation runs on hydroquinone solutions starting at approximately 4 g (x — x), 2 g (o — o), and 1 g (. — .) per litre. The same data is shown on a log ordinate. The broken line is the log plot of the straight line through the original data. The log plot of the data between 10 and 15 min has been fitted with a solid curve calculated on the assumption that the rate varies as the 0·7 power of the hydroquinone concentration.

(i.e. from approximately 1·0 g per litre of hydroquinone downwards) was not quite straight enough to correspond to the first order but could be matched with the curve calculated on the assumption that the rate varied as the 0·7 power of the hydroquinone concentration. This is shown in Fig. 6.

### (a) *Effect of Phenidone*

Having established that the rate of loss of hydroquinone depends on the concentration of that agent in the range below 1·0 g per litre, we tried the effect of Phenidone by adding it at 0·1 g per litre in runs, as in Section (5), starting at 1·0 and 2·0 g of hydroquinone per litre.

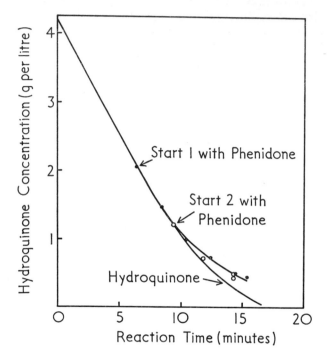

Fig. 7. Effect of Phenidone on the rate of loss of hydroquinone at lower concentrations. The main curve for hydoquinone is taken from the data in Fig. 6.

Fig. 7 shows the results plotted on the main curve derived from Fig. 6. When the hydroquinone was above 1·0 g per litre, the Phenidone had little or no effect. Below that level, however, a marked retardation was observed.

### (b) *Effect of pH*

The effect of changes in pH on the rate of autoxidation of hydroquinone was examined in the lower range of concentration starting from 1·0 g per litre. The oxygen was bubbled for 2 minutes. The results are given in Fig. 8 in a plot of log rate versus pH.

Figure 8 also shows the calculated log concentration of ions for an entity with *pK* values of 10 and 12, and also curves for the log rate calculated on the assumption that the ionizing entity is, or is derived from, this entity to the 0·7 power of its concentration (see Section (5)). The experimental log rate data have been adjusted vertically and are seen to

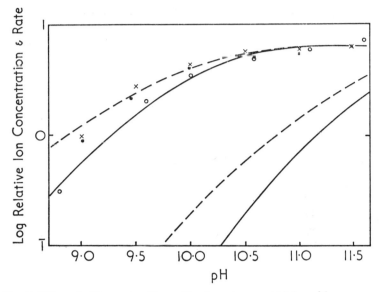

Fig. 8. Effect of pH on rate of loss of hydroquinone at high and low concentration. The rate of loss is plotted on a log ordinate and is compared with curves calculated for the concentration of total ion and of doubly dissociated ion for an entity with pK values 10 and 12. The broken curve is for the 0·7 power of the ion concentration. Hydroquinone 1 g per litre (x — x), 4 g per litre (o — o), 4 g per litre with carbonate buffer (o — o).

fit the curve for the singly-dissociated entity though it is not possible to say with certainty that the 0·7 power curve is better than the other.

## DISCUSSION
### 1. Effect of Phenidone

The present results for PQ developers show that under all degrees of aeration likely to be encountered in practice, the presence of a small concentration of Phenidone—other things remaining equal—makes no significant difference to the rate of loss of hydroquinone by autoxidation in the presence of sulphite. A large concentration of Phenidone tends to reduce the rate of loss of the hydroquinone because the Phenidone itself is then lost to an appreciable degree.

The main practical conclusion from this work is that, fortunately, the great acceleration of reduction of silver ion at a catalytic surface that results from the addition of Phenidone to a hydroquinone developer is not paralleled in the reaction between oxygen and the solution; otherwise PQ developers might be too readily oxidized to be of use in standing baths.

The semiquinone of Phenidone, i.e. the first, and reversible, oxidation product, does not react with sulphite at an appreciable rate. The principal route by which the semiquinone (S) can be lost from the solution is by dismutation to give the phenylhydroxypyrazole, which is the totally oxidized form (T), and Phenidone, the reduced form (R):

$$2S \to T + R.$$

Hence, the rate of loss of Phenidone from the solution will be proportional to the square of the concentration of the semiquinone.

Other things, such as the hydroquinone concentration, being constant, the concentration of the semiquinone (S) will increase as the concentration of Phenidone increases and this agent competes more effectively with hydroquinone in reducing the oxidant. Hence, when Phenidone is used at high concentrations its rate of loss can be expected to be appreciable, as is noted above. Conversely, when it is used at low concentration its rate of loss can be insignificantly small, as is usually observed.

## 2. Autoxidation of hydroquinone

Another conclusion of practical importance is that the rate of loss of hydroquinone is relatively independent of the concentration of that agent in solution through the range usually used, i.e. above 2 g per litre.

Although it is not the object of the present work to elucidate the autoxidation of hydroquinone as such, it is worth discussing the cause of this limitation of rate of loss.

The rate of loss of hydroquinone is proportional to the interfacial area between the gas and the solution; and the temperature coefficient of the rate corresponds to an activation energy (7 kilocal) low enough for a diffusion-controlled reaction. The fact that the rate can be varied under these conditions by changing the pH, shows that the limitation is not imposed by the rate of solution of oxygen unless the latter increases with rising pH. The solubility of oxygen in water is not affected by pH, and, though it is not necessarily the case, it is reasonable to suppose that the rate of solution is not affected either.

These findings suggest that the autoxidation occurs at the gas/solution interface, and that the interface, in effect, becomes saturated when the

concentration of hydroquinone exceeds about 2 g per litre. Hydroquinone itself, or when dissociated, is too soluble to seem likely to saturate the interface when the concentration in solution is as low as this. It is more likely that the saturating entity is a quinonoid, or semiquinonoid intermediate which catalyses the autoxidation and determines its rate[7].

## References

1. Levenson, G. I. P., *Photogr. Sci. Eng.*, **13,** 299 (1969).
2. Tausch, E., "Zur Chemie der Photographischen Entwickler" Thesis, Technischen Hochschule, Berlin, 1934.
3. Lee, W. F., Miller, D. W., *Photogr. Sci. Eng.*, **10,** 192 (1966).
4. Axford, A. J. O., and Kendall, J. D., *J. Photogr. Sci.*, **2,** 1 (1954).
5. van Vellen, G. F. and Ruysschaert, H., *Photogr. Sci. Eng.*, **4,** 129 (1960).
6. Levenson, G. I. P., *Photogr. J.*, **87B,** 18 (1947).
7. James, T. H., Snell, J. M. and Weissberger, A., *J.A.C.S.*, **60,** 2084 (1938). Kornfeld, G. and Weissberger, A., *J.A.C.S.*, **61,** 360 (1939).

# Development by Metals

MAX MEIER

*CIBA-GEIGY Photochemie AG, Fribourg, Switzerland*

ABSTRACT. Most metals are strong reducing agents. They can be used for developing photographic silver images in the presence of a suitable catalyst (e.g. a 1,4-diazine) which transfers electrons from the metal to the silver halide. In the presence of a diazine an imagewise exposed silver halide emulsion is developed by a metal layer adjacent to or brought in contact with the emulsion layer. In the course of development the metal layer is imagewise dissolved.

## INTRODUCTION

In the course of a detailed study of the chemistry of 1,4 diazines[1] their reduction products were found to constitute a new class of developing agents.[2]

1,4-diazines are compounds containing the following heterocyclic nucleus:

The diazines can be reduced reversibly to the radical and further to the dihydro compounds:

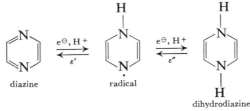

The chemical constitution of the dihydrodiazines obviously corresponds to the classical rule which states that organic developing agents have the following structure:

$$\alpha - (C = C)\overline{_n}\alpha'$$

where $\alpha$ and $\alpha'$ stand for an amino or hydroxy group.

145

Whether reduced diazines will act as developers depends on the value of the redox potentials $\varepsilon'$ and $\varepsilon''$.

It is easily deduced from the solubility product of silver bromide and from the normal potential of the electrochemical half cell silver metal—silver ion that a developer solution must have an electrochemical potential of less than $+450$ mV/NHE. A useful developer solution should have a potential of a few hundred millivolts below this maximum value since in the course of the development process bromide ions are liberated and thus the activity of silver ions reduced.

The values of the redox potentials $\varepsilon'$ and $\varepsilon''$ depend on the structure of the diazine and are in the range from $+400$ mV/NHE to $-200$ mV/NHE in acidic solution.

Reduced diazines are in fact developing agents in acidic solution.

The redox processes shown above are completely reversible. The oxidized developer is simply the parent diazine. Used developers are easily regenerated by reducing the diazine again.

The reduced diazines are easily oxidized in acidic solution by various oxidizing agents, including oxygen. The shelf life of a developer solution is, therefore, limited.

## EXPERIMENTAL

In order to avoid this difficulty we looked for a method which would allow the reduction of the diazine in or near the photographic layer immediately prior and during development.

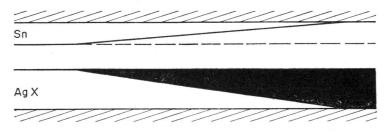

Fig. 1. Thin vapour deposited metal layers which in the course of development are imagewise dissolved.

From the values of $\varepsilon'$ and $\varepsilon''$ for the various diazines it can be seen that all the metals which are less noble than copper will reduce diazines to the radical or dihydro compound. Examples of such metals are tin, lead, iron, cobalt, nickel. These metals are quite strong reducing agents, many of them are, however, not easily attacked by moisture or oxygen in a neutral medium.

The chemical inertness of such metals is often due to a thin, impermeable oxide coating which protects the metallic phase from chemical attack. In an acidic medium, however, the oxide layer is dissolved and the metal becomes reactive.

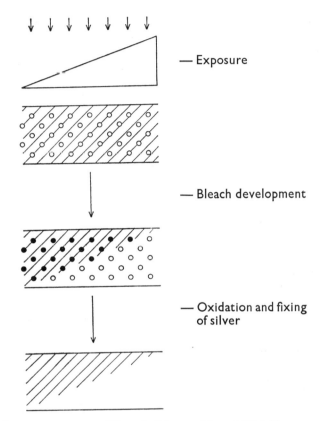

Fig. 2. Bleach development process. ○ Silver halide emulsion. ● Metallic silver. Plain diagonal lines. Azo dye.

A photographic silver halide emulsion layer can be developed by immersing it after exposure in an acidic solution of a 1,4 diazine and contacting it subsequently with a foil of lead, tin, iron, or, cobalt. The diazine is reduced at the metal surface, the reduction product in turn reduces the silver salt to metallic silver and is oxidized again to the diazine in the course of this reaction.

The diazine thus serves as a redox catalyst transferring electrons from the metal to the silver salt.

This can be shown by using thin vapour-deposited metal layers for the reduction of the diazine instead of rather thick foils; in the course of development the metal layer is imagewise dissolved (Fig. 1).

Reduced diazines also reduce (i.e. bleach) azo dyes irreversibly in acidic solution.

In an imagewise exposed silver halide emulsion layer containing an azo dye a competitional reduction of dye and silver halide takes place in the presence of reduced diazines. The result is a negative silver image and a negative dye image superimposed to it. This process is known as bleach development[3] (Fig. 2).

The development of the silver image is controlled by the latent image, the concurrent bleaching of the dye will, however, proceed as long as reduced diazine is supplied to the photographic layer.

By using a thin metal layer of controlled thickness for the reduction of the diazine the above mentioned difficulty could be avoided since the reduction equivalents available per unit area are determined by the thickness of the metal layer used for development.

## ACKNOWLEDGEMENT

The author is grateful to Prof. Dr. E. Schumacher, Dr. M. Schellenberg and Dr. R. Steiger for many interesting discussions and useful suggestions.

## References

1. Schellenberg, M., *Helv. Chim. Acta*, **53,** 1151 (1970).
2. Schaller, H., Schellenberg, M., Schumacher, E., Steiger, R. and Steinmetz, R., Swiss Patent 484454.
3. Steiger, R., *Photogr. Sci. Eng.*, **14,** 269 (1970).

Dye-bleach Processes

# Dye-bleach Processes

JACK H. COOTE

*Ilford Limited, Ilford, Essex, England*

ABSTRACT. Colour processes today owe much to the early experiments of pioneers like Schinzel and Christensen. In the 1930's Gaspar's discoveries with silver halide bleach reactions enabled the production of a colour film that could be used in the motion picture industry. The process known as Gasparcolor was used with success both in Europe and America. Agfa, Ciba, Gevaert, Ilford and Kodak all participated in the post-war years with experimentation and improvement of colour film both for the amateur photographer and the film industry. The high quality of colour film available today is the result of continued experimentation and the aim of this paper is to provide a history of its evolution, especially in relation to the silver-dye-bleach system.

## THE EARLY YEARS

Most of the photographic colour processes we use today had their origins in ideas that were formulated fifty or even sixty years ago, and one of the first patents ever to disclose the idea of a multi-layer colour material depended upon the destruction of dye adjacent to a silver image.

In 1905 Schinzel obtained a patent protecting a plate coated with three emulsion layers, one on top of the other and separated each from the other by plain gelatine layers. The combined layers formed what we now call a tripack, but in the case of Schinzel's material each layer, besides being sensitive to a single primary colour, was dyed in the mass to a colour complementary to its sensitivity. The top or outer layer of the pack was sensitive to blue light and dyed yellow, the middle layer was sensitive to green light and dyed magenta while the bottom layer was red sensitive and dyed cyan.

The dyes that Schinzel intended to use were stable to the action of water, alkaline developers and fixing baths, so that after exposure, development, fixation and washing they would remain intact in their respective gelatine layers together with the silver images resulting from development. After the first stage of processing, the plate was to be immersed in a solution of peroxide and where the solution came into

contact with the image, oxygen was released to bleach the dye immediately surrounding the silver.

Since the amount of oxygen released depended upon the density of silver present at every point of each component image, destruction of the three dyes followed an image-wise pattern. In the areas where there were heavy deposits of silver, most dye was bleached and highlights in the original were therefore reproduced as highlights on the plate—in other words this was a direct positive-to-positive reversal material.

It was unfortunate, but not surprising in view of the state of the art in 1905, that the process proposed by Schinzel was not made to work. Nevertheless, the concept did anticipate developments which eventually led to workable materials and procedures.

## GASPAR: THE IMPORTANCE OF HIS DYE-BLEACH PROCESS

In 1918 Christensen patented the destruction of dyes in a photographic layer by reduction rather than by oxidation, but here again the idea was ahead of the available technology. It was not until the early thirties when Dr. Bela Gaspar began to devote his attention to the dye destruction process, that the practicability of the system was really proved.

One of Gaspar's most important discoveries was that the silver dye-bleach reaction could be greatly accelerated by the addition of certain organic compounds. It is often mistakingly said that the silver image itself acts as a catalyst in the silver dye-bleaching process. However this is not really the case since the silver is converted by chemical reaction and therefore does not behave like a catalyst. If it had not been for Gaspar's discovery of catalysing compounds, the rate of reaction of the process might have remained extremely slow.

The principal objective of Gaspar's research during the thirties was to produce a colour film that could be used in the motion picture industry and in this he succeeded with the process that bore his name—Gasparcolor. It is interesting to note that when Gaspar achieved his first success with the dye-bleach process in the early 1930's, he employed an unorthodox distribution of emulsion layers on the two sides of motion picture film, the layers being exposed successively from three separation positives.

Because of this requirement for separation images as a starting point, all the films printed on Gasparcolor material were of cartoon or puppet subjects. At that time only Technicolor had three-strip or beam-splitter cameras capable of providing separation negatives of live action. Nevertheless Gasparcolor material was used for many successful short advertising films—particularly in Holland and in the U.K.

Although Gasparcolor motion picture print film had emulsions on both sides of the base, there was no necessity to treat the two sides separately during processing; in fact orthodox continuous processing machines were used—firstly in Germany and later in England.

Most of Gaspar's pre-war motion picture print stock was made for him by Gevaert in Belgium. It appears that Agfa had also made some material for him in Germany.

By 1941, Gaspar was operating in the United States and had made arrangements for processing Gasparcolor motion picture film in the laboratories of the Hollywood Color Film Company. There an up-to-date processing machine was installed for the purpose.

In an attempt to deal with the problem of producing prints of live subjects, Gaspar seems to have intended to work via Kodachrome originals, although this probably restricted him to 16 mm film, since at that time only Technicolor had supplies of 35 mm Kodachrome in motion picture lengths.

Perhaps these difficulties at the taking stage of motion picture production explain why Gaspar also offered a two-colour print as an alternative product, since then he could employ readily available bi-pack films in standard 35 mm cameras.

From the literature of the time it appears that Gaspar laid special emphasis on the superior definition obtainable with his process, as compared with Technicolor for example. But it is also quite clear that the dyes available for use in a silver-dye-bleach system more nearly approached theoretical requirements than those that were then obtainable by any process of colour development. It also happened that the classes of dyes used in the Gasparcolor process were more resistant to fading than either the dyes formed by colour development or those used by Technicolor in their dye-transfer process—although this particular advantage may not have been considered significant in the motion picture field at that time.

As we have seen, Gasparcolor film as used for motion picture printing was not a true monopack of three emulsion layers. It was not until some time later in the War that a true multi-layer dye-destruction material was made. The requirement came from the U.S.A.A.F., at Wright Field, Dayton, Ohio, and they were able to arrange for Ansco to produce a reflection print material that became known as Gasparcolor Opaque.

That early product and all subsequent silver dye-bleach materials have been coated on film base—loaded with a white pigment when required for reflection prints. There are two likely reasons for the choice of film. One is that the strongly acid bleach solutions—characteristic of dye-destruction processes—would damage a paper-based product.

Secondly, it is somewhat easier to avoid mottle effects when a reversal material is coated on to the smoother surface of a film base than on the normally rougher surface of paper.

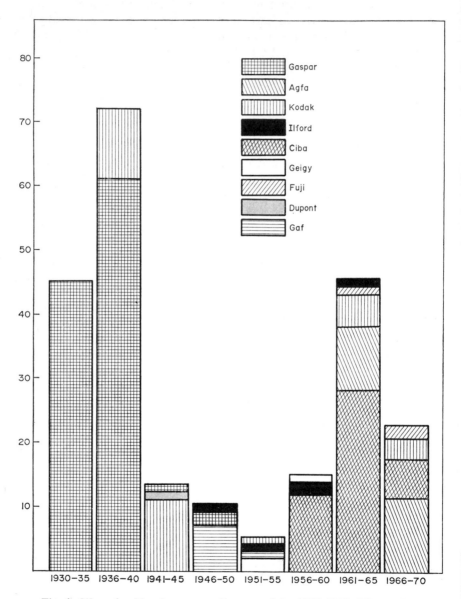

Fig. 1. Silver dye-bleach process—Patent activity 1930–1970. The vertical scale shows the number of British Patents issued.

## THE POST-WAR ERA

Shortly after the war, Gaspar established a company, Chomrogen Inc. in Hollywood, to operate a print-making service using Kodachrome or other subtractive transparencies as originals. By this time, his material was being coated by DuPont. For a short while, the process was also offered to the amateur for home use, but the difficulties of obtaining sufficient light for exposure by projection, together with the hazards of using strong acid bleach, probably accounted for the short life of this particular project.

In the late 1940's, Gaspar returned to Europe and entered into an arrangement with Bauchet, whereby that French company produced their version of Gasparcolor Opaque.

At the same time, Ilford became interested in the silver-dye-bleach process, and in 1954 they established a colour printing service for amateur photographers requiring colour prints from their Kodachrome or Ilford Colour transparencies. It is perhaps interesting to note that the dyes that Ilford used in their product were made by Geigy in Switzerland.

Little or no continuous printing or processing equipment was being made for photofinishing in the early fifties, and Ilford had to design and build their printers and processing machines for themselves. The high speed printers that were finally used, were described in an earlier R.P.S. Symposium, but the processing machines have not been discussed in any detail before.

The first processing machines were not particularly novel and were similar to those that had been constructed previously for the large scale processing of view cards. However impingement drying was used, perhaps for the first time on a print processor.

At a later date, the opportunity was taken to replace these early machines with larger units required for installation in a new laboratory at Basildon in Essex.

Knowing that large paper processing machines had previously given trouble as a result of variation in tension along the web, it was decided to build a machine in which the tension in each loop of paper (or film) would be controlled independently of all the others. Machines that did this for motion picture film were already in use in the Humphries processing laboratories in London and the same principles were adopted for the Ilford machines.

In order to limit the tension on a web of paper or film at any point in the machine, a series of rocking rollers are employed so that whenever tension in a loop increases, the rocking roller over which that loop is threaded, is pulled down into contact with a continuously rotating rubber covered roller so that the rocking roller is then driven fast enough to

create some slackness in the succeeding loop of paper or film. The flanges of the spring-loaded or counter balanced rocking roller than lift away from the rubber covered drive roller and arrest the progress of the paper until tension again builds up in that section. In practice, the on-off nature of this drive results in a fairly high frequency change of speed that is almost imperceptible.

One of the other problems that had to be dealt with in the design of a processing machine for operating the silver dye-bleach process was the extremely corrosive nature of the two bleach solutions that were required at that time. Rubber lined tanks and rubber covered rollers were used throughout the wet section of the machine and Hastelloy was used for shafts and any other metal components in contact with the acid solutions.

The Ilford silver-dye-bleach processing cycle extended over some sixty minutes in the wet section, and the processing machine had an effective output of 40 ft per minute, with two parallel strands. Because the emulsion layers were coated on film base, the prints dried with a high gloss and glazing was unnecessary.

Unbeknown to Ilford, Ciba had begun work on the silver-dye-bleach process around 1957, although the first public announcement of their interest came in 1964, when Ciba Photochemie introduced a service in Switzerland for amateurs wanting prints from their colour transparencies. Some attempt was made to link the print making service to the sale of Telcolor reversal colour film made by Telco, the Swiss photographic manufacturer already owned by Ciba at that time.

## RECENT DEVELOPMENTS

More recently still, Agfa–Gevaert have entered the market with their Agfachrome-60 process, announced at the 1970 Photokina, and so once more, the silver-dye-bleach system has been chosen for the provision of colour prints from amateurs' transparencies.

An initial field trial of the new process was carried out during 1969 in Agfa's own photofinishing plant in Munich and a year later at least two large independant photofinishers in Germany were operating the process, which seems to differ only slightly from its predecessors in terms of exposure or processing requirement. For printing, Agfa recommend a modified version of the Colormator printer they already make for use with their CU 111 Agfacolor chromogenic reversal paper. Exposed rolls of CU 410 material, as the new product is called, can be processed in one of Agfa's Labormator continuous paper processors, provided corrosion resistant materials are used in the neighbourhood of the tanks containing the bleach solutions. The solution sequence for the

Agfacolor-60 process is typical of earlier silver-dye-bleach systems and involves a total wet processing time of 50 minutes.

Neither Ciba nor Ilford, with whom they first became associated in 1963, continued to operate their reversal print services for amateurs after 1965. Instead, Ciba began to concentrate on the production of silver-dye-bleach materials suitable for professional and industrial uses, where it was considered that the characteristic advantages of the silver-dye-bleach process would be most valuable. This approach was thought to be particularly valid with the introduction in 1969 of Cibachrome CCT—a display transparency material—intended for use in applications where the light fastness of colour transparencies had hitherto been notoriously inadequate.

Because of the wide range of print and transparency sizes required in the field of commercial and industrial photography, it is necessary to use processing equipment that is quite different from the usual type of paper processor required for photofinishing. One of the most popular solutions to this problem is to use a drum type processor on which a very wide range and combination of print sizes can be handled. Typical of this type of machine is the Autopan, developed from the Holmüller machine designed by Gall in 1961.

It is fairly obvious that prints can be processed just as well when placed inside a rotating cylinder or tube as when they are attached to the outside of a drum such as is used in machines like the Autopan, or the Colenta. Several machines now use tubes into which prints are inserted before the introduction of the necessary sequence of treatment solutions. The Unitube, P.D.I. and Kodak Model 30 machines are examples.

In all of these processing machines, any metal parts must be replaced by components constructed from non-corrodible materials before the machines can be considered suitable for any silver-dye-bleach system— with the exception of the P-20 process devised by Ciba for use with their CCT or transparency material. Besides being the first silver-dye-bleach process to provide transparencies as opposed to reflection prints, Ciba broke new ground in 1969 by improving the processing in two ways. Firstly, they were able to replace the strongly corrosive mineral acids that had been characteristic of silver-dye-bleach processes by much less troublesome organic acids. And secondly they were able to shorten the processing cycle significantly.

The processing sequence that had been used for Cibachrome print material was typical of all such processes up to that time, requiring a total wet treatment of 47 minutes. The P-20 process used for the transparency material has a wet processing cycle of 37 minutes—the shortest

time yet achieved with a commercially available silver-dye-bleach process.

When the volume of work permits, it is of course quite practical to design a continuous web type processor of any desired size so that either single prints or continuous lengths of up to the full coated width, may be processed by continuous movement through the necessary series of tanks. Hostert and Simplex have made machines of this kind for use with the silver-dye-bleach process, and Ciba have designed and built such machines for their own use.

When one considers the relative merits of the kind of processing required for silver-dye-bleach materials as compared with other reversal colour processes, it becomes apparant that any reversal colour film or paper that uses colour couplers must require two separate development stages: black and white development, and colour development. Additionally, the film must be fogged, either by light or by chemical means before it is colour developed.

The silver-dye-bleach process on the other hand involves only one stage of development, and that uses a normal black and white developer. No fogging operation is required with this process.

# Practical Aspects of Silver Dye-bleach Processing

## A. MEYER

*CIBA-GEIGY Photochemie AG, Fribourg, Switzerland*

ABSTRACT. Silver dye-bleach systems are mainly used for positive-positive colour printing. Materials of different types are on the market, which allow either prints or transparencies to be made. The processing is dependent on the structure and the components of these materials. There are three main processing steps: Silver development, dye-bleaching and removing of silver. The transparencies used for printing need a low contrast of the printing system, therefore, silver halide emulsions of low contrast are needed. During processing, the gradation can be controlled with the silver developer and/or the dye-bleach bath. Reducing the activity of the silver developer reduces printing speed. New materials allow the use of ordinary hydroquinone-phenidone developers, therefore only the dye-bleach bath is the controlling step.

The dye-bleach bath, which has a low pH value, contains a silver complexing substance (e.g. thiourea or iodide) and a bleach catalyst (e.g. substituted quinoxaline). As thiourea forms soluble silver complexes which influence the sensitometric properties, iodide is often preferred. The bleach catalyst must be adapted to the dyestuffs used, and it must fulfil a number of conditions. Such dye-bleach baths are degraded by small amounts of thiosulphate used for fixing the silver image and need then a high regeneration rate. It is therefore preferred to use no stop-fix bath before the dye-bleach step.

If the removing of silver is made in two steps (oxidation, fixing), the processing sequence needs four photographic solutions. All the silver can be recovered from the fixing bath. Such a process compares favourably with chromogenic reversal processes.

## INTRODUCTION

Silver dye-bleach materials for colour photography contain silver halide crystals and an azo dye in each main layer.[1] The azo dyes, present during exposure, form the finished image. They reduce the sensitivity, but increase the sharpness. The process has a positive-positive characteristic and is therefore mainly used for the printing of transparencies. According to the base material, duplicate transparencies or reflection prints may be produced.

The processing sequence consists of three main steps:

1. Silver development
2. Dye-bleaching
3. Removing of silver

This is a very simple and attractive processing sequence for a reversal material.

Colour processing systems must be closely matched to the needs of the materials for which they are intended to be used. All the experience which is presented in this paper is based on various types of CIBACHROME ®. So far, the following varieties have been introduced to the market:

CIBACHROME PRINT Display            } white pigmented
CIBACHROME GRAPHIC                  }      base
CIBACHROME TRANSPARENT Display        transparent base

Display materials are mainly used for medium-size and large prints, e.g. for advertisement and exhibitions. The "Graphic" version is used in the Graphic Arts field, e.g. for proof prints from colour separation positives.

Obviously, the processing is dependent on the structure and the components of these materials. On the other hand, there is a strong tendency to make the processing as easy, fast and cheap as possible, even if this calls for a complicated layer structure of the films. Therefore the whole system should be considered prior to the discussion of the details of processing.

As already mentioned, the silver dye-bleach systems are mainly used for the printing of colour transparencies. Such transparencies show normally a large density range from about 0·4 (minimum density) to 3·0 (maximum density) in visual transmission density units. A range of 2·5 should be printed if there is to be no important loss of details in the highlights and shadows. This needs a flat gradation of the printing material.[2]

Silver dye-bleach systems have in general the tendency to show a relatively high contrast (Fig. 1).

## CONTRAST CONTROL

The first problem is therefore to control the contrast. A second problem results from the fact that different dyestuffs may have different bleaching properties in the same bleach solution. Therefore a very careful selection of the dyestuffs is important. This difficulty is further increased insofar as the azo dyes have to fulfil a number of other conditions such as appropriate spectral absorption, resistance to diffusion and high stability to

light. In the case of **CIBACHROME** materials many hundreds of dyes have been tested in order to find a few acceptable ones.

Coming back to the problem of contrast-reduction it must be taken into account that the contrast depends to a certain extent on the absorption of the light in the layers. The light is attenuated from the top to the bottom of each layer, and this absorption is partly or mainly controlled by the

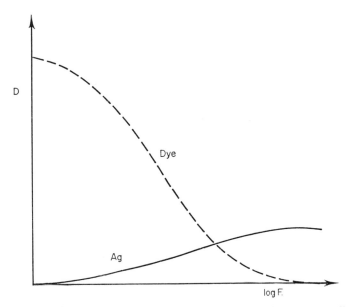

Fig. 1. H and D-curve of a silver image together with the corresponding dye image.

amount of dye per unit area and its spectral absorption; the stronger the attenuation, the lower the resulting contrast. It is obvious that there are two main cases:

Print material: the relatively low concentrations of the dyes per unit area lead to a high contrast. The contrast is further increased because under viewing conditions the light needed for the illumination of the print passes each layer twice, as it is reflected by the white base. In addition, there is multiple reflection.[3]

Transparency material: in comparison with the print material the concentrations of the dyestuffs are more than twice as high. The contrast is close to the values needed, but there may be problems of the printing speed.

As we shall see later, the contrast of a silver dye-bleach system can be controlled during processing, but in order to facilitate the processing it is preferred to use emulsions which give a low contrast. One method which is frequently used is the mixing of two or more emulsions with different speed, and this may be done for each layer. With such mixtures not only the total contrast but also the shape of the characteristic curve or the tone reproduction characteristic is influenced.

Another very interesting method is to use double layers.[4]

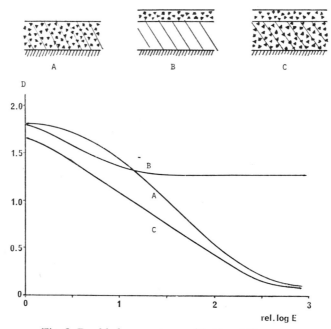

Fig. 2. Double layer systems with H and D-curves.

In Fig. 2 example A shows the characteristic curve of a conventional layer containing silver halide and an azo dyestuff. In example B a silver halide layer without dyestuff has been coated over a dyed layer without silver halide. The H and D-curve after dye-bleaching is the result of the adjacency effect from the silver halide layer to the dyed layer. This layer is only partially bleached, as a flat bleach-front is moving partly into the dyed layer. Therefore, the silver halide may contain coarse and sensitive grains, and the resulting granularity of the bleached layer is still low. Example C shows the combination of A and B: A flat H and D-curve with increased sensitivity and low granularity is the result.

With such methods, the contrast and shape of the H and D-curves can be controlled to a considerable extent.

## PROCESSING PROCEDURE

Turning now to the processing, it is obvious that the sensitometric properties can be controlled by the silver developer. Many different developers have been tried; the aim was mainly to reduce contrast but to avoid as far as possible a loss of speed. For this reason, a metol developer is used for CIBACHROME PRINT. In the patent literature[5] other developing substances like paraphenylendiamine derivates have been proposed. In comparison to well-known Phenidone®-hydroquinone developers they show, however, a loss in speed and the regeneration is more critical. Furthermore, the temperature of such baths, the agitation and the treatment time must be kept within narrow tolerances.

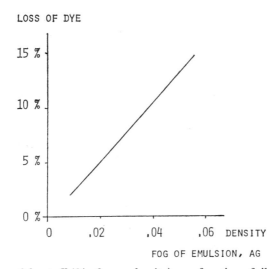

Fig. 3. Loss of dyestuff (% of max. density) as a function of silver fog of the emulsion.

As the methods for influencing the H and D-curves during the manufacture of the material have been improved, it has been found that ordinary developers for black and white materials of the Phenidone-hydroquinone type can be used. As nearly all the exposed silver halide is developed, there is an increase in speed and this bath is no longer critical. One thing is of paramount importance; the emulsion characteristics and the silver development together must lead to silver images with very low fog values. These values should be lower than 0·02 in density, otherwise a significant loss in dye density occurs. This would lead to too low colour densities for black reproduction and reduce the contrast in a way which is difficult to control (Fig. 3).

Therefore, the addition of small amounts of suitable antifoggants is recommended. If the silver development is carried out in such a way that it is nearly complete, no stop bath is needed afterwards, but a good water rinse is important, because the dye-bleach solution is sensitive to relatively small amounts of residual developer.

In the actual **CIBACHROME** processing sequences a fixing step using an acid fixing bath is included at this point. The pros and cons of this bath will be discussed later. A hardening bath containing e.g., formaldehyde may also be included before the dye-bleach step.

Hardening agents like glutaric dialdehyde can be added to the developer.[6] Hardening steps are not needed if the material is sufficiently hardened during the manufacture, so that the swelling ratios of the layers during the processing sequence remain small enough in order to prevent reticulation. This is the method chosen for **CIBACHROME** materials, and the processing is thereby facilitated.

The next step is the dye-bleach bath, in which the silver images are transformed to dye images. In a complicated redox reaction, the silver reduces the azo bridges of the dyestuffs to hydrazo forms which are further reduced and the products split to amines.[7] This reaction takes place in an acid solution with a pH value usually below 1; the acid catalyses the reaction. The normal potential of silver is reduced to zero or below zero by addition of ligands which form complexes or insoluble silver salts.

Furthermore, a so-called bleach catalyst is needed. The reason for this is that the silver grains and the dyestuff molecules or aggregates are both fixed in the gelatin matrix and can therefore not react directly. The bleach catalyst is reduced at the silver surface and, as it can migrate in the gelatin, reduces the dyestuffs, whereby it is reoxidized. By this mechanism a bleach halo is formed around each silver grain (Fig. 4).

The main constituents of a dye-bleach bath are therefore:

    Acid
    Silver ligand
    Bleach catalyst

## DYE BLEACHING

For the processing of silver dye bleach materials hydrochloric acid has been used.[1] This is due to the fact that dyestuffs need a very low pH value for rapid bleaching and the resulting colour fog values are lower than those obtained with sulphuric acid. Hydrochloric acid is corrosive and has therefore been avoided in the new processing sequence for **CIBACHROME TRANSPARENT**. As better balanced dyestuffs have

become available, it is possible to work with a bath which has a pH value of 0·8 containing sulfamic or sulphuric acid. This bath is not corrosive to stainless steel.

As a silver ligand, thiourea has been mentioned in the literature very frequently.[1,8] It forms soluble silver complexes. This property is a drawback for processing systems with regeneration because such a bath will exhibit an increasing amount of silver. It has been observed that the

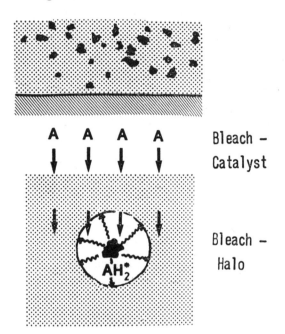

Fig. 4. Formation of bleach-halo.

sensitometric properties are significantly influenced if the silver concentration exceeds 100–200 mg per litre. If the silver halides are fixed prior to the dye-bleach bath it is possible to realize stable conditions, provided that the regeneration rate is not too small. Usually, thiourea is used together with potassium bromide which improves the result but is quite expensive.[1]

Thiourea can be replaced by potassium or sodium iodide.[9] In this case insoluble silver iodide is formed in the layers and the silver concentration in the solution is negligible. Such baths are more stable, but quite sensitive to very small amounts of thiosulphate. Fifty mg thiosulphate per litre of dye-bleach solution showed a significant sensitometric effect. Therefore, if the undeveloped silver halides are fixed prior to the dye-bleach bath, a

thorough intermediate water rinsing is needed. This system has proved to be very satisfactory under practical laboratory conditions; the price of washing and the relatively expensive iodide containing regenerator are the main drawbacks. It should further be mentioned that such solutions must be stabilized against aerial oxidation. For this purpose small amounts of, for example, ascorbic acid[10] or inorganic reducing agents like hypophosphite[11] may be used. Hypophosphite may lead to problems, because the tolerated concentrations in waste water are limited by law at a rather low level.

The question is now whether the fixing step before the dye-bleach bath is necessary. If the fixing bath is omitted, the regeneration rate of the dye-bleach bath can be reduced. Both methods have been tested experimentally and it has been shown that the process without a stop-fixing bath before dye-bleaching is 30–50% cheaper than with the first fixer, but leads to another problem. In an iodide containing dye-bleach bath the silver bromide is, to a large extent, converted to silver iodide. While the loss of iodide is small and the accumulating bromide does not affect the dye-bleach bath, the silver iodide is more difficult to fix at the end of the sequence.[12]

## BLEACH CATALYSTS

As already mentioned, the dye-bleach reaction needs a bleach catalyst. This substance is usually added in small concentrations, and it may be introduced into the material during coating or applied in the developer, where it is adsorbed by the gelatin layers. Normally it is added to the dye-bleach bath. These substances are usually azins, but quinoline and quinaldine[13] and many other substances have also been proposed (Fig. 5).

Pyrazine and its derivatives can be used, but their reduced forms diffuse too easily into adjacent layers causing colour distortions. Derivatives of phenazine and naphtazine are usually coloured and, as they may be adsorbed to gelatin, may cause stain. Derivatives of quinoxaline are more suitable regarding reaction rate and diffusion rate. 2,3-Dimethyl-quinoxaline and many other derivations of quinoxaline are often mentioned in the literature,[1] and many other compounds exist. The choice is dependent on several aspects of the system, e.g. on the dyestuffs and the dye-bleach bath used. A number of properties must be fulfilled, e.g.

Correct reaction rate and diffusion properties.
Nil or very low absorption of the visible light.
Sufficient solubility.
Sufficient stability in the dye-bleach solution.

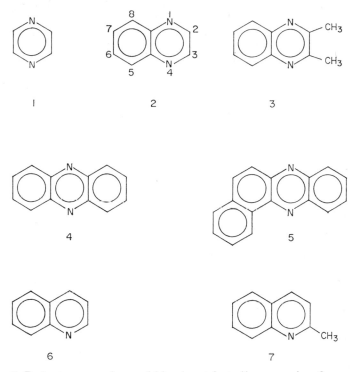

Fig. 5. Basic structure of several bleach catalysts (1 = pyrazine, 2 = quin-
oxaline,  3 = 2,3-dimethylquinoxaline,  4 = phenazine,  5 = naphtazine,
6 = quinoline, 7 = quinaldine).

It has been observed that certain catalysts show nearly the same H and
D-curve whether the bath is agitated by air or nitrogen, while others
lead to quite different sensitometric results (Fig. 6).

The effect is due to the oxidation of the reduced forms of the catalyst.
This leads to an additional silver consumption. In consequence, a
patent[14] exists which claims the use of nitrogen for the agitation of the
dye-bleach bath. The catalysts which are used for the processing of
CIBACHROME materials are almost completely insensitive to this
effect, and so no nitrogen is needed in the dye-bleach solutions.

Derivatives of quinoxaline are normally used in amounts between
0·02 and about 0·5 g per litre. According to the literature, quinoline and
quinaldine are used in larger amounts:

49   to 137 g per litre for quinoline

5,3 to   42 g per litre for quinaldine

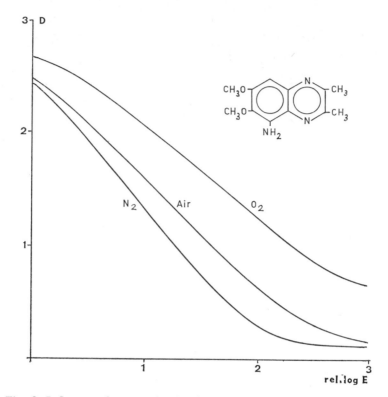

Fig. 6. Influence of oxygen in the dye-bleach solution. H and D-curves measured with a yellow-dyed layer and a bleach bath containing a catalyst of the indicated structure, agitated with $N_2$, air or $O_2$.

or both mixed together.[13] It is claimed that such a mixture has a super-additive effect.

For the regeneration step it is important to mention that there is a loss of bleach catalyst due to absorption or irreversible side reactions. Therefore, the regenerator may contain a relatively high concentration of bleach catalyst. This loss is proportional to the area of material that is treated in the bath. There is no problem with continuous processors, but with batch processors which are widely used in professional laboratories a compromise must be chosen.

Batch processors have the advantage that small or large prints may be treated according to the demands of customers. The area of the material processed in one batch may vary considerably. On the other hand, the carry-over volume of batch processors is relatively high even if no film is loaded. This carry-over must be compensated by regeneration. As

there is a substantial loss of catalyst proportional to the surface of material treated, correct regeneration would only be possible with a constant load per batch. Fortunately the catalyst concentration and the iodide concentration show, in a restricted range of concentrations, opposite effect. Therefore, the concentrations for these substances in the regenerator are arranged in a way that at small amounts of film per batch iodide is over- and catalyst is under-regenerated, whereas with a full load the opposite takes place.

This method leads to a stable and economic regeneration. Batch processors show in general a higher consumption of chemicals than continuous processors because the volume of carry-over is larger. Furthermore, backward and forward contamination of solutions must be carefully avoided.

In the processing of **CIBACHROME** materials the dye-bleach bath is the only one in which the gradations are controlled. When the time of treatment is increased, the contrast and speed increase also, but the balance of the gradations for the three layers remains nearly constant (Fig. 7).

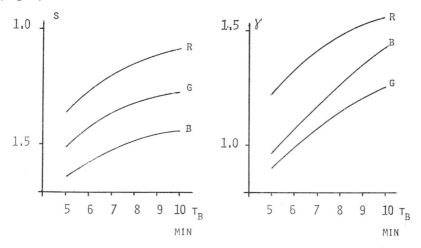

Fig. 7. Influence of bleaching time ($T_B$) on speed (S) and contrast ($\gamma$).

It is obvious that this bath must be held within narrow temperature tolerances and the treatment time should be carefully controlled. Furthermore, good agitation is essential (Fig. 8).

## FINAL PROCESSING STEPS

After the dye-bleach step, which is followed by a short rinse, the residual silver and silver salts must be removed. This may be done with a

bleach-fix solution or by a two step procedure involving a silver oxidation bath, the so-called "silver bleach," followed by an ordinary fixing bath. Both methods are well known from chromogenic processes. In the case of CIBACHROME materials the two-step method has so far been preferred. The oxidation bath is based on ferricyanide, bromide and a buffering system. The addition of phosphate prevents the corrosion of stainless steel. As azo dyes are stable against strong acids, a bath similar to the dye-bleach solution but with an organic oxidation substance can

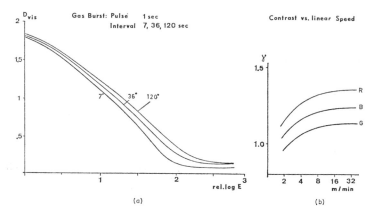

Fig. 8. Influence of agitation of the dye-bleach bath. (a) H and D-curves, gas burst agitation; (b) $\gamma$-value as a function of the linear speed of the film in a continuous processor.

also be used. This compound must be readily reduced by silver and should easily diffuse through the layers. Aromatic nitro- or nitroso-compounds with sulfonic groups may be used.[15] No bleach catalyst is needed.

The fixing step shows no problems if a fixing bath is introduced before the dye-bleach bath. Ammonium thiosulphate with sulphite is used. Omission of the first fixing bath has the advantage that all the silver is accumulated in the final fixing bath, from where it can be recovered by well-known methods. But, as already mentioned, the silver in the layers is then mainly in the form of silver iodide which fixes slowly. In the case of print material, which contains about 2 g Ag per $m^2$, no serious problems have been observed. Transparency materials, since they have higher dyestuff concentrations per unit area, need about 4 to 5 g Ag per $m^2$. Therefore the fixing is slower. The situation is improved if two fixing tanks are used, and the overflow of the second tank is introduced into the first tank.

In this case the fixing time may extend to about 8 min at 24°C whereas

4 min in one bath is sufficient if the material has been fixed prior to the dye-bleach bath.

The question now is how this process compares with conventional chromogenic processes. This comparison is rather difficult because experience with chromogenic processes is much greater than with the processing of silver dye-bleach materials.

We have seen that a typical version needs four baths. Experience has shown that 30 to 40 min of processing time at 24°C are needed, but shorter versions are possible. Processing times of 5 min at 35° to 40°C have been achieved experimentally. Such a process compares favourably with chromogenic reversal processing and is not more complicated than several chromogenic negative-positive processes. The solutions are not more corrosive than those of well-known colour processes, and no overall exposure for the reversal step is needed. Although the cost of the chemicals is somewhat higher than for the processing of certain chromogenic materials, experience in the laboratory has shown that more economic processing is feasible and may lead to a level that compares well with widely used negative-positive processes.

## Acknowledgements

The author wishes to acknowledge the contributions to this work from many of his colleagues within CIBA-GEIGY Photochemie Ltd.

## References

1. Friedmann, J. S., "History of Color Photography," Focal Press, London, 1968.
   Florstedt, J., *Bild und Ton.*, **24**, 181 (1971).
   Meyer, A., *J. Photogr. Sci.*, **13**, 90 (1965).
2. Hunt, R. W. G., Pitt, I. T. and Ward, P. C., *J. Photogr. Sci.*, **17**, 198 (1969).
3. Williams, F. C. and Clapper, F. R., *J. Opt. Soc. Am.*, **43**, 595 (1953).
4. CIBA-GEIGY, DT 2'036'918, FR 2'055'578, BE 753'861, NL 70'01'007, DT 2'132'835, 2'132'836.
5. AGFA-GEVAERT, DT 1'772'137.
6. KODAK, US 3'232'761.
7. Schumacher, E., SPSE-Conference, Washington (1969), p. 38.
   Schellenberg, M. and Steinmetz, R., *Helv. Chim. Acta.*, **52**, 433 (1969).
   Schellenberg, M., *Helv. Chim. Acta.*, **53**, 1151 and 1169 (1970).
   Günther, E. and Matejec, R., *J. Photogr. Sci.*, **19**, 106 (1971).
   Schellenberg, M. and Mollet, H., *Helv. Chim. Acta.*, **54**, 2431 (1971).
8. Gaspar, B., DT 679'745.
9. Gaspar, B., US 2'217'544.
10. CIBA-GEIGY, DT, 1'924'723.
11. GAF, US 2'564'238.
12. James, T. H. and Mees, C. E. K., "The Theory of the Photographic Processes," The Macmillan Company, New York, 1966, p. 398.

Frieser, H., Haase, G. and Klein, E., "Die Grundlagen der photographischen Prozesse mit Silberhalogeniden," Akademische Verlagsgesellschaft, Frankfurt am Main, 1968, p. 994.

Kodak, DT 659'720.

13. AGFA-GEVAERT, DT 1'270'949.

14. AGFA-GEVAERT, DT 1'522'365.

15. KODAK, US 2'625'477, DT 735'672.

    AGFA-GEVAERT, DT 947'221.

# Basic Electrochemical Aspects of the Azo Dye-bleach Process

## E. GÜNTHER and R. MATEJEC

*Research Laboratories, Agfa-Gevaert A.G., Leverkusen, West Germany*

ABSTRACT. During the various steps of the azo dye-bleach process (ADBP) certain electrochemical conditions must be adjusted, otherwise the redox processes involved will not run. The maintaining of these conditions during the various steps of the process and the requirements for the individual reactants are discussed in general terms.

## INTRODUCTION

In the azo dye-bleach process (ADBP) the photographic layer originally contains light sensitive silver halide emulsions with azo dyes incorporated. After exposure and photographic development of the silver halide emulsions the developed silver is used to reduce the (coloured) azo dyes to uncoloured amino compounds. Thus a coloured image is formed.[1,2]

A number of redox reactions is involved in the various steps of the ADBP. These redox reactions only take place, if certain electrochemical conditions are given.

In order to perform their functions, the chemical compounds used in the various steps must fulfil certain electrochemical requirements, too.

The electrochemical conditions during the various steps of processing are therefore of basic interest in the ADBP. As these electrochemical conditions are more concerned with equilibria, kinetic conclusions for the rate-determining factors during the various steps of the process cannot be derived. Nevertheless, suitable equilibrium conditions are necessary, if the process should run at all.

A general review on the electrochemical states of the reactants during the various steps of the ADBP is given schematically in Fig. 1.

To discuss this diagram, it is necessary to remember that an electrochemical reaction can only take place if the working potential of the oxidized compound (Ox) is of higher value than that of the reduced compound (Red). (See Fig. 2, case A.)

173

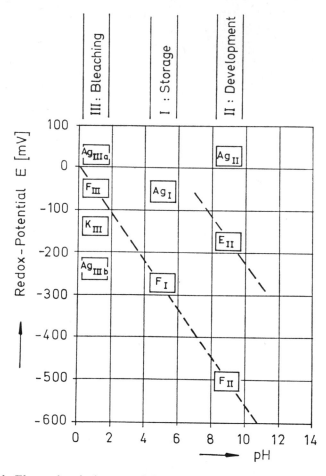

Fig. 1. Electrochemical states of the reactants in the various steps of the ADBP (schematically). (Potential values related to the saturated calomel electrode.)

If both reactants are in the oxidized state (case B in Fig. 2) or in the reduced state (case C), no electron transfer is possible. If the reduced compound (Red) is of much higher redox-potential than the oxidized compound (Ox), no reaction occurs, too, (case D): The reducing power of the Red-compound and the oxidation power of the Ox-compound then are "too weak" to promote a charge transfer.

With these results of Fig. 2 we easily can understand the conditions, which are necessary for the various steps of the ADBP (see Fig. 1).

**STEP 1 (Storage and Exposure)**

During storage of the ADBP layer, the silver ions of the silver halide and the azo dye are both in the oxidized state (case B of Fig. 2). Therefore no reaction occurs.

By exposure some of the silver ions (oxidized state) are transferred to the silver atoms of the latent image (reduced state). Nevertheless no reaction takes place between these (reduced) silver atoms and the (oxidized) azo dye, because, according to Fig. 1 the electrochemical potential ($Ag_I$) of these silver atoms is much higher than that ($F_I'$) of the azo dye (case of Fig. 2).

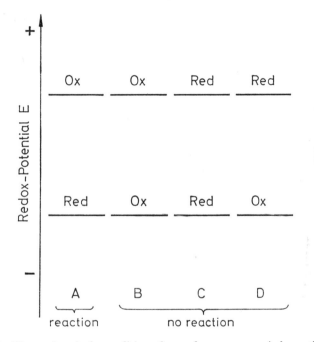

Fig. 2. Electrochemical condition for redox-processes (schematically). Reaction only occurs in case A, if the oxidized compound (Ox) has a higher working potential than the reduced compound (Red).

**STEP 2 (Photographic Development)**

For photographic development, the pH is shifted to higher values (see Fig. 1). Due to the pH-dependence of the reduction process:

$$R - N = N - R + 4\,H^+ + 4\Theta \longrightarrow 2\,R - NH_2 \quad (1)$$

the redox potential of the azo dye is shifted to lower values ($F_{II}$ in Fig. 1)

with increasing pH. The electrochemical potential of the $Ag^+/Ag$-system should remain unchanged; but according to a dilution of the strong halide concentration of the dry layer, the silver potential in the layer may be shifted by the developer to somewhat higher values ($Ag_{II}$ in Fig. 1).

The photographic developer, which is brought into the system during this step, is a compound in the reduced state. Its redox potential ($E_{II}$) has to be between that of the silver system ($Ag_{II}$) and that of the dye ($F_{II}$).

In this case between dye and developer exists a relation, as given in Fig. 2 with case D: The developer is too weak a reduction compound to reduce the azo dye.

On the other hand, between the silver ions of the silver halide and the redox system of the developer there exists the relation A of Fig. 2. Photographic development, i.e. the reduction of the silver ions by the developer, may occur.

## STEP 3 (Azo dye-bleaching)

To bleach the azo dye by the developed silver, the pH has to be decreased. The redox potential of the azo dye then is shifted—according to reaction (1)—to higher values (e.g. from $F_{II}$ to $F_{III}$ in Fig. 1). To start the bleach reaction between the (oxidized) azo dye and the (reduced) silver, the redox potential of the azo dye has to surpass that of the silver system (according to case A in Fig. 2). As can be seen from Fig. 1, this would be true only at very low pH values (pH $\ll 0$). To avoid such strong acid solutions, the silver potential can be lowered by complex formation (e.g. with thiourea) or by formation of a silver salt with very low solubility (e.g. silver iodide). The silver potential thus can be shifted, e.g. from $Ag_{IIIa}$ to $Ag_{IIIb}$ in Fig. 1. Then the relation between azo dye (Ox-compound) and developed silver (Red-compound) is adjusted to case A in Fig. 2.

With this adjustment of the electrochemical conditions bleaching of the dye will be possible. Nevertheless, there exists still a kinetic barrier for the bleach process: for preventing diffusion of the dye from the layer into the solution during processing, the dye must be fixed in the gelatine. On the other hand, the developed silver cannot migrate in the layer, too. To promote an electron transfer from the immobile developed silver to the immobile dye, a mobile catalyst must be present, which promotes this electron transport. This catalyst therefore must have a reversible redox potential ($K_{III}$ in Fig. 1) between the silver potential ($Ag_{IIIb}$) and that of the dye ($F_{III}$). For chemical aspects of such redox catalysts see references [3,4].

# References

1. Meyer, A., *J. Photogr. Sci.*, **13,** 90 (1965).
2. Schumacher, E., SPSE-Conference, Washington (1969), p. 38.
3. Schellenberger, M. und Steinmetz, R., *Helv. Chim. Acta*, **52,** 433 (1969).
4. Schellenberger, M., *Helv. Chim. Acta*, **53,** 1151 and 1169 (1970).

# The Reductive Cleavage of Azo dyes in Strongly Acid Solutions

M. SCHELLENBERG

*Ciba-Geigy Photochemie AG, Fribourg, Switzerland*

ABSTRACT. The cleavage of monoazodyes by dihydrodiazines is a two step consecutive reaction. Methylorange, for example, is reduced in a first very fast step to the corresponding almost colourless hydrazo-compound. The hydrazo stage is cleaved in a relatively slow reaction forming sulphanilic acid and N,N-dimethylquinoneimoniumion as products. The slowly formed quinoid particle reacts quickly with a further dihydrodiazine molecule. If no further reducing agent is present, the quinoneimoniumion oxidizes a hydrazo molecule, yielding one molecule of methylorange and N,N-dimethyl-p-phenylene-diamine, respectively. A solution containing not enough dihydro-diazine for the quantitative reduction of the formed quinoneimoniumion turns during the first reaction step from red to almost colourless and keeps colourless until all dihydrodiazine has disappeared. Then the colour returns to red because the protonated dyestuff is formed again.

General Processing Studies

# Influence of Development Retarders on the Colour Reversal Process

## H. D. MEISSNER

*Research Laboratories, Agfa-Gevaert AG, Leverkusen, West Germany*

ABSTRACT. The influence of phenylmercaptotetrazole and other development retarders on the Agfacolor reversal process was investigated. Retarding effects were found to depend on the solubility of the silver salt of the retarding compounds, and on the level of exposure. From the results obtained, some evidence is derived concerning the mode of action of retarders.

## INTRODUCTION

Organic development retarders are not only useful as antifoggants, but provide a means to control the properties of the developed image with respect to speed, gamma, and graininess. Especially in colour development, a method has been claimed to utilize these effects, without loss in sensitivity, by the incorporation of the so-called DIR-couplers which release the development retarder upon coupling with oxidized colour developing agent.[1] Although the mode of action of development retarders is not yet fully understood, evidence has been pointed out for the occurrence of several reactions. These include adsorption of the retarders to silver,[2] thus decreasing electron transfer to the latent image speck[3] and inhibiting solution physical development,[4] as well as formation of a "hull" of insoluble silver salt at the grain surface,[5] which may result in an inhibition of interstitial silver ion formation at the grain surface,[6] and/or decreased mobility of these ions within the grain surface boundary layer.[7]

Since all these effects depend on the activity, pH[5,8] and solvent action[9] of the developer, it would be of particular interest to study the influence of retarders on the colour reversal process where all these factors are involved to various extents in first and colour development.

## EXPERIMENTAL

The light sensitive materials used were Agfacolor reversal film CT 18 and Agfa ISS black-and-white negative film, respectively. All samples were given a 5 s low intensity white light exposure, either with

step wedge or continuous. Processing was performed with commercially available solutions following the scheme given in Table 1. All solutions

## Table 1
### Scheme of colour reversal processing

| Processing step | Time (min) |
|---|---|
| First development | 18 |
| Stop bath | 4 |
| Rinse | 10 |
| Re-exposure | 1 min each side, 500 W lamp, 1 m distance |
| Colour development | 14 |
| Stop bath | 1 |
| Bleach | 5 |
| Rinse | 5 |
| Fixation | 5 |
| Rinse | 10 |

## Table 2
### Addition of compounds to developer solutions

| Compound | | $L_{AgX}$ |
|---|---|---|
| PMT | | $1.66 \cdot 10^{-16}$ |
| MMT | | $2.82 \cdot 10^{-16}$ |
| MBT | | $4.90 \cdot 10^{-18}$ |
| MBI | | $0.93 \cdot 10^{-19}$ |
| BI | | $4.26 \cdot 10^{-12}$ |
| DPMT | | $1.23 \cdot 10^{-13}$ |

were thermostated at 20°C. Black and white as well as colour densities were read with a Macbeth densitometer. In one part of the experiments, developed silver was determined analytically by volumetric titration.

Retarding compounds were applied either by bathing the exposed strips in aqueous solutions of the respective compounds for 10 min or by addition of the compounds to the appropriate developer solutions as indicated. The compounds used are listed in Table 2. Apparent solubility products of their silver salts at pH 10·2 (the pH of the first developer) were determined from potentiometric titration curves, using the method of Günther[10] with a dye-pretreated silver electrode. Pretreatment was made by bathing the electrode, prior to use, in a 0·1 % erythrosin solution for 30 min.

## RESULTS
### Solubility products

Values obtained for the solubility products of the retarder silver salts are included in Table 2. They are in general considerably lower than those reported in literature which is partly due to the dependence of the apparent solubility product on pH.[5,8] On the other hand, Günther[10] has pointed out that values derived from potentiometric titration curves are usually found too high unless adsorption of the retarding compound to the silver electrode is prevented.

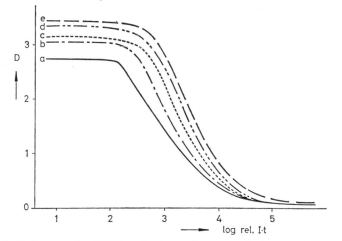

Fig. 1. Influence of a PMT prebath on the reversal characteristic curve. a = control, b = 0·056, c = 0·112, d = 0·168, e = 0·281 m moles PMT/l.

### Influence of PMT on development

The influence of a PMT prebath on the reversal characteristic curve is shown in Fig. 1. Increasing PMT concentrations result in a considerable

speed loss, whereas gamma and maximum colour density are increased.

In order to sort out the effects of PMT on the single processing steps, in the next series of experiments processing was interrupted after first development, the samples were fixed and rinsed and silver density curves were measured. The results are shown in Fig. 2, and it is obvious from

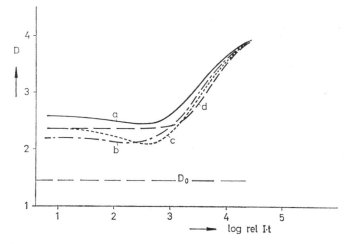

Fig. 2. Influence of a PMT prebath on first development (CT 18). a = control, b = 0·056, c = 0·112, d = 0·281 m moles PMT/l; $D_0$ is the density of the undeveloped material.

these curves that the overall effects of PMT observed in Fig. 1 are mainly brought about by the influence of this compound on first development. PMT pretreatment results in increased gamma, whereas the maximum silver density remains unaffected. However, the interpretation of PMT effects on speed is complicated by the occurrence of considerable fog. The observed minima at the toe of the characteristic curve may be attributed to covering power effects due to the combined action of chemical and solution physical development as has been pointed out by Klein.[11,12] In the case of CT 18 reversal film, the catalytic nuclei are possibly provided by the yellow filter and the antihalation layer which both consist of colloidal silver, whereas solvent action of the developer is due to its content of both sulphite and thiocyanate.

In order to exclude effects of this type, the last-mentioned experiments were repeated with an ordinary black-and-white material (Agfa ISS) that contains no catalytic nuclei. The results are shown in Fig. 3, and it is evident that the effects of PMT are practically the same with both materials. Increasing amounts of PMT decrease both speed and fog,

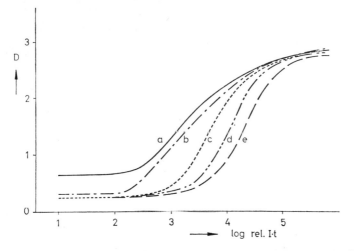

Fig. 3. Influence of a PMT prebath on the ISS characteristic curve. Indica-
tion of curves is the same as in Fig. 1.

whereas gamma is increased. In the range of maximum exposure, how-
ever, PMT effects are only negligible.

In order to examine whether or not this development inhibition is
reversible, ISS samples were treated as before, but then subject to pro-
longed development in first developer.

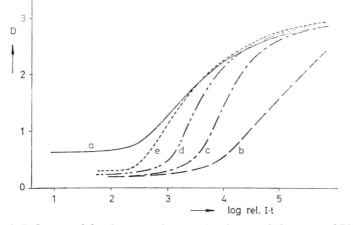

Fig. 4. Influence of development time on the characteristic curve of PMT
pretreated ISS. a = control (no PMT, 18 min), b–e: 10 min prebath with
0·168 m moles PMT/1. Development time: b = 10 min,  c = 18 min,
d = 30 min, e = 60 min.

The curves so obtained are plotted in Fig. 4, and it is evident that development inhibition by PMT can be fully compensated by prolonged development time.

From the results so far obtained one may conclude that PMT merely decreases the rate of development, and that the extent of this inhibition depends on exposure level.

On the other hand, gamma increase with development retarders has also been attributed to increased covering power of the reduced silver.[13]

Therefore, in the next series of experiments CT 18 samples were given a continuous white light exposure, the level of exposure being adjusted with neutral filters, pretreated as above with PMT solutions, and

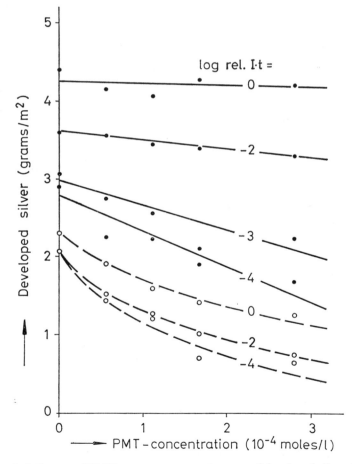

Fig. 5. Influence of PMT pretreatment on the mass of developed silver. Full lines: 18 min first developer. Dotted lines: 14 min colour developer.

developed for 18 min in first developer. The developed mass of silver was then determined analytically. The results are plotted in Fig. 5 (full lines), where log rel (It) = 0 corresponds to an exposure level just sufficient to reach maximum density. From these results it is evident that there is practically no effect of PMT—at least in the range of concentrations applied here—on maximally exposed samples, whereas PMT inhibition is considerably increased with decreasing exposure level.

### Colour development

In order to examine the influence of PMT on second development, CT 18 test samples were subject to the total reversal process, but PMT was added to the colour developer (Fig. 6). Here no significant influence

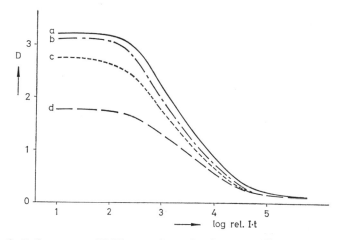

Fig. 6. Influence on PMT on colour development. Curve a = control, b = 0·056, c = 0·112, d = 0·281 m moles PMT/l.

of PMT on speed was found, but both maximum colour density and gamma are considerably decreased. Since here the residual silver halide is fully exposed after first development, and colour density is proportional to the mass of developed silver,[14] this means that PMT should inhibit colour development irrespective of exposure.

This was again checked analytically by pretreatment of continuously exposed CT 18 samples with PMT, 14 min development in colour developer, and determination of developed silver. The results are included in Fig. 5 (dotted lines) and it is obvious that there is PMT inhibition even at maximum exposure level.

This may be due at least partially to the higher pH (11·7 compared with 10·2 of the first developer) of the colour developer, which favours

the formation of insoluble PMT silver salt at the grain surface. It will be shown later that similar effects are obtained also with first developer, if compounds are used which form silver salts of lower solubility than PMT.

## Investigation of further compounds

Since it has been found that the effects of development retarders can be sufficiently characterized, at least for the present purpose, by these

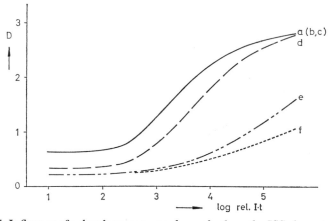

Fig. 7. Influence of a development retarder prebath on the ISS characteristic curve (18 min first developer). a = control, b = 0·79 m moles BI/l, c = 0·38 m moles DPMT/l, d = 0·35 m moles MMT/l, e = 0·30 m moles MBT/l, f = 0·33 m moles MBI/l.

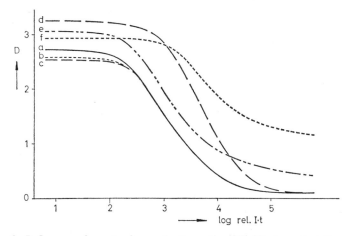

Fig. 8. Influence of a retarder prebath on the CT 18 characteristic curve (whole reversal process). Indication of curves is the same as in Fig. 7.

two sets of experiments, the investigation of the other compounds was restricted to (1) their influence on the ISS characteristic curve obtained from first development, and (2) their influence on the overall reversal process. The experiments were carried out as indicated above, and the results are plotted in Figs. 7 and 8.

From these data it is apparent that the retarding compounds can be roughly classified by the apparent solubility products of their silver salts at the pH of the developer.

No measureable effect on first development was found with BI and DPMT which both form silver salts with LAgX in the order of magnitude of silver bromide (see Table 2). Since emulsion pAg is usually adjusted, prior to coating, to values around 9, this means that there is no formation of silver salt at the grain surface during BI or DPMT pretreatment. This is even more unlikely since the pH of the prebath is around the neutral point where solubility of the retarder silver salts is higher than indicated by the values of Table 2 according to Klein[8] and Faerman.[5] Decreasing solubility by the increased pH of the developer, on the other hand, is at least partially compensated by increasing pAg due to the bromide content of the developer. Corresponding to the results shown in Fig. 7, there is also a negligible influence of BI and DPMT on the reversal characteristic curve (Fig. 8).

Effects similar to those with PMT have been obtained with MMT the silver salt of which has approximately the same solubility. If we now regard compounds forming extremely insoluble silver salts, like MBT and MBI, it is evident from Fig. 7 that these compounds even inhibit development in the range of maximum exposure. From further experiments not plotted here it was revealed however, that this is merely a rate effect similar to that obtained with PMT. By extremely prolonged development time up to several hours, the characteristic curve of the control could be fully restored.

Under normal processing conditions, this strong inhibition results in an only slightly increased maximum colour density, and in an extremely extended "toe" of the reversal characteristic curve (Fig. 8).

It was further observed that samples pretreated with MBT and MBI could not be fixed in an alkaline fixing bath. Fixing was possible, however, in an acid bath thus pointing out again the dependence of silver salt formation on pH.

## DISCUSSION

The mechanisms so far offered to explain the mode of action of development retarders, refer mainly to two distinct kinds of interaction of the retarder with the silver halide grain. From the correlation between

antifoggant activity and the solubility of silver salts of the retarding compounds, which has been established under controlled pH conditions,[5,15] the formation of a "hull" of silver salt at the grain surface was suggested. It has been revealed from both conductivity[7] and electrochemical[6] experiments, that this leads to a certain stabilization of the grain surface thus inhibiting here the formation of interstitial silver ions which is now generally regarded to constitute the source of the reactant for the development reaction.[16]

This mechanism would imply, however, a general decrease of both image and fog development, whereas enhanced selectivity has been reported with some retarders in that these compounds rather decrease the rate of fog than that of image development. To account for this, preferential interaction of these compounds with fog centres as compared with latent image centres or the grain surface has been claimed.[3,17] This seems to be supported by calorimetric data of Wood[18] who showed that retarders are more strongly adsorbed to silver sulphide than to silver or silver bromide, although the chemical nature of fog centres is still a matter of question.

On the other hand, Günther[2] has pointed out that the adsorption of PMT to silver is extremely sensitive to the presence of oxygen, which means that the adsorption of compounds like that primarily occurs via salt formation. This again introduces an influence of the solubility of silver salts of the retarding compounds so that the argument cited above could also be stressed in favour of poisoning the catalytic sites at the grain surface, at least if one would agree with Chibisov's suggestion[19] that fog centres consist of silver rather than of silver sulphide. From the present experiments, however, it is evident that there is no sharp distinction between the retarding action of the investigated compounds on fog and image development.

On the contrary, a gradual decrease of development inhibition was found with increasing exposure level, the extent of inhibition being at least qualitatively dependent on the solubility of the silver salts of the compounds under investigation.

Moreover, development inhibition was found to be merely kinetic in nature in that the compounds rather slowed down the rate of development, but did not affect developability as such. A very similar influence of exposure on the rate of development of PMT treated emulsions has been reported most recently by Land et al.[20]

To account for these effects it will be helpful to regard the changes occurring in a light sensitive layer with increasing exposure.

First of all, there is simply an increasing fraction of grains rendered developable due to the formation of at least one latent image centre of

sufficient stability. However, the grains already rendered developable by a weak exposure do not remain unchanged upon further illumination.

It has been pointed out by Klein[21] and by Matejec and Moisar[22] that both the number of latent image specks per grain and the size of the individual speck increase with increasing exposure. The former has been confirmed most recently in this laboratory by means of an entirely new technique of latent image speck enlargement (unpublished results of H. J. Metz). On the other hand, an influence of the size of latent image specks on the rate of development has been observed mainly during the very first period of development.[23]

Thus we may conclude from the results of the present investigation, that both effects mentioned above are involved in the retarding action of the investigated compounds. Due to their strong chemisorption to silver,[2] they impede transfer of electrons to the latent image speck. This is mainly effective during the early stages of development and may be overcome by increasing the size of the electrode by an increasing level of exposure. This view is greatly supported by recent results of Willis et al.[24] which indicate that the electrode mechanism of development is valid from the very early beginning of reduction. Effects of this type are superimposed by a general decrease of the rate of development due to the formation of a hull of insoluble silver salt at the grain surface which inhibits the formation of interstitial silver ions as a source of the development reaction.

Since both effects involve silver salt formation, they are equally dependent on the solubility of the silver salt of the respective compound. For the same reason, both effects are sensitive to the solvent action of the developer solution. A more detailed investigation on the influence of different compounds on the kinetics of development is necessary, however, to enable evaluation of the respective contribution on these different effects to the observed overall development inhibition.

## References

1. Barr, C. R., Thirtle, J. R. and Vittum, P. W., *Photogr. Sci. Eng.*, **13,** 74 (1969).
2. Günther, E., *Photogr. Korresp.*, **102,** 108 (1966).
3. Thompson, T. R., *Photogr. Sci. Eng.*, **3,** 272 (1959).
4. Newmiller, R. J. and Pontius, R. B., *Photogr. Sci. Eng.*, **5,** 283 (1961).
5. Faerman, G. P., *J. Photogr. Sci.*, **15,** 22 (1967).
6. Battaglia, C. J., *Photogr. Sci. Eng.*, **14,** 275 (1970).
7. Hamilton, J. F. and Brady, L. E., *J. Phys. Chem.*, **66,** 2384 (1962).
8. Klein, E., *Z. Wiss. Photogr.*, **52,** 157 (1958).
9. Sahyun, M. R. V., *Photogr. Sci. Eng.*, **14,** 192 (1970).
10. Günther, E., Paper presented at the International Congress on Photographic Science, Tokyo 1967.

11. Klein, E., *J. Photogr. Sci.*, **8,** 178 (1960).
12. Klein, E., *Z. Wiss. Photogr.*, **54,** 5 (1960).
13. Sheberstov, V. I., *Usp. Nauch. Fotogr.*, **4,** 210 (1955).
14. Chelt'sov, W. S., Jordanski, A. N., Bongard, S. A. and Katchenko, T. G., Proceedings of the International Conference for Scientific Photography, Köln, 1956. Verlag Dr. Othmar Helwich, Darmstadt 1958, p. 485.
15. Kikuchi, S., Sakaguchi, Y. and Murobushi, K., *Bull. Soc. Sci. Photogr. Japan*, p. 10 (nr. 2, 1952).
16. Mason, L. F. A., *J. Photogr. Sci.*, **16,** 177 (1968).
17. Sahyun, M. R. V., *Photogr. Sci. Eng.*, **15,** 48 (1971).
18. Wood, H. W., *J. Photogr. Sci.*, **14,** 72 (1966).
19. Chibisov, K. W., *J. Photogr. Sci.*, **9,** 26 (1961).
20. Land, E. H., Farney, L. C. and Morse, M. M., *Photogr. Sci. Eng.*, **15,** 4 (1971).
21. Klein, E., *Z. Elektrochem.*, **61,** 870 (1958).
22. Matejec, R. and Moisar, E., *Ber. Bunsenges. Phys. Chem.*, **69,** 566 (1965).
23. Mees, C. E. K. and James, T. H., " The Theory of the Photographic Process," Macmillan, New York 1966, p. 333.
24. Willis, R. G., Ford, F. E. and Pontius, R. B., *Photogr. Sci. Eng.*, **14,** 141 (1970).

# Auto-coupling Development

LASZLO LUGOSY, MARIUS GROSSA and WOLFGANG PISTOR

*Du Pont (Deutschland) GmbH, Photo Products Department, 6078 Neu-Isenburg, West Germany*

ABSTRACT. The auto-coupling development process involves a new type of silver halide developing chemistry which yields exceptionally high image densities. A $p$-aminophenol developer and a suitable colour coupler are connected via a methylene group. Upon development the oxidized developing part of the molecule reacts with the coupling part of a second molecule forming an oligomeric dye of the chinonomine resp. azomethine type of any desired colour. Compounds with $m$-aminophenol or $m$-phenylene diamine couplers yield dyes with very wide absorbtion bands which, in special cases, can provide neutral grey image densities of high extinction coefficients. The dye generated by auto-coupling development may contribute 60–70% of the total (silver + dye) image density.

## EXPERIMENTAL TECHNIQUES

New developer compounds have been discovered which upon oxidation by silver ions in the development process form polymeric dyes. In these compounds a developer and a coupler are connected via a methylene group or a methylene ammonium group (D/C-compounds). The developer preferably is a $p$-aminophenol, the coupler an unsubstituted or substituted $m$-amino phenol or $m$-phenylene diamine resp. of any conventional coupler compound.

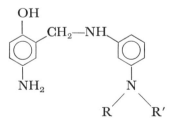

Upon development the oxidized developing part of one molecule reacts with the coupling part of a second molecule, thus generating a

dye which reacts after a second development step with the coupling part of a third molecule etc. This process we call auto-coupling development = ACD.

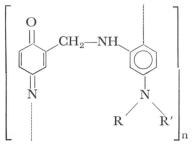

The dyes thus produced show marked absorption bands in the visible region, their position and intensity strongly depending on the pH. They may contribute 60—70% of the total (silver + dye) image density. Stabilization of image tone against pH changes can be achieved by treatment with alkaline metal complex solutions, e.g. with a copper tartrate bath. Compounds with $m$-amino phenol or $m$-phenylene diamine couplers yield dyes with very wide absorption bands which, if desired, can provide grey image densities of high extinction coefficients.

By measurements and interpretation of spectral absorption and dissociation constants of the dyes, it has been shown that they belong to the class of quinone imines resp. azomethines, thus explaining the colour/pH interdependence as an acid/base equilibrium. Neutral grey tones achieved by some D/C compounds result from a specific ratio of ionized and neutral forms of the dye.

Due to the bifunctional character of the D/C compounds, dyes of higher degree of condensation are formed. The average molecular weight of the dye was determined by end-group assay and by gel-filtration: An average of 3 to 4 D/C molecules combine to give the non-diffusing oligomer.

Over one hundred compounds of this type have been synthesized and found suitable for auto-coupling development. Substituting the $p$-amino phenol developer moiety by $p$-phenylene diamine prevents the formation of oligomers. No dyes were formed when we changed the methylene resp., the methylene amino/ammonium bridge or when we substituted the coupling positions by halogen or $-SO_3^-$, which is permissible in conventional chromogenic development. Any other kind of substitution in the molecule does not hinder auto-coupling development. It can be used to influence spectral absorption and the pH dependence of the generated dye.

# An Original Method for Computing Overall Diffusion Coefficients of Oxidized Colour Developers in Gelatin

G. GEHIN

*Centre de Recherches, Kodak Pathé S.A., 30 Rue des Vignerons–94,
Vincennes, France*

ABSTRACT. An original method to compute overall diffusion coefficients of oxidized colour developers in gelatin has been developed.

A flat silver electrode coated with a gelatin interlayer and a chromogenic coupler layer is used. In alkaline solution, the developer is oxidized electrochemically on the silver surface on the electrode. A flat cloud of oxidized developer is formed. It diffuses through the interlayer of gelatin and reacts with the coupler to form a dye. The rate of formation of the dye is recorded by a reflection densitometry technique.

Simultaneous diffusion and chemical reactions (deamination) of the oxidized developer in the gelatin interlayer are involved. Steady-state solutions of the differential equation describing the process are used to calculate the value of the overall diffusion coefficient.

The method has been applied to 4-amino-3-methyl-N-ethyl-N-($\beta$-methyl-sulphonamidoethyl)aniline. The results obtained at pH 10, 10·7, and 11·5 show a noticeable increase (about 4 times) of the overall diffusion coefficient when the pH increases from 10 to 11·5.

In summary the method appears to be suitable to evaluate overall diffusional properties of oxidized colour developers and for the first time allows operation under experimental conditions identical with those usual in customary photography.

## INTRODUCTION

In colour processes the silver-halide grain is used as a site of reaction where the silver halide is reduced to silver and the developer is oxidized. A cloud of oxidized developer diffuses away from the grain surface and in the system under consideration here, — reacts with tiny coupler-layer globules dispersed in the film to form a dye cloud surrounding the developed grain. The shape and size of this dye deposit will vary with the chemistry of the process and with the relative concentrations of the reactants. It is clear the rate of formation of the dye is dependent upon mass transfer terms in addition to the usual chemical terms of homogeneous

197

reactions. The present study deals with the overall diffusional properties of oxidized colour developer.

We have developed an original method to compute effective diffusion coefficients of oxidized $p$-phenylenediamine in gelatin. Previously Tong et al.[1] described a method for evaluating these coefficients in homogeneous alkaline solution but up to the present time no method was available for "in-gelatin" processes.

From a general standpoint the developed method is based on quantitative interpretations of kinetic data provided by a special electrochemical device.

The method has been applied to oxidized species of 4-amino-3-methyl-N-ethyl-N($\beta$-methylsulphonamidoethyl)-aniline (I) at pH = 10, 10·7, 11·5.

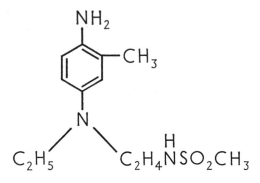

(I)

## EXPERIMENTAL

A flat silver electrode coated with two gelatin layers is used (electrode surface = 12·25 cm$^2$). The first is a simple gelatin interlayer, and a pyrazolone chromogenic coupler is dispersed in the second (Fig. 1).

In alkaline solution, the colour developer is electrochemically oxidized on the silver surface. A flat cloud of oxidized developer is formed which diffuses through the interlayer of gelatin and reacts with the coupler to form a dye. The reactivity and concentration of the coupler are adjusted to yield a front-progressing dye reaction. The rate of the formation of the dye is recorded by reflection densitometry (Fig. 2). Several different thicknesses of the gelatin interlayer were investigated.

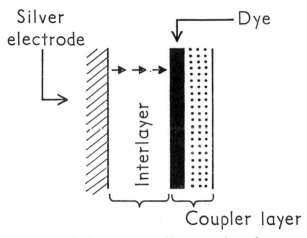

Fig. 1. Arrangement of layers on electrode.

A wide range of oxidation rates is obtainable. The various oxidation rates are kept constant with time (chronoamperostat).

The developer solutions contain a buffering agent and the colour developer, but no sulphite. To prevent aerial oxidation the working solution is maintained under an atmosphere of nitrogen.

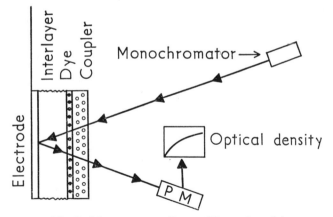

Fig. 2. Measurement of rate of formation of dye.

Under our experimental conditions the dye densities are linear with time. For a given oxidation rate the thinner the gelatin interlayer, the higher the dye rate. In Figs. 3, 4 and 5 the logarithm of the dye rate is plotted against the interlayer thickness for several oxidation rates at pH 10, 10·7, 11·5.

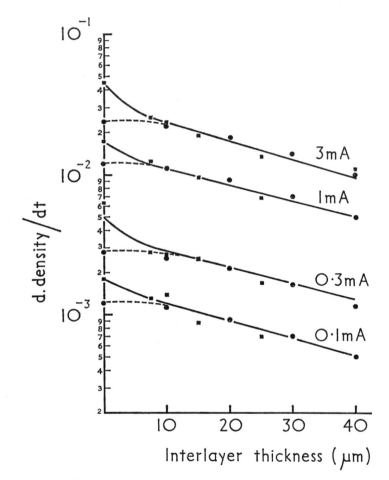

Fig. 3. Rate of formation of dye as a function of interlayer thickness. pH = 10.
● Experimental; ■ Calculated.

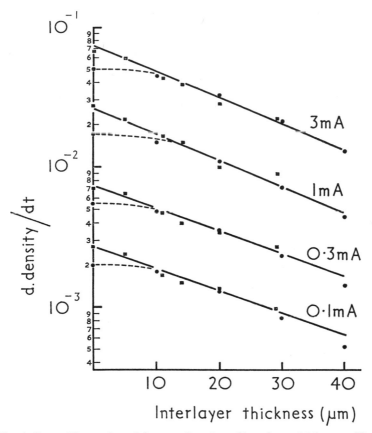

Fig. 4. Rate of formation of dye as a function of interlayer thickness. pH = 10·7. ● Experimental; ■ Calculated.

## METHOD OF CALCULATION AND RESULTS

From a kinetic standpoint, four different steps are involved in the process:

1. Oxidation of the developer: the rate of this reaction is known from the current used but this value is not needed for the calculations.

2. Diffusion of the oxidized developer from the electrode surface to the coupler layer. This step is the unknown step of the process. No experimental method is available to get the concentration profile in the interlayer.

3. Loss of oxidized colour developer: the rate of this non-chromogenic side reaction cannot be measured directly. However, the values of the related rate constants have been published by Tong[2] and were used in our treatment.

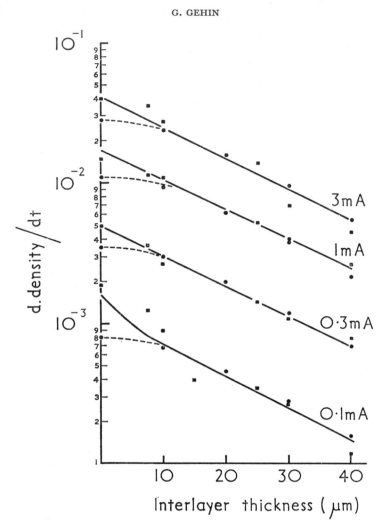

Fig. 5. Rate of formation of dye as a function of interlayer thickness. pH = 11·5. ● Experimental; ■ Calculated.

4. Dye formation in the coupler layer: the rate of this reaction is recorded directly (dye density).

The simultaneous diffusion and reaction of the oxidized developer in the gelatin layer can be described by the differential equation,

$$\frac{\partial c}{\partial t} = D \cdot \frac{\partial^2 c}{\partial x^2} - kc,$$

where $c$ is the oxidized developer concentration at the distance $x$ from the electrode surface, and $k$ is the rate constant of the side reaction.

When steady state conditions are assumed, this equation can be integrated and then yields the solution,

$$c = \frac{w}{\lambda} e^{-2\lambda l} \cdot \frac{e^{\lambda x} - e^{-\lambda x}}{1 + e^{-2\lambda l}},$$

where $w$ is the rate of oxidation, $\lambda = \sqrt{k/D}$, and $l$ the swollen thickness of the gelatin interlayer.

It should be noted that this expression applies only to the case in which the oxidized developer concentration at the interlayer/coupler-layer boundary is assumed to be zero. When the extinction coefficient is known, it is easy to verify that the diffusion coefficient can be derived directly from the calculation of the total amount of oxidized developer diffusing through the interlayer/coupler-layer boundary. But in general, the value of the extinction coefficient is not known and another method has to be used. Let us consider two experiments with identical oxidation rates but with two different interlayer thicknesses $l_1$ and $l_2$. It can be shown that if $\frac{dd_1}{dt}$ and $\frac{dd_2}{dt}$ are the dye density rates related to $l_1$ and $l_2$, the ratio $R$ of these two rates is a simple function of $\lambda$, $l_1$, $l_2$,

$$R = \frac{\cosh \lambda l_2}{\cosh \lambda l_1} \cdot \begin{cases} R = \dfrac{dd_1}{dt} \Big/ \dfrac{dd_2}{dt} \\ \lambda = \sqrt{k/D} \end{cases}$$

The solution of this equation, $\lambda = \sqrt{k/D}$, can be obtained by a numerical method and the diffusion coefficient calculated. For any given pH and oxidation rate a mean value of the diffusion coefficient can be computed by taking into account different pairs of interlayer thicknesses. In the present study, nine pairs have been utilized for each of four oxidation rates. As an example, Table 1 shows how the computed values of the diffusion coefficients depend on the various couples of interlayers employed. For the set of experiments carried out at pH 10, 10·7 and 11·5, the mean values of the overall diffusion coefficients were found to be:

$$\begin{aligned} &\text{pH 10} &&D = 1\cdot2 \times 10^{-6} \text{ cm}^2 \text{ s}^{-1} \\ &\text{pH 10·7} &&D = 1\cdot6 \times 10^{-6} \text{ cm}^2 \text{ s}^{-1} \\ &\text{pH 11·5} &&D = 4\cdot3 \times 10^{-6} \text{ cm}^2 \text{ s}^{-1}. \end{aligned}$$

The calculated curves obtained from these mean values are found to agree with the experimental curves for thicknesses ranging from about 5 to 40 $\mu$m but for thinner interlayers the agreement is not satisfactory (Figs. 3, 4, 5). It has not been possible to determine accurately the

**Table 1**

**Diffusion constants and interlayer thickness**
**(0·3 mA and pH = 10·7)**

| Interlayer thickness ($\mu$m) | | Calculated constant $\times 10^6$ |
|---|---|---|
| 1 | 2 | |
| 10 | 20 | 1·37 |
| 10 | 30 | 1·38 |
| 10 | 40 | 1·48 |
| 15 | 25 | 1·45 |
| 15 | 35 | 1·54 |
| 20 | 30 | 1·39 |
| 20 | 40 | 1·38 |
| 25 | 35 | 1·65 |
| 30 | 40 | 1·70 |

reasons for these discrepancies which may be due to the limitations in the assumptions of the mathematical model. The orders of magnitude of the values determined are in good agreement with unpublished results related to the diffusion in gelatin of the reduced species. For the oxidized forms however, no such values are available and our results cannot be compared.

The noticeable increase of the diffusion coefficient with pH may be explained by taking into account the ionization of the sulphonamido group and the related ionized and non-ionized forms. A linear dependence of the diffusion coefficient with hydroxyl concentration is found (Fig. 6). Assuming the sulphonamido ionization constant has the same

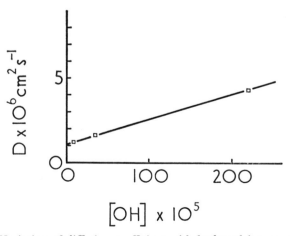

Fig. 6. Variation of diffusion coefficient with hydroxyl ion concentration.

value for the oxidized and the reduced form the diffusion coefficients of the ionized and non-ionized forms can be estimated to be:

for the non-ionized form $D_0 = 10^{-6}$ cm$^2$ s$^{-1}$, and

for the ionized form $D_1 = 4 \cdot 1 \times 10^{-6}$ cm$^2$ s$^{-1}$.

The value of the diffusion coefficient of the non-ionized oxidized developer (quinone diimine) in solution has been published[1] ($D = 5 \cdot 85 \times 10^{-6}$ cm$^2$ s$^{-1}$). The noticeable difference between in-gelatin and in-solution values may be explained by interactions of the diffusing species with gelatin. This observation suggests a method that could be used to study interactions of oxidized developer species with various photographic components (silver-halide grains . . .). For this purpose the component studied would have to be incorporated in the gelatin interlayer.

To summarize, the outlined method appears to be suitable to evaluate the overall diffusional properties of oxidized colour developers and for the first time allows to operate under experimental conditions which are those of the usual photographic conditions.

## References

1. Tong, L. K. J., Liang, K. and Ruby, W., *J. Electroanal. Chem.*, **13,** 245 (1967).
2. Tong, L. K. J., *J. Phys. Chem.*, **58,** 1090 (1954).

# Dihydroxyfuran Developing Agents

## R. W. HENN and I. A. OLIVARES

*Research Laboratories, Eastman Kodak Company, Rochester, N.Y., U.S.A.*

ABSTRACT. Ascorbic acid and hydroxytetronic acid may be thought of as dihydroxydihydrofuranones. Their activity is greatly increased by the substitution of a phenyl group for the dihydroxyethyl group of ascorbic acid. The corresponding imides are active developers. Superadditivity is obtained with combinations of the several dihydroxydihydrofuranones and -furimides with aminophenols and pyrazolidinones.

## INTRODUCTION

Ascorbic acids, for example, araboascorbic acid (I, Table 1), and hydroxytetronic acids, for example, phenylhydroxytetronic acid (II, Table 1), are usually thought of as acid lactones. However, they can also be thought of as 3,4-dihydroxydihydro-2-furanones. As furanones they differ only by the substituent in the 5-position. Similarly the imides (III) and (IV) of Table 1 have a close structural relationship. For convenience we shall hereafter refer to 3,4-dihydroxy-2,5-dihydro-5-phenyl-2-furanone (II) as "Furanone," and 3,4-dihydroxy-2,5-dihydro-2-imino-5-phenylfuran (III) as "Furimide." The L- or D-araboascorbic acid (I) will be referred to as simply "ascorbic acid." And D-glucoiminoascorbic acid (IV) will be referred to as "Ascorbimide." Ascorbic acid and unsubstituted hydroxytetronic acid were described as developers by Maurer and Zapf in 1935.[1] The ready availability of L-ascorbic acid, the vitamin, and its optical isomer, named variously as iso-ascorbic acid, D-araboascorbic acid, xyloascorbic acid and erythorbic acid, has led to its employment in numerous theoretical investigations and some practical applications. Hydroxytetronic acid, as such, has found little use, but a facile preparation of 5-substituted imides from aromatic or heterocylic aldehydes, glyoxal, and a salt of hydrocyanic acid[2] has made III and various homologs readily available. This preparation is shown in Eq. 1.

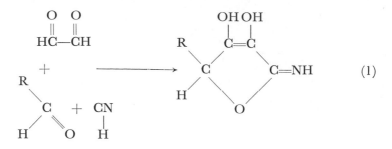

$$(1)$$

As written, this is purely a rearrangement reaction and uses all of the entering atoms. The imide is converted to the oxo compound by controlled oxidation-reduction reactions.[2,3] A number of patents have been issued on antioxidant or developing properties of II and III and their analogues.[3] Iminoascorbic acids are also known developing agents. However, no description of kinetics relative to common developers has been published. This description is the object of our paper.

## EXPERIMENTAL PROCEDURES

Rate determinations were made with Kodak Fine Grain Positive Film exposed to a step wedge and developed with high agitation at 20°C on the "wheel" designed by Henn *et al.*[4] for investigating experimental photographic chemicals. Each sensitometric strip requires only 12 ml of developer and results are uniform and reproducible. In experiments

**Table 1**
**Structures**

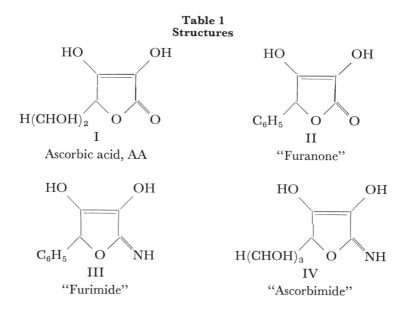

I
Ascorbic acid, AA

II
"Furanone"

III
"Furimide"

IV
"Ascorbimide"

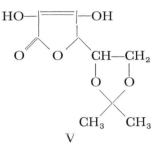

where silver determinations were made, a larger strip was needed and a nitrogen burst apparatus was substituted for the wheel. The basic developer contained 0·02 mol of the agents, 0·2 mol of sodium sulphite and 0·2 mol of an appropriate buffer. Sodium carbonate was used as a

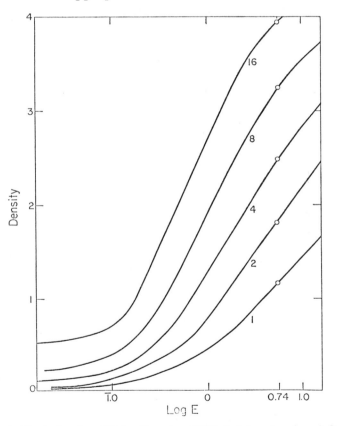

Fig. 1. Typical series of D-log E curves. N-Methyl-*p*-aminophenol, 0·02 *M* at pH 10. Developing times in minutes given on curves. Density of 4th exposure step, $D_4$, circled.

buffer for pH 10, sodium phosphate at pH 11·5, and sodium hydroxide at higher pH levels. The reduction potential measurement employed is the anodic peak potential, $E_p^a$, in reference to a calomel electrode. The more negative the value, the stronger the reducing agent. pK Measurements were determined with conventional acidimetry. Stability measurements excluded air and the loss of activity is presumed due to hydrolysis and not to oxidation.

## RESULTS
### The Density Log Time Plot

Density-time curves may, as James and Mees point out,[5] be linear, convex, or concave. It is not uncommon to associate linear results with very dilute developers and linearity is obtained in many theoretical studies. However, the curves obtained in practical work are usually convex, showing a larger increment of development, say, between 2 and 3 min than between 5 and 6 min. In order to get uniformly spaced curves the worker will select a more-or-less exponential time series, as is indicated in Fig. 1 for N-methyl-*p*-aminophenol.*

* Kodak Elon Developing Agent, hereafter denoted as Elon.

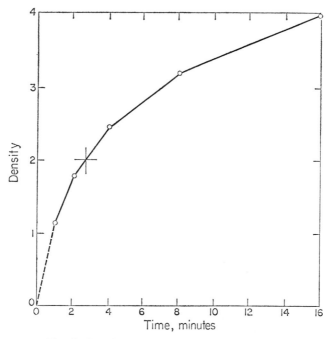

Fig. 2. Density ($D_4$)-time plot of values for Fig. 1.

A density-time plot for the step at 5·5 c.m.s. is given in Fig. 2. Slope changes continuously with time. It cannot be expressed as a simple rate function. Similarly, we have not had much success employing the log residual silver-time plot of Willis and his associates. However, a density-log time plot does indeed produce a conveniently linear result with many of our data (Fig. 3). Much the same result is obtained if developed silver

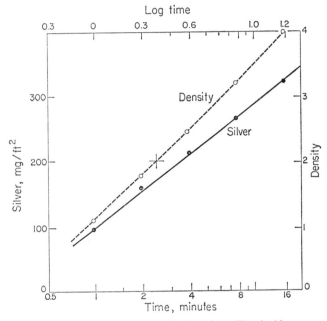

Fig. 3. Density ($D_4$)-log time plot of values from Fig. 1. Also corresponding silver values.

is plotted rather than density (solid line in Fig. 3). The density-log time plot has been previously employed by Elvegaard[6] and by Henn,[7] and will be used throughout this paper. It has advantages inherent in any linear plot and allows the use of an extended time scale. A full degree of development corresponding to a density of 2·0 at 5·5 c.m.s. is used as a basis of developer comparison, and the time needed to reach this density is a measure of the activity. The density at this step will be denoted as $D_4$, since it is the 4th step of the wedge used.

## Properties, Alone

Ascorbic acid develops only after a considerable induction period and is a weak agent below its $pK_2$ of about 11·8 (Tables 2 and 3, Fig. 4). It requires 7·3 min at pH 11·5 for $D_4$ to reach 2·0. In contrast, Furimide

is an active agent, comparable to aminophenols. Its $pK_1$ is 9·75 and it gains most of its activity by pH 10, developing in 2·65 min. This compares with 2·75 min for Elon. However, the two agents reach this degree

### Table 2
**Physical constants**

| No. | Name | $pK_1$ | $pK_2$ | $E_p{}^a$ |
|-----|------|--------|--------|-----------|
| I | Ascorbic acid | 4·27 ± 0·05 | 11·79 ± 0·04 | −127 |
| II | Furanone | 3·96 ± 0·02 | 11·70 ± 0·03 | −117 |
| III | Furimide | 9·75 ± 0·05 | 11·7 ± 0·1 | −144 |
| IV | Ascorbimide | 9·89 ± 0·02 | 11·5 ± 0·3 | −205 |

### Table 3
**Developing properties, alone**

| | Agent | pH | Time (min) | $D_4$ | Fog (gross) | Induction $t_0$ min |
|---|-------|-----|-----------|-------|-------------|---------------------|
| I | AA | 10·0 | 32·5 | 2·00 | 0·10 | 13·0 |
| II | Furanone | 10·0 | 5·35 | 2·00 | 0·06 | 1·0 |
| III | Furimide | 10·0 | 2·65 | 2·00 | 0·15 | 0·65 |
| IV | Ascorbimide | 10·0 | 9·0 | 2·00 | 0·14 | 2·4 |
| | Elon | 10·0 | 2·75 | 2·00 | 0·07 | 0·36 |
| | Hydroquinone | 10·0 | 12·4 | 2·00 | 0·08 | 3·5 |
| I | AA | 11·5 | 7·3 | 2·00 | 0·09 | 3·00 |
| II | Furanone | 11·5 | 2·5 | 2·00 | 0·08 | 0·60 |
| III | Furimide | 11·5 | 2·0 | 2·00 | 0·43 | 0·65 |
| | Elon | 11·5 | 1·7 | 2·00 | 0·11 | 0·30 |
| | Hydroquinone | 11·5 | 3·3 | 2·00 | 0·12 | 0·86 |

of development by somewhat different routes (Fig. 5); the tetronimide developer has a longer induction period and is more sensitive to changes in time and concentration. It also produces more fog, especially at higher pH (Table 3).

The properties of Furanone are reminiscent of those of both ascorbic acid and Furimide. Its pK values are close to those of ascorbic and it is also pH dependent; for example, the time drops from 5·35 min at pH 10 to 2·5 min at pH 11·5 and then becomes fairly constant (Fig. 6). It has low fogging propensity. But its high activity is reminiscent of the tetronimide and of aminophenols.

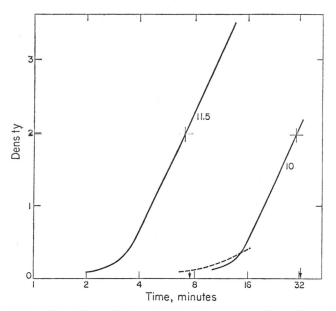

Fig. 4. Ascorbic acid at pH 10 and 11·5. The curve at pH = 12·8 is close to that at 11·5. The dotted curve is for fog at pH 11·5.

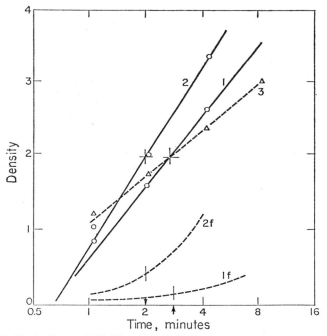

Fig. 5. Furimide at pH 10 (1) and 11·5 (2). The solid lines are for the density of the 4th step, the dashed lines (1f and 2f) for fog. Curve 3 is for Elon at pH 10

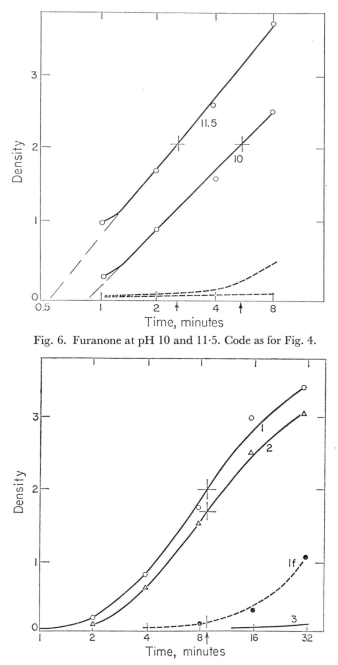

Fig. 6. Furanone at pH 10 and 11·5. Code as for Fig. 4.

Fig. 7. Ascorbimide at pH 10. Curves 1 and 1f, density and fog, fresh, Curve 2, density after ageing 8 weeks at 22°C, and Curve 3, density after ageing 1 day at 100°C.

Ascorbimide is a more rapid developing agent than ascorbic acid taking, for example, only 9 min at pH 10·0 vs. 33 for the ascorbic acid. It has a fairly low induction period, in the order of 1 min. It produces moderate fog and does not yield a very linear density-log time plot (Fig. 7).

## Superadditivity

The members of this furan group are superadditive with aminophenols and pyrazolidinones, rather than with hydroquinone. This is indicated in Figs. 8–11 and Table 4. Ascorbic acid has a very long

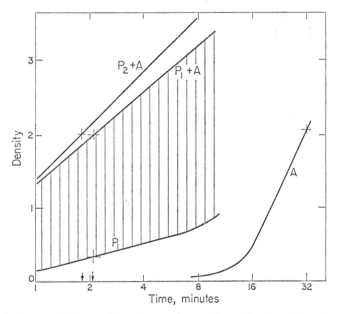

Fig. 8. Superadditivity, Phenidone + ascorbic acid. $P_1$ = Phenidone at 0·002 $M$; A = ascorbic acid at 0·02 $M$; $P_1$ + A = combination. Shaded area shows superadditivity. $P_2$ + A = 0·002 $M$ Phenidone + 0·02 $M$ ascorbic acid.

induction period at pH 10 whereas Phenidone† gives little density so that the vigorous development afforded by the pair is one of the well-known examples of superadditivity. Furimide, however, has a rather short induction period, 0·65 min at pH 10, and the increase in rate and moderate superadditivity produced by Phenidone come as a surprise. In contrast, Elon and Phenidone together are not superadditive and

† Ilford trademark for 1-phenyl-3-pyrazolidinone.

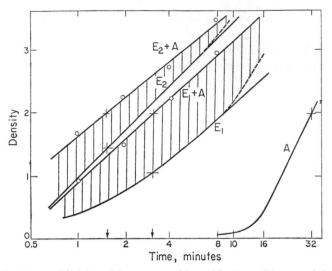

Fig. 9. Superadditivity. Elon + ascorbic acid. $E_1$ = Elon at 0·002 $M$, $E_2$ = Elon at 0·02 $M$. A = ascorbic acid at 0·02 $M$. Dashed line gives linear additivity, Superadditive areas are shaded.

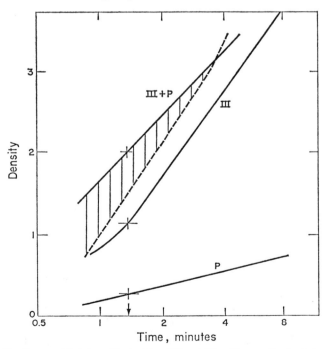

Fig. 10. Superadditivity, Furimide, III, +Phenidone, P. Activity alone and in combination. Code as for Fig. 9.

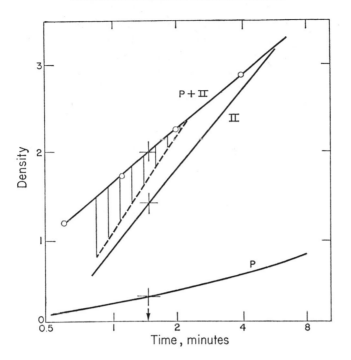

Fig. 11. Superadditivity, Furanone, II, +Phenidone, P. Activity alone and in combination. pH = 11·5. Code as for Fig. 9.

## Table 4

### Superadditivity

| Time (min) | pH | First agent Nature | First agent Concn. | First agent Density $D_a$ | Second agent Nature | Second agent Concn. | Second agent Density $D_b$ | $D_c$ | Combination Superadd. $D_c - (D_a + D_b)$ |
|---|---|---|---|---|---|---|---|---|---|
| 2·05 | 10 | I | 0·02 | 0·00 | Ph | 0·002 | 0·35 | 2·00 | 1·65 |
| 1·7 | 10 | I | 0·02 | 0·00 | Ph | 0·02 | 0·85 | 2·00 | 1·15 |
| 3·3 | 10 | I | 0·02 | 0·00 | E | 0·002 | 1·12 | 2·00 | 0·88 |
| 1·5 | 10 | I | 0·02 | 0·00 | E | 0·02 | 1·35 | 2·00 | 0·65 |
| 1·70 | 11·5 | II | 0·02 | 1·50 | P | 0·002 | 0·22 | 2·00 | 0·28 |
| 1·35 | 10 | III | 0·02 | 1·10 | P | 0·002 | 0·15 | 2·00 | 0·75 |

indeed, exhibit antagonism. Furanone also shows moderate super-additivity. In these plots we are using as a measure of superadditivity the production of more density by the combination than by the separate developing agents. This is an entirely valid type of superadditivity but we can alternatively compare conventional density-time rates and obtain much the same data. See Table 5.

### Table 5
**Expression of superadditivity in terms of rates (dD/dt)**
**for D = 1·0, at pH 10**

| First agent | | | Second agent | | | Combination Superadd. | |
|---|---|---|---|---|---|---|---|
| Nature | Concn. | Rate, $R_1$ | Nature | Concn. | Rate, $R_2$ | Rate, $R_3$ | $R_3/(R_1 + R_2)$ |
| P | 0·002 | 0·025 | AA | 0·02 | 0·11 | 1·6 | 10X |
| P | 0·02 | 0·30 | AA | 0·02 | 0·11 | 1·5 | 3·7X |
| E | 0·02 | 1·0 | AA | 0·02 | 0·11 | 2·1 | 1·9X |
| E | 0·002 | 0·255 | AA | 0·02 | 0·11 | 0·9 | 2·5X |
| P | 0·002 | 0·025 | II* | 0·02 | 0·88 | 1·68 | 1·9X |
| P | 0·002 | 0·025 | III | 0·02 | 0·76 | 2·1 | 2·7X |

\* pH = 11·5

The superadditivity of Elon + ascorbic acid vs. Phenidone + ascorbic acid provides some interesting thoughts as to the nature of super-additivity. Phenidone at a concentration of 0·002 $M$ when added to 0·02 $M$ ascorbic acid produces much the same activity as it does at a 0·02 $M$ concentration. The superadditivity is less for the higher concentration (Tables 4 and 5) because Phenidone develops more by itself. A combination of 0·02 $M$ Elon with 0·02 $M$ ascorbic acid produces the most active developer of the group, a matter of practical importance. But this mixture has the least superadditivity.

### Structural Variants

Araboascorbic acid is a dihydroxydihydrofuranone containing a dihydroxyethyl substituent in the 5-position. There are ascorbic acids containing 2, 3, or 4 carbon atoms in the side chain and they may be D- or L-rotary. We are under the impression that these are fairly similar in activity. Induction period and rates are affected by esterification in the side chain or by formation of the ketal, V. However, although V develops more actively by itself than I (9·5 vs. 33 min at pH 10), developers containing Phenidone and V or I develop at almost the same rate (2·4 and 2·05 min).

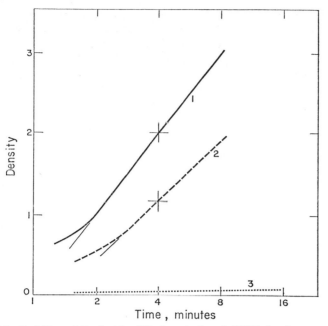

Fig. 12. Stability of Furimide, III, in solution (pH 10) in absence of air.
Curve 1, density response of fresh developer; Curve 2, density response after
7 days at 22°C. Curve 3, density response after 7 days at 60°C and 1 day at
100°C.

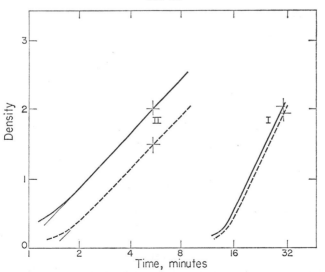

Fig. 13. Stability of ascorbic acid (I) and Furanone (II) in pH 10 solution
in the absence of air. Solid lines, density response of fresh developer. Dashed
lines, effect of aging 1 day at 100°C.

The largest effect on activity is obtained when aromatic groupings are substituted for the aliphatic grouping, that is, II vs. I. The tolyl compound is approximately as active as the phenyl.

The activity of the hydroxytetronimides is also dependent on the nature of the substituents. The data of Table 6 apply to development at pH 10. The most active compounds of this group are the phenyl, tolyl and pyridyl.

### Table 6
#### Rate data, variously substituted dihydroxyiminofurans
#### (0·2 $M$*, pH 10)

| Substituent | Time (min) | $D_4$ | Fog |
|---|---|---|---|
| 5-Phenyl (No. 111) | 2·8 | 2·00 | 0·12 |
| 5-p-Tolyl | 3·5 | 2·00 | 0·11 |
| 5-o-Chlorophenyl | 5·0 | 2·00 | 0·11 |
| 5-(2,4-Dichlorophenyl) | 22·5 | 2·00 | — |
| 5-Pyridyl | 2·7 | 2·00 | 0·24 |
| 5-(3,4-Methylenedioxyphenyl) | 19·2 | 2·00 | — |

* Solubility imperfect

### Stability in Solution

The common aromatic developing agents are indefinitely stable in alkaline solution if protected from the air. This is not true of many aliphatic and heterocyclic developing agents. For example, Alletag[8] has reported that Phenidone hydrolyses slowly in alkaline solution. And this proves to be the weakness of most of the dihydroxydihydrofurans.

Solutions of compounds I–IV at pH 10 were held at various temperatures in the absence of air. Photographic activity was then compared with that of the fresh solutions (Figs. 12 and 13). The effect on the Elon and hydroquinone controls was negligible but in the furan series activity was lost increasingly in the order; ascorbic acid < Furanone < Ascorbimide < Furimide. Ascorbic acid is very stable at this pH and Furanone hydrolyses slowly; it is stable for a few weeks at room temperature. But the rapid loss of activity of alkaline solutions of Furimide limits its use to a matter of a day or two at room temperature. This is a pH-dependent reaction and proceeds more slowly at lower pH but is still appreciable at pH 5·5.

## ACKNOWLEDGEMENT

We are grateful to Messrs. C. J. Battaglia, L. A. Blais, and C. V. Wilson of the Kodak Research Laboratories for the electrochemical measurements and for synthesis of compounds.

### References

1. Maurer, K. and Zapf, G., *Photogr. Ind.*, **33**, 90 (1935).
2. Dahn, H., Lawendel, J. S. and Schenker, E., *Helv. Chim. Acta*, **37**, 1309 (1951); **39**, 1366 (1956).
3. (a) Brit. 783,727, Ilford (1955); (b) Brit. 830, 625 (1957); (c) German 1,178,705, Agfa (1963); (d) Fr. 1,404,043, Ilford (1964); (e) Belg. 653,289, Kodak (1963); (f) Brit. 1,070,301 Kodak (1963).
4. Henn, R. W. and Hughes, K. R., *Photogr. Sci. Eng.*, **2**, 81 (1958).
5. James, T. H., in "The Theory of the Photographic Process." 3rd Ed., (C. E. K. Mees and T. H. James, Eds.), Macmillan, New York, 1966, p. 351.
6. Elvegaard, E., *Z. Wiss. Photogr.*, **41**, 81 (1943).
7. Henn, R. W., *PSA Journal (Photogr. Sci. Tech)*, **18B**, 51, 90 (1952).
8. Alletag, G. C., *Photogr. Sci. Eng.*, **2**, 213 (1958).

# Superadditivity Effects in the Photographic Bleaching Process

## J. F. WILLEMS

*Photochemical Research Department Agfa-Gevaert N.V., Mortsel, Belgium*

ABSTRACT. In much the same way as the development of silver halide by developer dianions e.g. hydroquinone, the oxidation of developed silver by negatively charged oxidizing agents e.g. persulphate dianions, is highly activated by onium compounds that penetrate into the negative barrier layer. Positively charged oxidizing agents, however, are not activated. In addition to this colloidochemical phenomenon and again on the analogy of the hydroquinone development other regeneration phenomena take place with reversible redox systems that possess an appropriate redox potential.

## INTRODUCTION

In applied photography it may sometimes be necessary that the developed silver is eliminated during one of the subsequent processing steps. This is the case in "toning", in reversal development, and especially in the processing of colour material.

The elimination of the silver is primarily based on an oxidation-reaction and it is the inverse process of the development (I).

$$
\begin{array}{c}
-1e \\
\text{bleaching} \\
\text{oxidation} \\
Ag \xrightarrow{\phantom{xxxxx}} Ag^+ \\
\xleftarrow{\phantom{xxxxx}} \\
\text{reduction} \\
\text{development} \\
+1e
\end{array}
\qquad (I)
$$

In practice potassium dichromate, potassium hexacyanoferrate (III), and the iron (III) chelate of ethylenediamine tetraacetic acid are used.

223

Bleaching baths essentially consisting of potassium persulphate, which is a very active and colourless oxidizing agent, are not common in applied photography.

In view of the very favourable redox potential of the persulphate system (II) as compared with that of e.g. the dichromate system (III) and the hexacyanoferrate (III) system (IV) this may cause some surprise.

## Table 1

| Structure of the compounds | No. of the compound | Structure of the compounds | No. of the compound |
|---|---|---|---|
| pyridinium, N–$C_2H_5$ · $Cl^{\ominus}$ | 1 | $H_3C$–N⊕ bipyridinium ⊕N–$CH_3$ · $2\,Cl^{\ominus}$ | 9 |
| pyridinium, N–$C_{12}H_{25}$ · $Cl^{\ominus}$ | 2 | bipyridinium, $CH_2$—$CH_2$ · $2\,Br^{\ominus}$ | 10 |
| $nC_3H_7$–N⊕($CH_3$)($CH_3$)–$(CH_2)_6$–N⊕($CH_3$)($CH_3$)–$C_3H_7n$ · $2\,C_7H_7SO_3^{\ominus}$ | 3 | bipyridinium, $CH_2$—$CH_2$ · $S_2O_8^{\ominus\ominus}$ | 10bis |
| $^{\ominus}O_3S$–$C_3H_6$–N⊕($CH_3$)($CH_3$)–$(CH_2)_6$–N⊕($CH_3$)($CH_3$)–$C_3H_6$–$SO_3^{\ominus}$ | 4 | bipyridinium, $CH_2$($CH_2$)—($CH_2$)$CH_2$ · $2\,Br^{\ominus}$ | 11 |
| dipyridinium, $CH_2$—$CH_2$—$CH_2$—$CH_2$ · $2\,Cl^{\ominus}$ | 5 | benzothiazolyl-pyridinium, $CH_2$——$CH_2$ · $2\,Br^{\ominus}$ | 12 |
| dipyridinium, $CH_2$—$CH_2$—S—$(CH_2)_6$—S—$CH_2$—$CH_2$ · $2\,ClO_4^{\ominus}$ | 6 | ⊕N($C_2H_5$)–CH=CH–N⊕($C_2H_5$) · $2\,C_7H_7SO_3^{\ominus}$ | 13 |
| quinolinium, $CH_2$–($NO_2$-phenyl) · $Cl^{\ominus}$ | 7 | $H_5C_2$–N⊕ –CH=CH– ⊕N–$C_2H_5$ · $2\,C_7H_7SO_3^{\ominus}$ | 14 |
| $H_3C$,$H_3C$–S⊕–$(CH_2)_6$–S⊕–$CH_3$,$CH_3$ · $2\,Br^{\ominus}$ | 8 | ⊕N($C_2H_5$)–CH=CH–⊕N($C_2H_5$)$C_2H_5$ · $2\,C_7H_7SO_3^{\ominus}$ | 15 |

In practice, however, it appears that persulphate solutions with or without bromide ions are almost incapable of bleaching away developed silver.

$$S_2O_8^{--} + 2e \rightarrow 2SO_4^{--} \qquad\qquad\qquad\qquad +2\cdot01\ V \quad (II)$$

$$Cr_2O_7^{--} + 14H^+ + 6e \longrightarrow 2Cr^{+++} + 7H_2O +1.33\ V \quad (III)$$

$$Fe(CN)_6^{3-} + e \longrightarrow Fe(CN)_6^{4-} \qquad\qquad +0.36\ V \quad (IV)$$

Since the active component for the oxidation is a negative ion carrying two charges, we examined whether the inhibition of the oxidation could not be due to a colloidochemical phenomenon.

**Table 1**—*(contd.)*

| Structure of the compounds | No. of the compound |
|---|---|

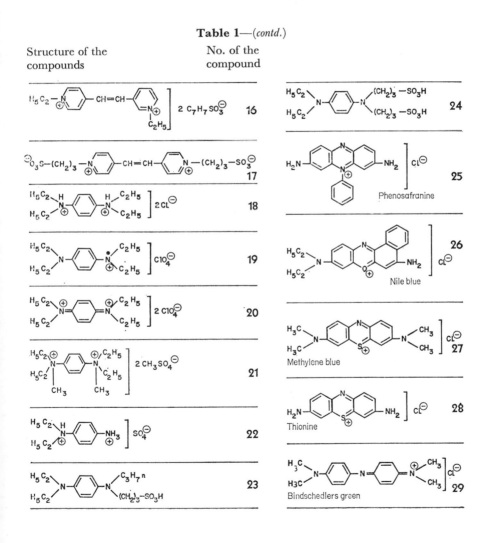

As appeared from studies[1,2,3] made on silver particles in the absence and in the presence of gelatin, we may assume that the developed silver contains a negatively charged electric double layer.

Electrophoretic measurements on the developed silver particles of the Positive Fine Grain Film Emulsion of Agfa-Gevaert N.V. used in this study result in a zeta potential of −25 mV.[4]

Therefore it seems not to be excluded that the same phenomena (inhibition of the development) occurring during the development of negatively charged silver halide emulsions with negatively charged developing agents e.g. hydroquinone, might manifest themselves here too with negatively charged oxidizing agents (inhibition of the bleaching).

## EXPERIMENTAL

### 1. Bleaching-accelerators

The bleaching-accelerators used are listed in Table 1. They were prepared according to known methods described in the literature.

### 2. Bleaching Tests

The photographic material used was the Positive Fine Grain Film of Agfa-Gevaert N.V. The film was exposed uniformly, treated in a Metol-hydroquinone developer to obtain a density of 2·4, fixed in the usual way, washed and dried.

The bleaching baths had the following composition:

1. *Persulphate bath.* 45 g of potassium persulphate and 2·5 g of potassium bromide per litre. The pH was adjusted to 3·1. If the accelerators were used in their bromide form, the potassium bromide concentration had to be adapted accordingly.

2. *Potassium hexacyanoferrate* (III) *bath.* 10 g of potassium hexacyanoferrate (III) and 2·5 g of potassium bromide per litre. The pH was adjusted to 6·4.

3. *Copper* (II) *chloride bath.* 5 g of copper(II) chloride and 2·5 g of potassium bromide per litre. The pH was adjusted to 4·3.

4. *Iron* (III) *ethylenediamine tetraacetic acid bath.* 19 g of the sodium salt of the iron (III) chelate of ethylenediamine tetraacetic acid per litre, 6·3 g of the tetrasodium salt of ethylenediamine tetraacetic acid per litre, 55 g of ammonium thiosulphate per litre, 5 g of sodium sulphite and 2·5 g of ammonium thiocyanate per litre. The pH was adjusted to 7.

The examined compounds were added, unless otherwise indicated, in a concentration of 2·66 millimol per litre.

The bleaching times at 20°C were varied as indicated in the different figures. After bleaching the tests were fixed, rinsed and dried.

## 3. Redox Properties

The values used for the electrochemical potentials of the redox indicators are those mentioned by W. M. Clark.[5]

## RESULTS

Figure 1 proves that potassium persulphate baths containing bromide ions bleach developed silver halide film but very slowly. The omission of bromide ions slightly improves the action of the persulphate, though the bleaching remains very slow anyway.

Various onium compounds considerably accelerate the bleaching out of the silver. Ethyl-pyridinium chloride (compound 1) and N,N'-tetramethyl—N,N'-di-3-sulphopropylhexamethylenediamine betaine (compound 4) are practically inert, whereas dodecylpyridinium chloride (compound 2) and N,N'-tetramethyl-N,N'-dipropyl-hexamethylenediamine ditolusulphonate (compound 3) have an accelerating influence on the bleaching process. Lauryl pyridinium chloride, in the concentration used, crystallizes after a few minutes.

The bispyridinium compounds (compounds 5 and 6) and m-nitro-benzyl-quinolinium bromide (compound 7) also highly activate the persulphate bleaching.

The most active compounds are 1,1'-dimethyl-4,4'-dipyridylium dichloride (compound 9), 1,1'-ethylene-2,2'-dipyridylium dibromide (compound 10) or the corresponding persulphate (compound 10 bis), and the 6,7-dihydrobenzothiazolo [2,3-a] pyrido[1,2-a] pyrazinium dibromide (compound 12), which are compounds that are known to form stable Weitz-radicals (Fig. 2). The analogous vinyl compounds are comparable with the highest activating onium compounds of Fig. 1. The ortho-ortho (compound 13), the meta-para (compound 16), the ortho-para (compound 15) as well as the para-para derivative (compound 14) are active. Also, 1,1'-tetramethylene-2,2'-dipyridylium dibromide (compound 11), which just like the above-mentioned meta-para-derivative (compound 16) cannot form stable radicals, accelerates the bleaching. The betaine (compound 17), however, as compared with compound 14 is but slightly active.

It is to be noted that all these onium compounds when used alone are not capable of bleaching silver. The influence of the concentration of the highly activating compound 10 is plotted in Fig. 3. Very weak concentrations suffice already to bring about an important activation. At the same time the influence of the initial density of the developed silver was

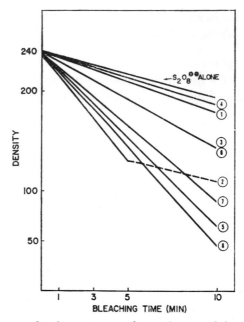

Fig. 1. Influence of onium compounds on the persulphate bleaching of
developed silver.

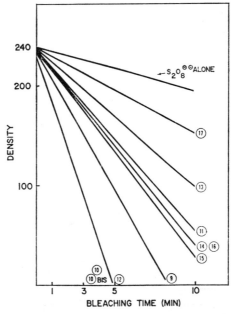

Fig. 2. Influence of onium compounds, forming stable Weitz radicals on the
persulphate bleaching of developed silver.

examined. The results are given in Fig. 4 for initial densities $d = 1\cdot4$ and $d = 0\cdot80$, whereas the linear dependency of the bleaching as against the logarithm of the concentration of the activator can be read in Fig. 5.

In view of the surprising analogy in the action of the examined onium compounds in the bleaching process with persulphate on the one hand and the activation of the development of silver bromide layers with

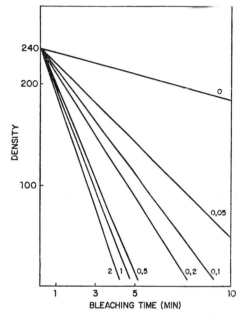

Fig. 3. Influence of the concentration of compound 10 on the persulphate bleaching of developed silver.

hydroquinone on the other hand, some superadditive developing agents of the p-phenylenediamine type, which possess a pronounced reversible oxidation-reduction system (V) and the oxidation products S and Q of which are a positively charged cation, were examined also.

$$R \rightleftarrows S \rightleftarrows Q \qquad\qquad (V)$$

The results for the bleaching can be found in Fig. 6 and those for the development in Fig. 7.[6] In order to visualize the analogy more clearly yet, the density is plotted in the abscissa in falling line (Fig. 6).

N,N'-tetraethyl p-phenylenediamine hydrochloride (compound 18) is the most active compound. The addition of R (compound 18), S (compound 19) or Q (compound 20) has no importance actually, since R and/or S are oxidized anyway by the persulphate to Q.

9

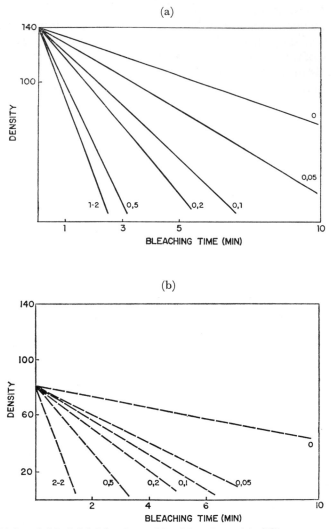

Fig. 4(a) and (b). Initial density *vs.* bleaching time with different concentrations of compound 10.

The activation caused by the diquaternary salt (compound 21), which has an analogous structure and which is not involved in a similar redox equilibrium, is not that pronounced anymore.

The activation power of N,N-diethyl-p-phenylenediamine sulphate (compound 22), which forms less stable semiquinones than the tetraethyl derivative (compound 18), is markedly inferior. The introduction

of one (compound 23) or two sulpho groups (compound 24) in the tetra-alkyl derivative, whereby a monocation and a betaine are formed, results in a reduction (compound 23) and a stopping of the bleaching (compound 24) (and of the development)[7] in analogy with the quaternary salts and the betaines thereof (Fig. 1, compound 3, 4— Fig. 2—compound 14, 17).

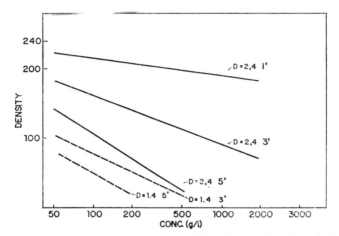

Fig. 5. Dependency of the persulphate bleaching in function of the concentration of compound 10 for different initial densities and different bleaching times.

Also photoreducible dyes of the phenazine (compound 25), oxazine (compound 26), thiazine (compounds 27 and 28), and the indoaniline type (compound 29), which are involved in a reversible redox-equilibrium and which are known to accelerate considerably the development of negatively charged developing agents (hydroquinone, ascorbic acid, sodium hydrosulphite) when their working potential is more positive than that of the main developing agent,[8] exert an activating influence on the bleaching by means of persulphate when their own working potential is more positive than that of the $Ag/Ag^+$ system.

From Fig. 8 we learn that Phenosafranine (compound 25) and Nile Blue (compound 26) are practically inactive and that the activation power increases in the following sequence: Methylene blue (compound 27), Thionine (compound 28), N,N'-tetraethyl-p-phenylenediamine (and oxidation products) (compounds 18, 19 and 20) and Bindschedler's green (compound 29).

The extent of the activation is almost equivalent to the respective redox potentials (Fig. 9).

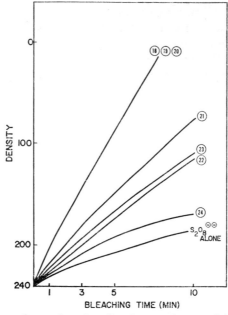

Fig. 6. Influence of paraphenylenediamines on the persulphate bleaching of developed silver.

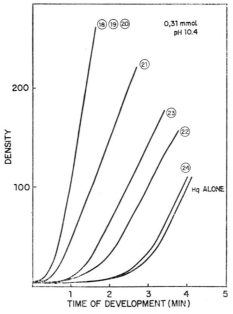

Fig. 7. Influence of paraphenylenediamines on the hydroquinone development of silver halides.

Although some of these redox indicators are oxidizing agents themselves, their bleaching action, without persulphate, in the concentration used is but weak.

The bleaching action of compound 20 is plotted in Fig. 10 as a function of the concentration for a bleaching time of 1 to 5 min.

To allow an exact evaluation of the observed facts the influence of some onium compounds on the bleaching rate of positively charged oxidizing agents such as potassium hexacyanoferrate(III) and copper(II) chloride was examined as well.

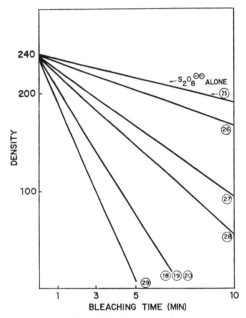

Fig. 8. Influence of photoreducible dyes on the persulphate bleaching of developed silver.

The results obtained with potassium hexacyanoferrate(III) plotted in Fig. 11 prove that the onium compounds, which activate the bleaching with persulphate, inhibit the bleaching with hexacyanoferrate (III). Corresponding betaines, however, are almost inert (compare compounds 3 and 4 and compounds 14 and 17). Also the oxidation products of N,N'-tetraethyl-p-phenylenediamine (compounds 19 and 20), which highly activate the bleaching with persulphate, inhibit the bleaching with hexacyanoferrate(III). This inhibition is eliminated also by the introduction of two sulpho groups (betaine; compound 24). The bleaching with copper(II) chloride (see Fig. 12) presents the same picture. The very important activation by compounds 10 and 14 of the

bleaching with persulphate changes into a marked inhibition of the bleaching with copper(II) chloride.

Finally, some results of the bleaching with another iron(III) salt i.e. the iron(III) chelate of ethylene diamine tetraacetic acid, are plotted in Fig. 13. This oxidizing agent is activated by onium compounds (compounds 9, 10, 11 and 14) though to a smaller extent, and not influenced at all by betaines (compound 17).

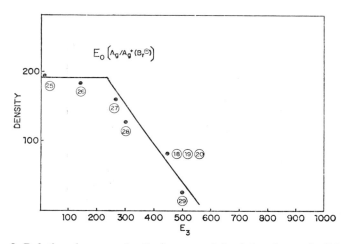

Fig. 9. Relations between the Redox potentials of the photoreducible dyes and the persulphate bleaching activation.

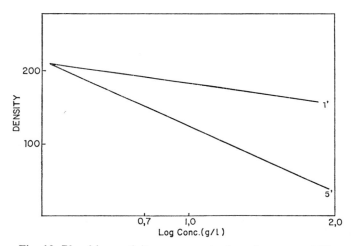

Fig. 10. Bleaching activity *vs.* concentration of compound 20.

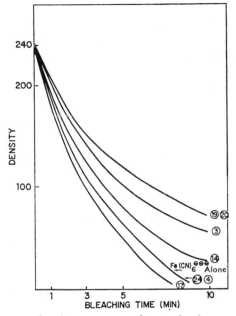

Fig. 11. Influence of onium compounds on the hexacyanoferrate(III) bleaching of developed silver.

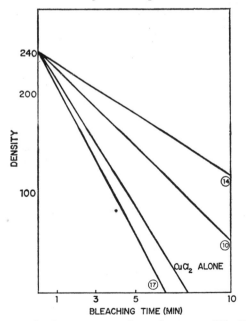

Fig. 12. Influence of onium compounds on the copper(II) chloride bleaching of developed silver.

## DISCUSSION

The oxidation of developed silver by persulphate dianions is highly inhibited by the negative double layer of the developed silver. Compounds capable of penetrating this negative double layer, highly accelerate the bleaching, so that in these circumstances persulphate becomes a suitable bleaching agent for developed silver halide films.

The same structure variables, which have an influence on the photographic development with negatively charged developing agents such as hydroquinone and ascorbic acid, determine the choice of the appropriate onium compounds.[9] Unlike lauryl-pyridinium chloride and m-nitrobenzyl-quinolinium bromide ethyl-pyridinium chloride, without association forces, has no influence on the bleaching rate.

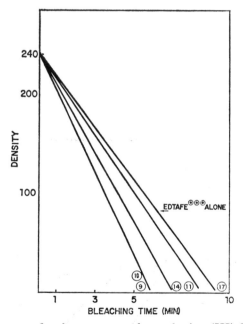

Fig. 13. Influence of onium compounds on the iron(III) EDTA-chelate bleaching of developed silver.

The high activity of bis- onium compounds can be annulled by destroying the onium character through betaine formation. These facts clearly suggest a colloidochemical aspect of the same nature as that we know in the development with negatively charged developing agents.

Positively charged oxidizing agents such as hexacyanoferrate(III) and copper(II) chloride adsorb without hindrance and these oxidizing

agents are not activated. In certain cases they are even inhibited by highly adsorbing onium compounds, probably owing to competitive adsorption.

This phenomenon is also analogous to the development with non-ionic developing agents, such as e.g. p-phenylenediamine.[10]

The fact that the iron(III) chelate of ethylenediamine tetraacetic acid is activated indeed by onium compounds, allows to assume that this compound unlike hexacyanoferrate(III) ions, is active as a negatively charged oxidizing agent.

From the complex formation constant of the hexacyanoferrate(III) we can compute that in the concentration used during the test, $10^{-4.6}$ mol $1^{-1}$ $Fe^{+++}$ ions are present. In the case of the iron(III) chelate of ethylenediamine tetraacetic acid this concentration is but $10^{-8.7}$ mol $1^{-1}$, which is considerably lower, so that the active oxidizing agent is the negatively charged iron chelate (VI):

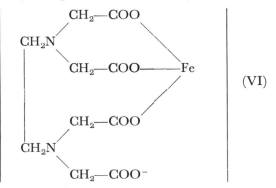

(VI)

In the case of the superadditive development we find in addition to the colloidochemical phenomenon also electrochemical phenomena, which contribute to the overall superadditivity effect. Reducing agents that adsorb in a better way than hydroquinone does, start the development, and as soon as the non-ionic semiquinone formed and adsorbed is stable, this product promotes the adsorption of the negatively charged hydroquinone molecule, whereby the latter transfers its electrons via the absorbed semiquinone to the silver halide crystal. An example of such superadditive system is N,N'-tetraethyl-p-phenylenediamine, the high efficiency of which can be attributed to a colloidochemical as well as to an electrochemical action. The diquaternary salt, which has an analogous structure and which is not involved in such a redox equilibrium, is less superadditive indeed.

The fact that this happens also in the bleaching, raises the presumption that here too electrochemical phenomena may contribute.

Actually, we can imagine that the adsorbed quinonediimonium salt, with a redox potential that is more positive than that of the $Ag/Ag^+$ system, starts the oxidation and is converted into the stable semi-quinone (VII). This semiquinone penetrates into the barrier layer (VIII) and the persulphate dianion can regenerate (oxidize) the semi-quinone in adsorbed condition to form the quinone-diimine (IX).

$$Q^{++} + Ag \longrightarrow Ag^+ + S^+ \tag{VII}$$

$$S^+ \text{ promotes the adsorption of } S_2O_8^{--} \tag{VIII}$$

$$2\,S^+ + S_2O_8^{--} \longrightarrow 2Q^{++} + 2SO_4^{--} \tag{IX}$$

Similar superadditivity effects, though of a smaller extent have been observed already with $Fe^{+++}$ or $Cu^{++}$ salts[11] added to persulphate.

The behaviour of the redox indicators seems to lend support also to the regeneration mechanism.

Superadditivity phenomenons manifest themselves only with redox indicators having a redox potential that is more positive than that of the $Ag/Ag^+$ system. This points to a very close analogy with the behaviour of the redox indicators in the superadditive development with negatively charged developing agents.

## ACKNOWLEDGEMENTS

The author is deeply grateful to Dr. Tavernier and Mr. de Jaeger for helpful discussions and some electrophoretic experiments.

### References

1. Barr, J. and Dickinson, G. O., *J. Photogr. Sci.*, **9**, 222 (1961).
2. Harrison, J. T. and Elton, G. A. H., *J. Chem. Soc.*, 3838 (1959).
3. Hurd, R. M. and Hackerman, N., *J. Electrochem. Soc.*, **103**, 316 (1956).
4. de Jaeger, N., Unpublished results.
5. Clark, W. M., "Oxidation—Reduction Potentials of Organic Systems", Williams and Wilkins, Baltimore (1960).
6. Willems, J. F. and van Veelen, G. F., *Photogr. Sci. Eng.*, **6**, 39 (1962).
7. van Veelen, G. F. and Willems, J. F., *Photogr. Sci. Eng.*, **12**, 41 (1968).
8. Willems, J. F., *Photogr. Sci. Eng.*, **15**, 213 (1971).
9. Willems, J. F., *Wiss. Photogr.*, (Ergebnisse der Intern. Konfer. Wiss. Phot. Koln 1956). Verlag Dr. O. Helwich, Darmstadt, p. 405, (1958). *Sci. Ind. Photogr.*, **27**, 487 (1956).
10. Neuberger, D. and Roberts, H. C., *Photogr. Sci. Eng.*, **12**, 121 (1968).
11. Gunther, E. and Matejec, R., *Photogr. Korrespondenz.*, **104**, 205 (1968).

# The Treatment after Development in Rapid Processing

M. AELTERMAN and G. VANREUSEL

*Research and Development Laboratories, Agfa-Gevaert N.V., Mortsel, Belgium*

ABSTRACT. A study is made of some aspects of the essential photochemical and mechanical parameters of rapid processing systems. Special attention with practical applications is given to fixing and rinsing as they have an important and unexpected influence upon rapid processing.

## INTRODUCTION

The last few years show an increasing trend towards rapid processing not only in medical radiography, but also in the other photographic applications. Rapid access and a good photographic quality are of course the primary requirements, but equally important is the conservation of completely processed film.

Today the total dry-to-dry processing time for medical X-ray films has been reduced to 90 s, but it is a pity that in this sort of race against the clock the main interest of the technicians still goes to the development stage, while the fixing and washing stages are treated in a rather stepmotherly way. This results in complaints regarding the conservation of film records in files or archives. It is obvious that for microfilm for example the fixing and washing stage are of utmost importance.

If moreover the serious actual problem of water shortage is taken into consideration, it will be quite clear that the fixing and washing operation should be submitted to a thorough investigation. The following order has been set for the study of the different aspects and factors of the processing stages.

1. Fixing stage
1.1. The fixing to clearing time ratio; 1.2. The composition of the fixing bath; 1.3. The influence of the agitation; 1.4. The influence of the temperature.

2. Washing stage
2.1. The degree of fixation of the film; 2.2. The water composition; 2.3. The influence of the agitation; 2.4. The influence of the temperature.

## 1. THE FIXING STAGE

The goal of this study is to determine the conditions necessary to obtain a well fixed and well washed film within the time limits available in rapid processing.

### 1.1. Fixing to clearing time ratio

"Good fixing" means that all the non-developed silver halide has been converted into soluble silver thiosulphate complexes. During fixing the emulsion becomes clear. As a rule of thumb, it has been accepted that

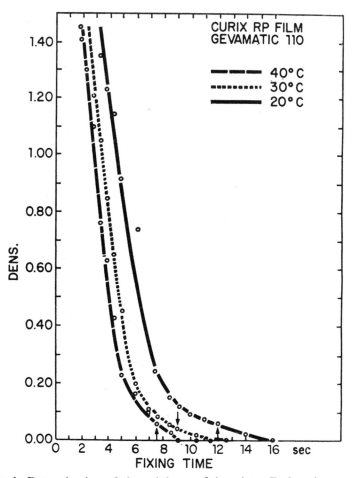

Fig. 1. Determination of the minimum fixing time. Each point on the ordinate gives the density reached for a given fixing time. For each curve the arrow shows the time of complete clearing. Complete fixing is of course obtained at 0·00 density.

the "fixing time" should be at least twice the clearing time. It was desirous to check this practical rule in the case of rapid processing with ammonium thiosulphate fixing baths. In Fig. 1 the results of these tests are shown. In order to check the completeness of fixing, the testing films, after thorough washing, have been redeveloped in a strong developer. The density obtained this way is a measure of residual non-fixed silver halide. This density is set in ordinate against the time of fixing. If the relation of 9 s (complete fixing time) to 7·5 s (complete clearing time) at 40°C and respectively 12 to 9 s at 30°C and 16 to 12 s at 20°C is taken, it will be clear that the rule of thumb, which recommends a factor 2, provides safe fixing values.

## 1.2. The composition of the fixing bath

One of the most important parameters is of course the composition of the fixing bath. The influence on the fixing speed of the ammonium thiosulphate content, the aluminium hardener and the silver content in

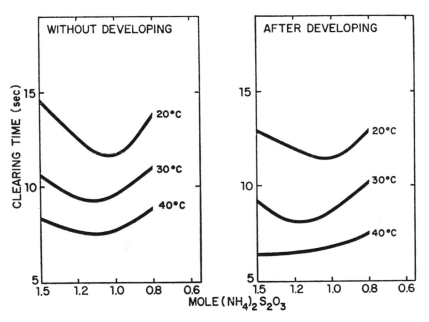

Fig. 2. Influence of thiosulphate concentration on the fixing time. One part of concentrated commercial package with two parts of water equals 1·5 mol of $(NH_4)_2S_2O_3$. One part and three parts of water equals 1·2 mol. One part and 4 parts of water equals 1·0 mol. One part and 5 parts equals 0·8 mol and 1 part plus 7 parts equals 0·6 mol. The clearing time after development is shorter by 10 to 15%, but the trend of the curves is about the same for both procedures (with or without development).

the fixing bath as complex silver ammonium thiosulphate compound have been studied.

### 1.2.1. *Influence of the ammonium thiosulphate content*

In rapid processing the common fixing ingredient is ammonium thiosulphate. It is known from the literature that a maximum fixing speed is reached with a given thiosulphate concentration. It was required to know if this holds true in actual practice. Figure 2 shows the content in mol of $(NH_4)_2S_2O_3$ at various dilutions of the fixing bath G 334.

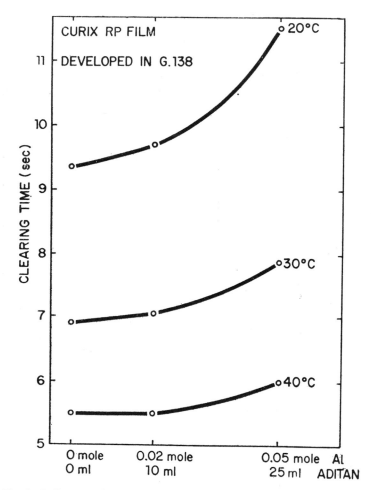

Fig. 3. Influence of the aluminium concentration on the clearing time. Fixing bath: G.334 $(1 + 4)$ or $1 \cdot 0$ mol of $(NH_4)_2S_2O_3$.

This figure shows that the highest fixing speed, therefore the shortest clearing time, is reached for a definite ammonium thiosulphate concentration, and is between 1·0 and 1·2 mol. This optimum content (between 1·0 and 1·2 mol) gives about the shortest clearing times for various emulsions. After developing at 40°C, the curve is very flat. But in normal working conditions with hardener and silver ammonium thiosulphate complexes, a curve very similar to the other ones is obtained (see Fig. 5).

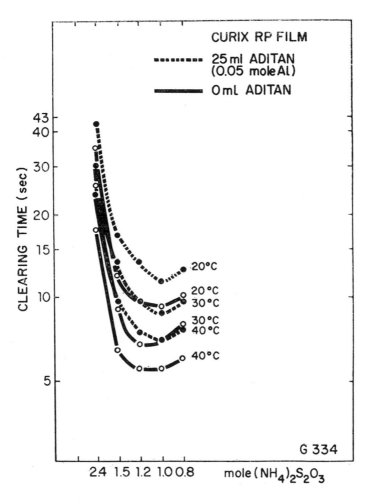

Fig. 4. Influence of the aluminium hardening on the clearing time. The clearing time is plotted in a logarithmic scale.

### 1.2.2. *Influence of the aluminium hardener*

Rapid processing is normally carried out at developing bath tempera-
ture of 30° to 40°C and at a comparatively high pH. In order to keep
the mechanical characteristics of gelatin between acceptable limits
when processing in this way, an aluminium hardener in the fixing bath
is needed. As this hardening is a part of the practical conditions in rapid
processing, its influence on the fixing speed has been examined. The
influence of the aluminium hardener is shown in Fig. 3. The slowing-
down effect of the aluminium hardener can be quite clearly seen. In
Fig. 4 it can be seen that the influence of the aluminium hardener on the
trend of the clearing time curve is not very strong. The curves are only
shifted to longer times and the optimum thiosulphate concentrations are
slightly shifted towards a lower concentration of the fixing bath. The
loss of fixing speed with a fixing bath on a 0·8 to 1·2 mol $(NH_4)_2S_2O_3$
basis is about 30% when 0·05 mol of aluminium is included, inde-
pendently of the fixing temperature.

### 1.2.3. *Influence on the fixing speed of the silver content in the fixing bath*

It is well known that in a used fixing bath the fixing speed becomes
considerably lower than in a fresh one. The more films that are processed
in the fixing bath, the more the complex ammonium thiosulphate com-
pound increases. An equilibrium sets in for the replenishing of a given
fixing bath in relation to m² of treated film.

In processors for X-ray film under normal processing conditions an
amount of about 5 to 10 g of silver per litre is reached.

Figure 5 shows the curves obtained with 0·00 mol, 0·03 mol and
0·06 mol of silver per litre of fixing bath at 20° and 40°C. Twenty-five ml
of Aditan, say 0·05 mol of aluminium per litre has always been added
per diluted litre.

As the silver content increases the curves become sharper, showing
that with increasing silver content the fixing speed becomes more
sensitive to the ammonium thiosulphate concentration. Knowing that
for the complex ammonium thiosulphate compounds only one mol
ammonium thiosulphate is used per mole of silver, unlike the natrium
thiosulphate complex where several moles thiosulphate are required for
one mole of silver, the loss in fixing speed cannot be explained through
exhaustion only, due to complex compound formation.

With a silver content of 6 g there is only 0·06 mol of silver while the
thiosulphate concentration in a normal fixing bath is about 1·00 mol.
An even greater retardation can be seen at the higher ammonium
thiosulphate concentrations of 1·5 mol at 40°C and 1·5 and 1·2 mol at
20°C. The only explanation for this behaviour seems to be an inhibiting

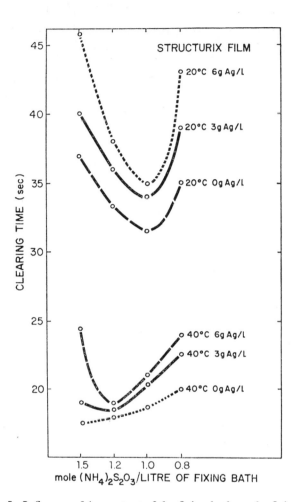

Fig. 5. Influence of Ag content of the fixing bath on the fixing speed.

effect of the silver thiosulphate complex on the fixing speed. The mechanism of this inhibiting action is still not clearly understood.

It can be stated that for the optimum concentrations of thiosulphate the speed loss at 20°C is about 10% for 6 g of silver per litre and for 40°C the speed loss, under the same conditions, is only 5%. This phenomenon is also observed with photographic emulsions of quite different halogen composition.

## 1.3. Influence of agitation

The most remarkable observation in this study concerning fixing phenomena is the fact that the fixing speed can be so strongly influenced by agitation.

**Table 1**

**Clearing times with fixing bath $(NH_4)_2S_2O_3$ (1·2 mol) + 0·05 mol Aditan**

|  | Cine positive | | | Curix RP film | | |
|---|---|---|---|---|---|---|
|  | 20°C | 30°C | 40°C | 20°C | 30°C | 40°C |
|  | Time in seconds | | | Time in seconds | | |
| Without agitation | 17·5 | 11·0 | 8·5 | 16·5 | 12·2 | 9·5 |
| Magnetic stirrer | 15·0 | 9·5 | 7·5 | 13·3 | 9·8 | 7·5 |
| Circulation pumping, 17 litres $min^{-1}$ | 12·5 | 8·5 | 6·6 | 11·5 | 9·0 | 6·5 |
| Circulation pumping, 37 litres $min^{-1}$ | 11·5 | 7·5 | 5·5 | 10·5 | 8·5 | 6·0 |

In Table 1 the clearing times which have been measured under various agitation conditions are given. Tests have been carried out in a 600 ml beaker-glass without and with agitation by means of a magnetic stirrer at 150 rev/min. Other tests have been run with circulation pumping in the pressure-chamber system, which is used in the new Gevamatic 110 processing-machine. The agitation tests have been carried out on a Cine Positive film (which is a chloride-bromide emulsion) and on an X-ray emulsion Curix RP film (which is a bromide-iodide emulsion). The progress of the effect of agitation is clearly shown in the table and results in a gain of fixing time of about 1/3.

## 1.4. Influence of the temperature

The rise of temperature also has a very marked acceleration effect. Surprising is the fact that at low temperatures the influence of agitation is almost the same as that at high temperatures.

Another favourable effect of the higher fixing temperature can also be seen in the minimal slow-down of the fixing time when the fixer has a silver content of about 5 to 10 g per litre.

## 2. THE WASHING STAGE

In order to obtain an archival quality that matches the standards, the washing stage plays an important role within the limits of the rapid processing.

This operation seems very simple at first sight but good washing of a thick film within a few seconds is quite a problem, because many factors influence the effectiveness and the speed of the washing.*

## 2.1. Influence of the degree of fixation of the film on the washing time

A first prerequisite is the degree of fixation of the emulsion. An insufficiently fixed film requires an unacceptably long washing time. It can be said that in rapid processing a sufficient fixing time is the preliminary condition to reach archival quality.

2.1.1. *The effect of different fixing and washing times on residual thiosulphate*

### Table 2
### Residual thiosulphate of Curix RP film after different fixing and washing times

Fixing bath: G 334 $(1 + 3) + 25$ ml Aditan at 20°C
Processor: Gevamatic 110 (pressure chamber agitation: 15 litres min$^{-1}$)

| Clearing time | Fixing time | Washing time at 20°C Residual $(NH_4)_2S_2O_4$ in mg m$^{-2}$ of film | | |
|---|---|---|---|---|
| 12 s | — | 12 s | 24 s | 36 s |
| | 12 | 495 mg | 451 mg | 396 mg |
| | 18 | 176 mg | 121 mg | 77 mg |
| | 24 | 110 mg | 88 mg | 55 mg |

When the fixing equals the clearing time (12 s), the residual thiosulphate is high and slowly lowers with longer washing times. When the fixing time is 1·5 times the clearing time or 18s, the residual thiosulphate comes within the limits of the standards and this in 12 s of washing.

2.1.2. *The influence of the composition of the fixing bath*

The presence of silver complexes in the fixing bath causes a supplementary inhibition of the washing speed. Figure 6 shows the influence of the complex silver compound content in the fixing bath on the residual

* The simplified method used to measure the residual thiosulphate content is described by Pope, (1969). As limit of the standard, 30 mg of $(NH_4)_2S_2O_3$ m$^{-2}$ was taken for each side of the film (PH$_1$-28-69 ANSI), but as the Crabtree–Ross method indicates only $\frac{1}{3}$ of the real amount of thiosulphate and as the silver nitrate method indicates all the ammonium thiosulphate present, the 30 mg of $(NH_4)_2S_2O_3$ had to be multiplied by three, and this for both sides of the film. Thus the real ANSI norm gives 30 mg $\times$ 3 $\times$ 2 = 180 mg of $(NH_4)_2S_2O_3$ for double-coated X-ray material.

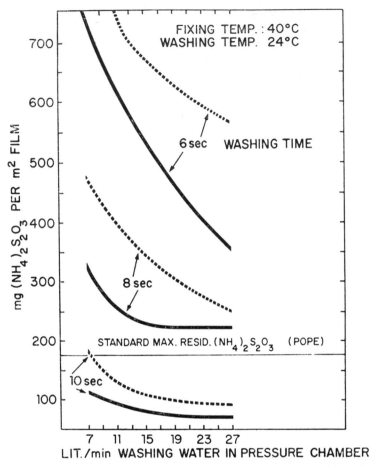

Fig. 6. Influence of the composition of the fixing bath on washing time. The dotted line represents the values obtained with "regime" fixing bath (i.e. fixing solution plus 6 g of silver per litre) and the full line represents those obtained with fresh fixing bath.

thiosulphate. The "regime" fixing bath contains in this case 6 g of silver per litre. The fixing time is always minimum 1·5 times longer than the clearing time, in order to be safe as far as fixing is concerned. In the case of a short washing time (6 s) the influence of the complex silver compound content on the residual thiosulphate can be clearly seen.

The washing-out-speed is much retarded by the complex silver compound content of the fixing bath. Consequently it is necessary to take this factor into account in rapid processing and to provide enough water circulation in order to obtain enough agitation.

## 2.2. Influence of the composition of the washing water

The composition of the washing water can also influence the speed of washing considerably. It is a known fact that the use of distilled water has an adverse effect on the washing speed. The presence of salts in the washing water favours the desorption of the complex silver compounds and of the thiosulphate from the photographic emulsion. A simple way to build up some salt concentration in the washing water is to reduce the washing water delivery. The thiosulphate content which may be allowed

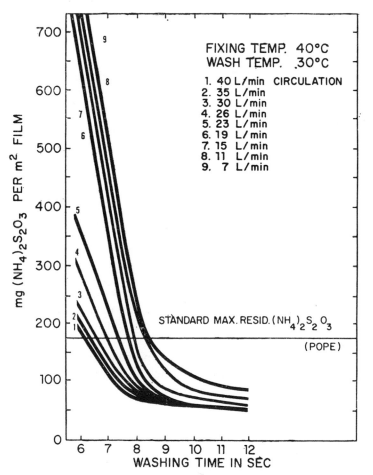

Fig. 7. Influence of the agitation on the washing time. Fixing bath: G.334 (1 + 4) with 25 ml of Aditan, at 40°C, while the washing water is at 30°C. Film: Curix RP X-ray film. Agitation is essential to shorten the washing time and to guarantee an homogeneous concentration of thiosulphate in the washing water.

in the washing water depends on the water content of the emulsion when leaving the washing water and on the limits of the standard of residual thiosulphate.

It was found that for an X-ray—90 s cycle, archival quality can be obtained with washing water containing 1% of fixing bath G.334 (1 + 3). This concentration can be reached with a water consumption of 3 litres of water $m^{-2}$ of processed film. This very low water consumption, about one tenth of the normal consumption in rapid processing machines, could be very interesting in places where water supply is a problem, e.g. industrial X-ray processing in the field, etc.

### 2.3. Influence of the agitation

Figure 7 shows a series of curves obtained by plotting the degree of washing against time for various agitation levels. Different agitation levels were obtained by changing the circulation in the pressure-chamber system of the new Gevamatic 110 machine. The highest agitation is represented by curve 1 and the lowest agitation by curve 9. The limit of the standard for residual thiosulphate content on the emulsion after washing is indicated by the horizontal line. It is obvious that agitation is not really important if enough washing time is granted, but if rapid processing is still to be optimized, agitation becomes an essential factor. Moreover agitation is necessary to obtain an homogeneous concentration of thiosulphate in the washing water.

### 2.4. Influence of temperature

Raising the temperature of the washing water has a favourable influence on the washing speed. In Fig. 8 the residual thiosulphate is plotted against various washing times and agitation levels at 24°, 30° and 40°C.

The influence of temperatures is very noticeable for Curix RP film with washing times of 6, 8 and 10 s, while with washing times of 12 s the same residual thiosulphate is obtained with washing water at room temperature.

### CONCLUSIONS

The fixing and washing stages in rapid processing are very important, not only for filing purposes but also in view of the water shortage and consumption problems of today.

The different parameters which play a significant role in these stages can be summarized as follows:

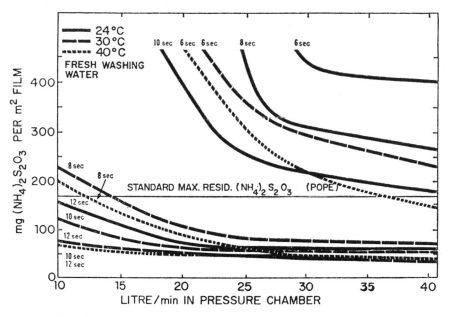

Fig. 8. Influence of temperature and circulation on the washing time. Processing machine: Gevamatic 110. Fixing bath: G.334 (1 + 3) with 25 ml Aditan. Fresh washing water. Film Curix RP X-ray film.

1. A minimum fixing time can be achicved: (a) with an optimal ammonium thiosulphate concentration; (b) with a good agitation.

2. The clearing time can be reduced by 50% if the temperature is increased from 20° to 40°C.

3. The retarding effect of the silver compound content in the fixing bath is less pronounced at a higher temperature of 30° to 40°C.

4. A good rapid washing can be achieved if the film is sufficiently fixed and if the washing water has the right salt concentration, while good agitation and adapted temperatures provide an acceleration of washing speed.

### Bibliography

Strauss, Fixierbad und Fixierzeit. *Photogr. Ind.*, **22,** 881–884, 911–916 (1925).

Karge, Elisabeth, Fixierbad und Fixierzeit. *Photogr. Ind.*, **22,** 1319–1322 (1925).

Allnutt, D. B., Some characteristics of ammonium thiosulphate fixing baths. *J. Soc. Motion Pict. Telev. Eng.*, **41,** 300–328 (1943).

Crabtree, J. I. and Eaton, G. T., Washing photographic prints and films in seawater. *J. Soc. Motion Pict. Telev. Eng.*, **40,** 380–391 (1943).

Goldwasser, S. R., Waterflow rates in immersion washing of motion picture film. *J. Soc. Motion Pict. Telev. Eng.*, **64,** 248–253 (1955).

Crabtree, J. I. and Henn, R. W., Increasing the washing rate of motion picture films with salt solutions. *J. Soc. Motion Pict. Telev. Eng.*, **65**, 378–381 (1956).

Henn, R. W., King, Nancy H. and Crabtree, J. I., The effect of salt baths on hypo and silver elimination. *Photogr. Eng.*, **7**, 153–164 (1956).

Blumberg, I. B., Ivanova, V. C., Newman, A. E. and Pikus, M. J. A., Kinetics of the fixing of photographic materials. *Zh. Nauchn. i Prikl. Fotogr. i Kinematogr.*, **6**, 39–49 (1961).

Pope, C. J., Determination of residual thiosulphate in processed film. *J. Res. Nat. Bur. St.-C.*, **67C**, 237–245 (1963).

Brumpton, E. R. and Hirsch, H., An ammonium argentithiosulphate bromide. *J. Photogr. Sci.*, **13**, 301–307 (1965).

Brumpton, E. R., Hirsch, H. and Newman, G. A., The solubility of the silver halides in ammonium thiosulphate. *J. Photogr. Sci.*, **14**, 202–208 (1966).

West, L. E., Water quality criteria. *Photogr. Sci. Eng.*, **9**, 398–413 (1965).

Mattey, D. A. and Henn, R. W., Determination of thiosulphate and thionates in film with silver nitrate. *Photogr. Sci. Eng.*, **10**, 202–208 (1966).

Levenson, G. I. P., The washing power of water. *J. Photogr. Sci.*, **15**, 215–219 (1967).

Blumberg, I. B., Ivanova, V. G. and Dimitrov, R. V., Study of the kinetics of ultra-rapid fixing. *Zh. Nauchn. i Prikl. Fotogr. i Kinematogr.*, **12**, 89–97 (1967).

Gerasimova, T. N. and Bromberg, A. W., Das Läsen von Silverhalogenid in Zweischichten system des Geliermediums. *Zh. Nauchn. i Prikl. Fotogr. i Kinematogr.*, **12**, 136–142 (1967).

Pope, C. J., A simplified method for determining residual thiosulphate in processed microfilm. *Photogr. Sci. Eng.*, **13**, 278–279 (1969).

Kulanck, Maria and Hähnel, H., Die Auflösungsgeschwindigkeit des Silverbromid photographischer Schichten in Natrium thiosulfat, Ammoniumthiosulfat und Ammoniumthiodanid. *Z. Wiss. Photogr.*, **63**, 75–85 (1969).

# A New Process for Dental Radiography

A. GREEN and G. I. P. LEVENSON

*Research Laboratory, Kodak Limited, Wealdstone, Harrow, Middlesex*

ABSTRACT. A new system for dental radiographic processing involves a film pack inside which the film can be processed, a monobath and a small machine which injects the monobath into the pack and then agitates the filled pack. The system is designed to meet the needs of a dental practice and the reasons for departing from certain features of conventional dental radiography are discussed.

## INTRODUCTION

Although what follows is about the processing of dental radiographs, the paper is really as much concerned to show how in a modern photographic system the processing is an inseparable part of the whole and how, in a particular instance, a shift on the processing front may involve a re-evaluation of the leading photographic operation itself.

In recent years the processing of radiographs has been transformed following the introduction of the X-Omat* roller transport machine. It seemed timely to our Medical Sales colleagues that something should be done to facilitate dental radiographic processing and we were asked if anything could be designed for this purpose.

In the case of dental radiography the principal consumer is the neighbourhood dentist and any equipment that is to be accessible to him must be priced closer to £100 than £1000. This ruled out schemes to open dental packs automatically and feed the film into a miniature X-Omat or similar machine.

We had already developed a scheme for the in-pack monobath processing of 35 mm film as part of the Nuffield Project for teaching physics in schools and thought that a similar approach might be made to the processing of dental radiographs.

The conventional dental film pack has a complex structure. The film is sandwiched between thin cards and a thin sheet of lead backs the card

* Registered Trademark of Kodak Limited.

on one side. It was clear that in order to use the envelope of the pack as the developing tank it would be necessary to empty it of all save the film itself. Once this had been done, it was found to be simple and effective to inject the pack with a tiny volume of monobath and process the film.

We had not gone far along this path before finding that the law that nothing is new under the sun applied equally in the field of dental radiography. Various schemes were available for in-pack dental processing. In Europe there were plastic packs which incorporated capsules of processing solution. In Japan there was a pack into which solution was injected by a hypodermic syringe. We would like to acknowledge these pioneering schemes before proceeding to describe our own approach. We had in mind something simpler than any of these, though what had been done by those who had gone before served to point to pitfalls that should be avoided.

Our objective was to achieve a means of chair-side processing in full daylight so that the dentist would not have to desert the patient in order for the newly exposed pack to be developed in "real time" as the computer phrase goes.

To some extent the existing in-pack systems met this requirement but they did need manual manipulation by the dentist or his assistant throughout the process. Secondly, while we intended to inject a pack with a hypodermic needle, we did not feel it proper to recommend such a process to be operated with ordinary syringes because, sooner or later, either the dentist, his assistant or the patient, would be injected with monobath by accident and bring the process into disrepute.

In effect, then, it was necessary to provide a system of a pack and a simple machine which would inject the pack with processing solution without danger to the operator, and then attend to the agitation of the filled pack for the requisite time.

The advantages to the dentist and the patient of having a process of this sort immediately at hand were obvious. However, to make this process possible it was essential to depart radically from certain canons of dental radiography that had become established over the years for the achievement of photographic excellence. Hence it was necessary critically to re-appraise every feature of the conventional practice. In so doing, we found that the conventional practice was justified when carried out under the recommended operating conditions, such as are found in major clinics and manufacturer's showrooms. The practice among most neighbourhood dentists, however, departed sadly from the standard recommended. The processing of radiographs was an unwelcome chore carried out once or twice a week in an under-stairs cubby-hole, or in some other closet.

It was clear that the busy dentist needed a process that would enable him to get the information he required in a radiograph of good quality, at the same level of quality each time, without any intervention on his part either for good or for ill.

The patient needed a process that would allow the radiograph to be made with a minimum exposure to limit the ionizing dosage hazard and which would give the results immediately so they could be acted on without another visit having to be arranged.

Any features of the conventional process that were intended to produce yet higher quality under ideal conditions but stood in the way of achieving these two objectives could be abandoned.

## THE SYSTEM

Essentially, the system[1] comprises the usual dental film enveloped in a simple, opaque plastic envelope which is just a little bit wider and longer than the film so that it can distend slightly when injected with monobath.

The prime feature of the processing machine is that it should reliably penetrate the pack with a hypodcrmic needle without any possibility of impaling the fingers of the operator and quickly inject the desired quantity of monobath, at the correct temperature, into the pack. A secondary feature of the machine is a means of agitating the contents of the filled pack until development and fixation is complete.

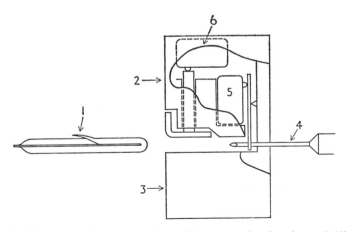

Fig. 1. Diagrammatic representation of the system showing the pack (1) the upper and lower jaws (2 and 3) and the hypodermic needle (4). Micro-switches set in the jaws control the start of pumping (5) and stop the filling when the pack is sufficiently distended (6). In fact the pack is not plump as shown in this diagram but is flat with only the non-sealed edge showing an appreciable thickness.

Various forms of pack and injector were made to find the simplest and most reliable system. Some packs had raised blisters into which the neddle would advance and fill the pack without contacting the film. In the end, the best, and simplest system was to have a pack that was heat-sealed on three sides only leaving the fourth side as a bluff fold as in Fig. 1. The needle was mounted so that it protruded a few millimetres into a narrow gap formed between upper and lower parallel jaws of plastic blocks. When the pack was advanced, folded edge forwards, into the gap between the jaws it became impaled on the needle. A micro-switch lever was placed so as to start the injector pump as soon as the film pack was fully impaled and another microswitch was placed suitably to stop the pump when the pack had swollen to the desired extent.

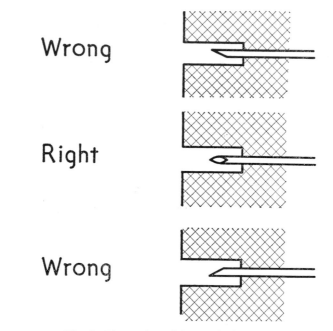

Fig. 2. The setting of the needle in the gap.

There are certain critical features in this design. The gap between the jaws must be just the right size so that the folded end of the pack is held nicely to shape when meeting the needle.

Too narrow a gap leads to rucking of the pack and the needle can snag and re-emerge through the pack wall. If the gap is too wide the pack may not meet the needle centrally, with similar results. A hypodermic needle is pointed in manufacture by grinding the tube to a bevel like a car-penter's chisel. It is important that the needle be aligned with its bevel

sideways, to the right or the left, so that the point is central in the gap (Fig. 2). This helps the needle to ride over the edge of the film and militates against its snagging on the inner wall of the pack.

Although the pack could be made most simply from black plastic sheet, this gives an appearance that is unacceptable for intra-oral use. Hence a laminate with a white or coloured outer face is used. This is not an irrelevant detail because in selecting a laminate for this purpose care must be taken to have the correct plasticity and elasticity in the material. If the plastic sheeting is too stiff the puncture will not close when the pack is withdrawn from the needle. If the pack too elastic the puncture closes too fast. When the material is suitable, the puncture does not seal immediately after withdrawing the pack and it is possible to expel the small bubble of air that forms in the filled pack. As soon as the monobath wells to the hole, momentary pressure between the fingers relaxes the plastic and the hole closes. Once it is thus closed, the pack itself would burst under pressure before solution will leak from the place of the puncture.

Fig. 3. View of production unit.

The system under the registered style of "Dentech" was announced early in 1971.

Figure 3 shows the production unit which is quite compact and can be stood close to the dental podium on a small table or bench. The design of the hardware within the cabinet involved numerous problems which need not be recounted here beyond saying that an attempt was made to produce a unit reduced to the logical essentials for reliable working in the hands of operators who are not photo-technologists.

Monobath is held in a collapsible sac within the machine so that air is excluded at all times.

The usual, periapical pack which is used for the greater part of dental work, needs 3 ml of solution and about 160 packs can be filled before the dentist is warned by a lamp that the sac needs replenishing. The proper response to this notice is to empty the contents of a 500 ml bottle of monobath into the intake funnel. If the warning is not acted on, the machine will fill a few more packs before the pump is automatically disconnected to prevent the machine being completely drained and having to be re-primed.

Once the machine has been installed, it needs only to be topped up at the time of each warning for it to continue operating indefinitely. On the basis of present consumption the small practice might need to top up the machine monthly.

Inevitably there is some bleeding of developer as the pack leaves the needle and the lower jaw has an absorbent block backed-up with absorbent dental rolls to take up this solution. From time to time it will be necessary to flush the jaw assembly with a jet of water from a squeeze-bottle and change the absorbent rolls.

The machine is expected to be used daily or at least weekly. Under these conditions the needle needs no cover to prevent blockage by dried monobath.

A slot entered from the top of the machine will accept six, filled, periapical packs, three each side of a reciprocating paddle which alternately squeezes the upper and lower halves of the packs to move the solution about. The agitator takes two of the larger, occlusal packs and more of the small, child-size packs, though these last are only infrequently used.

We tried various schemes for the automatic timing of the agitation process, including one which would note the arrival of each newly filled pack and separately signal the lapse of the respective four minutes but, in the end, all such schemes were abandoned on the combined scores of extra complexity and cost. The agitator is switched on and off manually and an external timer is used if necessary. Four minutes is the recom-

mended time but no harm follows from leaving the pack longer in the agitator.

## DEVELOPMENT

The machine runs at a temperature within the range 25°–29°C. The precise temperature is not critical because of the monobath operation. Our intention as designers was that the machine should be left permanently "on" once installed, just like an electric clock or refrigerator. Inevitably, however, some users will switch the unit off overnight and, if the surgery becomes cold, may need to wait a while until the temperature inside the unit has risen to 25°C before it can be used.

The recommended processing time of four minutes is set by the rate of fixation. The development is almost completed within the first minute. Four minutes is not an inconvenient time. If more than one radiograph is to be made, the first will be ready by the time the second or third is filled and placed in the agitator.

After four minutes the pack is opened by the rear flap, preferably while the pack is held under water to avoid a squirt of monobath. The film is taken out with a dental clip. A very brief rinse suffices before the radiograph is available for inspection and 60 seconds even in cold tap water is sufficient for washing to proceed to the archival standard. This is discussed in a separate paper.

It is technically feasible to wash the film within the pack and also to automate the drying. However, we rejected these courses as being too complex and expensive after examining them in relation to the need of the dentist. The washed film is squeegeed between the fingers and hung in front of an illuminated viewer while still wet.

The monobath, as is usual in this technique, had to be formulated to work with the film in question under the prescribed conditions. It has a basis of thiosulphate with hydroquinone and 4,4′ dimethyl-l-phenyl-pyrazolidin-3-one the latter being preferred as an auxiliary developer because it is stable in storage in warm alkaline solutions.

Figure 4 shows the sensitometric characteristic obtained from the in-pack monobath process in comparison with that obtained by the regular process in Kodak Dental X-ray Developer. It will be seen that this is a point at which we have departed from conventional sensitometric standards. The monobath-processed film has full threshold speed but does not give the same upper-scale contrast as Kodak Dental X-ray Developer.

When attention was shifted from the curves to the dental radiographs it was found that the visual contrast of the image was quite acceptable. It was fully adequate for ordinary dental procedures. Moreover, since

each pack is charged with fresh monobath, the same response is obtained each time, whereas, in the ordinary way the dental practice may continue to employ a developer long after it should have been rejected, thus obtaining results that are inferior in contrast and speed.

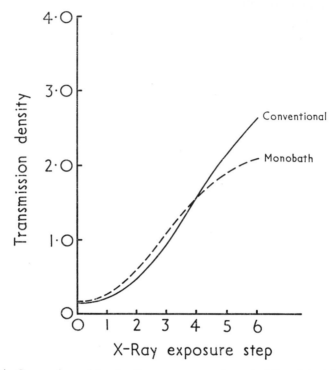

Fig. 4. Comparison of the density vs. exposure characteristics of dental film exposed via a metal step wedge (so that the exposure scale is roughly log-arithmic) and processed conventionally and in the in-pack, monobath process.

## RADIOPAQUE BACKING

The second point at which we have departed from accepted practice is in respect of the radiopaque, lead foil which is usually included in dental packs.

The function of this lead foil is commonly misunderstood. Its proper function is to prevent veiling of the less exposed areas of the film by radiation scattered from tissue behind the film. The increased awareness of radiation hazard since 1945 has given rise to the notion that the sheet of lead is there to protect the patient from X-radiation. This it can do only to a marginal extent. Most of the radiation incident on the patient

is necessarily absorbed in the teeth and jaws that are the subject of the radiography. In the plane of the film, only half the area of the cone of X-rays is impeded by the rectangular pack, unless the cone is very carefully limited, and of the half that passes through the film the lead absorbs three-quarters. Thus, at best, the lead spares the patient about 10% of dosage. Finally, because the pack is held in place by the patient's thumb, most of the transmitted radiation is absorbed in the thumb, which being an anatomical extremity, is not regarded as being so sensitive to radiation.

More important for the function of the system was the effectiveness of the lead in preventing veiling. Tests, with the help of patients, were made on packs with and without the lead, and on packs in which half the sheet was removed. The lead did give a perceptible improvement in contrast at 60 kV but the difference was not apparent on casual inspection even when half of a film was left unprotected. Since the difference, though real, was marginal and had to be looked for, the value of the lead in ordinary dental radiography was questioned more closely.

Experiments were carried out by the X-ray Group of our laboratory using a skull with the jaws embedded in wax to simulate flesh, with blocks of Perspex placed behind the film as scattering media. Measurements were taken with a dosimeter at the outer surface of the phantom, behind the teeth, behind the film, etc. The relative X-ray exposures were as follows:

|  |  | Relative exposure |
|---|---|---|
| 1. Incident on surface | . . . . . | 100·0 |
| 2. Behind teeth | . . . . . | 14·0 |
| 3. Behind pack, with lead foil | . . . . | 3·5 |
| 4. At lower jaw (pack with lead) | . . . | 2·1 |
| 5. At lower jaw (pack without lead) | . . . | 7·0 |

A number of radiographs were made with conventional packs with and without the lead and these were conventionally processed. Two sets were made, one at 60 kV and another at 80 kV. A group of four observers were just able to select the films taken with lead at 60 kV but could not distinguish those taken at 80 kV. Microdensitometer traces across the radiographs showed no significant difference in contrast even at 60 kV.

The difference will increase at lower levels of kilo-voltage and undoubtedly there will be dental conditions, treated in clinics, that will need every radiographic refinement in order to provide a record. Under these conditions a radiopaque backing may be invaluable. However, it is unnecessary to incorporate an expendable screen in every pack to meet this situation particularly if by omitting it there are greater advantages

to be gained. It is better to use an external radiopaque backing in cases where one is specially indicated.

As part of the system, therefore, radiopaque screens of various sorts were devised for use with the new pack. We found that the use of the external backing opened up conveniences for the specialist radiographer because backing shoes could be made to hold the pack flat or in various pre-set curvatures. For general purposes, to retain the flexibility allowed by the new pack, a flexible sheet of plastic filled with a non-lead, radiopaque pigment was designed. The sterilizable sheet, which is available in sizes appropriate to the three sizes of dental packs has a non-skid surface so that it is easily held in place behind the film pack either by the patient's finger or by one of the dental radiographic holders which are available for the location of packs. It is not expected that these radiopaque backings will be used except in special cases.

## DOSAGE BENEFITS

A corollary of the design of this system will be a reduction in X-ray dosage given to the patient in the general practice by ensuring that the full sensitometric speed is achieved each time. Exposure will not have to be increased to offset poor darkroom techniques through exhausted or rushed development. For example, we found in one instance that the duration of conventional development was limited by the time taken for the film to be fogged by light leaking into the cubby-hole where processing was being carried out. To offset the severe under-development the patient was being given double the proper exposure to X-rays.

Conventional, two-film dental packs are made so that a second record can be obtained with one exposure. The in-pack processing technique does not admit a second film in the same pack, nor are such packs necessary. When extra records are needed, two or more Dentech packs can be exposed one behind the other because the plastic envelopes have a very low density to X-rays. We have exposed five packs in a block, the hindmost still giving a usable record. For the same reasons two or more of the new packs can be arranged sideways with an overlap to cover several teeth in the same exposure.

## CONCLUSION

The design of a system of this sort involves problems other than those mentioned above which are vital to the successful realization of a marketable product but which would not be strictly relevant to a paper on processing.

In the work partly reported here we have gone through an exercise of research and development to evaluate the whole problem of dental

radiography in its professional (dentist), social (patient) and economic aspects as well as in the purely photographic ones, seeing processing not as a technique in itself but as inseparable from the other factors. Our answer is the in-pack processing system. Time will tell whether the system will affect dental radiography to the extent that roller processing machines have transformed hospital radiography.

## Reference

1. British Patent 1,212,192.

# Processing of Emulsion Photomasks for Semiconductor Applications

## KENNETH G. CLARK

*Micro-Image Technology Ltd., High Wycombe, Bucks, England*

ABSTRACT. Semiconductor device technology has advanced rapidly over the past five years in the fields of discrete devices, integrated circuits and the larger wafer sizes upon which these semiconductors are produced. This has had the resultant effect that photomask making has undergone ever changing requirements for the element dimensions, circuit sizes and overall mask sizes, with new equipment for the improved emulsion processing technologies. High resolution photomask requirements for element dimensions, die sizes, die placement accuracy, and allowable defect levels are discussed. The characteristics of Kodak High Resolution Plates, Type 2 and Agfa Micron Photoplates, and their processing are reviewed. A description is given of negative and positive working processes for producing accurately defined 1 μm to 10 μm geometries of high contrast (density above gross fog of greater than 2·0) and clear areas retaining the minimal residual silver. Photo-emulsion plate processing is evaluated to give minimal defect areas thus allowing large scale integrated circuits, up to 5 mm × 5 mm in size, to be produced at high yield. A comparison of applications in high resolution processing is made, emphasizing the extreme care taken in emulsion photo-plate processing for semiconductor applications.

## INTRODUCTION

The manufacture of modern semiconductor devices has been possible only through the application of techniques of microphotography and photolithography practiced as precise sciences. Semiconductor device technology has advanced rapidly over the past few years especially in the fields of high frequency devices, linear and digital bipolar MSI and LSI, MOS large scale integration and the increase in wafer sizes upon which these semiconductors are produced. This has had the resultant effect that photomask making and photolithographic techniques have undergone ever changing requirements in element dimensions, circuit sizes and overall mask sizes, with these new demands leading to improved photographic and photolithographic technology and processing equipments.

In order to be able to manufacture these semiconductors at some financially rewarding yield the following basic requirements must be carefully considered for the photo-processes involved: element dimensions, die size, die placement accuracies, and freedom from defects.

Element dimensions in emulsion photomasks have become rather limited by the finite wavelength of light, the photo emulsions available and the mechanics of the photo-equipment. When working with hard surface photomasks, and exposing onto a photopolymer layer, the use of a scanning electron microscope has overcome many of these difficulties, although this technique, as yet, has not shown large scale manufacturing capabilities. In both the laboratory and in small scale production, devices with minimal elemental dimensions of $1.0 \mu m$ are available whilst in MSI circuits a more conservative requirement of $2.5 \mu m$ is commercially available. For MOS/LSI, the minimal element dimension would be in the order of a $5.0 \mu m$ width. The raio of length to width of these elements can vary considerably from $1:1$ to as great as $1:5000$, as can the density of elements within a die from single elements to many lines and spaces, sometimes closely representing a resolution target.

The maximum die size of the circuits has become a little limited by the difficulty of filling this area with many thousands of defect free elements and by the severe limitations of optical systems. The die sizes vary considerably from discrete devices to large scale integrated circuits. Some typical dimensions are: discrete device, $30 \mu m \times 30 \mu m$; medium scale integrated circuits, $2.0 mm \times 2.0 mm$; and large scale integrated circuits, $4.5 mm \times 4.5 mm$. Currently, the largest die sizes are in the region of $6.5 mm \times 6.5 mm$.

The majority of semiconductor devices require extremely accurate placement of the fine elements within the die and of the various layers required to produce the semiconductor device. A large scale integrated circuit is illustrated in Fig. 1, and is an MOS silicon-gate structure. Some typical die placement accuracies may be understood by the following element alignments which must be obtained die to die throughout the layers of the semiconductor device: a discrete device having a $1.5 \mu m$ window into which a $1.0 \mu m$ strip must be fitted centrally; an MSI circuit having a $3.5 \mu m$ window into which a $2.5 \mu m$ strip must fit centrally; and an LSI circuit having a $5 \mu m$ gap between two windows into which a $5 \mu m$ strip must be placed with the only tolerance being the lateral diffusion of $0.5 \mu m$ outside of the window area.

In addition to these primary circuits it is often required to leave spaces within the stepped array into which may be stepped test circuits or automatic alignment targets to the same required accuracy as the primary pattern.[1] Thus, it will be seen that the positional accuracy, die to

die throughout a mask series, must be to 0ʼ25 μm or better, when a typical mask series can contain from as few as four levels (MOS device) to as many as eleven or twelve levels (bipolar device) on a variety of photomasks from 2 in × 2 in. to 4 in × 5 in. in plate dimensions.

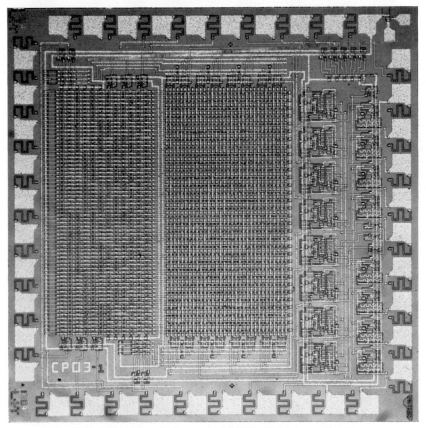

Fig. 1. Large scale integrated MOS silicon-gate circuit.

The major defect categories can be listed as follows: broken elements, distorted elements, elements with poor edge acuity, pinholes in hard areas, dark spots in clear areas, diffuse spots in both dark and clear areas, particulate matter, residual silver in clear areas, embedded glass chips, gels, low density dark areas, high fog levels, etc. Some of these defect modes are illustrated in Fig. 2.

Some typically allowable defect levels may be given as: 1% of the die per level for discrete devices, 4% of the die per level for MSI circuits and between 6% to 10% of the die per level for LSI circuits.

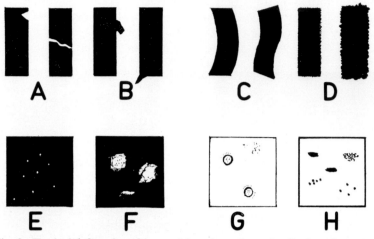

Fig. 2. Typical defects found in emulsion photoplates. A—Broken elements; B—Additions to elements; C—Distorted elements; D—Poor edge acuity; E—Pinholes; F—Diffuse light spots; G—Gels and silver clumps; H—Diffuse and dark spots.

## High Resolution Photoplates

The types of emulsion photoplates available for this application are extremely limited. In fact the following three Lippmann Type high resolution emulsion plates are the only types suitable.

### Kodak High Resolution Plates (KHRP)[2]

This micro-fine-grain emulsion, type CDR, has ultra high resolution capabilities exceeding 2000 lines $mm^{-1}$, with an emulsion thickness before processing of approximately 6 $\mu$m and after processing of about 4 $\mu$m thickness.

The emulsion is characteristically of extremely high contrast, extremely high acutance and extremely fine granularity having less than 0·1 $\mu$m thick silver halide grains suspended in gelatin on an ultra-flat glass substrate. The optimum performance of these plates is at the peak spectral sensitivity of 545 m$\mu$. Illustrated in Fig. 3, this single colour light source would normally be obtained by filtration of the artwork illumination source. The plates are coated with an anti-halation layer on the reverse side from the emulsion.

### Kodak High Resolution Plates (Type 2)[3]

This micro-fine-grain emulsion type DA-C also has ultra-high resolution capabilities exceeding 2000 lines $mm^{-1}$, with an emulsion

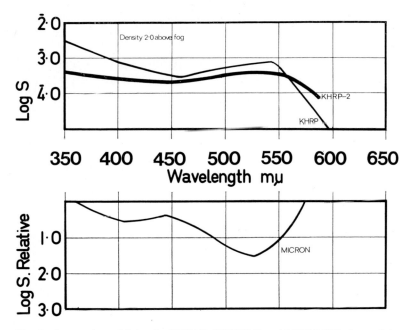

Fig. 3. Spectral sensitivity for KHRP, KHRP-2 and MICRON photoplates.

thickness before processing of approximately 6 µm and after processing of about 4 µm thickness. The emulsion is characteristically of extremely high contrast, extremely high acutance and extremely fine grain structure. It gives optimum performance with both blue and green light sources; see spectral sensitivity curve, Fig. 3. This emulsion was prepared to limit the effects of optical scattering; therefore the reverse side of the plate does not have the anti-halation layer, thus reducing the presence of unwanted particles and gels.

### Agfa–Gevaert Micromask[4]

This micro-fine-grain emulsion has ultra high resolution capabilities exceeding 2000 lines mm$^{-1}$, with a mean, unexposed and undeveloped, grain diameter of 0·068 µm suspended in gelatin on an ultra-flat glass substrate. The emulsion is characteristically of extremely high contrast, extremely high acutance and extremely fine grain structure.

The emulsion has optimum performance when exposed at its peak spectral sensitivity of 525 mµ to 546 mµ; see the spectral sensitivity curve, Fig. 3. It is prepared with an anti-halation agent to limit the

effects of optical scattering; the reverse side of the plate, therefore, does not have the anti-halation layer, thus reducing the presence of unwanted particles and gels.

These photo-emulsions are all coated onto glass to meet the most demanding requirements for flatness, dimensional stability and rigidity. The plates are normally coated on glass of a large size and in the final part of the manufacturing process are cut to a standard size (for this report we will consider $2\frac{1}{2}$ in $\times$ $2\frac{1}{2}$ in to be this standard) with the inevitable problem of glass chipping and falling onto the relatively soft, thin, sensitive emulsion layer. It has been found that this edge chipping continues throughout the plate packing, shipping and in storage before use.

## PREPARATION OF PHOTOPLATES PRIOR TO EXPOSURE

From the first two sections it will be understood that extreme precautions must be taken to minimize the possibility of microscopic imperfections in or on the emulsion at the point of exposure or during processing. These precautions implemented prior to exposure, are described in the following sequence of events: (a) control of environment, (b) cleanliness and control of working staff, (c) cutting of large area photoplates, (d) sorting and grading of photoplates, (e) precleaning of photoplates, and (f) storage and recleaning of photoplates.

### Control of Environment

Controlled environmental conditions are essential if the required high degree of plate cleanliness is to be attained. These conditions would normally be as follows: a "dirty room" for cleaning off the containers for all incoming photoplates and processing solutions; from this point onwards all areas will meet clean room conditions with the open plates being handled only under laminar flow class 100 conditions. The necessary temperature and humidity controls are provided in all rooms.

### Cleanliness

The people now working in these clean rooms are probably the largest source of particulate contamination to the photoplates. Therefore they should be clothed in single-piece clean room garments providing for protection of shoes, normal clothing and hair. The employees should be encouraged to wash their hands frequently and not to use cosmetics. Obviously, personnel with skin disorders should not be employed in these areas.

## Cutting

The problems incurred by having precut plates have been found to be numerous; thus the advent of purchasing and storing large quantities for a given emulsion batch number of 8 in $\times$ 10 in plates. These plates undergo a diamond scribing followed by an ultrasonic clean in room temperature freon TMC to eliminate the glass dust from the scribe. Then the plates are broken into the appropriate size on a vacuum table with the residual glass chips and dust being sucked away from the areas between the individual plates. The plates are then sorted into edge cuts and centre cuts and stored in stainless steel racks which can be used throughout the process and once again ultra-sonic cleaning takes place.

## Sorting

The photoplates are next further sorted into the three basic grades of flatness as specified by Eastman Kodak Company, namely, ultra-flat, precision-flat and micro-flat. The flatness determinations are obtained by interferometer measurements which allow for non-contact of the photoplates and a light source which does not interfere with the emulsion exposure. The plates are then inspected for major defects. The micro-flat plates are for use in the step and repeat camera, the precision-flat for submasters and reticle camera use, and the ultra-flats for contact printing.

## Precleaning

Precleaning of the photoplates by ultrasonic techniques has resulted in a major improvement in plate and image quality, with the removal of most particulate contaminants. A typical ultrasonic vapour unit is illustrated in Fig. 4.

Many solvents can be used with this system. To name a few: 1-1-1 trichloroethane, cyclohexane, butyl alcohol, freon TF, TA, TC and TMC. The system which by practical analysis has proved to be compatible with all plates and which given the best cavitational results is the freon TMC. This freon TMC is used in the ultrasonic system described with the following sequence of operation. The rack of photoplates is lowered into the vapour zone for 1 min and then further lowered into the ultrasonic bath, the plates being perpendicular to the transducer, and subjected for a period of 2 min to an ultrasonic action of 25 kH at 500 W. The rack is next raised back into the vapour zone for 1 min and further into the free zone for 1 min of drying-action, thus giving a total cycle time of 5 min. This system has proved to be exceptionally good in dislodging and removing particulate contamination and glass chips. The freon is used at a temperature of $36.5°C$.

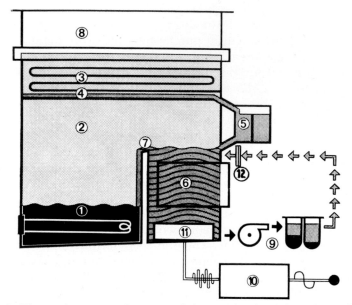

Fig. 4. Ultrasonic vapour-cleaner used for precleaning photoplates. 1—Heating sump; 2—Vapour zone; 3—Cooling coils; 4—Condensing channel; 5—Feed and water absorber; 6—Ultrasonic bath; 7—Overflow; 8—Free zone; 9—Recirculating pump and depth filters; 10—Ultrasonic generator; 11—Transducer; 12—Membrane filter.

### Storage and Recleaning

The plates should now be microscopically inspected and stored in accordance with the prescribed grading. The racks and container should also go through a suitable cleaning system before use and should be manufactured from non-particle generating materials.

As the plates are requested for exposure they should once again be cleaned. In this instance room temperature freon TMC with ultrasonic agitation will suffice for the recleaning process. The photoplate exposure must take place within a relatively short time period from the time of recleaning, otherwise the photoplates should be recycled for further cleaning.

## NEGATIVE PROCESSING

Great advances have been made in the field of H.R.P. emulsion processing and what several years ago was an "art form" is now practiced as a very precise science. Most forms of high resolution photography have used a very basic five step process consisting of develop, stop, fix, wash,

dry. In order to obtain the required high degree of uniformity and plate cleanliness for batch processing, many refinements have been made to the basic process[5] and to the control of the process. These advances have been brought about mainly over the past few years and since the introduction of large scale integrated circuits, whose large complex areas have made stringent requirements on the number of allowable defects over the total plate area.

A typical process suitable for LSI circuit photomask processing would be an eleven step process, namely: (1) removal of antihalation backing, (2) wash, (3) develop, (4) stop, (5) fix, (6) wash, (7) residual backing removal, (8) wash, (9) 50% alcohol, (10) 100% alcohol with ultrasonic agitation, and (11) dry. In all cases the water used for washing and mixing with chemicals is filtered de-ionized water and all chemicals are filtered before use in tanks.

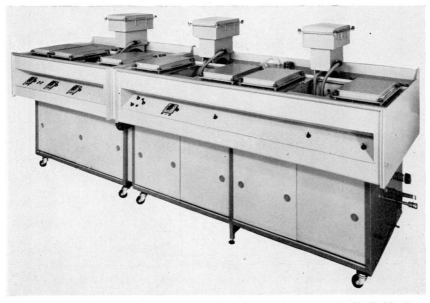

Fig. 5. Varney photoplate processing bench, showing removal of individual process tanks.

The chemical processing would be carried out in a processing system similar to that illustrated in Fig. 5, in either a manual[9] or automatic[10] timing and transfer mode. All chemical tanks are of a continuous overflow recirculating construction, while the wash tanks provide for continuous fresh water with overflow to waste. This overflow technique is used to minimize surface particulate matter.

A typical recirculating system for the chemicals is illustrated in
Fig. 6. The stainless steel tank (1) overflows solution into the collection
and return well (2) then to the pump (3). The solution is pumped through
a depth filter (4) and the rate is controlled by the flow·valve (5). Mem-
brane filtration (6) then takes place and the rate of flow is read on the
meter (7) with the ultraclean solution flowing back into the tank.
Nitrogen burst agitation (8) is provided in the tank with the nitrogen
being membrane filtered (6). The solution is monitored by use of an

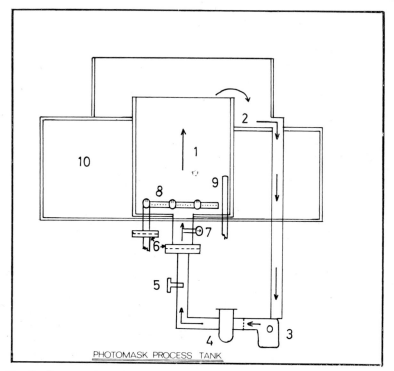

Fig. 6. Cross-section of the process recirculating tank. 1—Stainless steel
tank; 2—Return well; 3—Pump; 4—Depth filter; 5—Flow value; 6—
Membrane filter; 7—Meter; 8—Nitrogen agitator; 9—Electrode to pH
meter; 10—Water jacket.

electrode (9) connected to a pH meter; this meter is coupled to all tanks
in the process so that absolute control over all solutions is possible.
Temperature control of the solution is maintained by the water jacket
(10) and the solution temperature can be held constant to within
$\pm \frac{1}{2}°$F. The flow rate of the solution is extremely important when con-
sistency of processing for large batches of plates is required. This rate can

be initially determined by viewing the solution patterns within the tank using an easily removed dyed solution.

A considerable amount of development has gone into establishing this process for high quality photomasks. It is now a long way from the simple five step process with either dish or tank development as used in most other forms of high resolution photography. The eleven processing steps for the negative process are enumerated and described below.

## Negative Process

1. Anti-Halation backing removal
2. Wash
3. Develop HRP 1:4
4. Stop
5. Fix
6. Wash
7. Residual backing removal
8. Wash
9. 50% Alcohol
10. 100% Alcohol
11. Dry

1. In the first step, a solution of 5% sodium carbonate (50 g per liter) is maintained at a pH value of 11·5. The solution is used in the recirculating system described with continuous nitrogen agitaton and a solution filtered to 1·5 μm by a Millipore solvinert membrane filter at a relatively high flow rate. This initial process step is to first reduce the anti-halation layer to a gelatinous condition, thus releasing all embedded particles, and then to release the backing dye itself. A typical process time would be three minutes for KHRP or one minute for KHRP-2 and Micronmask plates. This accomplishes a great reduction in the number of particles which would have been transfered to and liberated in the developing solution, whilst not detrimentally affecting the exposed emulsion.

2. The second process step is a water wash at a high flow rate. The wash water used in this process and also for the mixing of all process chemicals is of a pH value of 6·25. Final membrane filtration of the water is at 0·8 μm using the MF-AA filter. This process step accomplishes the removal of all traces of sodium carbonate and any remaining particulate matter prior to development.

3. The third process step is development, being carried out in a solution of 1:4 HRP-developer: water at a controlled pH value of 10·8 ± 0·1. The pH value is regularly monitored; the frequency of monitoring is governed by plate through-put. The solution is maintained at the nominal value by the addition of acetic acid (50% solution) to the developer if the pH value is ever greater than 10·9 or the addition of sodium hydroxide (0·2% solution) should the pH value fall below 10·7. The working life of the developer is dependent mainly upon the

number of plates processed and is ascertained by the processing of test plates of controlled exposure with the criteria being image size and density. It can be seen from Fig. 7, that variation in the pH value for a given developing agent can seriously affect the density obtained with

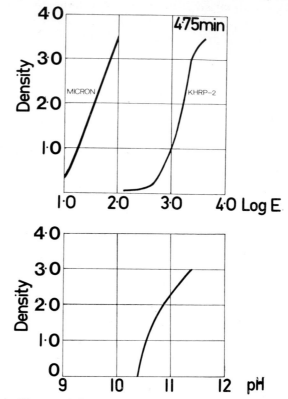

Fig. 7. (a) Characteristic curve for KHRP-2 and micron photoplates developed in HRP 1:4 developer; (b) Variations in density for varying developer pH values.

conditions of fixed exposure and development time for any given emulsion batch. Using the hydroquinone developer shown in Fig. 8, a change in pH of 0·2 (taken from 10·8 at density 2·0) to 10·6 will result in a density change of 0·6 down to 1·4, which would be unacceptable for photomask purpose, thus illustrating that the buffering of the alkali is of extreme importance. When processing large numbers of plates it should be understood that the reaction of the developer with the silver halide emulsion results in the liberation of acid with an associated loss in development activity. Therefore, considerable pH sampling of the developing solution should be undertaken.

The developing solution is used in the recirculating system with intermittent nitrogen burst agitation (7·5 s every 30 s). It is filtered to 0·5 μm by a final membrane Solvinert filter and is temperature controlled at 68°F $\pm \frac{1}{2}$°F. The flow rate is relatively low with approximately two full changes of solution within the 4·75 min processing time.

4. The stop bath, in the fourth process step, is a solution of 35 cm$^{-3}$ acetic acid per liter of water and has a pH value of 3·1. The processing time in this solution is 30 s which accomplishes neutralization of the developer action in the emulsion, thus abruptly stopping the development process. The solution is used in a recirculating system with continuous nitrogen agitation. It is filtered to 0·6 μm by a final membrane Polyvic filter with the solution flowing at a reasonable rate.

5. The fifth process step, that of fixation, is carried out in a solution of 1:3 Kodak Rapid Fix (part A): water, with the addition of Kodak Rapid Fix (part B) to the dilute solution "A" at 14 cm$^{-3}$ per liter of solution. This solution should be maintained at a pH level of 4·75, as significant variations to this value (for instance to pH 4·0 or 5·5) will result in only 50% of the gelatin hardening obtained at pH 4·75. The removal of the residual silver halide is accomplished in a process time of one and a half min. The acid thiosulfate solution with the added potassium alum hardener reduces the susceptibility to mechanical damage and distortion of the gelatin through the ensuing process steps. Excess processing time will result in an image of lower density.

The fixing solution is used in a recirculating system with continuous nitrogen agitation. It is filtered to 0·6 μm by a final membrane polyvic filter with the solution at a reasonable flow rate.

6. The sixth step, washing the photoplates after fixing, removes by diffusion the thiosulfate together with any soluble silver thiosulfate complexes which remain within the gelatin. Washing is accomplished in a process time of five minutes at a very high flow rate with final membrane filtration to 0·8 μm using the MF-AA filter. Continuous nitrogen agitation is employed.

7. This seventh process step applies only to Kodak KHRP plates with the anti-halation backing layer. A solution of 0·2% sodium hydroxide (2 g per liter) at a maintained pH value of 12·25 has the function of removing any residual anti-halation backing which has remained through steps (1) and (3) of the process, in a process time of 30 s. This solvent is used in the recirculation system with continuous nitrogen agitation and final filtration to 0·5 μm through a Solvinert filter at a reasonable flow-rate.

8. The eighth process step also applies only to Kodak plates KHRP with the anti-halation backing layer. This water wash is at a reasonable

flow rate to waste, with final membrane filtration through a 0·65 μm MF-DA filter. This washing of the photoplates is to accomplish the removal of all traces of sodium hydroxide and any remaining particulate matter of contaminants in a process time of 5 min.

9. The ninth process step is that of dehydration of the gelatin with the first part of this process being carried out in a bath of 50% methyl alcohol. This dilute alcohol bath is provided to speed the process of drying the gelatin layer but without the action of physical shock and distortion which could result in going from the water wash to a concentrated alcohol solution. The alcohol is used in a recirculating system with final membrane filtration to 0·5 μm by a Celotate filter; the process time is one min, at pH = 5·90.

10. The tenth step in the process is that of final cleaning and dehydration of the gelatin. This is accomplished by the use of a 100% methyl alcohol bath with ultrasonic agitation of the solution. The solution is recirculated with final membrane filtration to 0·5 μm by the use of a Celotate filter and the process time for this step is one min. This process step reduces the tackiness of the surface and thus speeds up the drying process. pH = 7·0.

11. The eleventh and final process step is that of completely drying the photoplates. This is carried out in a nitrogen dry-box using heated, oil-free, dry nitrogen filtered to 0·8 μm with an MF-AA membrane filter and pre-filtered through a micro-fibreglass filter. The normal drying time will be about 8–10 min.

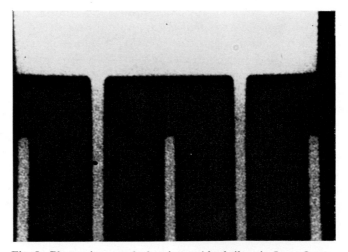

Fig. 8. Photomicrograph showing residual silver in 5 μm fingers.

## REVERSAL PROCESSING

Reversal processing[7] has been extensively employed in photomask making for semiconductor applications, especially in the production of the reticle, the step and repeat master and in contact prints which have predominantly opaque areas. The photomask maker generally uses artwork with all levels having opaque backgrounds (although this may not be so in the final photomasks), and it is normal to reverse process the reticles which have been photographically reduced from the artwork so that they also will have opaque backgrounds. These reticles are then stepped and repeated with the resultant masters being either negatively or reversal processed, dependent upon the final tone requirements, but without any mirror image problems which can be experienced when only negative processing is carried out.

The attainment of fine lines, let us say of less than 5 $\mu$m, with good densities is more easily achieved using the reversal process due to complete saturation during the second exposure. In addition, because of this second exposure, the incidence of pinholing (clear areas in an opaque background) is extremely low whilst silver clumping (dark areas in a clear background) is eliminated.

The greatest problem in reversal processing, when producing photomasks with image dimensions of less than 5 $\mu$m, has been with residual bromide. This is a result of unexposed or undeveloped silver halide in the opaque areas of the initially developed image; a typical example is shown in Fig. 8. These problems with residual bromide are more severe in the production of the reticle and the stepped master where projection exposures are made, allowing for convergence and divergence of the exposing light paths at the optimum exposure condition for fine image quality.

The technique most widely employed for the effective elimination of this residual bromide is the use of a developer giving a high chemical reaction of reduction and oxidation. The developer selected for the process was D8 for KHRP type CDR emulsion. The 15 processing steps for the positive process are enumerated and described below.

### Reversal Process

1. Anti-halation backing removal
2. Wash
3. 1st Developer
   D8 + 2·5% NaOH
4. Wash
5. Bleach
6. Wash
7. Clear
8. Wash and Reversal Exposure
9. 2nd Developer
10. Wash
11. Fix
12. Wash
13. 50% Alcohol
14. 100% Alcohol
15. Dry

Note that Step (3) in the reversal process (that of first development) is carried out in an extremely alkaline developing solution resulting in a very soft and swollen emulsion condition on the photoplates. Therefore handling of the photoplates, until bleaching is accomplished must be carried out with extreme caution.

1. The first process step is that of removing the anti-halation backing and all of the particulate matter which may be trapped in it. This is accomplished in a 5% solution of sodium carbonate maintained at a pH value of 11·5. The solution is used in a continuously recirculating system at a relatively high flow rate, with continuous nitrogen agitation. The solution is filtered to 1·5 μm by a Solvinert final membrane filter for a process time of 3 min.

2. The second step is a water wash at a high flow rate to remove all traces of sodium carbonate and any remaining particulate matter prior to development. The water flows through a final membrane filter of 0·8 μm type MF-AA. It should be noted that the washing water throughout the process and the water used for chemical mixing is filtered deionized water of pH 6·25.

3. The third process step is that of first development which results in a normal negative image. It is this development cycle coupled with the initial exposure which controls the final image size and resolution. The developer used is D-8 with 2·5% sodium hydroxide added, in a process time of 2 min 45 s at a controlled pH of 12·35 ± 0·1. This solution has been found to have a very short working life and daily changes of solution can be recommended. The developing solution is used in the recirculating system with intermittent nitrogen burst agitation (7·5 s every 30 s). It is filtered to 0·5 μm by a final membrane Solvinert filter. Temperature control is strictly maintained at 68°F ± $\frac{1}{2}$°F and the solution flow rate allows for two changes of solution during the process time.

4. The fourth process step is a water wash at a high flow rate to minimize the developer action within the emulsion. The water flows through a 0·8 μm type MF-AA membrane filter.

5. The fifth process step is that of bleaching which accomplishes the removal of the initially developed silver image. This bleach consists of a 1·0% solution of potassium dichromate with 12 cm$^3$ per litre of sulphuric acid added and maintained at a pH value of 1·65. The potassium dichromate is a strong oxidizing agent and in the sulphuric solution it converts the developed silver to soluble sulphate; thus the original image is made soluble and washed away from the emulsion. This solution is used in the recirculating system with intermittent agitation for a process time of

2 min. The solution flows at a reasonable rate through a final membrane filter of $0\cdot5$ μm type Solvinert.

6.  The sixth process step is that of a water wash for one min to minimize the carry-over of the bleach solution. The water flows through a $0\cdot8$ μm type MF-AA membrane filter at a relatively high flow rate.

7.  The seventh process step employs a clearing agent. This clearing bath consists of a $1\cdot5\%$ solution of sodium sulphite with the addition of 1 cm$^3$ per litre of Acationox, a nonionic detergent compound, and is maintained at a pH value of 9·7. The potassium dichromate[8] in the bleach solution leaves a chromium oxide precipitate which the sodium sulphite now converts into a soluble form and removes from the emulsion. This solution is used in the recirculating system with continuous nitrogen agitation and is filtered to $0\cdot5$ μm by a final membrane Solvinert filter.

8.  The eighth process step is a combination of a wash and the second exposure to form the reversal image. The water wash time is of five min duration, during which an exposure is given from a lamp containing some ultra-violet energy to which region the plates now have a maximum sensitivity. A typical exposure time would be 1 min using a 500 W enlarging lamp fitted directly below the wash tanks transparent surface.

9.  The ninth process step is that of the second development. This development now reduces all remaining silver halide to silver in an HRP:Water 1:4 developer at a controlled pH value of $10\cdot8 \pm 0\cdot1$ and in a process time of 4·75 min. The developer is used in a recirculating system with intermittent nitrogen burst agitation (7·5 s every 30 s). It is filtered to $0\cdot5$ μm by Solvinert final membrane filtration with the solution flowing at a relatively slow rate giving two full changes for the process cycle. The temperature must be precisely controlled at $68°F \pm \frac{1}{2}°F$.

10.  The tenth process step is that of water washing to remove all traces of developer, thus leaving the fixing solution free from contamination. The water flows at a high rate through a final membrane filter of $0\cdot8$ μm type MF-AA.

11.  The eleventh process step, that of fixing is primarily to harden the gelatin as there should be no unexposed or undeveloped silver halide at this point in the process. The colution consists of Kodak Rapid Fix (part A): Water, 1:3, with the addition to this dilute solution of 14 cm$^3$ per litre of Kodak Rapid Fix (part B). It is maintained at a pH value of 4·75 for a process time of 1·5 min. The solution is used in the recirculating system with continuous nitrogen agitation and is filtered to $0\cdot6$ μm by a final membrane Polyvic filter with the solution flowing at a reasonable rate.

12. The twelfth step in the process is that of water washing to remove from the fixing bath, by diffusion, any remaining thiosulphate that is within the gelatin. Washing is accomplished in a process time of 5 min at a very high flow rate through final membrane filtration type MF-AA to 0·8 μm. Continuous nitrogen agitation is employed.

13. The thirteenth step is that of dehydrating the gelatin to speed up the process of drying. This process is carried out in a solution of 50% methyl alcohol in a recirculating system. Final solution filtration to 0·5 μm is accomplished by a Celotate type membrane filter. Process time is one min; pH = 5·9.

14. The fourteenth process step is that of final dehydration of the gelatin and ultrasonic cleaning. This is carried out in a solution of to 0·5 μm by the Celotate type filter in a process time of one minute, pH = 7·0.

15. The fifteenth and final step is that of completely drying the photo-plates. This is carried out in a nitrogen dry-box using heated, oil and

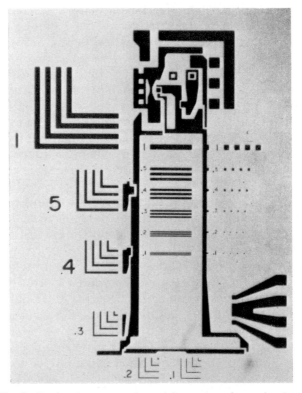

Fig. 9. Evaluation test mask used for process determination.

water free, filtered dry nitrogen. Normal drying will be accomplished in a time of from 8 to 10 min.

Figure 9 shows the test target used for the evaluation of exposure and process conditions and for the actual negative and positive processes described.

## CONCLUSIONS

From this investigation it can be seen that the degree of sophistication of the processing equipment coupled with the evaluation studies of solution flow rates, agitation conditions, pH values, filter compatibility and solution cleanliness, along with the actual cutting, pre-cleaning and grading of the photoplates has resulted in both processes and controls far in advance of those applied to normal high resolution techniques as typically employed in printed circuit masks or precision masks for chemically milled parts.

In conclusion, it can be said that the ever increasing demands of the semiconductor industry have advanced the techniques and controls employed in both high resolution photography and photographic processing very rapidly.

### References

1. Clark, K. G., "Automatic Mask Alignment in MOS/LSI Processing," *Solid State Technology*, February 1971.
2. "Kodak High Resolution Plates," Eastman Kodak Pamphlet No. P-47 (1970).
3. "Kodak High Resolution Plates—Type 2," Eastman Kodak Pamphlet No. P-226 (1970).
4. "The Micromask Plate," AGFA-Gevaert Pamphlet No. 21 (1970).
5. Lydick, H. D., "Cleaning and Processing of Plates for Ultra-Microminiaturization," Eastman Kodak Company, Rochester, New York, U.S.A. (1970).
6. James, T. H. and Higgins, G. C., "Fundamentals of Photographic Theory," Morgan & Morgan Inc., 1968, 2nd Edition.
7. Triacca, J. P., "Let's Go Ahead in Reverse," Qualitron Corporation, Danbury, Connecticut, U.S.A. (1970).
8. Glafkides, P., "Chimie Photographique," Paul Montel, Paris, 1957, 2nd Edition.
9. "Manual Processing Units," John Varney & Co., Ltd., Blidworth, Notts., England (1971).
10. "Automatic Processing Units," Fluoroware Corp., Chaska, Minnesota, U.S.A. (1971).

# Early Stages in Chemical Development

## W. E. MUELLER

*E. I. du Pont de Nemours & Co. Inc., Photo Products Department,*
*Experimental Station, Wilmington, Delaware, U.S.A.*

ABSTRACT. Examinations with the electron microscope of very early development stages in chemical development reveal the consecutive steps in silver filament formation. It is shown that the filaments initially do not consist of metallic silver but are rather made of some dissolved or complexed material. As time proceeds the filaments become partially, and finally completely reduced.

## INTRODUCTION

In an earlier paper[1] we have discussed a possible mechanism for the growth of silver filaments in chemical development. This mechanism helps to understand some facts that cannot be explained on the basis of an extrusion process. The solubility of the silver halides, AgCl, AgBr and AgI to the rate of development is proportional but indirectly proportional to the bulk conductivity of silver ions. Assuming extrusion, the development rate should be proportional to the conductivity because the silver ions have to be supplied through the crystal. The filaments extrude from the silver halide crystal when an electron—or under certain conditions a light-beam interacts. The so formed silver filaments are single and relatively thick.

Chemical development, however, creates filaments that look different and their physical shape alone makes their creation by an extrusion hard to explain; they are often branched many times.

Observations of very early stages in the development reaction with electron microscopy reveal that the filaments created by chemical development initially do not consist of metallic silver but are rather formed by some dissolved or complexed material originating from the silver halide grains.

The latent image probably catalyzes a solvent action of the developer on the silver halide grain in selected areas. A fine stream of dissolved or

complexed material pours into solution and forms filaments. The forming of branches becomes quite plausible under these circumstances: the filaments can follow along binder or adsorbed developer molecule-structures. The catalytic effect of the latent image on the solubility of silver halide was shown by Blake[2] in his paper on photo-solubilization. The filament material is possibly conducting and so any place in the filament is electrically connected with the latent image.

The filaments are reduced to metallic silver simultaneously along their structure and this leads to partially reduced or ruptured filaments. These results suggest that the complex formation between silver ions and developer molecules is a very important step in the development reaction. James[3] points out this complex is comparatively stable and a high activation energy is required to decompose it into silver and oxidized developer. In practice, with normal developer concentrations, it is impossible to separate the complex forming from the reducing-stage but a diluted developer slows down the reaction rate and the individual steps can be prolonged.

When the development reaction is observed under an optical microscope, only the grain and the reduced silver-structures or -spots can be seen. Even if the resolution were good enough to reveal the filaments, they could not be seen until they have been reduced because at first they are transparent. With an electron microscope the common technique in sample preparation is to replicate the grains and fix to avoid interaction with the electron beam. The intermediate steps of the filament formation are thus missed completely. Statements in the literature refer to unstable filaments[4,5] or relatively mobile platelets that are easily incorporated into the growing filaments.[6] James[5] reports the filaments become chemically attacked and destroyed in unfixed films whereas they are stable after fixation.

Our observations indicate once metallic silver is formed it remains stable even when bombarded with a electron beam of high intensity in the electron microscope. Very thin silver platelets formed photolytically on silver halide grain surfaces were also exposed to the electron beam. The only observed effect was a recrystallization of the metallic silver expressed by a translational movement of the dark lines across the platelets that represent crystal planes. No boiling was visible and the shape of the platelets was preserved. In cases where filaments show instability it is therefore very likely that they have not been reduced completely and that still large amounts of dissolved or complexed material are present. Our experiments show that this filament growth mechanism is a universal phenomenon in silver halide photography.

## EXPERIMENTS

In the earlier paper[1] pictures were shown of individual grains in their very early development stages. In these experiments a liquid nitrogen cooled stage was used in the electron microscope to slow down the inter- action of the electron beam with the silver halide. We demonstrated that the filaments interacted with the electron beam in regions where they were not reduced to metallic silver, leaving "empty tubes". We also showed that other material than metallic silver is present around the grains in the early stages; the silver was bleached off but large amounts of other material remained in the tubes. This of course proves that the filaments do not initially consist of metallic silver. However it is assumed in the literature that silver is formed at the location where the filament leaves the grain. No experimental evidence of this assumption exists.

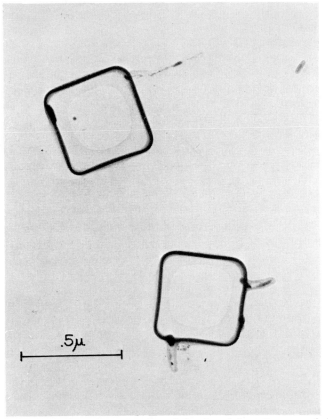

Fig. 1. Cubic AgBr grains exposed and developed for a few seconds in a hydroquinone developer. The filaments grow out of the grain but contain very little silver.

In this paper we would like to demonstrate the sequence in filament formation when individual grains are developed.

Cubic AgBr grains were exposed and processed for a few seconds in hydroquinone developer and the results studied as a function of time. The samples were replicated and then fixed. Figure 1 shows the start to the formation of filaments. Short, single filaments grow into solution; very little silver is formed and it is finely distributed. A few seconds later in a different sample the filaments are already more reduced (Fig. 2) but they still show a ruptured structure because they are not converted into metallic silver along their entire length. As time passes the filaments are reduced thoroughly and they show up as solid structures. Figure 3 shows this stage. At the end the entire grain is reduced and the familiar silver structures, characteristic for chemical development, appear (Fig. 4). This figure also shows that the filaments are branched.

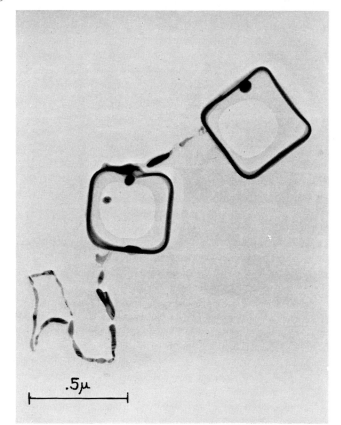

Fig. 2. Cubic AgBr grains in a later stage than in Fig. 1. The filaments are formed and are partially reduced to metallic silver.

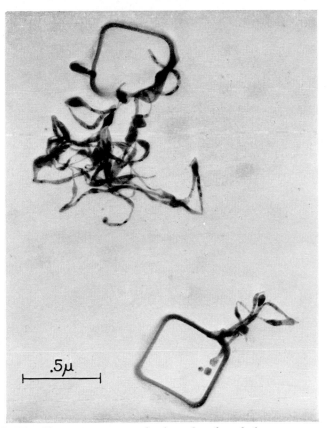

Fig. 3. The filaments are completely reduced and show no ruptured structures.

Another explanation for the existence of ruptured filaments could be that the fixer attacks the silver and dissolves parts of filament structure. Different fixers were used to study their effect on the fine silver structures. Ruptured filaments showed up even when a pure KI solution which has no solvent action on silver was used as fixer. Only potassium cyanide attacked the silver directly. Also the fact that longer developed filaments show no interruptions speaks against a damage caused by the fixing bath. Therefore the only explanation for ruptured filaments is that they are an intermediate step towards the complete reduction of silver halide to metallic silver.

## SUMMARY

Electron microscope studies on cubic AgBr grains that were developed for a few seconds only and observed as a function of time, show the

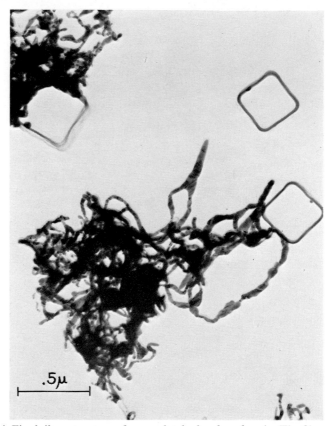

Fig. 4. Final silver structure of a completely developed grain. The filaments
are branched and touch an undeveloped grain.

different intermediate steps in filament formation. At first very little
silver is formed in fine single filaments but later the reduction sets in
rapidly and simultaneously along their structure; this accounts for
ruptured filaments. It is also shown that the filaments are truly branched
and how they become completely reduced as development proceeds.

## References

1. Mueller, W. E., *Photogr. Sci. Eng.*, **15,** 369 (1971).
2. Blake, R. K., *Photogr. Sci. Eng.*, **9,** 91 (1965).
3. James, T. H., *J. Phys. Chem.*, **66,** 2416 (1962).
4. Solman, L. R., *J. Photogr. Sci.*, **18,** 179 (1970).
5. James, T. H., *Photogr. Sci. Eng.*, **9,** 121 (1965).
6. Levenson, G. I. P. and Tabor, J. H., *Sci. Ind. Photogr.*, **23,** 295 (1952).

# Electron-Microscope Studies on Chemical Development

## W. GROSS

*Department of Photography, Swiss Federal Institute of Technology*
*(ETH-Z), Zürich*

ABSTRACT. AgBr-emulsions were developed under monitor-control in an IR-TV-microscope. Electron-microscope observation shows, that the filaments produced initially do not consist of silver, but of AgBr or some complex. The part of the filament closest to the grain gets reduced to silver only towards the end of development. The filaments often appear branched and are stable in the electron microscope under normal conditions of use. The findings support those reported by Mueller.

## INTRODUCTION

Many papers have been published investigating chemical development by means of an electron microscope.[1,2,3]

Eger[4] described development using a light-microscope fitted with an IR radiation source and an IR-sensitive TV-camera. This paper describes a method, where an IR-TV-microscope is used as a "processing-microscope", which allows one to develop emulsion grains under TV-control. The samples are then examined in an electron-microscope.

The mechanism of the later stages of chemical development has been described by Jaenicke and Schott[5] and by Matejec and Meyer.[6] A recent paper by Land *et al.*[7] concerned with the early stages of development showed that dissolution of silver halide often accompanies the initiation of development. I have tried to investigate the early stages of the development with the method described below. In doing so, I independently made observations which support the findings reported by Mueller.[8] Some of the results are given below; they may be of interest, since a different type of emulsion and developers somewhat different from those of Mueller were used.

## EXPERIMENTAL
### Emulsion
The emulsion used for all experiments was a modified Trivelli-Smith type.[4,9] The formula is as follows:

| | | | | |
|---|---|---|---|---|
| A KBr | 24 g | | B AgNO$_3$ | 20 g |
| Gelatin* | 1 g | | Water | 320 ml |
| | | | | |
| C KBr | 20 g | | D Gelatin* | 13·5 g |
| Water | 60 ml | | Water | 160 ml |

\* Atlantic 030713 "inert".

Solution B was poured into solution A in 40 min at 75°C. After adding C and ripening 30 min at 75°C, the emulsion was cooled to 32°C and the pH brought down to 2·5. The emulsion was then floculated with sodium-sulphate and washed several times in ice-water. Solution D was added (at 60°C) and the pH brought to 7. pAg was 9. The emulsion was not deliberately chemically sensitized.

### Coating
The emulsion was diluted with water and a drop of this was applied to a microscope cover slip. The cover glass had been first cleaned with ether, then wiped with soft tissue paper soaked in 3% chrome-alum solution. The emulsion layer was dried at 35°C.

### IR-TV-Microscope
The method of viewing and filming was essentially that used by Eger.[4] The emulsion-coated cover glass was mounted, grains facing downward, on a specially designed solution-cell[10] which was set up on an optical microscope stage. The microscope used was a Leitz Orthoplan fitted with a TV-system (Grundig FA 32 with a 875-lines monitor). The light source for observation was a Leitz 12 V tungsten lamp behind a Kodak Wratten filter No. 88A for infrared observation. The objective was a Leitz Apo Oil 100x, N.A. 1·32, and the condenser a Leitz Apl. Oil N.A. 1·25.

The emulsions were exposed directly in the microscope by means of a microscope lamp, which was mounted on one of the eye pieces of the binocular viewing system and fitted with a leaf shutter.

### Processing
All experiments were carried out in total darkness and at room temperature. The temperature in the solution cell was not measured. The exposed area was very small (a spot of 0·3 mm diameter). The

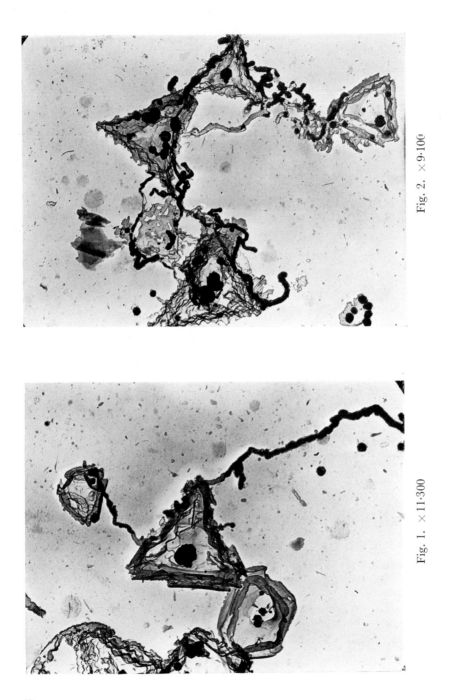

Fig. 2.  × 9·100

Fig. 1.  × 11·300

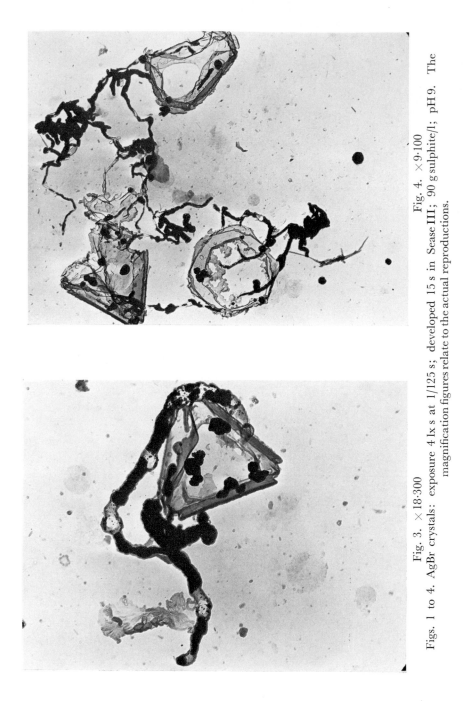

Fig. 4.   ×9·100

Fig. 3.   ×18·300

Figs. 1 to 4.  AgBr crystals:  exposure 4 lx s at 1/125 s;  developed 15 s in  Sease III;  90 g sulphite/l;  pH 9.   The magnification figures relate to the actual reproductions.

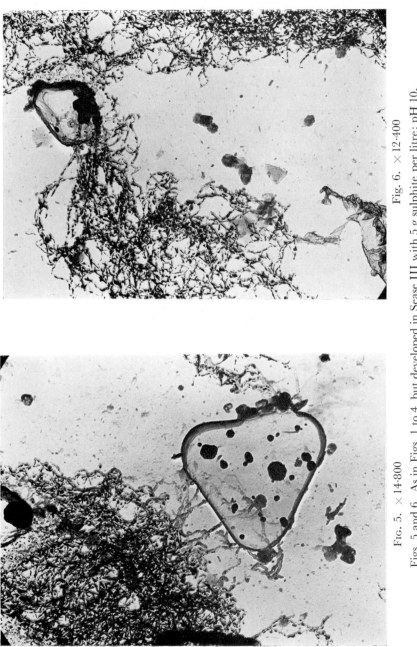

Fig. 6. ×12·400

Fig. 5. ×14·800

Figs. 5 and 6. As in Figs. 1 to 4, but developed in Sease III with 5 g sulphite per litre; pH 10.

exposure time was 1/125 s, the colour temperature of the light source 2200°K. The exposure was 4 lx s, which was determined by exposing a half-tone emulsion in the microscope and then in a calibrated sensitometer.

Immediately after exposure, developer was injected and processing observed on the TV screen and filmed by means of a Bolex H 16 camera at 4 frames $s^{-1}$. After a certain time (depending on the developing time wanted) the developer was quickly drawn out with a water jet pump, and a 2% acetic acid solution was injected. After 20 s the cell was washed several times with distilled water.

The developers used were fine-grain developers of the Sease III-type, developing slowly and controllably in the IR-microscope. The formulae are as follows:

| | |
|---|---|
| p-Phenylenediamine | 10 g |
| Glycin | 6 g |
| Sodium sulphite | 90 g (5 g) |
| Potassium carbonate to reach | pH 9 (10) |
| Water to make | 1000 ml |

**Electron-microscopy**

The processed, washed and dried emulsion (always on the cover glass) was evaporation-coated with carbon, the replica obtained removed (in 0·5% HF), then washed, fixed, and washed again several times with doubly-distilled water. The replicas were examined in a Siemens Elmiskop la at 100 kV.

**RESULTS**

Figures 1 to 4, and in particular Figs. 1 and 2, show clearly that the filaments at the beginning of development look like empty tubes in some regions filled with silver. Figure 2 shows grains which have produced long filaments consisting of AgBr or some complex[7,8] which must be plastically deformable, but not really liquid. If they consisted of a liquid, a bubble would be produced and not a filament, since the grain is embedded in gelatin.

The filaments show several black dots, consisting of silver, which must be the reduced material of the tube-forming substance. First it was thought that under the electron beam, the silver had evaporated and condensed as small silver dots. This is impossible for two reasons:

1. As described by Mueller, pure silver filaments cannot be melted by the electron beam, not even with 100 kV and the highest possible beam current under normal conditions of observation. Melting of filament and

even of print-out silver could be induced, however, by removing the condenser aperture. (No cooling stage was used!)

2. The silver filament, if it did evaporate, would not condense in the tube only. Silver dots should be visibly spread around the tube. Since the samples are carefully fixed, the small silver dots also cannot consist of silver reduced from silver halide in the electron microscope. If silver halide is left in the sample, the electron beam reduces it very quickly to photolytic silver, which is always in the shape of spheres or very thick and short filaments. Another striking feature of the filaments formed is their branching, as stressed by Mueller.

It is remarkable that reduction seems to begin simultaneously at many different points of the filament. The part closest to the grain surfaces seems to get reduced last (Figs. 1 and 5). AgBr developed with Scase III containing only 5 g sulphite per litre shows much the same effects (Figs. 5 and 6). The filaments are thinner than those of Figs. 1 to 4; also the grains are less heavily etched.

## CONCLUSION

The findings are in complete agreement with those described by Mueller, using, however, a different emulsion and somewhat different developers in that:

1. The filaments formed early in development do not consist of metallic silver, but of material readily removed in fixing solution.

2. The filaments are branched.

3. Later on in development the filaments get reduced to silver.

4. Once silver filaments are formed, they are stable in the electron beam under normal conditions of use.

### References

1. Horne, R. W., McMorris, M. N. and Ottewill, R. H., *J. Photogr. Sci.*, **10**, 235 (1962).
2. Klein, E., *Z. Electrochem.*, **62,** 505 (1958).
3. Klinke, D., Reuther, R. and Schmidt, I., *Z. Wiss. Photogr.*, **53,** 32 (1958).
4. Eger, H., Ph.D. Thesis "Ultrarot-mikrokinematographische und radiochemische Untersuchung der photographischen Entwicklung", TH München 1969.
5. Jaenicke, W. and Schott, C., *Z. Elecktrochem.*, **59,** 956 (1955).
6. Matejec, R. and Meyer, R., *Z. Wiss. Photogr.*, **57,** 18 (1963).
7. Land, E. H., Farney, L. and Morse, M. M., *Photogr. Sci. Eng.*, **15,** 4 (1971).
8. Mueller, W. E., *J. Photogr. Sci.*, **19,** 132 (1971); *Photogr. Sci. Eng.*, (1971).
9. Trivelli, A. P. H. and Smith, W. F., *Photogr. J.*, **79,** 330 (1939).
10. Berg, W. F. and Ueda, H., *J. Photogr. Sci.*, **11,** 366 (1963).

# Influence of Development on the Properties of Non-exposed Grains*

## S. COUPRIÉ

*Centre de Recherches Kodak-Pathé S.A., 30 Rue des Vignerons–94, Vincennes, France*

ABSTRACT. During development, the non-exposed crystals are modified by development of the exposed grains in their vicinity. This modification is latent and cannot be seen during development. It can be detected only when the development is followed by a complementary treatment. Two phenomena occur during development and modify the properties of non-exposed grains:

(a) Under some conditions, the development protects the non-exposed grains against a fogging action.

(b) Under other conditions, the development of the exposed grains increases the reactivity of the non-exposed ones.

The first phenomenon is probably associated with the presence of metallic silver while the second is due to the action of the oxidation products of the developer.

## INTRODUCTION

During development, the non-exposed crystals located close to exposed crystals present no perceptible changes, except for those grains which have undergone infectious development. However, the fact that development provokes certain changes on the non-exposed grains has been shown by several authors.

The Sabattier effect gives a partial inversion influenced by the development of the exposed grains; numerous factors have been considered to explain this phenomenon and several papers, particularly those of Stevens and Norrish[1] have shown its complexity. The Waterhouse inversion[2,3] shows that the influence of thiourea and of its derivatives is modulated by development. The solvent action of thiosulphate, different according to the position of grains from the developed silver has been studied by Zyuskin.[4]

* Part of this study has been presented at the International Congress of Photographic Science held in Moscow July–August 1970. S. Couprié and J. Pouradier C–25 pp. 109–112, C–26 pp. 133–115.

In the present work the influence of the development of an exposed film on the properties of the non-exposed grains in immediate proximity was shown by two methods:

(a) By studying the action of the development on the non-exposed grains of the same photosensitive layer, when a protective action is shown against fog (the result of which is analogous to the Sabattier effect).

(b) By studying the influence of the development of an exposed film on an unexposed film kept in contact: during development, an increase of reactivity of the non-exposed film, proportional to the development of the exposed layer is shown.

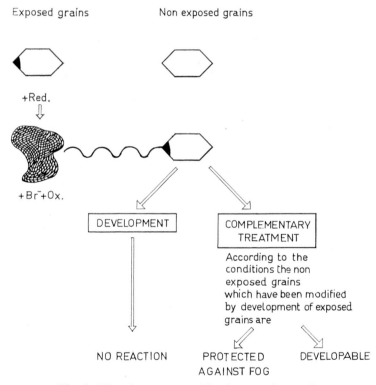

Fig. 1. The phenomenon of "action at a distance".

The two studies show that the development of exposed grains can modify at a distance the properties of non-exposed grains. To illustrate this action at a distance, we shall consider Fig. 1. In ordinary development, the exposed grains which bear a latent image are reduced to

metallic silver by the developer while the non-exposed grains remain unchanged (with the exception of the fog). In fact, the situation is more complicated and we have observed that the development of a silver-halide crystal influences the properties of the non-exposed grains in immediate proximity. Something occurs during development which affects the surrounding grains. The nature of the interaction will be discussed later. We have schematized it on the diagram by a wavy line.

The modification schematized by a spot cannot be detected by an ordinary development. It is necessary, to be able to see it, to carry out a complementary treatment. In this sense it is different from an ordinary anti-foggant action, from an infectious development or from an inter-image or an interlayer effect.

According to the experimental conditions, and after the secondary treatment, the non-exposed grains which have been modified by the development of the exposed grains are either protected against fog, or developable. Two techniques have been used for this purpose: either we have studied the effects of the development in the same layer; or we have studied the effects coming from keeping two layers in contact during development.

## DEVELOPMENT IN THE SAME PHOTOGRAPHIC LAYER
### Experimental Procedure
For the study in the same photographic layer, the procedure comprised the following operations:

(a) Exposure to the light of a tungsten lamp behind a Wratten 39 filter and a step wedge of $0 \cdot 15$ increment.

(b) Surface development (5 min).

(c) Immersion in a sodium thiosulphate solution of concentration between $4 \cdot 10^{-3}$ and $4 \cdot 10^{-2}$ M (1 to 10 g per litre) in order to fog the emulsion (3 min).

(d) Oxidation in a potassium dichromate solution ($3 \cdot 10^{-2}$ M; pH $\simeq 1 \cdot 6$) to eliminate the silver image (5 min). This solution does not destroy the fog nuclei (probably $Ag_2S$ induced by the thiosulphate bath).

(e) Second surface development, identical to the first one, to develop the surface image resulting from the previous treatment. This development bath acts on the crystals which all have undergone the fogging treatment, in a layer from which the silver image due to the first development has been eliminated.

(f) Fixing, washing and drying.

Between each operation, there is a 5 min washing in tap water. The formulae of the processing solutions are given in the Appendix.

The general shape of the sensitometric curve of an emulsion treated as above is given in Fig. 2.

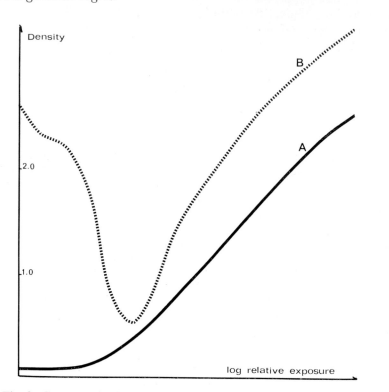

Fig. 2. Coarse-grain iodobromide emulsion. Characteristic curves for treatments A and B.

|                                                    | A   | B   |
| -------------------------------------------------- | --- | --- |
| Exposure                                           | +   | +   |
| Development in a surface developer                 | +   | +   |
| Immersion in a thiosulphate solution ($4 \cdot 10^{-3}$ M) |     | +   |
| Bleaching in an acid dichromate solution           |     | +   |
| Development in a surface developer                 |     | +   |
| Fixing                                             | +   | +   |

**Experimental Results**

We can see that the films so treated show a partial reversal (dotted curve) in the area corresponding to the toe of the H and D curve obtained after the first development (full curve). So, we can consider two levels of

exposure: the low exposure level where a reversal occurs and the higher exposure where there is a negative image.

*High Exposure Level*

The density increases as a function of the exposure.

This part of the curve depends on the nature of the emulsion: the increase of density as a function of exposure exists if the first development is unfinished. For the standard time of development (5 min) taking into account the properties of the emulsions, the increase is strongly marked for a coarse-grain, no-screen X-ray emulsion; it is practically non-existent with a fine-grain positive emulsion.

This part of the curve is not influenced by the fogging action of thio-sulphate, as is shown by comparison of the results obtained after complete processing and the results obtained without thiosulphate: the shape of the curve is slightly modified. On the other hand, this part of the curve is strongly influenced by the first development and is non-existent if the first development is omitted or replaced by a solution equivalent but without reducing agent.

This observation shows that oxidation destroys the latent-image specks but does not destroy developability due to the action of development on the latent image specks. In spite of the action of the oxidant, the density seems to be due to a prolongation of the development of the highly exposed areas.

*Low Exposure Level*

The density decreases when the exposure increases and the image is always grainy.

The existence and the magnitude of this reversal depends on numerous parameters:

(a)  The duration of the first development: we have studied the results obtained for varying times of development. After a complete processing and for a given exposure, the density of reversal decreases when the duration of the first development increases.

(b)  The concentration of the thiosulphate solution: the density increases with the concentration until a maximum (corresponding to $2 \cdot 10^{-1}$ M for an X-ray film).

(c)  The nature of the emulsion: the reversal has been obtained with all the emulsions studied (coarse-grain, fine-grain, iodochloride, iodo-bromide . . .) but in varying degrees. Nevertheless the phenomenon has been observed on both commercial films and on experimental emulsions.

(d) The nature of the reducing substance used in the first develop-
ment. For instance, the reversal is more accentuated with hydroquinone
than with glycin.

(e) The reversal decreases when the second development bath
contains a solvent of silver halide; in this case, the non-exposed grains
lose their developability.

(f) Treatment in a $10^{-1}$ M sodium sulphite solution between the
thiosulphate solution and the oxidation bath decreases the reversal effect
by decreasing the developability of non-exposed grains and sometimes
by cancelling it.

(g) The modification of the fog is not due to the oxidation products
which arise from development of the silver, because it is observed on
sensitometric strips which have not undergone bleaching.

## Discussion

These experiments, as far as the low exposure level is concerned, show
that non-exposed grains are influenced by the development of exposed
grains. It is interesting to note that a small number of developed grains
prevent the development of a large number of fogged grains; this fact
explains, in part, the grainy image obtained.

We can say that the halide ions liberated during development have,
if any, only a small action. This action is never preponderant, as is shown
by experiments with bromide ions added in the developer. Moreover,
washing after development has almost no influence. The protective
action is not due to the liberation of iodide from the reduced grains as it is
also observed with pure silver bromide emulsion. This action is not due
to the oxidation products of the developer as it is observed with com-
pounds very different and particularly with hydroxylamine whose
oxidized form is nitrogen and with ferrous oxalate.

The protective action can also be seen on a non-exposed film kept in
contact with a sensitometric strip during development and submitted
after development to a fogging action; the greater the developed density
on the strip, the smaller the fog on the non-exposed film (Fig. 3). There
is a desensitization when the receiving film is exposed to light.

When the sensitometric strip is developed in contact with another
film, there is a mutual influence of the two films, and the properties of the
non-exposed grains of the strip depend on the structure of the receiving
film. For instance, the protection against fog is greater when the strip is
developed in contact with a film previously developed to the $D_{max}$ than
when it is developed in contact with a plain gelatin sheet.

Taking into account all these experiments, it seems that the protective
action against fog is due to the presence in the neighbourhood of the

metallic silver resulting from the development. This hypothesis can be correlated to the observations of Stevens and Norrish about the Sabattier effect.

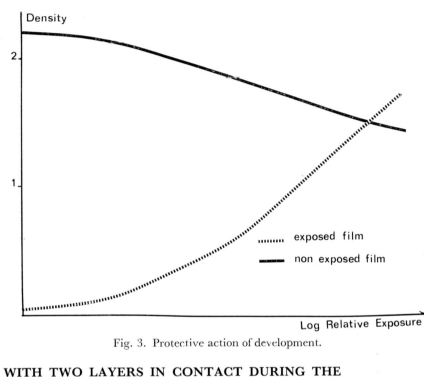

Fig. 3. Protective action of development.

## WITH TWO LAYERS IN CONTACT DURING THE DEVELOPMENT

### Experimental Procedure

For the study of the incidence of the development of an exposed film in contact of a non-exposed film, we have proceeded as follows:

(a) The film exposed to light behind a step wedge is soaked with surface developer and pressed after a predetermined period against a non-exposed film also soaked in the developer for 5 min. According to the purpose of the experiments, the two films brought into contact can be identical or different.

(b) When the development of the strip is finished the two films are separated: the strip bears the usual developed image, but strongly coloured. The unexposed film does not bear any silver image but shows a trace of colour corresponding to the image of the strip. At this stage, a prolonged stay in the developer does not change the aspect of the unexposed film.

(c) A few minutes washing under tap water or immersion in a thiosulphate solution ($4 \cdot 10^{-3}$ to $4 \cdot 10^{-2}$ M) followed by surface development gives an imagewise silver deposit. In Fig. 4 curve A′ shows the image obtained on the unexposed film after washing and surface development.

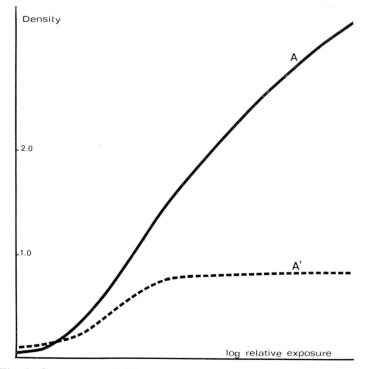

Fig. 4. Coarse-grain iodobromide emulsion. A—sensitometric strip; A′—non-exposed film after washing and surface development.

**Experimental Results**

The maximum density of the transferred image is always small and the graininess is high. The transferred image is coloured, usually green-yellow. This coloration is weakened but not effaced by a dichromate solution which dissolves silver; this leads one to believe it is due to the oxidation products of the development.

These phenomena have been observed, in varying degrees on all the studied commercial or experimental emulsions. The magnitude of the transferred image depends on several factors.

(a) The nature of the developing agent: while glycin has a stronger action than Elon, hydroxylamine gives a barely perceptible image. As

the oxidation product of hydroxylamine is nitrogen, it seems that the very weak image obtained with this developer is probably due to the impurities of hydroxylamine.

(b)  An oxalate developer gives no image.

(c)  The period of time elapsed between the immersion of the sensito-metric strip in the developer and the moment when the non-exposed film is placed in contact with it is of the highest importance. There is no transfer if the two films are placed in contact immediately on immersion of the strip in the developer or if they are not brought into contact until development has finished. In order to obtain an image, the two films must be placed in contact after the inhibition period, when development has already started. In our operating conditions, the best results are obtained from a coarse-grain X-ray emulsion after two minutes, as it is shown by the series of experiments performed for varying times (Fig. 5).

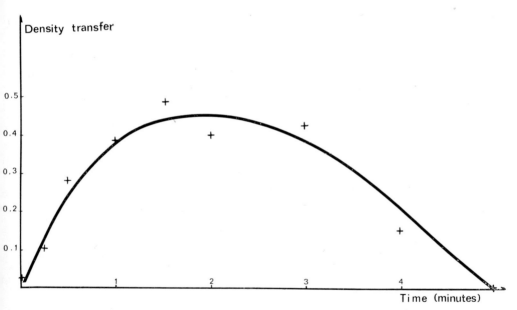

Fig. 5. Influence of development time before contact. The sensitometric strip is exposed so as to obtain on the unexposed film the plateau of curve A in Fig. 4.

(d) The temperature of water used for the washing made after separation of the two layers strongly influences the transferred image. A rise of temperature from 10° to 20°C increases the magnitude of transfer threefold.

(e) The sulphite concentration of the developer has also an influence: the presence of sodium sulphite in the first developer decreases the strength of the transfer, which is reduced by half for concentrations of about $10^{-1}$ M. For higher concentrations, the transfer can be cancelled.

(f) Pinakryptol yellow considerably modifies the phenomenon: incorporated in the non-exposed layer, it inhibits any transfer. On the other hand, when it is introduced into the sensitometric strip exposure, it promotes transfer; for equality of density of the exposed films, the transferred image is more important when the strip has been desensitized. In this case, transfer occurs even when the two films are placed in contact immediately on immersion in the developer.

**Discussion**

It appears that the phenomena can be correlated to the migration of the oxidation products of the developer. This hypothesis is in agreement with the influence of sulphite which, added to the first developer, decreases the effect. It also explains that there is almost no transfer when hydroxylamine or ferrous oxalate are used. The influence of pinakryptol yellow added to the sensitometric strip is not due to an interaction of the desensitizer with the oxidation products of the developer, as it cancels the transfer when it is incorporated in the receiving film. Its action can probably be correlated with its influence on the kinetics of the development.

E.S.R. experiments were made, according to the Roberts[5] technique. They confirm our ideas concerning the role of the oxidation products and it is shown that the quantity of semiquinone released during development is connected with the density of the transferred image.

**CONCLUSION**

These experiments show that non-exposed grains are influenced by the development of exposed grains. This influence is latent and cannot be seen during the development. It can be detected only when the development is followed by a complementary treatment and by a second development.

The two sets of experiments show that two phenomena occur when under some conditions, the development protects the non-exposed grains against a fogging action; and under other conditions, the development of the exposed grains increases the reactivity of the non-exposed ones.

The mechanisms of these two phenomena are quite different. The first phenomena is probably associated with the presence of metallic silver, while the second is due to the action of the oxidation products of the developer.

# APPENDIX

Formulae used in this paper are given below.

## Developers (quantities in g)

| | Glycin[6] | Hydro-quinone | Elon | Elon \| Hydro-quinone | Hydroxy-lamine |
|---|---|---|---|---|---|
| Developing agent | 30 | 5 | 2 | 2 + 5 | 30 |
| Sodium carbonate (anhydrous) | 44 | 25 | 30 | 25 | 40 |
| Sodium sulphite (anhydrous) | | 30 | 30 | 20 | |
| Water to make 1000 ml | | | | | |

## Developer with Ferrous Oxalate[7]

A. 25% solution of potassium oxalate.

B. 25 g of ferrous sulphate and 1 g of citric acid in 300 ml of water.

Mix A and B in equal volume.

## Bleaching Bath

| | |
|---|---|
| Potassium dichromate | 8 g |
| Sulphuric acid (conc.) | 10 ml |
| Water to make | 1000 ml |

# References

1. Stevens, G. W. W. and Norrish, R. G. W., *Photogr. J.*, **78,** 513 (1938).
2. Waterhouse, J., *Brit. J. Photogr.*, **37,** 601 (1890).
3. Rawling, S. Q., *Photogr. J.*, **66,** 343 (1926).
4. Zyuskin, N. H., *Usp. Nauch. Fot.*, **3,** 212 (1955).
5. Roberts, H. C., 23rd Annual Conference of the Society of Photographic Scientists and Engineers, New York, May 18–22, 1970.
6. Stevens, G. W. W., *Photogr. J.*, **82,** 42 (1942).
7. Hautot, A. and Sauvenier, H., *Sci. Ind. Photogr.*, [2], **23,** 169 (1952).

# Straight-line Photographic Processing Devices

SAMUEL KITROSSER and HUTSON K. HOWELL

*Itek Corporation, Optical Systems Division, Lexington, Mass., U.S.A.*

ABSTRACT. The demand for rapid access to a variety of photographically recorded data, coupled with the availability of materials with greater high temperature and abrasion resistance, has resulted in the development of a class of photographic processors that employ a linear (or nearly so) processing path. This paper discusses and illustrates the development of the linear approach, including the patent literature and the technical considerations, and shows a number of examples of commercially available systems.

## INTRODUCTION

The requirements for quantity, quality and rapid access to recorded photographic imagery present a genuine challenge to the photographic engineer called to create new and novel processing mechanisms. Although the processing of photographic materials involves principles similar to those encountered in the handling of other types of webs, the delicate nature of photographic materials and their value as high density information storage media narrows the choice of conventional processing techniques from those suitable for plastics, textiles, paper, metals, etc.

The engineer's task in designing processing mechanisms has been eased considerably by the availability of papers, films and plates whose resistance to higher processing temperatures is greatly improved. This improvement has resulted in a significant reduction in the duration of the individual processing steps and makes possible the production of small machines having relatively short path lengths.

Continuous photographic processing machines now in use treat photographic materials while being transported from one processing step to another without stopping the transport mechanism. In most of these machines the materials must follow complex paths in order to provide sufficient processing time. Since typical configurations depend upon

helical, spiral or serpentine paths, the material must be sufficiently flexible to withstand transport over such complex routes. This paper discusses a class of simple systems, the straight-line processing machines, in which photographic materials are transported in essentially linear paths with relatively little flexing. Also considered are a few systems which, though not absolutely linear, are closely related to linear types.

## DEVELOPMENT HISTORY

Processing was at one time a completely manual operation depending on human hands to carry film from tanks, to trays, to the dryer, etc. As processing volumes increased, demands for greater productivity and reproducibility inevitably forced mechanization of processes. Mechanization resulted in two basic types of devices: batch processors, in which the hands were replaced by a robot-type automatic mechanism, and continuous-flow processors that overcame the intermittent aspect of batch processing providing by conveyors for carrying long strips of materials from one stage to another.

The first mechanized processors were designed for motion pictures and the amateur finishing trade. The long processing times used in early applications prevented an efficient use of short, straight-path machines. On the other hand, the office copying and duplicating fields presented an opportunity for simplifying photo-processing. Figure 1 shows one of the

Fig. 1. Beidler's copying apparatus and straight-line processor.

early straight-path patents that issued to Beidler, U.S.P. No. 1 057 397, which involved a rack and pinion mechanism for pulling a cut sheet of paper over a series of shallow trays. Soon after, Crompton patented a device, U.S.P. No. 1 057 712, which processed a sheet of film with a soft pile roller impregnated with processing solution as shown in Fig. 2. Pask, however, found a more practical use for straight-line systems in reversal processing performed by small portrait studios. Figure 3 illustrates that his U.S.P. No. 2 419 853 disclosed a complete processor with processing stations placed between sets of roller pairs, all configured

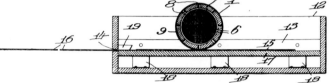

Fig. 2. Crompton's porous roller developer applicator. Original drawing.

in a straight path. From Pask, the automatic straight-line system developed rapidly and, within the past 10 years, several commercial processors have become available for the processing of papers, films and

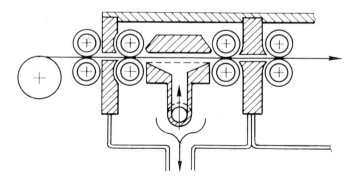

Fig. 3. A single module of Pask's processing machine.

glass plates. Straight-line machines are widely used in such fields as office copiers, copying, microfilming, graphic arts, radiography, and other specialized areas.

## TECHNICAL CONSIDERATIONS

The basic processor configuration consists of a series of stations in which the photographic material is treated with various liquid-chemical solutions, rinsed or washed with water to eliminate processing solutions that include by-products of chemical reactions, and finally, is dried. A transport mechanism is necessary for carrying the material from the loading end to the delivery end. While the mechanisms and approaches described here apply primarily to "wet" types of processing, some general principles are also applicable to dry processing, such as processing by heat treatment.

## TRANSPORT MECHANISMS

Straight-line processing machines use cylindrical rollers arranged in pinch pairs for the transport of materials. These rollers, in addition to their transporting function, also act as isolators between processing stations. They effectively squeegee the materials traveling through their nip and are placed so that surplus chemical solutions will drain back to their proper tanks. Several pairs of rollers in multiple banks satisfactorily replace the conventional air-knife blowoffs found between the wet and dry sections of many regular processors. The favored elastomeric coverings for these rollers are synthetic and natural rubbers, plasticized polyurethane, and plasticized polyvinyl chloride. The roller pairs can be compressed with springs or mounted on permanent centers, relying on their own elasticity for compression. The exact choice of coverings and mounting system depends on the types of materials and the chemistry of the process. For instance, some films will accept a combination of one solid stainless steel roller with a resilient mating roller, but in other cases, like glass plates, the rollers must be made of a soft easily compressible material.

As in all photographic processing machines, tension problems arise as a result of the cumulative effects of shrinkage and expansion in the materials themselves and slight differences in transport speed. Care in roller manufacture is necessary to ensure that roller diameters are closely matched, a requirement met by precision grinding of the roller covering. Additional control of tension is obtained by selective placement of larger-diameter rollers at the output end of the assembly. More importantly, however, the kinetic friction between wet rollers and the photographic materials is low enough to allow adequate self-adjustment of web tension through minute slippage. The rollers in the dry section, where no slippage occurs, assure precise pacing of the entire transport system.

Since most straight-line machines are self-threading and splicing

between sheets or rolls is not needed, the distance between roller pairs determines the minimum length of material that can be transported in a self-threading mode. The distance between rollers also determines the maximum size of the solution or air applicator that can be used per station. In practice these distances range from 5 to 8 inches (12 to 20 cm). To insure self-threading for shorter lengths, a leader tab can be attached to the material being processed.

## SOLUTION APPLICATION METHODS

One of the simplest methods for applying processing chemicals is to place the lower transport rollers within solution trays and use them as roller coating applicators. Satisfactory uniformity can be obtained with this method to activate and stabilize printing materials which already contain developing agents in the emulsion layer. Processing machines for the universal use normally are designed with a circulating applicator to provide a liquid layer on both sides of the processing web. Wright's

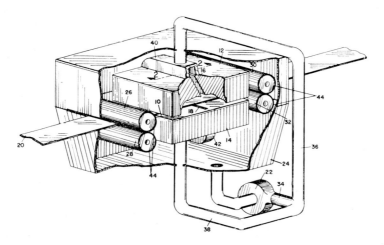

Fig. 4. Wright's arrangement of a straight-line transport mechanism with a circulation solution applicator. Original drawing.

patent, U.S.P. No. 3 192 846, describes in Fig. 4 an applicator consisting of a pair of plates parallel to the processing web, with slit orifices feeding a layer of processing liquids. Kitrosser's patent, U.S.P. No. 3 344 729, shows a processor consisting of one chemical station, one rinse and one drying station as in Fig. 5. The configuration of solution applicators in this processor combines a turbulent flow at the slit exit with a laminar flow in the remaining area of the processing tunnel.

Figure 6 illustrates another approach for application of solutions, in which the Luboshez system, U.S.P. No. 3 057 282, forms roller confined cavities. In designs where self-threading is not a primary consideration, one could consider frictional seals. Land's patent, U.S.P. No. 3 120 795,

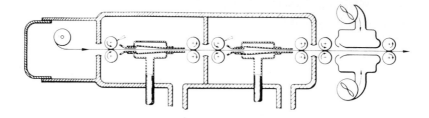

Fig. 5. Itek processor for removal of the anti-halation layer from Polaroid 55-PN negatives.

describes in Fig. 7 a flat container with resilient foam input and output seals. For narrow-width films, self-threading can be combined with friction seals as described in Kitrossers U.S.P. No. 3 618 506. This approach is successfully used on several types of 16 mm recording films

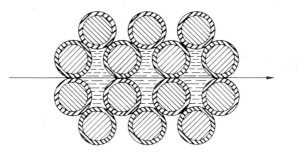

Fig. 6. The Luboshez method of forming closed cavities by means of adjacent rollers.

and is shown in Fig. 8. Troidl, in U.S.P. No. 2 848 931, shown in Fig. 9, uses saturated porous webs which are laminated to and separated from photographic materials in a continuous straight-line processor. A more elaborate porous applicator system is described in Fig. 10 by C. J. Boyle *et al.* in U.S.P. No. 3 616 742. Here the inventor has assembled a series of hollow porous roller pairs through which are circulated processing solutions. Another type of applicator, described by Hans Dieter Frick

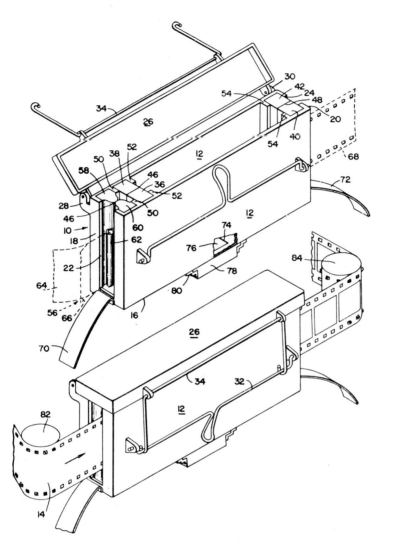

Fig. 7. Dr. Land's straight-line seal enclosed processing device. Original drawing.

in U.S.P. No. 3 610 131, improves the randomness of solution agitation by combining a wave-shaped applicator with strategically located solution-feeding orifices, as illustrated in Fig. 11.

All of the above systems required only moderate amounts of solution to maintain the circulating system in operative mode. In some instances,

a continuous operation is obtained by conventional replenishing of solutions. In other cases, solutions are used for a predetermined length of film and then replaced by fresh solutions. In some small size machines,

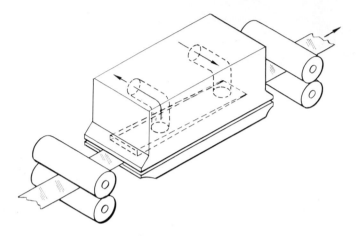

Fig. 8. A module of an experimental Itek 16 mm film processor.

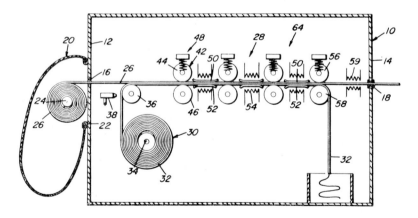

Fig. 9. The Troidl saturated webb processor. Original drawing.

fresh solutions can be fed in continuously and the overflow rejected as waste, further improving the sensitometric reproducibility. Straight-line machines that process films up to 12 inches in width may use as little as four liters of solution per tank.

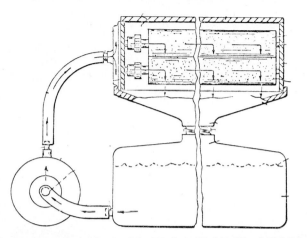

Fig. 10. Porous roller pairs used by Boyle in U.S.P. No. 3 616 742.

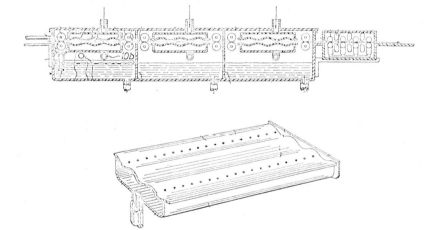

Fig. 11. Wave-shaped applicators used in processor designed by Hans Dieter Frick.

## WASHING AND DRYING

Straight-line paths do not present any special or unusual photographic washing and drying problems. The washing and drying stations resemble those of the liquid-chemical applicator stations but are supplied with water or warm air. Kitrosser, U.S.P. No. 3 293 775, describes a dryer that provides an air flow in the same direction as the film path, a feature that facilitates the self-threading of the film. This particular approach, when used in a dual drying section has proven practical for drying rates up to 10 ft min$^{-1}$ in a total drying path as short as 12 inches.

## TYPICAL STRAIGHT-LINE PROCESSORS

A representative group of straight-line processors has been developed in the laboratories of Itek Corporation in Lexington, Massachusetts. Figure 12 shows an early version of the Itek Flofilm™ Processor, developed for a trailer installation and adapted for processing rolls or

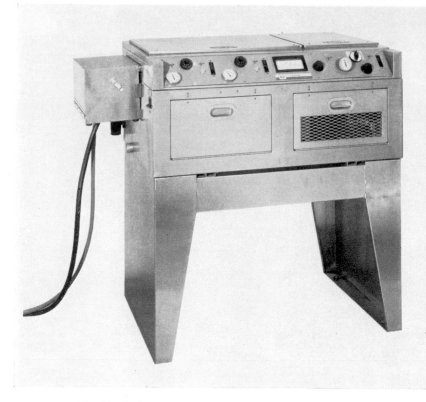

Fig. 12. Itek Flofilm processor for roll films, cut films and paper.

cut sheets of various films or paper. Later versions of this machine were developed by Rolor Corporation under the trademark of Transflo. A microfilm processor, the Itek 335 Transflo™, now part of the Itek microfilm equipment series is shown in Fig. 13.

The same Itek approach to straight-line processing is found in several of the GAF Transflo Processors. Among these, the Model 1210, shown in Fig. 14, can be adapted for the processing of black and white or color materials.

Two other companies using the straight-line approach to microfilm processing are Cordell Engineering in Everett, Massachusetts and the Houston-Fearless Division of Technology Incorporated in Los Angeles, California. A typical Cordell processor, type 240, is illustrated in Fig. 15; a plumbing schematic of the Houston-Fearless Micro-Flow Processor is shown in Fig. 16.

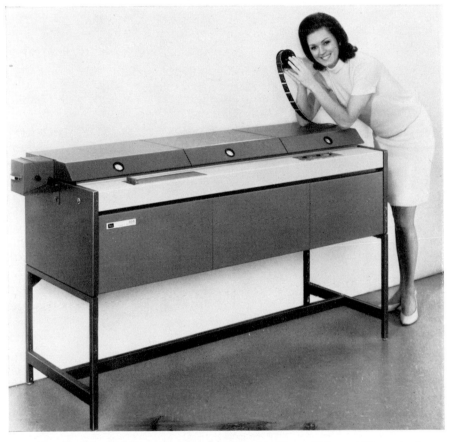

Fig. 13. The Itek Transflo processor for microfilms of 16 mm, 35 mm and 105 mm.

The straight-line concept has been applied to medical X-ray film processing in the Pixamatic III Automatic Film Processor by Picker X-ray Corporation of Cleveland, Ohio. Figure 17 shows a solution applicator and the roller transport assembly of this processor.

As previously mentioned, some processors represent variations of the straight-line approach. Thus, the Itek 18–24 RS Processor shown in

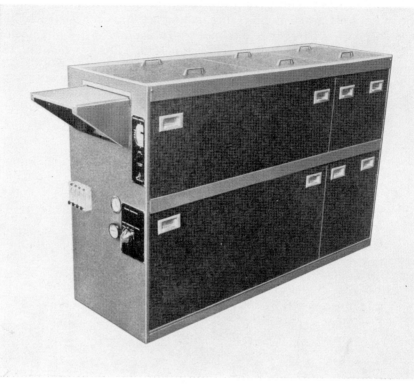

Fig. 14.  GAF processor type 1210 for black and white and color films.

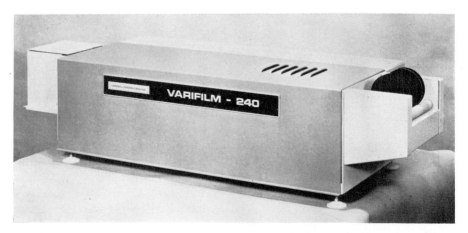

Fig. 15.  A table top microfilm processor made by the Cordell Corporation.

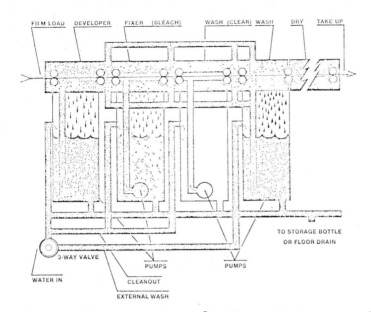

Fig. 16. A plumbing schematic diagram of a Houston-Fearless processor for conventional black and white or reversal processing.

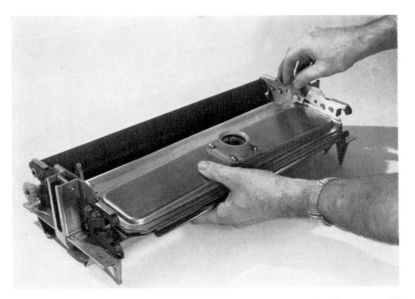

Fig. 17. Solution applicator for a Picker X-ray processor for films up to 17 inches wide.

Fig. 18 is a combination of a straight-line "kiss roller" section followed by a slightly curved "dip" section for treating the material simultaneously on both sides.

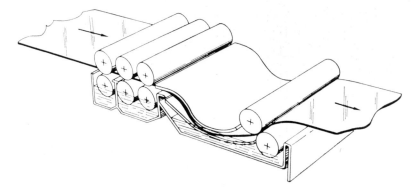

Fig. 18.  The processing module of an Itek RS 18·24 reader printer.

The PAKO Corporation of Minneapolis, Minnesota has adapted a straight-line drying section to many of their photo-finishing processors, for example, Models 17-1 and 24-1, shown in Fig. 19.

An interesting approach has been chosen by Eastman Kodak Corporation in their line of wide-web Supermatic engineering-drawing

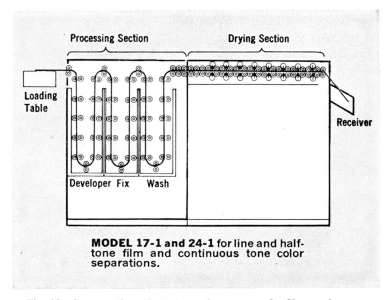

Fig. 19.  Cross-section of a Pakomatic processor for films and paper.

processors. Fig. 20 shows that this processor actually consists of three straight-line sections configured in a folded, space-saving module.

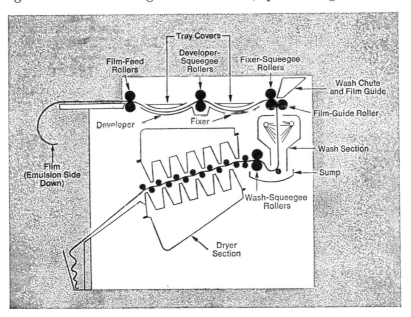

Fig. 20. Diagram of the folded path of an Eastman Kodak Supermatic processing machine.

## CONCLUSIONS

The wide acceptance accorded straight-line processing systems stems from their basic operational flexibility, simplicity and compatibility with rapid-access requirements. The straight-line approach simplifies the problems commonly encountered in the design of guiding, tracking and threading mechanisms. Since in-and-out turns are not used in the straight-line designs, the moving web of photographic material gains substantial beam strength across the web, causing the web to track in a path established at the loading station. Thus, guide flanges are not needed and multiple strands of sheets or rolls can be processed simultaneously, the number being limited by the channel width only. It is also worthy of note that the physical characteristics of the base material are not critical and wide differences in thickness and stiffness can be tolerated without the necessity of elaborate tension adjustments.

The roller-type transport mechanisms used in virtually all straight-line systems lends itself to leaderless processing of film at all lengths greater than the separation between adjacent roller pairs. This feature is very important for processing applications in the recording field, where rapid

access may be required regardless of the length of the record. Furthermore, the short access time permits frequent checks on sensitometric performance and minimum-delay adjustments in transport speed and solution temperatures.

While the straight-line approach does have physical limitations in processing path length, it does offer practical solutions to many problems encountered in the design of present day processing equipment for the gathering of photographic data.

## Bibliography

1. Dimsdale, W. H., Processing Machines and Automation. *In:* Mannheim, L. A., "Prospective World Report, 1966–69, of the Photographic Industry, Technology and Science". Focal Press, New York, 1968.
2. Frankel, Seymour, "A Straight-line Immersion Processor Utilizing Modern Agitation". A preprint of papers presented at the SPSE Conference in San Francisco, California, 1966.
3. Titus, Arthur C., "A Novel In-flight Processor Design". A preprint of papers presented at the SPSE Symposium on Photographic Processing. Washington, D.C., 1969.
4. Jacobs, Joel, "The Art of Silver Film Processing for the Microfilm Industry". *In:* Microfilm Techniques, Vol. 1/No. 4, August–September 1972.
5. Bates, James E., "Review of Processing Methods". *In:* Image Technology, Vol. 14/No. 5, August–September 1972.

# Author Index

Numbers in *italics* refer to pages on which references are listed at the end of each paper. The references, in parenthesis, start from 1 for each paper.

# Subject Index

## A

Acetate, 57–61
Acetic acid, 18, 58–60, 65, 275
Activated complex, 12
Activation energies, 8–10, 15, 138, 142, 286
Acutance, 268–269
Adjacency effect, 162
Adsorption
  developing agents, 237
  DIR couplers to silver, 183, 185
  retarders to silver sulphide, 192
Aeration, 132–134
Agfa ISS negative film, 183
Agfachrome-60 process, 156
Agfacolor chromogenic reversal paper, 156
Agfacolor reversal film CT18, 183
Agfa-Gevaert Micromask, 269–270
Agitation, 239, 246–251, 254–258
  nitrogen, 274–281
Alcohol, 273, 275
Aluminium
  hardener, 241–244
  ion, 57
Amines, 164
Aminophenols, 79, 82, 88–90, 98, 212, 215
  dialkyl-, 74
m-Aminophenol, 195–196
p-Aminophenols, 88–90, 96, 103–104 122–129, 195–196
  anionic substituents, 90
  1-(p-aminophenyl)-3-aminopyrazoline 125
  p-benzyl-, 104, 114, 125
  p-benzal-, 125
  dialkyl-, 96
  dialkyl-, sulphonic acid, 92
  p-dimethyl-, 125
p-N,N-ethyl-isopropyl-, 125, 127

N-methyl-, 88, 209–210
  monoimine, 122
  N-propyl-, 89–90
  reducing power, 126
  substituted, 75, 105, 125
Aminorcductone, 37
Ammonium metabisulphite, 57
Ammonium thiocyanate, 226
Ammonium thiosulphate, 53–61, 170, 226, 241–244, 251
Aniline
  4-amino-3-methyl-N-ethyl-N(β-methyl-sulphonamidoethyl)-, 198
Anodic peak potential, 210
Antagonism 218
Antifoggant, 164, 183
  activity, 192, 301
Anti-halation layer, 268–269, 273, 277, 279
  removal, 316
Anti-oxidizing agents, 104, 166, 208
Archival storage, 239, 247, 259
Ascorbic acid, 8, 10, 18, 25, 37, 73, 84, 86, 93–95, 97, 207–220, 231, 236
  antioxidant, 166
  derivatives, 207–219
  L-, or D-arabo-, see Ascorbic acid
  D-glucoimino-, see Ascorbimide
  imino-, 208
  induction period, 211, 215
  iso-, 207
  stability, 219–220
  superadditivity, 215–216
  xylo-, 207
Ascorbimide, 207–215
  induction period, 215
  stability, 220
Atmospheric pressure, 138
Autocatalytic reaction, 32
Autoxidation, PQ solutions, 131

331